AFRICAN ROOTS, BRAZILIAN RITES

African Roots, Brazilian Rites

Cultural and National Identity in Brazil

Cheryl Sterling

First published in 2012 by
PALGRAVE MACMILLAN®
in the United States—a division of St. Martin's Press LLC,
175 Fifth Avenue, New York, NY 10010.

Where this book is distributed in the UK, Europe and the rest of the world,
this is by Palgrave Macmillan, a division of Macmillan Publishers Limited,
registered in England, company number 785998, of Houndmills,
Basingstoke, Hampshire RG21 6XS.

Palgrave Macmillan is the global academic imprint of the above companies
and has companies and representatives throughout the world.

Palgrave® and Macmillan® are registered trademarks in the United States,
the United Kingdom, Europe and other countries.

ISBN 978-1-349-43622-4 ISBN 978-1-137-01000-1 (eBook)
DOI 10.1057/9781137010001

Library of Congress Cataloging-in-Publication Data

Sterling, Cheryl, 1964–
 African roots, Brazilian rites : cultural and national identity in Brazil /
Cheryl Sterling.
 p. cm.

 1. Blacks—Brazil. 2. Blacks—Race identity—Brazil. 3. Group
identity—Brazil. 4. Brazil—Race relations. I. Title.

F2659.N4S74 2012
305.896'081—dc23 2012011144

A catalogue record of the book is available from the British Library.

Design by Newgen Imaging Systems (P) Ltd., Chennai, India.

First edition: September 2012

Contents

Acknowledgements

ABORU ABOYE BO SISE

This book has been a long time in the making, beginning during my dissertation research in 2000. Over the years, there have been so many people and institutions that have contributed to my ability to undertake this research that it would be impossible to name them all. However, I must acknowledge the Tinker Field Research Grant, given through the Latin American, Caribbean, and Iberian Studies (LACIS) Program at the University of Wisconsin, Madison, and the research fellowship from the Organization of American States, which funded the earliest parts of this research. I would also like to thank the Liberal Studies Program at NYU for its Research Development Grant, which sustained the research at a crucial stage. I also must thank the Fulbright Scholars Program, which funded my last research journey in 2010–2011, and the Humanities Initiative Grant-in-Aid at NYU that provided crucial final funding for the publication of the manuscript. I would be remiss if I did not thank Prof. Henry John Drewal, who served as a mentor, guiding me in the pursuit of my studies of Africa in Brazil. And I must acknowledge the ladies of CEAFRO in Salvador who adopted me and helped me learn the nuances of their struggles. Special thanks must be given to Dr. Lisa Earl Castillo, who shared her research and resources, and reshaped crucial parameters of the book. Key organizations opened their doors and allowed my inquiries, such as *Ilé Aiyê*, *Olodum*, *Malê de Balé*, the writers collective *Quilombhoje*, and the *Bando de Teatro Olodum*. Overall, there were many people who offered their time to explain crucial events in the society, and who provided interviews and the primary contexts to sustain my inquiries. To all of you, I give a grand AXÉ. I only hope this work fairly represents your voices, and, of course, any inaccuracies are mine.

Introduction: What Roots?
Which Routes?

> *To speak means to be in a position to use a certain syntax,*
> *to grasp the morphology of this language,*
> *but it means above all to assume a culture,*
> *to support the weight of civilization.*
>
> Fanon, *Wretched of the Earth*

> *What is spoken or silenced depends on who is speaking,*
> *who is doing the documenting, from whose perspective,*
> *by whose criteria, and what is being recorded.*
>
> Brenda Dixon Gottschild[1]

Issues of identity are considered part of the hallmark of modern consciousness. If we view modernity as the point from which to give voice to rupture and displacement, queries such as who am I? and where do I belong? arise out of the modern subject. This is why Paul Gilroy (1993) relocates the discourse of modernity to the triangular route of the slave trade, renaming it the black Atlantic. For who else but the enslaved Other (and their descendants) embodies this crisis of non-belonging to the extent that it transcends existential angst to develop into new myth-making realities. This work's engagement with Afro-Brazilians' articulations of Africanness and blackness incorporates their quest for rootedness in Africa but also places them in the unified oeuvre of diaspora space that Gilroy reconceptualizes to include the history of enslavement, racism, and the engagement of black peoples with practices of nation building, citizenry, and modernization in the Western discourse of modernity.

In any interrogation of identity, the tension lies within the very articulation of the term. Identity is often viewed as the dichotomy between notions of being and becoming. Being relates to the fixed,

unitary, originary source, while becoming is the variable, polysemic narrative that changes with each encounter. Embedded within this tension are the following questions: If the nature of identity is fluid and malleable, how does it motivate social interconnection? And at what point does it generate the stable, autonomous individual self that connects with the larger social grouping? These questions present the paradox within identity construction as individuals and groups assert an identity to inscribe their social/political positions and places in the world, which run contrary to the formulations by other groups about who they are and the significance of their cultural forms. What is seemingly a natural heuristic system, in which mutual exchange leads to greater knowledge, becomes quite nefarious within an asymmetrical power dynamic.

Theoretical models that straddle the postcolonial and postmodern divide privilege the malleability, fluidity, and negotiation attendant to identity construction (Burke and Stets 2009; Alcoff et al. 2006; Friedman 1998; Hall and du Gay 1996; Bhabha 1994). Identity, for García Canclini, is a narrated construct; however, its authorial source is predicated on the foundational, consecrational events in a nation, perpetuated through educational systems, reified in museums, and rhetorically promulgated in civic rituals and political discourse (*Consumers* 89). What interests Canclini and has a direct bearing on this work are the different "symbolic matrices" that narrate heterogeneity and the differing, nuanced codes that exist simultaneously in the national construct and the individual subject (ibid. 94–95). Rather than consigning the construction of identity to state-sanctioned representations, Stuart Hall (1996) further problematizes its source coding, questioning who needs identity to polemically theorize it as a temporary construct manifesting itself from discursive practices and the body of representations taken from the position as Other rather than subject. Said (1979) addresses this paradox within identity formation in both its formulation through hegemonic apparatuses (political, economic, educational, and their institutional counterparts) and the interrogation of such dominant discourses in acts of self-representation that become political. Insofar as Said (1993) raises the spectrum of culture as a site of resistance and self-representation, James C. Scott (1990) addresses the distinctiveness within subordinate groups that lends itself to such formations. Identity arises from what group members choose to emphasize in their cultural repertoires: by selecting stories, songs, dances, texts, and rituals based on their use value, they create new artifacts and

cultural practices to meet their needs. The agency of such cultural selection derives from what is accepted, what survives, and what is transmitted (Scott 157).

Identity in this work is conceived as a complex layering of Brazilian hegemonic discourses that defines the Afro-Brazilian subject and the ways Afro-Brazilians define themselves based on their cultural referents. Culture, too, has its dichotomies and contentions in this work between its conceptualization as a way of life, the lived reality of Afro-Brazilians (Williams 2009), and as a hegemonic, dominating, and saturating purview (Said 1993), due to the racialized zones of contestations under which Afro-Brazilians live. This text contemplates and interrogates the ways in which Afro-Brazilians deliberately choose a cultural identity based on their sense of ancestral location—their rootedness in Africa—and generate a stable, normative racial and social categorization through conceptualizations of their blackness to engage with dominant political and social paradigms. Discourses of Africanness and blackness are analyzed through the combined lens of Candomblé, specifically the Yoruba-influenced sector of the religion, and the metaphor of *Quilombo* agency (the independent communities formed by runaway slaves). Candomblé and Quilombo paradigms are interpreted as autogenous, intrinsic models that arise out of Afro-Brazilian subjectivity and signification, to which is added a third, external vector, formulated through the rubric of Black Power ideals.

This text discusses the formulation and epistemology of Candomblé rites and rituals and, analogically, extends its performance modalities from the private space of the *terreiros* [the religious enclaves] to the public space through the *festas populares* and the *Blocos Afros*, the Afro-based carnival groups, in Salvador da Bahia. It examines the discursive and performative articulations of an African/black subjectivity in drama, poetry, and hip hop, extending the research to encompass São Paulo and Rio de Janeiro. Cultural performances are read as "auto-hegemonic" articulations of identity that interpellate state discourses in movements away "from a reactive position pitted in perpetual conflict with authority, to an active position that derives authority, power, autonomy, and agency from itself" (Okediji 5). Such auto-hegemony allows for a framework that embraces subject articulation and dialogic accord in the creation of identity, and the two epigraphs to this chapter focalize the understanding that only a speaking subject can be definitional in regard to positioning, placement, trajectory, capability, and capacity in the world order.

"Why Keep Asking Me About My Identity?"[2]

Race and culture as social categories generate a formidable alliance and conundrum in which to discuss Afro-Brazilian subjectivity due to the tensions, affective ideologies, negations, negotiations, and embracements found in the particular compounding and rejection of each signification, whereby culture is racialized and racial identification becomes culture. Historically, race relations have always been sites of tension in Brazil. Socially and politically charged discourses and policies, based on the ideal of a *"democracia racial,"* promote an ethnic plurality in which the idealized being, albeit racially mixed, chooses his or her racial identity. This myth of a racial democracy horizontalized racial hierarchies in its purported celebration of the three vectors of identity found in the mix of European, indigenous, and African bloodlines. The blending of peoples became epigrammatic in the characterization of Brazilian cultural multiplicity, and within those celebratory treatises African-derived cultural forms, delineated to their essences, became symbolic markers of the racial and cultural melding of the nation. Systemic closure between phenotype and institutionally and socially defined identities allows Brazilians to create an unprecedented array of color codification. Phenotype determines representational identity, and Brazilians choose how they want to identity and be identified in a chain of raced-based, color-coded significations, but the choices are never between racial identities or color codings that are equal; rather, a clear privilege is given to an individual with a white/European aesthetic over an African/black one, or simply put, the whiter one looks guarantees greater access to social and economic ascension (Telles 2004; Htun 2004; Reichmann 1999; Twine 1998).

Such overt privileging of whiteness dates back to the concourse of transatlantic slavery that began these African diasporic societies but, more specifically for the purposes of this work, also to the codification of the policy of *"embranquecimento"* or *"branqueamento"* [social whitening] (1889–1911) that prevailed after slavery (Twine 1998; Burdick 1992; Winant 1992; Fontaine 1985; Skidmore 1974). Afro-Brazilians are the targeted group in this process of embranquecimento because whitening is equated to social mobility. Governmental policy banned all immigration of African and Asian peoples and, in turn, actively sponsored the immigration of whites in order to lighten the population. In tandem with its immigrationist agenda, the policy of embranquecimento promoted miscegenation in order to genetically attack and alter the black being. For the members of

the black population, as subcitizens,[3] it was explicitly forecasted that only their lighter-skinned descendants could achieve social mobility (Bailey 2009; Guimarães and Huntley 2000; Degler 1986). The legacy of institutionalized embranquecimento is reflected in popular Manichean beliefs that undergird the social fabric of Brazilian society: by blacks, that through this gradual whitening caused by miscegenation all social and economic impediments will disappear and, by whites, that with a whitened (and less backward) population, Brazil will take its place as a model of modernity in the world.

Brazil today is one of the ten largest economies in the world, with one of the most inequitable distributions of wealth. The Human Development Index marks it as a nation with markedly substandard conditions for the poor and the working class, and severely lacking in social policy or infrastructure to ameliorate this vast disjunction (Nobles 6; Baeto 778–80).[4] What becomes the dangerous camouflage in the national imaginary is that these economic and social cleavages are considered class-based issues, rather than racial ones, and that, due to the myth of democracia racial, even to suggest that the society is racially demarcated is evidence of one's own racism (Sheriff 2001; Nobles 2000). However, Afro-Brazilians are 33.7 percent of the 53 million poor Brazilians, which equates to 63 percent of the overall poor population, who are disproportionately affected by these "subhuman conditions" (Baeto 778). In tandem, they are the most likely targets for state-sanctioned violence, receive the lowest wages, and are allocated the most menial employment (Moehn 2007; Vargas 2006; Baeto 2004; Arias 2004). The combined racialized pathologies and nonfunctioning institutional structures continue to code Afro-Brazilians as outside the system of social and economic ascension.

These race-based discourses of embranquecimento and democracia racial are read in this text as the point from which to theorize and construct a discursive and representational alterity to the negation of the Afro-Brazilian subject. Néstor García Canclini argues in *Hybrid Cultures* (2005) that Latin American national identities incorporated the popular—the cultures of the social underclass—to legitimate their rulership of the people, yet simultaneously, in policy enactment, tried to eradicate their cultural forms in the nation's vision of the linear progress to modernity. However, in regard to Brazil, African cultural forms were co-opted rather than eradicated as key markers of *Brasilidade*, Brazilian identity. This narrative emphasizes a selective criteria of Africanness through topical invocations of cultural melding that allow *feijoada*[5] to become the national dish, samba the

national dance, and deracinated versions of the African-based religion of Candomblé and the martial art *capoiera* to be folklorized as popular performance genres.

How Does Hybridity Function in Brazil?

While hybridity purports to function outside of race, each of its theoretical vectors functions within the complex codings of the discourses of embranquecimento and democracia racial, as well as the processes of incorporation into the particular type of capitalist modernization that the nation underscored, to become discourses of social exclusion. To speak of hybridity in (post)modern cultures is to speculate on processes that are at once interruptive and transgressive, and yet commonplace and pervasive (Werbner 1997). Questions that such relations engender and that are immediately applicable to the Afro-Brazilian subject are the following: Whose culture determines the hybrid? What are the terms of hybridity when relations are not equal in access or resources and one is considered of lesser stature in the society or a member of a co-opted culture? Hybridity, as a lived reality, in the everyday movement of ordinary people within national spaces, within regions, cities, and neighborhoods, subject to influences from local and international forces, both culturally and politically, is a naturalized phenomenon that enables transmutations and entrenchment of values, behaviors, and ideas. Hybridity also connotes the social interrelations generated between different ethnic groups, genders, classes, technologies, and systems of power. It may apply to a total syncretic process in which all differences are nullified; an intermix in which the differences are apparent, but a new altered form is created; or even a continuous remixing of a previous syncretism.

What these discourses have conveniently forgotten or elided is the original formulation of hybridity as racial mixing and the biological determinism of cross-pollination. Hybridity's connotative significance expands to a combination of racial, cultural, and linguistic mixing, and the text *Eloge de la Créolité* is the apical proclamation of mixedness. *Creolité* promulgates a radicalizing counternarrative to *Francophonité* and creates a sense of Caribbeanness for those of the literati and the learned. The interrelation of Europe, Africa, and the Caribbean becomes a celebratory cultural, linguistic, and literary source, and a new way to be in the world. Hybridity here becomes a self-congratulatory construct in its assumption of equal relations, equal access, and equitable displacement, purporting the counterhegemony of such discourses in allowing for the voicing of difference.

The problem readily apparent in such postrace discourses is that, in the attempt to liberate us from the category of race, they do not eradicate institutional racisms, individual constructs of race, or the effects of race-based social policies that flourish all over Latin America and the world (Andrews 2010; Gudmundson and Wolfe 2010; Ben, III., and Restall 2009; Marable and Agard-Jones 2008; Clarke and Thomas 2006; Torres and Whitten Jr. 1998). For instance, in Paul Gilroy's (2000) ill-timed treatise against race, he declares, "skin is no longer privileged as the threshold of either identity or particularity" (47), postulating an obvious limit to his theorizing in the Brazilian context. His analysis cannot possibly extend to the complex figuration that marks Afro-Brazilian subjectivity, in which race translates into a complex pigmentocracy that hierarchializes based on skin shade, and the body that symbolizes *mesticismo*[6] is the tropic ideal. When the equivalent term to *creole* in Portuguese, *crioulo*, translates to "nigger," how can hybridity or creoleness be a transformative discourse? When hybridity becomes the normative, how does it amplify the role of Afro-Brazilians in the society, especially if they conform to neither its idealized standards of beauty nor the idealized values it upholds?

My attempt here in laying out some aspects of hybridity theory is to point to the limited modality in which it functions as an evocative paradigm for Afro-Brazilians' identity. Approaching Brazilian hybridity outside the paradigm of race, however, leads us into a non sequitur, but neither can we approach it just through the parameter of race-based identification. Given these issues, the Afro-Brazilian subject is a *hybrid* construct, both culturally and racially, but the manifold ways in which Afro-Brazilians reconstruct and choose to advance their Africanness and blackness is at the heart of this interrogation. What form of hybridity is then useful in order to study the dichotomies in representation between the hegemonic discourses of negation embedded within Brazilian society and the deterministic paradigms of Afro-Brazilians? In answer, an evocative modality from which to explore Afro-Brazilian identity arises from Canclini, who extends hybrid theorizing beyond areas of racial mixtures, religious syncretism, and traditional movements (*Hybrid* 2).

Hybridity also emerges when multiple and heterogenous traditions exist at the same time and share the same spaces, allowing for the simultaneity of modernity and practices deemed archaic. Allowing for in-depth perceptions about the functioning of power dynamics inside asymmetrical systems, such "reconversions" denote the adaptation of knowledge and the reshaping of ideals to reinsert into old frameworks and generate new modalities. The top-down phenomenon of power

relations is replaced by significations of the multifaceted dimensions of social action and the negotiations underlying the political processes within heterogeneous dynamics (*Hybrid* 3). Canclini's model advances an understanding of individual and group positioning in the midst of heterogeneity and the manner in which alternate figurations of hybridity lend themselves to identity formation. Even though he detaches from identitarian postulations, Canclini, in acknowledging the provisionality and transitoriness of hybridity, points to its limits and highlights an ever-present conundrum in Afro-Brazilian relations: Why do individuals and groups opt out of such open frameworks of multiplicity? The self-determining processes involved within Afro-Brazilian attempts at closure of identity become the target of investigation in this work.

The Profound Call of Africanness and Blackness

The desire for a root source is at the center in the Afro-Brazilian quest for Africannness. What must be understood is how Africa is defined and reconstituted in this particular diasporic lens. And how do conceptualizations of Africa become the formulaic base for the Africanness or the Afro in their identity formation? Similarly, how does the discourse of blackness develop in its relational sphere and manifest in the ideation of the Afro-Brazilian subject? In formulating Afro-Brazilian subjectivity, it must be understood that identities considered black in other spatialities are not necessarily black in Brazil. "To be black in Brazil," writes Marshall C. Eakin, "means to have no white ancestors"(115) and connotes social and economic exclusion rather than a racial identification (M. Guimarães 44). To identify as black may be a process of auto-selection, often prevented by the color stigmatization in the society. Hence, many Afro-Brazilians will call themselves anything but black, which translates into local parlance as "*Negro*" or "*Preto*"; additional categories such as *Moreno* [light brown] or *Pardo* [brown] become the official forms of identification endorsed by the census (Baeto 2004; Telles 2004; Piza and Rosemberg 1999). Even though the theorists addressed in this introduction condemn identitarian constructs as essentializing notions, none have addressed why and how these terms and subjectivities persist in real-world discourse. The proliferation of texts on blackness tells another story, one of peoples questing for a claimable center of self-determination (Fleetwood 2011; Andrews 2010; Gudmundson and Wolfe 2010; Yancy 2008; Elam Jr. and Jackson 2005; Sansone 2003; Moore 1997). Blackness in this work is a purposeful injunction of a chosen

identity as "*Negra*," "*Preta*," "*Parda*," *Afro-Brasiliera*, or even "*Afro-descendente*,"[7] in relation to a discourse of empowerment and social transformation. Key questions that such positionalities engender are the following: Why do individuals and communities refuse and resist hybridizing identities? What do they gain from positioning themselves within narratives of fixity and rootedness? And how are these forms of belonging generated from the actuality of transatlantic crossings, transculturation, and transnational groupings?

To further understand the dialogic doubleness in the tension between the appropriation of root discourse and heterogeneous frameworks of articulation, through which Afro-Brazilians restructure their interethnic, mixed race, and cross-class valence, I turn to Edouard Glissant's theory of roots and rhizomes. Glissant similarly decries the attachment to roots and advocates for a multiple-rooted system in his ideation of the rhizome. Attachment to root cultures is an attachment to legitimating ideologies that dominate other cultures. Rootedness evolves from narratives of mythic origination, is structured through lines of descent or "filiation," and is ratified by claims to land and territory, preserved through the conquest of other territories, authoritatively encoded in colonial enterprises (Glissant 144–45). Vehemently eschewing atavistic ideologies that seek to destroy or control others, Glissant alternatively theorizes the rhizome within the contradictory experiences of cultural contact, reproduced in a network of *Relations*, of fertile contacts and synergies, without a predetermined beginning or predictable end. It is rather part of a cycle of expansion and creation of the new, evident in the poly-rooted character of Caribbean subjectivity. With its beginnings in the traumatic memory of slavery and its assertion of creolization,[8] the tentacle-like proliferation of a rhizomatic identity allows differences to have a place; systems of shared belonging may then construct relational identities in concert, out of shared communication, without imposition or warrants from above.

This exploration of root ideologies, their permutations, and their *route*s is much more Glissantian in its character, but not because of an intent to negate the concept of root. Rather I begin to write against Glissant's concept of the root source as an ideological construct to perpetuate domination. However, I see within his theory of the rhizome the relational root, the spreading of different aspects of Afro-Brazilian subjectivity and identity. Facets of that rhizomatic root, I argue, are found in Candomblé rituals, carnival, drama, poetry, and hip hop culture as explored in this work. Glissant's relational root refutes the notion of identity as imposed from a hegemonic system outside of the

subject position. In such a formation, identity is constructed as part of an amalgam with relativized, multiple centers that coexist with each other à la Canclini (2005).

This work shifts the issues regarding Afro-Brazilian identity from the focus on the impossibility of an imagined past to the more agentative foci Ella Shohat advocates, by understanding the mobilization of the articulation of the past, the deliberate deployment of sets of representations, and the political vision they access and represent for Afro-Brazilians ("Notes" 110). Many of the primary and scholarly texts used in this work are originally in Portuguese, and the translations are mine. I have attempted to be as faithful as possible to their intent, to allow Afro-Brazilians' voices to articulate their own paradigms and relations to their society.

The first chapter is an overall historical analysis, focusing on the link to the Yoruba peoples from Benin and Nigeria, from which Afro-Brazilians undergo a symbolic reterritoritalization of a sense of Africanness in the transposition of Candomblé discourse and ritual. This is not to deny the intercultural flow of Africans in Brazil or the "transnational formation" that results (Gilroy, *Black Atlantic* ix) but to argue that the Yoruba model is deliberately remembered and enshrined to signify Africa. The chapter focuses on three vectors in which one may trace this imbrication of roots and relational ideations. The discourse of rootedness in Candomblé is examined within the construction of first a Nagô-centric (Yoruba-based) identity, specifically out of the conditions of forced and voluntary transatlantic travel; second, the legitimation of the *pureza nagô* [pure Yoruba] by religious adherents and the scholars they co-opt; and, third, the articulation of Africanness through the "reconversion" of ritual and symbology out of the Yoruba-based matrix (Canclini 2005).

Chapter 2 examines three public rituals in Salvador, the *festa de Santa Barbara*, the *festa de Iemanjá*, and the *Lavagem do Bonfim*, considered rhizomatic implantations from the discursive and performative fields of Candomblé. Linking the ritual forms within the *terreiros* to the public ceremonies in the city of Salvador, the festas are read as forms of cultural politics. Their celebratory aspects are analyzed in light of the project of political and social transformation that they illustrate through their performative strategies. Examining performance encompasses subject formation, the internalization of subjectivity, and its representation in the public sphere. As public reflexivity, performance inverts and reverses established social order, articulates social issues, and strengthens group identity. Shifting the negotiation of discourse to the performer, the body is the visual text

in which identity is simultaneously formed and performed. This chapter then engages with public performances of an "African" identity as contrastive ideations of power that are sources of communal identification and transformative praxis.

In 1975, the year after *Ilê Aiyê* was founded, their carnival presentation marked the beginning of a new cultural era. Openly challenging the established hierarchy, their first popular hit, "*Que Bloco É Esse?*," marks the transition to a black aesthetic as a source of creativity. Chapter 3 thus interrogates the polemical discursive and performative iterations of Africanness and blackness by the blocos afros. The body of representation of an African identity found in the bloco, Ilê Aiyê is juxtaposed against the more hybridic formulation of the bloco, *Olodum*. Such comparison allows for an exploration of the causative factors, strategies of engagement, and field of affect/effect in the refusal of a hybridic identity (Ilê Aiyê) and the sanctioning of one (Olodum). As the two major blocos afros, the representational sphere of these two carnival groups are read as delineative texts of what Brazilians consider a transgressive political ideation in the way they denounce oppression in all forms and seek to revise the historical archive on the black world. However, the tension such work generates is in understanding the actual points of transformation within the society. While carnival allows for a spectacular representation of Africanness and blackness, does the representational corpus generated by the blocos afros indeed connote transformative praxis?

Chapter 4 examines the works of the writing collective Quilombhoje as a literary movement that challenges the aesthetical code of blackness inherited from Enlightenment discourse and undergirds the formulation of the policy of embranquecimento. Comparing Quilombhhoje's project of articulation to the United States–based Black Arts Movement (BAM), it analyzes a similar convergence of political thought and action. Each movement's aesthetic quest, it deems, poses radical challenges to conventional literary models and are consciously shaped by an interrogation of the symbols, ideals, and social forces reflected in the poetry analyzed. The works of Quilombhoje are read as a collective continuation of the ideals of the BAM poets, but with crucial differences in the insertion of specific Afro-Brazilian spheres of representations that speak to their desired telos to restore a "lost" history and generate a "pluricentric" ideology (Quilombhoje 1985).

Chapter 5 compares the two major Afro-Brazilian theater groups, *Teatro Experimental do Negro* (TEN) with the *Bando de Teatro Olodum*. It situates each group historically, but within a similar quest

for an aesthetic form derived from Candomblé as a template for dramaturgy. Analysis focuses on a seminal play by each group, *Sortilégio* by TEN and *Cabaré de Raca* by the Bando, to elicit their imbrication of aesthetics and politics in their desiderata to generate impact beyond the field of performance on conceptualizations of the self, community, and society. Focusing primarily on the Bando's creation of aesthetic signifiers that speak to the real, lived experiences of Afro-Brazilians, it situates the Bando's use of mimesis within a canonical framework in order to highlight its difference in its development of a singularly unique Afro-Brazilian theater form.

Chapter 6 situates the hip-hop movement in the network of philosophies and aesthetics of blackness, power, and resistance, and examines the songs and performance textures of the artists through their videography as testimonies for the dispossessed and disenfranchised. Hip-hop is both a cultural movement and a political one, and this chapter situates it as an alternate social movement in Brazil that generates a site of contestation and a specific political positioning as *marginal*, within an Afro-Brazilian identitarian framework. I argue that the hip-hop movement arising from within the ingenious, experimental cultural reformulations of blackness, beginning in the *bailes* black, the soul and funk dance movement from the 1970s, allows for the transposition of hidden forms of protest to engage symbolically with the dominant social and political sphere (Scott 1990). It frames the hip-hop movement as proactive rather than reactive, in that its oppositionality is not its only paradigm; it not only renders resistance to subordination but is also engaged in the project of actively shaping subjectivity and agency.

This text concludes by bringing together the interpretations of Afro-Brazilian negotiation in their quest for inclusion in the Brazilian narrative ideal. Its wide-ranging themes and reworking of subjects, such as their dialogues of rootedness and alternate spheres of relation, the dynamics and reconfiguration of centers of power, and the agency and self-reflexivity of performance and representation, shed critical light on the ways in which cultural and political identity is dually inscribed hegemonic discourses and the self-reflexivity of the subject.

Conclusion

To reflect the unique trajectory of Brazil, this work elides the boundaries between race and culture by analyzing their representations in written and performance-based texts. By linking Yoruba ritual and

discourse to the desires for social and political change promoted in aesthetic considerations of public rituals, carnival performances, drama, poetry, and hip-hop, this work gives a new understanding of Afro-Brazilian identity. It introduces readers to alternate textualities, reframes texts, and generates new aesthetic models that engage in political praxis. By deliberately exploring verbal, visual, and performative modes, it allows for the transliterary dimension of Afro-Brazilian cultural modalities to be interrogated. Traversing the dynamics of the spoken and written word, ritual specialists, dramatists, poets, hip-hop artists, and cultural and political activists conjoin to transform the issues of identity within verbal, scribal, and visual narratives. In these (extra)literary transitions, the transformation occurs in the voice of the subject, and in the performance the voice and body combine to contextualize Afro-Brazilian identity.

Chapter 1

Where Is Africa in the Nation?
History as Transformative Praxis

How can we as intelligent beings submit to the self-imprisonment of a
"saline consciousness" which insists that, contrary to all historic evidence,
Africa stops wherever salt water licks its shores.
> Wole Soyinka, *"The African World and*
> *the Ethnocultural Debate"*

Orúko tó wu ni làá jé léhìn di.
> [Outside the walls of your birthplace, you have a right
> to choose the name that is attractive to you.][1]

For officialdom-Brazil of the past and the present, Africa and all
beings and things that claim an African identity are relegated to the
abyss and deemed unsuited for social and economic access and mobil-
ity. If not deemed peripheral, African cultural markers were modified,
co-opted, and renamed to suit the prevailing myth of *democracia
racial*. Through the process of *"limpar o sangue"* [cleaning the blood]
(Mattoso 191), the deliberate choice of racial and cultural identifica-
tion began. Choosing to forget one's African ancestry insured access
to power and prestige. Thus the elite erased blood ties to Africa,
although the bloodlines carried visible markers. Participating in this
erasure, blacks chose to marry progressively lighter-skinned individu-
als in order to "whiten" their descendants who, they hoped, would
then gain access to social advantages. Given the pressure to whiten,
identifying oneself as African/black and choosing a black identity
stands as a revolutionary, subversive act aimed at challenging the
national consciousness and the processes of power construction and
consolidation. Since most Afro-Brazilians are of mixed heritage, the
pivotal query is, How is this African and black identity constructed?

It is my contention that a discourse of Africanness arises out of the practices of Candomblé and becomes a legitimating source from which to generate auto-hegemonic narratives of identity for Afro-Brazilians. In the hybridic forms of culture found in Brazil, a remembrance of Africa takes on political signification and is equated with constructs of black subjectivity. Using terms such as "*Negra/o*," and to a lesser extent "Afro-descendente," as personal forms of identification become life-altering declarations, in that they denote a personal counterhegemonic stance to the imbedded discourses of whitening and racial democracy with centrifugal repercussions that have specific connotations in the public realm. Calling oneself Negra is a declaration that the subject considers her African ancestry of primary importance and, second, that she considers herself black despite her mixed heritage. The term Afro-descendente is arguably an alternate term for those who value their African heritage and who may have obvious African-defined phenotypes, whether lighter in complexion or not, but who will not refer to themselves as "Negra/o" because of the real negative denotations still attached to blackness.[2] These articulations of subjectivity become "transformative practice," as suggested by Lawrence Grossberg, in the way that a subject not only engages with historical agency but also negotiates through structures of power. S/he is not a passive or unwitting Other but a fully engaged subject that shapes self and community to articulate narratives of identity in relation to discourses that attempt to deny that subjectivity and agency (88).

In the hermeneutical sphere of Candomblé and the socioreligious constructions in the terreiro [the religious enclave],[3] I argue, Africa is remembered and revised to suit the unfolding contestations for place and position. This chapter examines how Candomblé-nagô,[4] which developed from a Yoruba matrix, becomes an idyllic representation of Candomblé practices and a metonym for a lived engagement with Africa. I focus on Bahia and the city of Salvador because it is the central source of the religious discourse, disseminating to other urban centers in the northeast and to the southeast cities of Rio de Janeiro and São Paulo.[5] Edward Said's concept of "traveling theory" informs this inquiry in its questioning of what happens to theory when it moves from one location to another. For Said (1983), theory is not migratory by nature, but when it is subject to migration it relates to individual subjectivity and addresses issues of power. A parallel can be made with Glissant's rhizomatic, nomadic root that shifts and generates alternate points of embedment, due to the unpredictability and fluidity that migration or movement brings. Yet Glissant's conception

that its rhizomatic character must repudiate a source or point of origin is countervailing to this work, as I will argue later in this chapter. More so, Said's traveling theory lends itself to a comparative analysis and discovery of the points of similarity and difference from a coded source to its reconfiguration in alternate spaces, in examining the significance of an African-based identity and the means by which Africa was remembered and transplanted in a new diasporic space. Hence the two epigraphs speak to the tension at play in this work, the sense that Africa indeed did not stop at the shores of the continent and that it continues to live in alternate, diasporic spaces. The Yoruba proverb also speaks of the contingency of experience and the agency and deliberation involved in all articulations of identity.

This work privileges Candomblé-nagô in comparison to other Candomblé forms because, as diverse scholars have opined, Candomblé-nagô became a source of study for social scientists, who conferred on it a special transcendence as a symbol of African purity or a source of Africa in Brazil (Capone 2010; Dantas 1988; Costa Lima 2003). Harding (2000), Butler (1998), and Bastide (1978) argue that Candomblé discourse and rituals are a result of a Pan-African synthesis that occurred in the eighteenth and nineteenth centuries. Systemizing these perspectives, Butler specifically highlights the nineteenth century as the period in which Yoruba principles became institutionalized liturgical and secular discourses, consecrated through the growth of terreiro communities (*Freedoms* 52–59; see also "Africa" 138–48). The Yoruba template of naming the gods, the mythos, the songs, dances, foods, and colors of divinity became supraimposed on other forms of Candomblé and inherently, if inaccurately, links all Candomblé practices under a Yoruba homogenizing rubric. It must be noted that this Yoruba contextuality is viewed in this work as points of articulation that become authorized and legitimized through cultural performance and discourse. Tellingly, the ritual signifiers from Candomblé and the liberatory ethos of Quilombo communities are articulated by Afro-Brazilians as "nossa matrix Africana" [our African matrix].

Looking for Africa

Much has been critiqued about the imagined Africa of the diaspora, and I daresay, Gilroy's dismissal of notions of origin or root and Glissant's implacable stance on root cultures as atavistic, totalitarian, and destructive are due to both the Caribbean subject's and the black British subject's (as another extension of the Caribbean) inability to ground themselves in a specific locus or culture in the areas of West,

Central Africa, and Southeast Africa from which the majority of the enslaved came. Unlike European immigrants, who proudly proclaim their attachment to root sources, Africans during the slave trade did not enter ships because of manifestos guaranteeing their betterment due to immigration. The entry logs may have reported their port of embarkation,[6] but they did not list their ethnic identifications or list family members undergoing the same journey. Although the history of enslavement in Brazil parallels enslavement in other diasporic spaces, a crucial difference is found in the quantity of enslaved that came from similar regions in both central and West Africa. Hence the discursive pendulum shifts from how to define Africa in Brazil (Pinho 2010; Tavares 2009; Luz 2000) to suggesting that the relationship with Africa is largely mythical or imagined, and thus debunking processes of identification with African root sources (Pinho 2010;[7] Capone 2010; Sansone 2003).

Livio Sansone (2003) most cogently leads the negation, arguing that Africa is a contested icon in Brazil and a pivotal factor in the commodification of Afro-Brazilian culture. This Africa is visual and auditory, as language, music, and "objects" define it. Sansone comments that "[l]ooking African or sounding African is, in fact, what makes things African," given that these markers of Africanness are not subject to rigorous intellectual scrutiny (65). While Sansone suggests a concept of Africa that is derived from popular culture, the Africanness to which this work speaks comes out of the epistemological and ontological foundation of Candomblé practices. For Roger Bastide, one of the most noted anthropological interlocuters of Candomblé, it represents the living memory of Africa in Brazil. "African social structures were shattered, but the values were preserved," he writes, "[t]hus the superstructure had to create a whole new society. . . . It starts with values and collective ideas and flows down into institutions and groups" (Bastide, *Religões Africanas* 82). Knowledge derived from this ontological source is constative, performative, and lived, subject to intellectual scrutiny, theoretical and philosophical formulations, and rigorous praxis. A prime example is seen in the concept of the *orisas*,[8] the personifications of forces of nature or archetypal heroes and antiheroes with deified properties, explored in the latter part of this chapter. Given the historical context of displacement and alienation of Afro-Brazilians as a diasporic peoples, the engagement with the discourse and the ritual context of Candomblé presupposes the conduit of this African matrix across temporalities and spatialities, but as traveling theory it must be asked, What was carried and what was left behind? It leads

to further queries as to what were the conditions, terms, and forms of its reconfiguration. And, in its present form, does it appear at all like its originating context?

From Yoruba to Nagô

The story of the Yoruba presence in Salvador da Bahia must begin in West Africa, with the tumult caused by wars for survival and hegemony largely evident in the disintegration of the Oyo Empire by 1836. To even speak of the Yoruba as the Yoruba is a misnomer. A monolithic designation, the term Yoruba implies a unified whole, which the historic presence of the society clearly repudiates. The Yoruba took on the identity as Other, apparently accepting a designation from their neighbors in the north, the Hausa, as their dominant referent (Clapperton 4; Law, *Oyo* 5). The Yoruba share cultural signifiers, a common language, and a mytho-historic bond, but were divided into independent political units configured as city/states or empires. Identified by location, members of political units were known by the names of the individual states, that is, Ijesa, Ijebu, Ondo, Oyo, Ife, Ketu, Egba, but attested to a common point of origin, *Ìlé-Ifé* (Smith, *Yoruba* 15–20).

Considered the center of creation and the beginnings for all the Yoruba peoples, Ìlé-Ifé has both mythic and historic importance in the tale of Yoruba origination. According to Yoruba mythos, the Supreme Being, Olodumare, sent his emissary Oduduwa to earth, to Ìlé-Ifé, where s/he founded a dynasty.[9] Historical sources report that Oduduwa migrated from the east and founded the city (Na'Allah 60; Lloyd 223; Law, "Oduduwa" 210; Apter, "Historiography" 3). Historians also agree that from Oduduwa's descendants, who scattered to various areas comprising Yorubaland, a myriad of subgroups evolved (Pemberton and Afolayan 2). Common referents used to designate these peoples were *olukumi* [my friend], often used by the Yorubas as a term of address, and *Anago*, the term used for the language (Ajayi and Smith 2). There seems to be some discrepancy in the significance of the term *Anago*; Paul Lovejoy suggests it denotes a subgroup of the Yoruba (Lovejoy, "Yoruba Factor" 41).[10] Either meaning, however, does not change the importance and impact of these terms, for they survived in the New World as forms of identification for Yoruba descendants. In Cuba they were known as *lukumi*, and in Brazil *Nagô*, and with time these terms denoted the Yoruba-based religious practices of Santería and Candomblé (Lovejoy, "Yoruba Factor" 41; Parés, "Nagôization" 187–88).

The first distinguishing stages in the development of Candomblé, states Kim Butler, occurred within the sets of identification to which Africans subscribed in Brazil. The cultural or ethnic group they belonged to on the African coastline was recast into more all-encompassing *nações* [nations] (*Freedom* 52–59). Before these newly diasporic Africans became Pan-Africanist in their orientation, and broadly identified as African, they were regionalists, who subsumed their particular ethnicity to a more encompassing sense of collective belonging and identification. Restructuring ethnic affiliations and alliances, groupings such as Gêgê or Jêje, Nagô, Angola or Bantu, and Malê[11] became overarching nomenclatures that encompassed a host of ethnic groups from specific regions in West and Central Africa. These patterns of identity formation were further compli-cated, because the slavers used the term nacão to denote the port of embarkation of the enslaved rather than their ethnic group (Butler, *Freedoms* 32). Since the actual point of origin again muddled with these imposed categorizations, these newly arrived Africans culti-vated relationships based on tangential consanguineal ties and loca-tive affiliations (*Freedoms* 52–59; "Africa" 138–48). A prime example is seen resulting from the jihad of 1817; in spreading Islam across West Africa, it crossed many ethnic borders, allowing for pan-ethnic identifications. Whether one's ethnic origin was Nupe, Hausa, Oyo, or Fon, a reclassification occurred in Brazil, and a term such as *Malê* became the generic descriptor for Muslims regardless of actual nation-ality (Butler, *Freedoms* 190–91).

The beginnings of the Yoruba diaspora within West Africa, how-ever, dates to between the 1600s to the 1800s. Yoruba hegemony extended to include the Oyo and Dahomean Empires, with Dahomey standing as a tributary of Oyo. The Aja peoples of Dahomey, which include the Gun, Fon, and Arada, along with numerous others, were closely related to the Yoruba in language, custom, and religious prac-tice. The lingua franca among the Aja was, in fact, the Yoruba lan-guage, and it was called lukumi. J. A. Akinjogbin states that both groups belong to a single cultural area and share the same mytho-historic origins found in the story of Oduduwa, identifying Ifé as the source of their cosmological beliefs (307). This unifying mythos extends to the configuration of the orisas, as the cosmic forces resid-ing in both the material and spiritual realms. Slight modifications in their naming were apparent across the groups, but the innate prop-erties remained the same. Hence *Nana Buruku* in both systems is considered an ancient mother figure and a warrior goddess. *Eshu* or *Elegbara*, the trickster deity among the Yorubas, is *Legbara* for the

Aja, and *Ogun*, the orisa of war and creativity, is *Gu*. Having a language, filial ties, and complementary cosmological systems, it is to be expected that these groups form a natural synthesis in religious practice, as demonstrated in the current practice of Candomblé in Brazil.

Yoruba dominance occurred, however, in Salvador due to the wars between the Dahomey and Oyo (1750s–1830s). During the late 1700s, Whydah became the principal export center for the enslaved, as Dahomey's economy revolved around the trade (Akinjogbin 332–33). Civil wars within the Oyo Empire also contributed to the growing supply of enslaved as its tributary states fought to gain their hegemony.[12] Although, in comparison, Oyo was a minor participant in the overall trade, the wars yielded a steady supply of beings that were transported to the New World (Crowder 66–78, 108–23). With the vast translocation of the Yoruba-speaking peoples to Brazil, Nagô as an identity crossed ethnic, cultural, and religious barriers and became the chosen ethnicity by those Africans, who generated an ideal of Africa through their cultural and political positionings (J. J. Reis,"Candomble" 117; Butler, "Africa" 138). In these initial phases of displacement, identification within the nações signals a continued attachment to homeland, a marker of a diasporic consciousness, in that the growing Afro-Brazilian population had "a sense of being a 'people' with historical roots and destinies outside of the time/space" in which they lived (Clifford 255). Once the consanguineous link to the Yorubas became more nebulous, the terms became associated with the practitioners of the religion, regardless of whether they had traceable Yoruba ancestry.

Still, the Nagô-centric mode of explication found in Candomblé confirms the presence of a majority Yoruba-speaking population in Salvador, especially given that the slave trade continued between Lagos and Brazilian ports up to 1851 (O'Hear 64–65; Bethell 73). Arriving relatively late in the cycle of enslavement, the Yorubas impacted society on different levels. Most apparent was the ability to bridge the lingual gulf; since African languages coexisted with Portuguese, the Yoruba language became the lingua franca among blacks in Salvador (J. J. Reis, *Slave* 146; Harding, *Refugee* 48). The enslaved, although without locational autonomy, arrived in Brazil with their languages, names, and cultural forms. Finding others like themselves, these new arrivals adapted to the imposed groupings. Managing to form bonds of affiliation across the disjunctive space, they carved niches from which to maintain affirmative ties to the past and allow for moments of cohesion in the daily tribulations. Remembering their sense of self and their cultural beliefs in the passage, Yoruba mythos and language,

serving as a unifying context in the diffused terrain of West Africa, when transplanted to the developing diaspora also created linkages where possibly none existed.

João José Reis, in particular, acknowledges the multiplicity of African identities in Bahia, yet he suggests that the African population in Salvador converted to a Nagô-centric identity, as "Nagô became almost equivalent to African" in the nineteenth century ("Candomblé" 117). Identifying as Nagô allowed for a process of unification among Africans in Salvador and presaged the burgeoning of a communal affinity. Being Nagô, however, did not confer a seamless transference of Yoruba identity. Within the multiplicity of African ethnicities in Bahia, those identifying as Nagôs deliberately chose to reformulate their ties with Africa under this unifying rubric. Religiously, they could be "muslim, Catholic, animist or a follower of a combination of several spiritual traditions" (Butler, "Africa" 138). In choosing this ethnic tag they subsumed their other ethnic and religious identities and homogenized the remembrance and rearticulation of Africa. Other dominant ethnic groups, such as the Gêgê and the Bantus, having similar cosmological visions and a lesser influx of Africans to refresh their belief systems, yielded their ascendancy to the numeric force before them. This is not to say that these traditions were completely forgotten or are any less important, for present-day Candomblé houses are divided into categories such as Candomblé-gêgê, Candomblé-nagô, Candomblé-angola, and Candomblé-caboclo based on the determining principles found in each ethnoreligious form. Yet the sheer numbers of Yoruba-speaking peoples eclipsed the other African populations and influenced all aspects of black life. In the ritual context of Candomblé, it led to a construct of Yoruba purity and transcendence, a pureza nagô ideal, whose disputation is discussed later in this chapter.

Liberto and Escravo

Rachel Harding suggests that the development of Candomblé can be better understood as both a "pan-African and Afro-Brazilian synthesis" (*Refugee* 40) generated in nineteenth-century Bahia. The decline in the slave trade in the early 1800s sharply reduced the cultural infusion from different ethnic groups and forced another level of negotiation of identity. Since more blacks were born on Brazilian soil, the natal identification with Africa, which conferred a level of authenticity, resonated less and eventually formed part of the ancestral bond apparent in the religious discourse. For blacks with the

desire to assimilate into mainstream culture, eradicating the visible ties to Africa was, of course, a boost in the journey of social mobility. For those in the Candomblé community, it meant a rethinking of subjectivity and a reorganization of structural affiliations. Owing to the difference in mobility and status found between the enslaved and the free, the libertos were the natural leaders, and that role duplicated and doubled in the sacred space of Candomblé. Katia M. de Queirós Mattoso proposes that due to the conditions of forced servitude and the absence of personal autonomy, the enslaved lacked the freedom of movement and the luxury of time to fulfill ritual obligations and undergo initiations (*Slave* 125–49). Yet the enslaved in Salvador were integral participants in the religion, undoubtedly due to the greater freedom they enjoyed compared to their counterparts on the *fazendas* [plantations].

Life in Salvador differed greatly from life on a plantation, in that the liberto [free] and escravo [slave] populations mixed freely. Both J. J. Reis (1993) and Harding (2000) speak of such cohesive groupings as distinctive to Brazilian slavery in the ways the libertos and escravos shared living and working spaces, and conducted friendships and intimate relations. Living in an urban setting, the enslaved had a degree of locational autonomy, choice, and social access missing in the fazendas, in particular, because they lived separately from their owners and frequently cohabited with the libertos. Urban slavery gave rise to this diffused fusion, allowing the religion to flourish outside the purview of the master/slave dialectic and the different color and ethnic identifications of the enslaved. The Malê Slave Revolt of 1835 reveals the complex interaction between all sectors of the black population in Salvador. Although it was characterized as a Muslim revolt, João José Reis illustrates its Pan-African composition shown by the marked influence of participants from all ethnic groups in the rebellion.[13] Yet, just like in the practice of Candomblé, the libertos were its leaders.

The *ganho* system of labor also fostered the communal consciousness between the populations because the enslaved performed contractual labor services alongside the libertos. Vending their services around the city, *escravos do ganho* gave a portion of their wages each week to their owners but otherwise maintained their autonomy. Other forms of collective belonging developed through *cantos* [male work groups] and *juntas de alforria* [manumission groups], to aid each other in acquiring the actual and social capital necessary for freedom. Manumission was a commonly accepted practice, and the earned wages, beyond the obligatory remittal, were often saved to purchase freedom. Seemingly an oxymoron, buying oneself was not

an easy task because it took years of payments and was subject to the whims of the slave owners. Without the owner's consent, freedom remained an elusive dream. Yet more than in other slave societies, the enslaved acquired their freedom and the freedom of kinfolk and friends (Nishida, "Manumission" 1993; Cohen 25–26).

As religious adherents, the libertos and the escravos were commonly banned or persecuted for their religious practice. Through their social and economic networks, they sustained and maintained the communal solidarity needed to ensure the continuation of the rites and rituals. This is not to belie the complexities within the relations of the black population, because deep fissures did indeed exist. There were definitive hierarchal divisions between those born in Brazil and those born on the continent, and clear alliances due to one's ethnic origins and one's work. Racial mixing produced a color-gradated hierarchy that still prevails. These differing levels of identification promoted dissension and, therefore, prohibited more extensive alliances that could lead to rebellion. Since patterns of differences became the mode of identification, and the configuration of difference was predicated on color, blacks descending from African parents without any white mixture were dubbed crioulos or pretos.[14] A complex system of color classification developed out of the multiracial groupings in the society. A category such as pardo signified a range of color in the mulatto category. Other classifications, such as *caboclo, sarará, café com leite*, or *cor de tônajura*,[15] were based on the quantifiable and visible signs of indigenous, European, and African bloodlines. Each color category carries specific phenotypic characteristics based on hair texture, eye color, the broadness of the nose, and the fullness of the lips. Due to the "self-described" classifying of race and color allowed on censuses, in place until the early 1990s, over 200 such color divisions remain (Eakin 115): a remarkable testament to the psychosocial implications of the ideal of whitening, for any point of difference to what is considered a typical African phenotype confers a different racial identity.

Undoubtedly, the tensions lessened between the free and the enslaved populations because of their cohabitation and strong conjugal bonds (Reis, *Slave* 96–124; Mattoso, *Slave* 106–24). Points of difference were further mitigated between the populations in the face of a common ethnicity. At once exclusive and inclusive, this ethnically based identity was the central integrative denominator that secured the network of social support that developed, with mutual aid and cooperative economics as the goal. To further secure the bond, the libertos often purchased slaves of their own ethnic group (Castillo and Parés

2010; J. J. Reis 2008; Verger 1992; Oliveira 1988). Since it was quite prevalent for the libertos to own slaves, in the spirit of fostering an ethnocommunal consciousness, they seemed to have preferred those with the same ethnicity, and each side referred to the other as *parentes* [relatives], somewhat foreshadowing the more all-encompassing communal affiliation that later developed in Candomblé houses (Harding, *Refugee* 53). Later in this chapter I will address the liberto/escravo beginnings of the first Nagô terreiro, which further elucidates the marked transcendence of their divergent statuses.

Organizations such as the Catholic-based *irmandades* [lay confraternities] also provided succor to their members on manifold levels, similarly ranging from buying each other's freedom to providing proper burial rites (Mulvey 1982; Nishida, "Ethnicity" 330–32; Harding, *Refugee* 117–18).[16] Intentionally or not, these sodalities helped to preserve the sense of Africanness through shared cultural bonding. Within the irmandades, in particular, African languages were spoken and religious rituals found new contexts for expression, due to the protection provided by being part of the socially acceptable epistemic system through a Catholic sodality (Harding, *Refugee* 122–27; Mulvey 1982; Mulvey, "Black Brothers" 261).[17] Although fewer women than men participated in the irmandades, the sisters of *Boa Morte* [Good Death] served as a prime example of the fluidity between African and Catholic religious practices. Boa Morte is a female-only confraternity that celebrates the Assumption of the Virgin, their protective saint, in an annual ceremony.[18] To become a member of the irmandade, the Sister must be initiated in Candomblé, she must be over 40 and have lived an exemplary life, and she must be a descendant of the enslaved, commemorating the group's beginnings as a enterprise for manumission.

The ceremony to honor the Virgin becomes an illustration of how theories transform when they travel, for it becomes a reformulated version of Candomblé beliefs. Under this tribute to Our Lady of Glory lays the essence of the veneration of the orisas, Yemanja and Oxalá, and the preservation of the key Yoruba epistemes, Orun and Ayê, the spiritual and the secular worlds, for the Sisters do not refer to heaven and earth but to these Yoruba monikers. The overarching ceremony simulates Catholic rituals, beginning with public Masses and corteges on Friday, the day dedicated to Oxalá, the orisa of purity, in which they also recode his incarnation ritual. The ladies all wear the white, ceremonial clothing used in Candomblé,[19] and even food offerings reflect the dietary prohibitions of the orisa, including only seafood, bread, and wine. The ceremony continues for three days, as

a symbolic reenactment of the death, burial, and resurrection of the saint. The third day becomes one of pure celebration, culminating with a *samba da roda*, in which the elders demonstrate their best samba style. Every seven years our Lady (Yemanja) is said to incarnate through the body of the leader to celebrate with her devotees.

Conducting the ceremonies under the disguise of a Catholic sodality tells of the ingenuity of the enslaved and their determination to transform what is often perceived as spheres of powerlessness due to their enslavement, because they allow the devotees to metaphorically cross the transcendental divide to laud the orisas and corporalize them under the gaze of the dominant society. Since such sodalities were less patrolled by the dominant culture, adherents selected what they needed from within their shared experiential and hermeneutic knowledge. In consecrating an African worldview, culture became a site for resistance (Said, *Culture* 157), generating filiations that belie bloodlines and, rather, privilege the most useful practices in the quotidian struggles and negotiations with the centers of power. They generated the modalities for new forms of unity and identity through "collective belonging within the terreiro community" (Harding, *Refugee* 54).

Candomblé Beginnings and Terreiro Formations

Although scholars cannot quite agree on its etymology and meaning, the origination of the term Candomblé points to a Bantu-Kongo matrix and is derived from the term *Kandombele* (Omari-Tunkara, *Manipulating* 2; Merrell 16). Harding relays that the term is suggestive of the devotional attitude of the adherents in the practice of the religion (*Refugee* 45); Omari-Tunkara extends the meaning to encompass the aspects of dance, festivity, and musicality in the rituals (*Manipulating* 2). Musician, scholar, and Candomblé devotee Nei Lopes proposes an alternate orthography, *candome*, but with the same signification of festivity in both profane and sacred contexts (839). Conflating the terms Candomblé and terreiro, Omari-Tunkara defines them as "quasi-autonomous associations and corporations that possess their own esoteric belief systems, practices, and linguistic forms spoken internally by initiates" (*Manipulating* 3). Integral to Candomblé's growth, the terreiro, according to Clyde Taylor, is a "point where the mundane and the secular intersect" (*Masks* 281). "Politically, the terreiro is a Black territory in a space controlled by White men," indicates scholar/practitioner Juana Elbien (qtd. in Taylor 282); since initiates could openly practice Candomblé neither

in slave society Brazil nor in the post-slave era without proper licensing, the sites of the first terreiros were on land owned by Africans (Oliveira, "Ethnicity" 167). The importance of this hierarchal inversion cannot be denied, because the terreiro space, metaphorically, became a mini-Africa, an independent entity outside the jural and political authority of the Brazilian state, both in its territorialization and its institutional framework.

While terreiros are enclaves of religiosity, their beginnings as spaces in which blackness dominates is central to understanding their roles in the incubatory nurturing of the pan-ethnic, Pan-African base of identity among the African populace and their descendants in Brazil. As sites for the incarnation of the African gods, the power contained within their walls is that of the transcendental, mediated through the devotees; the language spoken within these enclaves is African based, whether it was primarily of Yoruba or Bantu origination, and their rules, if not all the practices, are derived from African oral hermeneutical texts. Based on communal acceptance of African patterns of worship, liturgical discourse, and ritual enactments, belonging to a terreiro or religious community allowed for the recreation of familial and community ties through the reconfiguration of a worldview and hierarchical context that modeled African structures. Their ability to provide *safe* spaces in which to alleviate psychosocial exigency cannot be diminished. As *Mãe de Santo* [mother of saint][20] Maria José Espírito Santo França suggests, as autonomous spheres they provide the necessary outlet "appropriate for reflection, allowing us to know and analyze our own reality in such a way that our action will be committed to fulfilling our aspirations in a conscious, efficient, and responsible manner" (54–55). Dually on both the personal and political fronts, the terreiros offered sanctuary to those in need, whether it was to freely express internal conflicts or overt controversies on race and culture, and warranted the spiritual, social, and political to dialogue with each other through the subjectivities of the initiates.

Pureza Nagô—Pure Black, Pure Female?

Luis Nicolau Parés, one of the most recent scholars on Candomblé, suggests that its religious expansion coincided with the growing prestige of the Nagôs and a gender shift in the leadership roles wherein women became the undisputed heads of the terreiro communities (Parés, "Nagôization" 192). Referring to the pureza nagô model, which promotes a vision of black racial and religious purity and African ancestral rootedness, Parés argues that its entrenchment

occurred simultaneously with the vision of black female ascendance in the terreiros. Both perspectives (pureza nagô and female transcendence) are generally disputed; however, the perception of matriarchal dominance in Candomblé prevails and has become a defining characteristic of the practice. Ruth Landes, who, in *The City of Women*, first documents the centrality of female leadership in the terreiros, highlights the divergence of such matriarchal power from the society at-large.[21] Female dominance in Candomblé, João José Reis explains, occurs because women had higher social standing in slave-society Brazil, disposing them to roles as religious leaders ("Candomblé" 131). None of these scholars, however, have pointed out that female dominance is a natural feature in most African traditional religions. Women are the supplicants, the devotees, and often the priestesses. Within Yoruba tradition, the ideal orisa devotee is female, and in New World manifestations of African religions, such as Voudou, Santería, and Obeah, female dominance is the norm (Clark 2005; Paravisini-Gebert and Olmos 2003; Abiodun 2001; Harding, "River" 2001; Oyewùmí 1997). I would propose, rather, that Candomblé matriarchal hierarchization is not an aberrant phenomenon but part of the epistemic foundation of the religion and its struggles between safeguarding and recreating an African worldview in the midst of Euro-dominated sacred, secular, and jural authority.

Randy Matory, however, has challenged this notion of female dominance by pointing out that Ruth Landes only studied the Nagô-Ketu[22] Candomblés and was influenced in her argument by Edson Carneiro, who was her guide, informant, and lover ("Gendered Agendas" 413–14). Matory establishes a long history of male participation in the religion as *Pais dos Santos* [fathers of saints] and leaders of terreiros. He also constructs his argument based on the relationship he has cultivated with select priests. Admittedly, the female leadership in Candomblé has been overstated, in that, by inference, male roles were limited to secondary-or tertiary-level positions, as initiated or uninitiated ogãns,[23] drummers, or *asoguns*, those who perform the ritual sacrifices. Men have always been in leadership roles; the proliferation of Pais dos Santos in Salvador following the Nagô-Ketu models attests to this, and within the tradition of Umbanda men have always had ascendant positions.[24] What Matory silences in his analysis is that Pais are often certified and endorsed in their roles because of a relationship to a Mãe de Santo. Either the Pai inherits a terreiro from his biological mother or is sanctioned to open a terreiro from his Mother-initiate: Matory's own Pai de Santo, Pai Francisco, was

authorized and supported by his Mãe and her initiates from the Nagô temple, *Terreiro do Omolu* (Matory, *Black* 235–39).[25]

Pureza Nagô Beginnings

What is certain is that the great Nagô-Ketu houses of Candomblé are female dominated and have been inscribed as the "traditional" houses of worship or manifestations of the pureza nagô ideal. Stephania Capone disputes the pureza nagô concept, asserting that a claimant stance on traditional authentication occurs strategically to formulate future group identity:

> Those possessing a tradition possess a past, a historic continuity which transforms them into the subject of their own history; asserting one's traditionalism, then, implies distinguishing oneself from others, who no longer have a defined identity. Constructing one's own representation of the past—tradition—thus becomes a means of negotiating one's future. (204)

Capone presupposes that the claims of traditionalism by the great Candomblé houses are part of their constructed history of origination and their mythological link to Africa. However, in the interim between the first printing of her text in Portuguese in 2004 and its current English edition, scholarship has uncovered the African sources for the first Nagô-Ketu terrerios in Bahia, validating their mytho-historic narrative.

The oral history states that the first terreiro in the Nagô-Ketu model was *Axé Ilê Nassô Oká* (aka *Casa Branca* or *Engenho Velho*), founded in 1830 (Parés, "Nagôization" 193–94; M. Oliveira "Ethnicity" 166; Harding, "River" 101–2). However, the scholar/researcher Lisa Earl Castillo (2011b) offers evidence to suggest that the terreiro *Alaketu* may indeed have been the first. While Alaketu's inception date is still speculative, Castillo (2011b) has authenticated the African origins of the terriero and its founding by the princess Otampê Ojarô, from the Ketu royal family, who was kidnapped in a slave raid and sent to Bahia. Yet without definitive confirmation of Alaketu's date of inception, Axé Ilê Nassô Oká remains the first documented terreiro. The mythos surrounding Axé Ilê Nassô's origins states that two priestesses, Marcelina da Silva and Iyá Nassô,[26] traveled to Yorubaland and returned with a priest of Ifá, Bamboxê Obitico. According to Rachel Harding, he was the *Babalowo* [fathers of secrets],[27] who established the *siré/xiré* (Yoruba/Portuguese orthography), the ritual ceremonial

order of entrance and address of the orisas in the terreiro (*Refugee* 101). Based on the customs of Oyo, the *Iyá Nassô* is a title given to the priestess who is in charge of the ritual care of the King's shrine to Shango. Such a title marks the bearer as the most important priestess in the Shango cult; hers is the ultimate word in the interpretation of its ontological corpus.

Confirmed is that Marcelina da Silva was a slave of fellow African freed persons, Francisca da Silva and José Pedro Autran, and in the manner of *parentes* they were all Nagô. All evidence details that Francisca was the titular Iyá Nassô and the leader of a Candomblé temple that operated out of a house she owned, in Pelourinho, the center of the city. Living in the area of Santa Ana, she was just a short walk from the Barroquina church, which according to oral history is the locational genesis of Casa Branca. Marcelina was Francisca's *filha de santo* [daughter of the saint] or initiate, and is the famous Obá Tossi, who is the officially recorded first Mãe de Santo of the terreiro, in its transition to the area of Engenho Velho da Federação, where it still stands today. In 1837 Francisca, José, and Marcelina, who had by then purchased her freedom along with that of her daughter, Magdalena, left Salvador to return to West Africa with several other former ex-slaves of the couple.[28] Castillo and Parés (2010) speculate that they undertook the journey because Salvador had become increasingly intolerant to Africans after the Malê revolt, which led to a significant increase in police harassment of the libertos. Historical records show that this return journey was a solution Francisca posed to local authorities to avoid the prosecution of her sons for allegedly participating in the revolt.[29] Marcelina stayed in either Ketu or Whydah until at least 1844, and on her return she began acquiring property both in land and slaves, who were also Nagôs.

Significantly, the postures of servility and force that characterized the master/slave relationship were missing between Francisa, José, and their enslaved *parentes*, as the former slaves voluntarily chose to return to West Africa with them. The depth of these relationships is attested to by Marcelina, for even in her will she ordered that a series of Masses be said for Francisa, José, and Francisa's son, Domingos (Castillo and Parés, "Marcelina da Silva" 4). By 1850, the terreiro was relocated to Engenho Velho, and by 1890, with the death of Marcelina's second daughter, who was also her successor, Maria Julia de Figueiredo, the terreiro's infrastructure was well established (ibid. 20). Revealing the complex interrelation and agency of the African-descended population, the terreiro's growth is due to the combined efforts of the sisters of Boa Morte and

the male-dominated irmandade of *Senhor Bom Jesus dos Martirios* (Harding, *Refugee* 100).

The Babalowo, Bamboxê Obiticó, who is said to have returned from West Africa with Obá Tossi, was in fact Rodolfo Manoel Martins de Andrade, a freedman in Brazil of *Mina* origin.[30] He was undoubtedly an important character in the network of relations with Marcelina da Silva, and Lisa Earl Castillo (2011a) speculates that he had a relation of indebtedness to her through the Yoruba *iwofa* system,[31] because archival documents show that Marcelina was involved in the purchasing of his freedom. Castillo (2010a) details multiple journeys of Rodolfo Martins to the Yorubaland and other parts of Brazil. As a Babalowo, his services were in demand not only in the processes of divination but also in creating the opening rituals for Candomblé terreiros, namely, generating their siré. In the embodied memory of the terreiro, his role as a ritual progenitor is always acknowledged and he is evoked as a revered ancestor through salutations to him in the opening prayers. If indeed Bamboxê Obiticó implemented the siré for Casa Branca, he began the project of institutionalizing the religion, under a Yoruba religious matrix through the forms of address, worship, and rituals of the spiritual forces (Harding, *Refugee* 101; Carneiro, *Religiões* 95).

The siré is the order of ritual address for the orisas, and in its consecration it reterritorializes the terreiro space as a space for the incarnation of the Yoruba-based orisas. Giving legitimacy to the religious rites, the sacredness of these Yoruba-derived traditions imposes a standard from which other terreiros and Candomblé devotees gauge their fidelity to the originating African principles and, thus, in the thinking of the adherents, authenticate their embodied practices. Other terreiro communities undergo scrutiny in regard to their pureza nagô status based on this originating siré initiated in Casa Branca. Such standardization influenced the growth of the Nagô-centric taxonomy found in the religious practices and the specific terreiros that are outgrowths of Casa Branca, such as *Gantois* (*Ilê Iyá Omin Axé Iyamassé*) founded in 1850 by Maria Julia da Conceição Nazaré, speculatively another initiate daughter of Iyá Nassô and sister-initiate of Obá Tossi, Marcelina da Silva[32] and *Ilê Axé Opô Afonjá*, founded in 1910 by Mãe Aninha (Eugênia Ana dos Santos), *Obá Biyi*.[33] Considered the great houses, these terreiros become the undisputed seats of African matriarchal power and the uncontested centers of Candomblé religious traditions. The Nagô identity became so ubiquitous that even though it is commonly known that Mãe Aninha was of Gurunsi heritage (from the area of present-day Ghana and Burkina Faso), because of

her initiation in Casa Branca and her eventual leadership of a central Nagô terreiro, she is considered Nagô (Butler, "Africa" 144; Matory, "Cult of Nations" 179–80, Parés, "'Nagôization'" 186).

"Traveling Theories"

Founding members of the Candomblé community conducted transatlantic relationships within a complex zone of trade, exchange of ideas, and services (Matory 2005; Costa Lima 2003; Ralston 1970). Bamboxê Obiticó traveled across the Atlantic and up and down the coastline of Brazil practicing Ifá divination. He eventually relocated to Lagos, and another branch of his family line still exists there and continues the religious practices (Castillo 2010a). It was common for the elite, African freed folk to send their children to be educated in West Africa, and Bamboxê Obiticó and fellow Casa Branca affiliate Eliseu do Bomfim often served as guardians for them in their transatlantic crossings. Eliseu was an *Africano livre* [liberated African], originally from Abeokuta, who worked as a trader and frequently traveled across the Atlantic to buy and sell African products (Castillo, "Between Memory" 204–6).[34] The social and religious bonds that existed between Bamboxê Obiticó, Eliseu do Bomfim, and Marcelina da Silva crystallized in the influence of their descendants on the growth of the religion (Castillo and Parés 2010; F. B. Lima 65; Braga 48). Just as Marcelina's daughter took over the running of the Casa Branca terreiro, the descendants of these two men became pivotal to the next generation of Candomblé practitioners.

Seu Martiniano Eliseu do Bonfim,[35] the son of Eliseu do Bomfim, and Felisberto Américo Souza, the grandson of Bamboxê Obiticó, were both Babalowos credited with shaping the Nagô structural forms of discourse and ceremonial practice (Verger, *Orixás* 31–32). A terrain of contestation developed between them, and Martiniano and Felisberto were known rivals for the titular distinction of being the undisputed apical source of spiritual knowledge (Verger, *Orixás* 31–32; Carneiro, *Candomblé* 112; Parés, "Birth" 2005). Baba Martiniano worked in concert with Mãe Aninha, the founder of Ilé Axé Opô Afonjá, in 1910 to create and consecrate the siré of the now famous Nagô-centric terreiro.[36] In his youth, from 1875 on, as part of the elite, transatlantic corpus, Martiniano traveled back and forth between Lagos and Bahia. Over the course of his initial journey, which lasted until 1886, he completed his secondary education, learning to read and write in both Yoruba and English, and became initiated in Ifá (Castillo and Parés 2010; Romo 61–62). Baba

Felisberto, conversely, was born in Lagos and was also known by the anglicized name of Sowzer. He first visited Bahia with his mother in 1886, coincidentally when Baba Martiniano was returning from his studies in Lagos.[37] Characterized as the younger, more aggressive Babalowo, he trained as an engineer and worked as a contractor and businessman. Following in the itinerant footsteps of his grandfather, Baba Felisberto became one of the founding fathers of Candomblé in Rio de Janeiro. Speculatively, maybe due to their rivalry, they divided their sphere of influence between these two major centers (Carneiro, *Candomblés* 112; Verger, *Orixás* 32; Matory, *Black* 46–47; Capone 99; Parés, "Birth" par. 42).

Journeys like those of Marcelina da Silva, Eliseu and Martiniano do Bonfim, Baba Obiticó, and Felisberto da Souza must be contextualized in accordance with the history of returnees between Brazil and West Africa, for it places them at a special crossroads in these transatlantic interactions. Lagos, Whydah, and Accra, as international centers of commerce, disproportionately absorbed the new arrivals.[38] Similarly, due to the growth in the palm-oil export trade, Lagos after 1851 was in the midst of an economic boom, attracting the Afro-Brazilian freed population with desired skills to work as cobblers, masons, carpenters, seamstresses, and such professions. Many of these returnees benefitted from the largesse of King Dosomu, who included them in the land grants given to certain citizens (Lindsay 1994; Mann, *Slavery* 242–56). The British occupation of Lagos also facilitated such Pan-African concourse, as a sizeable number of freed Africans used British passports to facilitate their journeys.[39] Dating the height of the transatlantic exodus to the latter part of the of the nineteenth and early part of the twentieth centuries, Matory, most likely taking his data from Manuel Carneiro da Cunha, details that 8,000 Afro-Brazilians traveled to West Africa and established permanent residence, with several hundred traveling back and forth for reasons of business, education, or pilgrimage (Matory, "Cult" 174; Cunha 115–33, 213).

In examining this Pan-African/Afro-Atlantic network of communication, Matory (2005) notes that in the British-dominated sphere of transatlantic relations, the Yoruba gained an ascendant prestige and a reputation for cultural superiority over other Africans. The developing black bourgeois Lagosians cultivated that reputation in the face of new forms of racial and economic discrimination. The thrust of Matory's argument is that *these* values of black racial and religious purity, embedded in the pureza nagô ideal of contemporary Candomblé, are also rooted in the racial and cultural

nationalism of the Lagosian renaissance of the 1890s. Since Castillo dates this period of extensive migration of Afro-Brazilians to West Africa to the 1870s and 1880s, based on actual records of embarkation, the relationship with the Lagosian renaissance remains speculative ("Between Memory" 203–38). As indicative of these reforged transatlantic connections, both she and Matory agree that the Afro-Brazilian elite preferred to send their children to West Africa for further education and training, unlike their white Brazilian counterparts, who looked to Europe. I would propose that rather than considering such transatlantic journeys as remarkable, they point to one of the key differences in Afro-Brazilian society compared with other diasporic societies. Since such voyages were common, they allowed for the deliberate remembrance and codification of African religious modalities. A corollary to the added prestige in undertaking these passages of return, which accounts for the increase in migration, is the changing political climate in Brazil in its transformation from a slaveocracy to a modernizing oligarchy.

By the early 1900s the actual voyages had declined, but what remained was the codified legacy of the siré coming from West Africa and a new generation of Mães dos Santos who had verifiable African ancestry and belonged to the lineage of initiation going back to Obá Tossi, such as Mãe Aninha of Ilê Axé Apô Afonjá and Mãe Menininha of Gantois, (Maria Escolástica da Conceição Nazaré) who then solidified the pureza nagô ethic. The ascendancy of such Mães replaced the actual journeys through symbolic acts of transit that confirmed heredity and positionality. For instance, when Mãe Senhora, (Maria Bibiana do Espírito Santo), Oxum Muiwà, the great-granddaughter of Obá Tossi, succeeded Mãe Aninha as the leader of *Apô Afonjá*, she received confirmation of her positionality as a cultural purveyor, Yoruba descendant in the New World, and spiritual leader from the Aláàfin of Oyo, who conferred on her the title of Iya Nasó. Almost as significant, Pierre Verger carried the letter to her in what I consider a symbolic coronation, for the title holds dual significance in its belonging to the founder of the Nagô terreiros and its recognition of metaphysical ascendance as the head priestess in the shrine of Shango (Capone 217; D. Santos, *Historia* 18–19; Matory, *Black* 170). It is open to speculation why the Aláàfin chose to bestow such an honor: Was it an empty diplomatic gesture? Was it to solidify ancestral bonds? Or was it a reconciliatory gesture, given Oyo's participation in the slave trade? While the act may have had little or infinite signification in Oyo, in Bahia it placed Mãe Senhora as the premier Mãe de Santo and affirmed the Nagô model as the truly ascendant system, sanctioned by ancient authority.

Verger also aided the return of Mãe Senhora's son, Deoscórdes dos Santos (Mestre Didi), who benefited from this reforged alliance. For in his return voyage to Ketu and Oyo, in 1967, he recited the *oríkì* of what he considered his family line as one of the founding families of Ketu: *Asipá Borogun Elesé Kan Gongóô*. In turn he was recognized by the King as a legitimate descendant of that land and then given a new title, *Bàbá Mógba Ògá Onísàngó*, the Most Respected Non Possession Priest of Shango. In Oyo he was also given the title *Bàálè Sango*, Chief of the Shango community (in Brazil) and was later given the title of *Alapini*, the head of the Egungun cult in Brazil (Matory, *Black* 170; Morton-Williams 253–25; Johnson 1973).[40] Capone, however, in constructing her argument that the connection with Africa is largely mythical, points out that *Asipá* is an honorary title given to war chiefs in Yoruba kingdoms; hence, almost anyone can gain such a title (220). In Oyo's political schematization, the Asipá title was given to a member of the *Oyo Mesi*, the ruling families, who resultingly became the head of the Ogun cult and chief of the hunter's guild. It may have been a lesser title used selectively across Yoruba kingdoms, but in Oyo it denoted an ascendant position in the authority of the state. Although Mestre Didi's line of descent may be questioned, and he may not be Ketu royalty, in Brazil his lineage in one of the great houses of Candomblé, his status as the head of the Egungun shrines, and his personal role as an artist and religious purveyor confirms on him royal status.

What must also be understood is that the remembrance of this particular *oríìkì* cannot be belittled or considered insignificant as can so many endeavors of black peoples. It is an incredible feat of agency to have an oral text passed down from generation to generation, maybe across centuries, and preserved in such a way that modern day Yoruba kings could recognize within the language and content of the poem, recited by an Afro-Brazilian, a link that traverses space, time, a history of trauma, negation, and negotiation, to affirm their mutual rootedness in a common African past.[41] Even though only a select few of these voyages and personages have been addressed, they are the key issues and components in questioning the issue of Nagô purity. While I do not purport to suggest that modern-day Candomblé is a seamless transplantation of Yoruba spiritual values, neither can the relationship between the two systems be deemed imagined or mythical. Too many deliberately remembered that African past, recoded it to suit their prevailing contestations, and passed it down to future generations to be dismissed. Their actions must be reinscribed as heroic acts

of personal and communal agency, given the persecution and trauma they faced daily.

Worthy of further investigation, however, is the way these journeys back and forth, having become encoded narratives of origin, are now traded in diplomatic circles and selectively co-opted for state and personal aggrandizement. Relations between Brazil and areas of Nigeria and Benin are strengthened because of the bond, which allows select elite members of the Candomblé community to be received with veneration in their present-day journeys to West Africa. It has also spawned a similar reverence for almost anyone with a Yoruba background coming to Brazil, regardless of whether they have knowledge of sacred religious modalities.

Strategic Re-Africanization and the Pureza Nagô Ideal

Nicolau Luis Parés (2005) notes that a central component in what he refers to as the "Nagôization" process of Candomblé is the increased racialization in post-Abolition Brazil, which, in turn, may have reinforced the ideals of racial dignity promoted by Yoruba cultural nationalism. Abolishing slavery in 1888, Brazil was the last nation to do so in the Western hemisphere. Laws such as the *Lei de Ventre Livre* [Free Womb] passed in 1871, granting freedom to children of slave mothers [ingênous], and the Sexagenarian Law of 1885, giving slaves over 60 years of age freedom, did nothing to alleviate the slave condition, since minors under the age of 21 could only become workers along with their parents, and after 60 years a slave's productive capacity was seriously hampered (Santos and Hallewell 62; Abreu, "Slave Mothers" 568–69; Bethell 81; Martin 178). Post-abolition Brazil, like most post-slavery societies, did not bring a new, inclusive form of governance. Seeing the practice of the religion as contra the project of modernity and modernization, post-abolition politics sought to "establish a nation that excluded ex-slaves and indigenous people" (J. Santos, "Mixed" 118). White Brazilians did indeed react with fear and horror at the thought of the blackness of Brazil, which, between the years 1889 and 1914, resulted in the official policy of embranquecimento. Racialist thinkers such as Comte Gobineau, who saw the mixed-race population of Brazil as "primitively depraved," suggested the possibility of whitening. Ratifying the social determinist beliefs of the Brazilian elite, such discourse sanctioned their construction of immigration policy and promoted miscegenation to change the racial composition of the nation (qtd. in Santos and Hallewell 74–76; Agier 249; Seyferth 87). Before its official enactment, the Brazilian

government began subsidizing European immigration, and between 1884 and 1913, 2.7 million Europeans immigrated to Brazil. By 1940 the rapid scale of immigration had resulted in radical decreases in the black population (Santos and Hallewell 70–71). Simultaneously, African cultural and religious expressions were restricted in the public domain and private ceremonial functions had to be registered beforehand with the police.

In the year 1890, two years after the abolition of slavery, the penal code became more restrictive with regard to all forms of black social, cultural, and political expressivity, and for Candomblé devotees specifically, all ceremonial interactions, from drumming to spiritual possessions, were forbidden. The law extended to prohibit the practice of capoeira, public congregations in the batuques and sambas, and other drumming and dancing sessions, and lessened the age of criminal liability to nine years of age. Such codification created an unpredictable landscape of terror and restriction for the African-descended population. In an unprecedented display of autonomy, many moved to Salvador and the Recôncavo towns, augmenting the black enclave in the northeast (Kraay, "Introduction" 10–11; Parés, "Birth" 2005). For those in the Candomblé community, it meant restrategizing a relationship with hegemonic forces to continue the all-important concourse with the orisas.

It is still amazing how aspects of black self-empowerment are viewed as aberrant notions, or, to interpolate current academic discourse, essentializing ideals, or just ignored in scholarship or not investigated at all. I say this in response to Beatrice Góis Dantas's argument that the pureza nagô ideal was constructed in anthropological discourse and, specifically, in the studies done by Raymundo Nina Rodrigues in 1896.[42] The question must be asked, Where is black agency in this entire event? As a forensic physician, Nina Rodrigues's project of studying Afro-Brazilian religious communities was to shape a psychological understanding of Negros in order to enact penal legislation befitting their inferiority. Even though this role is selectively forgotten and he is celebrated for his pioneer documentation of Candomblé systems, Rodrigues believed in the psychological inaptitude[43] of the Negro and concluded that the predominance of African cultural remnants limited the potentiality of Afro-Brazilians and impeded any possibility of integration into Brazilian society. Such prejudices sustained the policy of embranquecimento and justified the illegality of African cultural expressions. Mikelle Omari-Tunkara, however, inscribes the agency and voice of Afro-Brazilian informants on Rodrigues's work; in concordance, a factor that is largely overlooked, suggests Randy

Matory, is the influence of Baba Martiniano on Rodrigues (Omari-Tunkara, *Manipulating* 6; Matory, "Cult" 180; Matory, *Black* 62–63). Even though Rodrigues conducted his studies primarily at Gantois, under the leadership of Mãe Pulchéria (Maria da Conceição Nazaré, the daughter of founder, Maria Julia da Conceição Nazaré), Baba Martiniano was his guide in all matters related to Candomblé (Capone 178; Landes 27–28). Mães of the great houses such as Mãe Pulchéria and Mãe Aninha were simultaneously Baba Martiniano's students, cohorts, colleagues, and friends, and subject to his spiritual guidance as a Babalowo (Landes 29, 81; Romo 64).

Rodrigues's importance to the creation of the Nagô-centric model must be characterized in the context of his work and the time. As the state official who could determine the course of religious persecution, his cooperation and co-option was indeed necessary to the successful perpetuation of the religious concourse. In his seminal text, *Os Africanos no Brasil*, Rodrigues created a hierarchy of religious models in which Candomblé-nagô stood at the apex, much to the detriment of other forms of Candomblé, such as Umbanda and Candomblé-angola. Rodrigues characterized the Yoruba-based model as naturally superior in comparison to the other forms of worship because the mythos, ritual practices, and divination systems demonstrate elevated forms of organization lacking in other African religions (Rodrigues 1938; Dantas, *Vovó* 150–56). Since knowledge of these systems comes through participation and, at the time, was orally transmitted, then who, it must be asked, informed Rodrigues of the myths, rituals, and divination practices? Because of Rodrigues's support, the Nagô terreiros, under Baba Martiniano's sphere of influence, were de facto exempt from police interference and prosecution. What cemented this alliance between scholar and practitioner was Baba Martiniano's creation of the institution of the *Obás* of *Xango* in Ilê Axé Apô Afonjá, a title given only to the most influential ogãns in the terreiro (Costa Lima, "*Obás*" 65; Butler, "Africa" 145).

Júlio Braga (1999) argues that the institution of the Obás is part of a process of re-Africanization, which stands outside the debate on root structures in Candomblé. I instead see it as the essence of strategic Africanization in the creation of an auto-hegemonic practice that manifests the agency of Candomblé devotees. Based on Baba Martiniano's extensive knowledge of Yoruba religious and political structures, he transfigured the hierarchical structure from the shrine of the chief priest of Shango in Oyo, who has twelve assistants delineated by order of authority: six on the right hand [Oton] and six on the left hand [Osin], and he reproduced their numerical significance

and gave them titles from within Yoruba history (Matory, "Cult" 210; Capone 224–25;[44] Ellis 97). Baba Martiniano took what some skeptics of the system consider imaginary ties and infused them with complementary significance and value relevant to Afro-Brazilian society. He affirmed a connection that lasted through the appalling transportation across the Atlantic, navigating and parlaying a triumphant return from Lagos, as a center for education and inspiration, into an authenticating narrative due to the cultural and ontological knowledge he acquired. He successfully swayed a generation of Western-based thinkers, who saw in his system of belief a predetermined pathology that enabled their reformulation of debasing legislation.

Martiniano's and Mãe Aninha's sphere of influence extended to the next generation of scholars, such as Arthur Ramos and Edison Carneiro, but that participation is selectively silenced in the narrative of Yoruba authentication. Edison Carneiro, the only Afro-Brazilian anthropologist of the group, was the first to show the Yoruba bias in Rodrigues's work (*Religiões* 29–32); however, he never addressed the influence of the practitioners on the researchers. Carneiro also explained how Arthur Ramos expanded Rodrigues's Nagô-centric claims in his text on Africanism in Brazil, *The Negro in Brazil*. Ramos, as Rodrigues's successor, was a psychiatrist similarly sent to study Negro aberration to enact suitable penal legislation. Building on his predecessor's work, Ramos created opposing polarities by deeming Bantu-based practices degenerate cults marked by sorcery and Nagô rites as pure religion controlled by priests. He suggested that seven levels of syncretism or diffusion occurred in the African religions, along with their integration of indigenous practices and Catholicism.[45] In effect, his sense perception, like that of Rodrigues, was manipulated behind the scenes to dismiss all forms of Candomblé except for the Nagô-based model. However, due to his studies of Bantu-derived Candomblés, the discourse of religious participation shifted from the issue of racial inferiority to one of cultural inferiority. In a type of solipsistic defense that can only come out of a racist dialectic, Ramos, also like Rodrigues before him, advocated that with time Afro-Brazilians would acculturate and evolve through processes of education and exposure to other religious forms and repudiate their belief systems (Ramos 1951). It a remarkable testament to the ingenuity of Candomblé leaders such as Baba Martiniano, Mãe Pulchéria, and Mãe Aninha that they could mobilize action within the obvious racialism of these individuals, allowing them enough of a glimpse into their world to co-opt their original hypotheses so that

as white interlocutors they could indeed propagate the religion even in the midst of condemning its continued practice.

Carneiro, too, was an important proponent of the pureza nagô model, in shifting the discourse of Africanness from a cultural modality to a racial one (Romo 57–59). Carneiro's relationship with Mãe Aninha and Ilê Axé Apô Afonjá has become part of the legend of Candomblé; she was even known to have hidden him in the house of Oshun at the terreiro to prevent his arrest by the military police during the Vargas administration (Landes 35; Matory, *Black* 162; Romo 66). As Matory notes, Carneiro was involved with Northeastern Regionalists, who sought to transform the reputation of the region as backward due to its dominant African-descended population ("Gendered" 416). The policy of embranquecimento had transformed the South, allowing it to become the home of immigrants and the model for modernizing Brazil. Whether regional patriotism was his motivation, Carneiro did promote the high/low or pure/degraded models for Nagô/Bantu and Caboclo and Angola-based Candomblés. The most significant event that solidified the relationship between the social scientists and Candomblé leaders was the second Afro-Brazilian Congress (1937), organized by Carneiro (Matory "Gendered" 431; Capone 187). Mãe Aninha's and Mãe Menininha's strategic agency in hosting ceremonies for conference participants in their terreiros began a model for state/educational/practitioner dialogue that continues today. The conference became a forum in which to demonstrate the heightened cultivation of the Nagô model and the intellectualism of Candomblé leaders, with both Baba Martiniano and Mãe Aninha presenting papers to the gathered scholars and practitioners (Romo 75–77). Baba Martiniano was elected the honorary president of the congress, and he later became the honorary president of the Union of Afro-Brazilian Cults, with Carneiro as the general secretary. Previously known as the African Council of Bahia, it pursued religious freedom for the Candomblé community. The new Union, in bringing together intellectuals[46] who sanctioned the pureza ideal and the Candomblé adherents, was revisionary and subversive in its authentication of the nature of black discourse and ritual, in that Capone affirms "anthropologists became the guarantors of the Africanity of the cults and, consequently, of their legitimacy" (188).

Dantas also argues that this pureza nagô ethic influenced the course of Gilberto Freyre's thought (161). Racial democracy, as promulgated, if not named by Freyre, idealized African subjectivity and cultural forms, but instead of examining African retentions or Africanisms

from their root source on the continent, Freyre's formulations began with slavery and the relations formed from the master/slave dialectic. Freyre's slave, however, contrary to historical sources (Mattoso 1986; I. Reis 2001),[47] was the happy Negro whose simplicity added to the joyous panorama of life on the plantation. Advancing the theory that the mixture of races and ethnicities provided the foundational strength for Brazil, Freyre concluded that "the substance of African culture will be in us permanently across all our formations and consolidations into a nation" (Freyre 650). Freyre's contribution lent shading to the discourse of whitening, as it is from his work in *Casa-grande e Senzala* (1974) that the *mestiço* identity became such an idealized figuration. Due to Freyre's romanticism, combined with Rodrigues's categorizations, the Northeast and especially Bahia became known as "o reduto da África" [the African stronghold] (B. Dantas 161). The racial demography of Bahia, having over an 80 percent black and mixed-race population, also contributed to its construction as a miniature Africa. In a passing conversation, a "white" *Baiano* explained that he is conferred a black identity when traveling to other parts of the country, simply because he is from Bahia. Yet in Bahia he is part of a dominant power structure and, accordingly, his whiteness remains unchallenged.[48]

From Rhizome to Root

This perception of Nagô supremacy has of course been reproduced in the works of some of the most widely read and well-known scholars, such as Melville J. Herskovits (1943), Roger Bastide (1978), Pierre Verger (1997), and Juana Elbien dos Santos (1986). Recent scholars, however, have validated the Pan-African synthesis in Candomblé, as named by Roger Bastide and Rachel Harding, by adding to the corpus of knowledge in elucidating the particularly Gêgê influence on Candomblé (Parés 2005; Costa Lima, *Família* 72–73; Castro, "Língua" 75). Instead of arguing against a standard of purity as they have chosen to, it appears that the Africanness found in Candomblé is a testament to the spiritually affiliative and consanguineous genealogical relationship to the earliest foundational terreiros. Constructing a relationship between the Afro-Brazilian religious discourse of Candomblé and its specifically Yoruba antecedent, or the relationship of early Afro-Brazilian religionist to Africa as mythical, is indeed absurd. What exists instead are deliberately enshrined historical narratives that highlight the connections and conjunctures across a sea of infinite possibilities. In relation to Brazil, these connections also

point to the limits of theorizing in other diasporic spaces about the experiences of the overall African diaspora. I specifically recall and return to the limits of exploration placed on the attachment to Africa or a sense of root in the works of Paul Gilroy and Edouard Glissant, because neither has examined the rootedness that comes from the spiritual.

Spiritual work is a call to memory, suggests M. Jacqui Alexander (2005), and in African-based cosmological systems the spiritual exists within bodily praxis in symbiotic relationship with social, political, and cultural interactions. Theoretically, there are four different types of memory: the habitual—skills or behaviors acquired through repetition; the cognitive—the capacity to remember learned facts or previous experiences; the personal—recalling events from one's life and past; and, the collective or social—knowledge from educational and historical sources that provide a shared context for personal and group experiences (Lawal 43; Connerton 1981). Working with the spiritual involves all aspects of memory codification. The endless repetition of bodily praxis are seen in prayers, invocations, drum calls, singing, dancing, offerings of food and drink, sacrifice and *ebós* [offerings] of appeasement to the orisas, in simultaneous reactivity with prohibitions on consumption of food, drink, sexual intimacy, dress, and comportment of the supplicant. Such bodily processes are ritualized, and practitioners become habituated in their actions to such an extent that they become codified in memory and epistemologically formulized for oral transmission. These oral-kinetic inscriptions on the body, the formulaic chants, songs, calls, prayers, and divination sequences are integral to the African matrix that traversed traumatic space and lives because of the "praxis of embodiment" that keeps memory refreshed (Alexander 297).

Quite simply to Gilroy, the roots exist and are constantly remembered, cultivated, refreshed, and reaffirmed through the embodied praxis guarded and transmitted in Candomblé. Indeed, these shrines of remembrance also allow for the making of something new through the constitutions and articulations of its protagonists navigating in and out of realms of alternate social spheres and halls of power. This, too, challenges Glissant's construction of root discourses as legitimating ideologies that allow for domination. Legitimation, in Glissantian terms, is centered on a mythic creation that inspires and allows for collective identification and justification of conquest, projection unto other territories, and control of other lands. While this may indeed be true, in this diasporic space the quest for root, for a legitimizing ideology, is to ensure contiguity across the traumatic space of

dislocation, dismemberment, and disaffiliations. It is a desire for ownership of oneself, one's voice, one's social and political context, through the articulation of a cultural paradigm that is centered on an African source narrative. Rootedness here contravenes Glissant's framework, for it does not signify a single, strangling root, aiming to engulf other ideological terrains, but a single root developing from the rhizomatic strands to fortify itself and guard against predatory forces. It is indeed a constructed process, but an entirely organic response, when commonalities and compatibilities in underlying belief structures and a shared social structure of negation adjoin disjunctively due to their oppositional dynamics.

With the consecration of these terreiros under the Yoruba siré and the practitioners embracing and acquiring a Nagô identity, whether or not they descended from the Yoruba line, their rites and rituals became institutionalized signification and praxis. Miscegenation between the ethnic groups, Fred Aflalo (an initiate and a scholar of the religion) suggests, allowed new ritual and liturgical aspects of the religion to form. For Aflalo, the Yoruba dominance, however, is overwhelmingly apparent in the naming of the spiritual forces more than in the ritual context (21–22). Yet for Miklelle Omari-Tunkara, it is in the manipulation of the *asé/axé*, the sacred energy and power in all beings and things through a "commingling of tangible elements, spiritual ideas, and art forms," to channel transformational acts, and through the art of divination as practiced by priests at all levels, that the Yoruba dominance manifests itself (*Manipulating* 35–36). For the practitioner, the Yoruba consecration means mastering the use of the Yoruba language in chants, prayers, songs, and ritual evocations; learning the dances of the orisas, the herbology, and its efficacious applications to effect remedy; gaining knowledge of the ebós, the sacrifices of appeasement that would please particular orisas; and learning the *odus*, the sacred texts of divination to aid each supplicant in her quest. It also includes developing a personal relationship with one's orisa that cannot be defined, catalogued, explained, or rationalized because it is a manifestation of the essential spark that conjoins humanity and divinity.

Traveling the Roads of the Orisas

Through the siré, the ceremonial ritual order, the memory of Africa became institutionalized practice but reconfigured differently as Roger Bastide asserts. Continuity, however, as Mãe Valnizia Pereira points out, is found in the passage of knowledge from one generation

to another (Harding, *Refugee* 147). When the transmittal of the religious knowledge is reconfigured as "traveling theory," memory serves as a conduit, revealed through the configuration of the orisas—in the names and identifications of each, the existing mythos, the patterns of divination, and the ritual processes encompassed in the belief system. But even more so, it is apparent in one's subjective orientation through the communal ethics, shared affiliation, and sense of belonging to a larger continuum, which are all hallmarks in the formation of a diasporic consciousness. Differences are apparent in the institutional arrangements from its African origination, but not necessarily in the content of the ritual encounters. Among the Yoruba, for example, each principality had its own patron orisa. When a supplicant needed the aid of an orisa outside her home territory, it was commonly accepted that she would travel to the source of that orisa to obtain succor. However, in New World contexts this level of individuality and independence could not be maintained. The terreiro, in becoming the figural ground for the transplanted Africa, reconfigured and reconstituted that Africa in the image that fit the times and the modality of life. Therefore, within that sacred space, the Pais and Mães dos Santos cultivated all the orisas. This is not to say that the terreiros strayed far from their generative source. In fact, with the configuration of the most prominent terreiros in the Nagô line, care was taken to follow Yoruba structures in the development of the siré, the call of the orisas during ceremony, but not necessarily in all the deeper ritual forms. What is most interesting are the concepts that prevailed and blended with the beliefs of other ethnic groups. Existing myths represent aspects of the discourse that were retained and, by implication, selectively forgotten.

Four hundred and one orisas exist in the Yoruba pantheon, yet only a few are accessed in Brazil. Those surviving spiritual forces find equivalence with the other dominant African religious practices, such as the Bantu *inkises* and the Gêgê *voduns*. The similarities in the religious beliefs from West and Central Africa lend themselves to the organic integration found in this diasporic space. Hence an orisa like *Oshun*, written as *Oxum* in Brazil, the deity of beauty, fertility, creativity, and femininity, is likened to the Bantu *inkisi*, *Dandaluna*, *Kicimba*, or *Samba*, and among the Ewe-Fon, *Aziri*; the messenger figure Eshu is known as *Aluvaiá*, *Bombo Njila*, or *Pambu Njilia*; and the Yoruba supreme deity *Olorun* is *Nzambi Mpungu*. In the vodun pantheon, the orisa *Ochumare* among the Yoruba, who epitomize the forces of regeneration and continuity, is reconstructed in the vodun construct of *Da*. Accordance is even found in the symbolic essences of

these entities, which emphasizes their regenerative qualities through depictions as a rainbow (a sign of renewal), and a snake (a symbol of continuity).

Selective remembrance may also characterize the relations deemed appropriate between the supplicants and the orisas. For instance, *Orisa Oko*, who is the energy that governs farming and husbandry, is not acknowledged in Brazil. If we can access the mind-set of the enslaved, to address and venerate this orisa signified acceptance of the position of enslavement. Yet Eshu is also not cultivated as an orisa as he is in Yorubaland and other parts of the diaspora; instead he is seen as a messenger and a mediator, and ceremonies of appease-ment are done to him before any ceremony begins. Rather, orisas such as Ogun, who embodies war and creativity, and Shango, the spirit of retributive justice, were given preeminent space and place. For instance, Shango, the orisa who controls thunder, is said to have been the fourth *Aláàfin* [king] of Oyo. Demonstrating his prowess, his mastery over elemental forces, he sets fire to his town and destroys all. In repentance, he commits suicide. Within the hermeneutical dis-course, Shango's transformation from an individual filled with hubris to a penitent supplicant is interpreted as a metaphorical invocation of the principles of retributive justice. As a deified force, he is called on to bring about justice to any situation (Edwards and Mason 1985; Sangode 1996).

Changes in the standing of the divinities then resulted from their use value within a society defined by its oppressive order; for instance, Ochossi, who is a minor orisa among the Yoruba, gains preeminence in his Brazilian incarnation. Ochossi is considered the orisa of the virgin forests and of hunting, and is brother to Ogun, the entity that governs metals and warfare. As the guardian of the Ketu people, his ascendancy can easily be explained by the number of Ketus sold in the transatlantic trade. Yet Ochossi is also the orisa of justice, and his symbol is the bow and arrow. In dance, his devotees join the tips of their fingers to form a triangular arch, patterned after this bow and arrow. When accessed, it is said that he shoots straight to the heart of any matter to correct wrongs and to guarantee his supplicants vic-tory over all malfeasance. Made manifest in the everyday reality of Afro-Brazilians today, the Yoruba nomenclature *Araketu* [the people of Ketu] is the name given to the popular carnival bloco afro dedi-cated to Ochossi. This restructuring of affiliation is also apparent in the emphasis placed on the tempestuous and turbulent natures of Iansã and Oshun (Carneiro, *Candomblés* 20). Both Iansã and Oshun are wives of Shango; yet each one materializes an entirely different

personality from the other. Iansã is the tumultuous force symbol-
ized by the whirlwind, who simultaneously serves as the guardian
of the dead; Oshun is the epitome of beauty, fertility, and the cre-
ative nurturing force that gives life. In their Brazilian incarnations,
their abilities as warrior queens, *Ayabas*, receive primary emphasis. It
must be noted that Oshun's warrior energy is not divorced from her
femininity, but what is emphasized is the manner in which she uses
this feminine energy to manipulate her opponents. Given the need
for resistance ideologies and positionalities in a slave-based society, it
seems logical to underscore the combative nature of the orisas.

The orisas are multivalent entities, and even though each one has
a dominant trait, it is quite feasible for that orisa to invoke the oppo-
site of that defining characteristic. Thus, Oshun can be both love
and war, as both energies often exist in complementary engagement.
This polarity and reconciliation apparent in the multiconsciousness
of the orisa may well have served as a model for the comportment of
the enslaved, and it is certainly used by the present-day Afro-Brazilians
in their role as objectified Other. As subalterns in society, overt dis-
plays of subjectivity or autonomy contradicted society's notions of
place and position. Mastering the double-voiced rhetoric that slave
societies demanded, they found spaces in which to project their sense
of self and communal configurations. Such sanctified spaces allowed
for a departure that confronts legitimized cultural constructs, and
in communion between the transcendental forces and the human
agent, the enslaved and the dispossessed forged spiritual practices
that enabled them to negotiate and circumvent white dominion.

The embodied memory in Candomblé provided outlets for cel-
ebration and catharsis and, according to Mãe Valnizia, allowed for
a "very intimate, immediate consciousness embedded in comport-
ment which connects present activities, present orientations, with the
experience of preceding generations" (qtd. in Harding, *Refugee* 147).
Serving as the basis of an African "codex," which Rita Segato calls
the collective repository of knowledge, it derives from a shared epis-
temological foundation and ways of being (141). Afro-Brazilians rally
around the matrix to generate their resistant ideologies and narratives
of identity to transform their social and economic marginalization.
The embodied responses to the transcendental power of the orisas
allows the practitioner to construct specific modalities that enable
her survival and victory in the face of power structures that deny her
subjectivity and even her humanity. The terreiro space, in becoming
the domain of black matriarchy, controverted such daily negation, for
verifiable African ancestry and hermeneutic knowledge provided the

base for belonging and ascension.[49] Power then signifies the range of action and agency in the transformative potential of the ritual sphere and the rites within, exercised intentionally outside its purview to effectuate a sense of blackness that is processional, a work in process and progress with the aim to liberate.

Inversions/Re-visions

By the mid-twentieth century, Candomblé had become the accepted marker for the authenticity of black cultural life. Its practices encompassed members from all socioeconomic strata, ethnicities, and racial categories. Supplicants came and advice was dispensed, the prescribed formulas were given. But with time, Ifá, the oracle of divination, was also transformed within the new cultural contexts. With women becoming the font of power in the terreiros, Ifá divination, considered the purview of men, gave way to the *jogo de búzios* [divination with cowrie shells],[50] allowing women to divine and dominate the hermeneutic tradition. Left out of the conversation and the purview of Afro-Brazilian religiosity is another significant titular distinction in the system of divination, *Iyanifa*, given to women who are trained to do Ifá divination. Being an Ifá diviner is a highly selective distinction, and in general, women trained in the art are much fewer in number, and even more so within a diasporic context.

Another key difference is found in the system of patronage within the terreiros. Quite commonly, prominent citizens, who have wealth, power, and influence, are given honorary positions and conferred the title of ogãns.[51] The persecution received by the adherents in the religion, during and after the slave era, undoubtedly explains the development of the system. As protectors of the terreiros, the ogãns gave and still give financial support, and even more importantly, they intervene in political processes to facilitate the continued functioning of their particular terreiros.[52] The configuration of the Obás do Xango, in Ilê Axé Opô Afonjá, accentuated such patronage by conferring an even more select title to its warrantors. Not all ogãns were honorary members in the terreiros. Male initiates, who helped to perform the ritual duties, were also given this title. The distinction occurs through the initiation process, allowing one to learn the daily care and ritual practices for the orisa (Carniero, *Candomblés* 137–39).[53] In times past, these roles were easily distinguished by color, since the initiates were black and the protectors white.

Ambivalence, however, characterizes the past relations of elite whites and their black counterparts in Candomblé. This is not quite

the ambivalence suggested by Homi Bhabha (1994), who still makes centric the role of the colonizer. According to Bhabha, the colonizer authorizes the discourse, but the colonial subject reshapes it. Losing its monolithic, unidirectional character, it reveals itself as double voiced. In contestations about Candomblé, the order of influence is reversed; rather, the black Other takes on the subject position and authorizes the discourse, and the white member is in the position of corrupted Other. For much of the white-identifying population in Bahia, the religious practices were part of the daily reality, but it was a factor of life that had to be eliminated. As a metonym for blackness and all that the term connoted, the elite viewed Candomblé as a set of "superstitious beliefs" practiced by "ignorant" people (Graden 57). The centrality of African women in the religion also added to its pernicious quality. Inverting the social order, the matriarchal emphasis stood in direct opposition to white male patriarchy and the evolving character deemed appropriate for the Brazilian nation. This, too, points to the deep points of ambivalence in the practices because, more often than not, whites used the divinatory-pharmaceutical services found in the terreiros. Living in such close proximity to blacks, they daily witnessed the effectiveness of the rites, rituals, and herbal lore in Candomblé and frequently sought the services of practitioners to help in all forms of distress, from sickness to love. Yet even as supplicants, their equivocation resonated as they constantly feared reprisals through poisonings or ritualistic attacks (Page 1995; Eakin 1997).[54]

White ambivalence shifts, however, in present-day discourse, with their increasing participation. In addressing the complexities that mark Candomblé in its current incarnation, anthropologist Júlio Braga points out that a minority black population participates in Candomblé,[55] validating Butler's conjecture that the present stage in the religious development is marked by its co-option by society at-large (*Freedoms* 52–59; "Africa" 138–48). Since white and black identities are so subjective, understanding an increase in white participation in the terreiros must be accompanied by an understanding of how these whites identify in the color spectra of Brazil. In participating in the religion, do these adherents give primacy to their African antecessors? Are they affirming an "African" identity in like manner as such famous converts as Roger Bastide, without addressing the multiple structural flaws in the socioeconomic sphere with regard to blacks? Rita Segato suggests that the base of white/black power relations are fundamentally eroded due to the increased conversion of whites in the terreiros. Segato argues that in the religious space,

power relations found in the dominant society are inverted: in the sacred space, whites bow down to blacks, and through this inversion of power the vanguards of the terreiro are slowly converting society so that it has a perspective of life that is based on this African discursive practice (129–51). Given the absolute negation of blackness, assuming a black identity in the space of the religion must be understood as a radical transformation in the psychological processes, and, in the sociological-scape, it is a direct challenge to the internalized and externalized manifestations of embranquecimento. However, it does not signify that Candomblé adherents are fervidly avowing their identity as "Negra." Rather, they acknowledge their Africanness and would more proudly proclaim that they are "Afro-descendentes," manifesting an alternate resonance and consciousness regarding the hierarchization of their society.[56]

It still remains, however, that outside the terreiro space whites continue to have all the privileges and access to socioeconomic resources. The Mãe de Santo, in front of whom they may have prostrated the night before, may selectively be acknowledged in the public domain.[57] The problem then lies in how to shift public discourse to reflect this private dynamic. Political activists, considering the transformative capacities in these cultural dynamics, use them as points of articulation to rally communal support.[58] Speaking of "nossa matrix Africana" and the need for its full inclusion in the Brazilian cultural sphere, without the pejorative tags attached to its representational corpus, is less polemically charged than open accusations of discrimination and racism. Social activists and intellectuals, working to redress the political disparity that underscores black/white relations in Brazil, often profess a belief in Candomblé or a belonging to that spiritual tradition in order to connect to that cultural source. Longstanding adherents to the tradition deem this a transient phase. If it is a fad, it is a transformative one, for in accepting their ancestry they seek new methodologies found within the culture to combat the discrepancies in social, political, and economic access. Openly acknowledging one's ties to Candomblé in the public sphere has become a marker of revolutionary impetus. It signifies a personal revaluation of one's Africanness and blackness and what it means in the society to be Negra/o, even if one does not identify as such. Outside the terreiro space, consciously choosing to identify as Negra/o is to affirm that African ancestry. With the amalgam of forces involved in the religious practice, select terreiro spaces have become sites in which dissent unfolds. The sacred and the secular blend as it is common for local intellectuals, political activists, politicians, cultural groups, and

the layperson to use terreiros as sites from which to conduct debates about political and social injustices. A prime example is found in Ilê Axé Opô Afonjá, which, since the 1937 Afro-Brazilian conference, has opened its doors to host public fora and informational sessions.[59] In the public forum, the nodal points from the ritual contexts generate transformative cultural practices.[60] This confluence of culture and politics is apparent in manifold levels of society, as explored through public rituals, carnival presentations, drama, poetry, and hip-hop representation in subsequent chapters.

Conclusion: Candomblé's Roots, Routes, and Rhizomes

In an interview, anthropologist Júlio Braga stated that Candomblé "marks a way of life, a way of being for the individuals." Since Candomblé denotes the space in which Africanness is given fundamental importance and reconfigured as an alternative modus vivendi, my contention has been that its adherents, whether overtly or not, challenge the system of whitening and the mythos of racial democracy as they externalize its living modality. The center of power for the devotee is not found in state discourse but in the word of the orisas, mediated through the institutional hierarchization of the terreiros and the entrenchment and rootedness in the Nagô-centric ideations of the religion.

To theorize cultural identity, Afro-Brazilians look to Africa as a generative source, but not a source of being. Africa, then, in the Afro-Brazilian psyche, is not just a romantic imaginary, nor is it simply a place for return voyages to connect with mythical ancestors. It is rather a source of sacred knowledge. It is the signifier for the metaphysical, psychic, and actual relations between humanity and transcendental forces. This is less an imagined construct and rather a very real one, for while the significance of Africa in its totality as a continent resonates best in the realm of the symbolic, the Africa of Candomblé revolves around, but is not limited to, the Yoruba-influenced world of West Africa. Significantly, however, it is from the areas of Nigeria and present-day Benin that sacred knowledge is sought and refreshed. Africa exists in the reconstructed image of the cosmos promoted in the sacred space of the terreiro, and it becomes tangible through the spiritual forces accessed and venerated in ceremony. Reverberating in the songs and dances performed in the ceremonial acts, the connection between memory and ancestry codifies to allow for the dramatic engagement between the initiate, the spiritual realm, and the community.

Chapter 2

Ritual Encounters and Performative Moments

Power is a breeze descended that comes
as a rushing wind into the heart.
When it leaves, you feel something leaving you.

Shakers of St. Vincent

We relive the past in rituals of revival
Unraveling memories in slow time; gathering the present.

Abena Busia, *"Migrations"*

Rituals are often seen as static forms of communal remembrances. Yielding to the onus of tradition and elements of cultural fixity, rituals are characterized by their attempts at reviving or vivifying the past, generating normative standards of conduct for individuals and their societies, while allowing for celebratory moments that access a shared reality (Myeroff 1984).[1] Rituals reify social order, contends Néstor García Canclini (2005), but they also impel transgressive movements (*Hybrid* 23). In the limits of hybridity, rituals occur and are perpetuated because the subject can only bear so much interlocution, negotiation, mixing, and transformation; but they may also signify the movement toward difference that society proscribes or incorporates as a new defining order (ibid. 23–24). I reposition the ritual contexts to examine them as part of organic, dynamic, evolutionary processes that draw on African traditions to construct Afro-Brazilian identity. Cultural reconversions happening through the hybridic, rhizomatic transposition of ritual forms, I contend, reassemble concepts of Africanness/blackness as markers and anchors for that identity. Ritual life is often conducted through both public and

private performances. This chapter examines the dynamics at play in three annual public rituals in Salvador, known as the *festas populares* [the popular or public festivals]: the *festa de Santa Barbara*, the *festa de Iemanjá*, and the *Lavagem do Bonfim*. Privileging the celebratory quality of ritual, these festas give homage to the respective orisas, Iansã, Yemanja, and Oxalá. As all-day events, they bring key sections of the city of Salvador to a close, and the participants create a necessary pause in the daily events of life. Transforming from moments of sacred communication to pure revelry through these festas, multidimensional levels of performance occur simultaneously.

In Salvador, in particular, streets, beaches, courtyards, lakefronts, churches, government and office buildings, parks, theaters, museums, and bars, as well as terreiros, are all spaces for ritual performances. Constantly intertwining the sacred and the secular, the city is a staging ground from which all manner of performances may erupt. In a city that revolves around staging its own corpus of identity, the average citizen is in the "know," and at times it is nearly impossible to differentiate between spectator and participant in these processes of public affirmation. The spectator, who easily becomes the participant, is alternatively touched by moments of sanctity or allowed to abandon herself to the all-around merriment. These cultural performances are often the foundational or causal element in public celebrations. Questions such constitutive relationships engender are, How then do we construct concepts to frame the all-inclusive nature of performance? How do these cultural performances function within the asymmetrical power structure perpetuated by the sublated discourse of embranquecimento and the myth of democracia racial? And how do these performative modalities shape and influence Afro-Brazilian identity and how are they, in turn, shaped and influenced by Afro-Brazilian identity?

The rituals examined here are in dialogue with their own historical processes and the images of Africanness/blackness eschewed, stereotyped, and mediatized in the local environment. The challenge is to examine cultural performances in such a way as to bridge and transcend the conventional oppositional dynamics generated by the terms ritual and festival, public and private, sacred and secular, spectator and participant, and political and cultural (MacAloon 1).[2] This chapter examines the polyphonic interplays found in the festas through the roles of the ritual specialists and their interactions with the public. These interactions manifest themselves through the unfolding of the sacred rites, public processions, possession trances, prayers and public supplications, singing, dancing, elaborate

costuming, and general disorder found in these encounters between ritual and festival. Popularizing the simulacral vectors in Candomblé emphasizes an ideal exegesis, a hermeneutic fusion that must be analyzed as situations of communicative harmony, a convergence of intent and meaning in Afro-Brazilian constructions of themselves. In making familiar and common the matrix of Candomblé, the festas articulate a sense of belonging to a larger African continuum, around which individuals and the community find correspondence and rally to generate a transformative field of vision of who they are and who they long to be.

Performance Theories and Ritualized Bodies

Performance in its simplest mode is the human corpus reflecting itself and its cultural forms. For Richard Schechner (1985), performance is "twice-behaved behavior" that involves choices and invention to imbue the creative capacity (*Between* 36). It is not simply a repetition of an action but the periodic repetition of the entire event with full communal participation as seen in the festas populares. Performance is not limited to any single phenomenon. According to Schechner, it

> originates in impulses to make things happen and to entertain to get results and to fool around; to collect meanings and to pass the time; to be transformed into another and to celebrate being oneself; to disappear and to show off; to bring into a special place a transcendent Other who exists . . . to be in trance and to be conscious; to focus on a select group sharing a secret language and to broadcast to the largest possible audience of strangers. (*Performance Theory* 142)

Elizabeth Fine and Jean Spear (1992) suggest that performance is best conceived of "as a discovery and making of behavior"(8). Performance, as it involves creative reconstruction, is not simply imitation or mimesis, state Fine and Spear; it evolves to poiesis as it creates or makes cultural identity through its representational acts.

What characterizes performance, as opposed to ordinary human behavior, depends on the level of reflexivity of the performer (Diamond 1996; Schechner 1988; Turner 1969). In other words, a performer knows that she is performing. Eliciting the performative, self-aware, expressive component of the public self, this reflexivity asserts through one's actions the intricacies of the social, cultural, and political environment to decode the symbols and meanings and to (re)present the complexities of these relations in active concourse. The body of the performer then appears to be a complex coded text

from which to read society's construction of itself. This issue of self-reflexivity in performance becomes contestable when dealing with trance phenomena, since trance implies a loss of conscious will and self-awareness. Given that ritual actors are trained to perform, does possession trance imply a level of self-reflexivity on their part? Within the sacred, the body acts as the medium for spiritual energy; it is a repository of a consciousness whose source is from somewhere else that is truly unknown. In the Yoruba episteme, Orun is that source, and embodiment functions as a journey-way to greater knowledge about self, community, and society. Its intelligibility, however, is also derived from deciphering its codes and messages. The social space of ritual incorporation becomes an epistemic space girded by the spiritual expertise of the community in the process of decoding the sacred knowledge imparted (Alexander 298). Hence, also imbricated in the self-reflexivity of the ritual actor is the intersubjectivity that develops between both the actor and the community in the mirroring of the effectualness of the ritual moment through shared perceptions and mutual celebration.

Both Victor Turner (1990) and Richard Schechner (1988) speak of "universals of performance" or, borrowing Schechner's terminology, "a unifiable realm of performance" (Turner, "Universals" 8; Schechner, *Performance Theory* 257). Linking rituals, rites, theater, plays, and other entertainment arts, these universals are made evident in Turner's theory of social dramas. Predating Canclini, Turner argues that social dramas and rituals share elements that both validate and reinforce social arrangements (structure) and allow for spontaneous disruptions to the social order (antistructure). Whereas social dramas occur during "aharmonic or disharmonic" phases of the social process, when attitudes of individuals or groups conflict with the dominant, accepted practice (Turner, "Social Dramas" 38), rituals occur in the liminal border spaces of social practices. Likening the dialectic tension found in social dramas to the processual actions in rituals, Turner (1969) aligns these instances in which social order and conventions give way to freedom of thought and action to the negotiation between forces of chaos and order found in ritual actions (*Ritual* 94–97). Elements of spontaneity and freedom shared by both processes generate a sense of *communitas*, a shared celebratory experience (Turner, *Celebration* 21; *Ritual* 131–40). Free of the impositions caused by social, political, and economic hierarchies, the interconnectedness of the living community prevails in this feeling of communitas. It is the building of communal relationships, without these hierarchies, that brings about a "bond uniting . . . people over

and above all formal social bonds" (Turner, "Social Dramas" 45). Reflecting an interstitial dynamic in the social process, a pause in the daily events of life, this sense of communitas is seldom maintained. Suggestively, if this celebratory, participatory sense can be carried into daily life, into secular events, it can help alleviate conflicts within social relations (ibid. 55–56). Turner, however, concentrates on the completion of the actions, the acts of reintegration into the social structure, as a definitional essence in rituals. To gain a better understanding of Afro-Brazilian ritual forms, it is important to focus on the transitional modes, in which the shared celebratory experience transcends scripted social arrangements.

In the actuality of Salvador, for the specialists/participants, the teleology is of lesser importance in the conjoining of public rituals and festivals; alternatively crucial moments in the cycle of events allow for greater dramatization of self and culture. Within these segmented pauses, social arrangements are not just suspended or inverted, as Turner posits; instead, awareness is placed on aspects and personas within society that remain outside the arena of political visibility. Such performative moments during the course of the ritual cycle awaken the sense of communitas, the communal spirit of celebrating a unified cause, centering on the belief in and recognition of the power of the orisas to become corporeal and concretely affect one's life. Communitas is predicated on the belief in and positive recognition of an African god-force in everyday life, engendered by spontaneous, free-flowing emotions and behaviors. This sense of communitas, rather than remaining in the liminal realm or the staging ground of the ritual (Turner 1984), transforms the subject and shifts the political dynamics to allow alternate definitions of power to come to the forefront. Embodiment in these celebratory encounters allows cultural politics to assume "style, shape and significance"(Manning 16). It is not just a matter of personifying an otherworldly force, nor is it limited to the body alone; it is an integrative whole of body, mind, and spirit in communion, symbolic codes and dress in action, and cultural and political modalities in cooperation.

Racialized Bodies and the Festas Populares

To suit the dominant paradigm of Brasilidade, symbols of racial identity become markers of cultural identity, and cultural practices are co-opted as social and political capital. African matrix symbology functioning as a repository of transcendent codes becomes figural and metaphorical representations of the miscegenational configuration

of the nation. Adding to the already complex sociocultural config-
uration, performance modalities taken from Afro-Brazilian life are
exploited as folkloric tropes to bolster this myth of racial democracy,
while those who are of obvious African heritage remain at the bottom
of all hierarchical arrangements. Tension forms in society as public
entities from the tourist industries, merchants to governmental orga-
nizations, and political bodies invest in co-opting the African/black
imago without giving full jural, social, and economic access to its
black populace.

The model of the black *Baiana*,[3] one of the most omnipresent
folkloric representations, is currently used to sell any and all tour-
ist articles, from kitchen magnets to jewelry and clothing. Images
of the Baiana, in the full regalia of a long, flowing, corseted skirt, a
colorful head wrap, a lace blouse, and undergarments hearkens back
to the days of slavery. In the tourist center of the city of Salvador,
Pelourinho, rather than stressing its importance in the slavery nar-
rative of Brazil (as it was the pillory yard, where the enslaved were
punished), new forms of exploitation occur and are condoned, from
more explicit prostitution to its lesser forms as young, black women
dressed in the elaborate Baiana costumes parade on the sidewalks and
through the narrow streets soliciting customers for exclusive shops or
posing for photographs with tourists for a fee. The evident compli-
cation is that this mining of the iconography of Afro-Brazilian cul-
ture as promotional leitmotifs allows for a mediatized, erroneously
replicated standard perceived as the cultural norm. Yet these visuals
only access the public representations developed out of Afro-Brazilian
historicity; the deeper knowledge that impels ritual behavior is still in
the hands of those who are the keepers of these traditions.

The precepts, principles, and verity of the African/black matrix,
however, is proudly accessed and acknowledged in the public domain
through the confluence of ritual and festival found in the festas popu-
lares. Reminiscent of Bhabha's (1994) view on culture, the festas, in
allowing for the public expression of cultural values, empower the
objectified Others to become sites of their own discourse. Becoming
an arena for "cultural recovery," as suggested by Stuart Hall (1989),
the festas bring to the forefront the history, language, and belief sys-
tems of displaced Africans through processes of identification and
identity formation in the midst of celebration. Instead of the persis-
tent focus that considers these aspects just markers for a topical focus
on Africanness and blackness (Pinho 2010; Capone 2010; Sansone
2003), the task at hand is to access the points of cultural identity that
stem from the deeper, spiritual knowledge. For this reason, Yoruba

cosmology also engenders a framework from which to explore the festas performance textures.

Improvisation and Play

Margaret Drewal, in her seminal study of Yoruba rituals, characterizes these rituals as journeys in which the subjective experience of the participants, their self-reflexivity and their transformations, are affected by levels of improvisation and play (*Yoruba Ritual* 28). By emphasizing the unity between Yoruba concepts of improvisation, *"eré,"* and its translation into the English term "play," Margaret Drewal stresses the indeterminacy in the ritual process. Improvisation as the cornerstone of ritual or as "praxis," states M. Drewal, "generates multiple and simultaneous discourses always surging between harmony/disharmony, order/disorder, integration/opposition" (8). Improvisation allows for repetition with a difference, and its transformational dynamics become destabilizing factors, making ritual "open, fluid and malleable" (23). Yet improvisation in its dual aspect, "play/eré," or through the verb *"seré"* [to play], often implies a competition in performance (15). Ritual performances are by nature multivalent and multidimensional acts, open to transformative possibilities that express the sameness, difference, and evolution of cultural forms. De-emphasizing the teleological focus of Turner's analysis, M. Drewal shifts the study of ritual to the momentary encounter, in which the improvised alters the intent of performance, giving free reign to invention, creative inspiration, and the dialectic processes that breed its opposites: disorder and chaos.

Yet is the seré of Margaret Drewal the same as the siré of Henry Drewal (1996), or does it denote a contrasting but parallel meaning in terms of the ritual process? The siré, according to Henry Drewal, sets the tone for the ritual incarnation of the gods. In the configuration of the Nagô terreiros, this siré invokes the ritual order by which the orisas are acknowledged and allowed to incarnate through the possession of their devotees (Chapter 1). Improvisation is also central to the unfolding of the siré, as ritual is subject to interruption and transformation due to the delicate balance sustained between the seen and the unseen and, therefore, unpredictable forces (H. Drewal, "Signifyin'" 269). Both terms signify "to play" and seem to represent shifts in dialect. Seré evolves from the Yoruba construct *se eré,* literally translating as "to make play"; siré reconstructed as *se iré* also signifies "to make play," but it also connotes "to make/do celebration or blessing." Given that in the Yoruba diaspora the

tonality, orthography, and structure within the language have under-gone radical changes, we may infer that either term could have been modified and used as the Portuguese equivalent xiré.

While V. Y. Mudimbe (1984) suggests that most of what is known about Africa is constructed in anthropological discourse, he also sub-verts his argument to speak of an "architectonic process," an under-lying order that exists in artistic forms to allow one to speak of an Africa that is not defined by Western constructs. It is an underlying creative complex that suggests a unifying source for African cultural representations (Mudimbe 155–56). This underlying order allows for equivalence in the concepts of seré/siré and xiré, and for the find-ing of similarities among the varied, multifaceted, and at times diver-gent ritual forms, between a Yoruba interpretation of the gods and a Brazilian one. It appears that it is in this order, rather than in a seam-less transportation of form and action, that we find Africa, manifest-ing most profoundly in the transference of the patterns of belief in the Yoruba gods and in the rituals dedicated to their revival. As Abena Busia suggests in the poem *Migrations*, which serves as an epigraph to this chapter, such rituals forge affective connections that recode the present despite the miasma of alienation.

Ritual Practices and Their Nature

The siré as performance theory allows for an investigation into the simultaneity of order in ritual incarnation and the disorder in such processes of embodiment and corporeality. Suggestive of an improvi-sational dialogue between the transcendental forces and the human agent, it allows for engagement with both the sacred and the secu-lar through the overlapping rubric of celebration. In Afro-Brazilian contexts, the siré, as the "notion of empowering improvisation" (H. Drewal, "Signifyin'" 269), provides a theoretical framework with which to unpack and elaborate upon the performative aspects of ritual and the dramatic enactments that occur between the adept, her orisa, and the communal participants who have come to experience a bit of the divine.

Sacred ceremonies begin and end with the *roda*, the circle, the metaphorical realization of the continuity of the life cycle. The roda as the physical manifestation of the Yoruba cosmos makes visible the Yoruba concepts of Orun and Ayé (Chapter 1).[4] The Yoruba believe that Orun and Ayé exist in symbiosis best illustrated by the continuity of the circle, with points of intersection embedded within. Orun is the center for otherworldly forces such as the orisa, and Ayé, the world, is

the center for humanity. Priests and priestess physically inhabit Ayé, but with the knowledge accrued through years of training, they are the conduits that bring Orun into the material plane (Drewal et al. "Yoruba" 14–15). In ceremonies, while dancing in the roda, the devotees traverse between Orun and Ayé during possession, asking the deities to manifest themselves in this physical plane. The initiates, dressed in the garb of their personal orisa, dance in a circular pattern until they achieve the state of trance. As each orisa is called, the dancing style of the adepts changes to mimic the movement and gestural patterns that characterize the orisa.

This initial call and response pattern varies depending on the terreiro, but most often the siré prescribes that the ceremony begin with a homage to Ogun, who is considered one of the youngest and "hottest" of the orisas, and that it always end with a homage to Obatalá or Oxalá, the "coolest" orisa, who is most venerated in his role as the father of them all. The concepts of "hot" [*gbígbóná*] and "cool" [*etútù*] in the Yoruba system also speak to the essences of the orisas and the ideal behavior of the human agent (Drewal et al. "Yoruba" 14). Illustrating the metaphorical implications between the concept of cool, its representations in the aesthetic field, and human action, Robert Farris Thompson links it to the ideals of good character and good behavior:

> To the degree that we live generously and discreetly, exhibiting grace under pressure, our appearance and our acts gradually assume virtual royal power. As we become noble, fully realizing the spark of creative goodness God endowed us with . . . we find the confidence to cope with all kinds of situations. This is àshe. This is character. This is mystic coolness. (*Flash* 16)

This is not to say that the hot orisas such as Ogun are less revered, for they, too, bring necessary balance to the cycle of life, but the archetype for human relationality and transformation is found in the purity, humility, and wisdom offered by the cool. Eshu, the principle of opposition or the manifestation of opposites, is seen as an agent provocateur and is pacified before the ceremony commences (Pemberton 25). In a special rite called the *padê*, the opening, Eshu is propitiated and asked to remain outside so that the malevolent energy he invokes does not impede the ceremony.

Rituals and Their Revival

In the standard, prescribed script of the siré, when the first orisa, Ogun, is called it signifies playing his drum rhythms and dancing in

the patterns that evoke his specific qualities. Manifesting an alternate social and political concourse, when an orisa incarnates the devotee mounted by that orisa is in the place of honor as the entity interacts with the congregants. The devotee may be deemed a subcitizen in the world outside the terreiro, but as the conveyer of the orisa, she is venerated as the orisa. The order in which orisas are acknowledged changes based on the terreiro, but regardless of the entity being venerated, Oxalá is usually the last to be called. The siré, Henry Drewal acknowledges, is playful and encourages innovation ("'Signifyin'" 269). In the ideal ritual the orisas incarnate only when acknowledged and called, but play generates spontaneous activity that camouflages multiple points of resistance. The orisas may subvert their corporeality and open the moment of sacred communication to a floodgate of improvisational possibilities in which they incarnate in unpredictable sequences or, at times, do not respond to the call. Uninitiated supplicants fall into trance. Mães and Pais dos Santos endeavor to control their own states of trance, seeking either to resist being mounted by their deity or searching for the opportune moment to incarnate the deity for the most effective representation of spiritual power.

Even though theorists have tried, trance is a phenomenon that, as yet, cannot be fully understood or explained (Alexander 2005; Omari-Tunkara 2005; Dobbin 1986; Deren 1970). Maya Deren is the only scholar/practitioner to actually describe the trance state, and she refers to it as "white darkness" in its simultaneity of "glory" and "terror" (259). Through trance, anything can happen and is allowed to happen; improvisational possibilities become actualized because the embodiment of the orisa is seen as the apical manifestation of divine authority. In the liminal state it is impossible to tell where the consciousness of the initiate lies in relation to the possession by the orisa. Suggestive of a melding of the two consciousnesses, as part of the training cycle the Mãe de Santo will dance with the novice during the course of the possession and teach her the correct movements of the dances.[5] Contrastingly, however, Deren states that two consciousnesses cannot occupy the same human frame in the same moment; thus the human consciousness flees and is replaced by the divine. Where does it go? What does it do? And at what point does consciousness reenter the body? These are all aspects yet to be voiced. Even more evocative is the transfiguration implied by the trance state. The ease with which initiates become possessed, suggests Omari (Tunkara), is interpreted as proof that the orisa is pleased with the ritual and the sacred offerings ("Candomblé" 150). During possession the devotee is thought to become the orisa, and the awesome power of divinity

becomes a tangible, accessible force to help supplicants mediate and negotiate imbalances in the social and political realm. In this transposition from spiritual action to political effect, James C. Scott (1990) considers spirit possession as a "quasi covert form of social protest" for the marginal and the oppressed (115). When open protests are too dangerous or easily nullified, the spirit can speak through the human vehicle, and in performance they release a "seditious message" that the audience readily grasps, which is an invocation of power in the most dynamic and chthonic form (Scott 158).

Dance makes the state of possession most visible. Each orisa is allowed a period of time during the ceremony when s/he alone performs. Dramatizing the fundamental nature of these spiritual forces, dances of possession allow the orisas to reveal themselves and to interact with their devotees, bringing the mythical and the incorporeal into the sphere of the tangible. The dance form allows the supplicant to touch, talk, and feel the presence of the divine, promoting communal bonding as adherents unite in the knowledge that they share in the protection and receive guidance from forces with transcendental knowledge. Dressed in the appropriate ceremonial regalia, the orisa takes control of the floor and dances in the circular pattern while exhibiting her or his agility. For the young initiates possessed by an orisa, these moments foster the bond between them and their guardian spirits; it solidifies their place and placement in the terreiro hierarchy; and it guarantees their role in the community as purveyors of sacred knowledge. Often stopping in the midst of the dance to speak to favored individuals, the orisas offer consolation and give homage to the terreiro elders.

As the ceremony continues, each orisa has a caretaker, an *ekede*, a nonpossession initiate, who acts as a guardian in the trance state. When possession occurs, the semantic field shifts to indicate which orisa is present; the adept shouts, her eyes close, and she begins to pace back and forth. The manifesting orisa is immediately recognized based on the quality of the shout, or *ika*, as it is called in Yoruba, and is attended to by an ekede, who removes her shoes and headgear. According to Omari (Tunkara), this allows the head and feet to have contact with the air and the earth, sources of the sacred force of the orisa ("Candomblé" 150). This disrobing, I also suggest, brings the forces of Orun together with Ayé through the body of this medium. Soon after possession occurs, the adept is whisked away to a private space. If it is a major ceremony, all of the orisas return together, led by a Mãe de Santo ringing an *agogo* (the bell used to set the drum rhythm) to signal this heightened phase of the ceremony. If not, the

orisas may return individually, but always to the accompaniment of the agogo.

When an orisa returns to the public space, she is dressed in the garb indicative of the specific characteristics personified and she holds her ceremonial instruments in preparation for her moment in the roda. Each aspect of her dress is metaphorically tied to the qualities she incarnates; for instance, when Iansã incarnates, she is usually dressed in red or purple, she carries a copper sword in one hand and a flywhisk in the other, and strung around her body are the horns of a ram. Red and purple are "hot" colors, signifying her choleric, warlike nature. Her famous temperament resonates in the sword that she carries. It is copper, as opposed to the usual iron, because copper is the metal used to conduct electricity. This relationship is metaphorically extended through the connection Iansã has with lightning, an element given to her by Shango because she is his favorite wife. The sudden electric charge it produces, which lights up the sky and sends fear through its observers, is conceived of as the same energy manifested by Iansã. Even with all her raging, warrior-like energy, Iansã is also an Ayaba. Lest we forget, the ram horns strung around her are figurative reminders of that regalness, as she is the queen of the ancestral forces [egungun]. Among the Yoruba she is called Oya, and her signature colors are black and white, reflecting this engagement with the ancestors. Red, the color used for her in the Afro-Brazilian context, is also emblematic of her engagement with the ancestral. Additionally, the flywhisk she carries has dual significance: it reflects her sovereignty, because it is an emblem of kingship, but it also characterizes her ability to know the future (Luz 62).

In comparison to Iansã, Oshun and Yemanja are considered cooler orisas. Often dressed in yellow or white, Oshun carries a mirror in one hand and a sword in the other. Yemanja uses the same ceremonial objects as Oshun, but whereas Oshun's regalia are made of gold, Yemanja's are made of silver, and she tends to wear blue, white, or green. The mirror carried by both orisas reflects their femininity and fecundity, and at times it is adorned with carvings of fishes to depict their relationship to water, a generative source. Oshun is considered the orisa of fresh waters, rivers, and lakes, and Yemanja is the potent force of the sea. Differences are strikingly apparent, for Oshun is the epitome of beauty and the legendary vanity that it implies. When incarnated and manifested through dance, her devotees use undulating arm movements to signify her relationship to water, but they also incorporate gestures in which she looks at her mirror in obvious self-admiration (Luz 67). Yemanja is the prototypical mother, and this

role is central to all her incarnations. In dance, the gestures that illus-
trate her presence also incorporate the undulating waves of the sea,
seen in the arm and pelvic movements, a signifier for the generative
capacity of her womb (Martins 95). Her sword, although a symbol of
war, is rather indicative of her maternal love, for she uses it to open
the roads for her children. By clearing the obstacles in their path, she
helps them to fulfill their destiny (Luz 67–68). As queens who are
also kings, these orisas always appear with a beaded veil. Among the
Yoruba, the kings wear beaded crowns that shelter their eyes from the
public. Equating regal power with the transcendental, the eyes, due
to their fearsome ability to manifest the divine, must never be seen by
the people. The public must be shielded from the awe-inspiring force
epitomized by the orisa presence in embodied form.

The ceremonies continue until all the orisas have a chance to dem-
onstrate their individual style. Trance must occur for the ritual to be
effective and to foster social cohesion and group identification. Since
the ancestral space of Africa is evident in the corporality of the orisas,
the transcendent link fosters an alternate subjectivity regarding one's
Africanness and blackness and one's connection to the black world.
For the set of codes the rituals perpetuate derive not only from the
consciousness of divinity but also from an epistemological system that
is sourced in an African geography. This connection can neither be
forgotten nor deemed spurious, because within African-based cosmo-
logical systems the spiritual cannot exist outside bodily praxis, and it
generates a natural conjunction between social, political, and cultural
relations. The body, as an intersubjective text, forms an integral part
of the African matrix, navigating in and out of social contexts and
spheres of power (Alexander 297).

A ceremony cannot end without feeding all who are present, and
whoever attends is offered part of the sacred meal blessed by the ori-
sas. Significantly, the observer is partaking of the *axé*, the spiritual
energy of the orisas. She carries with her and within her that transfor-
mative energy and, therefore, the force necessary to foster communal
consciousness and agency. Key personages are invited to the private
spaces in the terreiro. Notably, as at an exclusive club, only a few are
able to enter that inner sanctum.[6] Such an invitation indicates one's
status and, if the individual is well known and respected, the invita-
tion is extended. Despite the lesser numbers of conversions spoken of
by Júlio Braga, blacks still dominate within the space of the terreiro.
Recognition is not based on the white/black dynamic apparent in
society but on a black/black configuration of the world.[7] Thus a per-
son who has a privileged position in the terreiro, who receives the full

respect and esteem of his or her peers, outside of that space may be a domestic worker or a street cleaner, but for that moment, that night, s/he is a person whose status cannot be challenged.

Yet how is the siré applicable to the public performances apparent in Salvador? The term suggests a blending of celebration and solemnity that characterizes the public rituals in Salvador. In such public communal celebrations, the border between ritual and festival disappears, becoming what I term a *rituval* (Sterling 2010). The siré speaking both of order and its disruption rather implies an ordered chaos; it appears chaotic to those outside the ritual process, but it is easily accessible to the insiders. It allows ritual outsiders to temporarily become insiders and the form of the ritual process to be constantly malleable (Grimes 271). In the rituval, improvisation dominates and allows for the imbrication of three essential components of dramatic representation: (1) it overlaps the roles of spectator/performer/ritual specialist; (2) it engenders moments of interconnectedness or communitas between the ritual participants and spectators; and (3) it gives form to the unexpected, indeterminate aspects and invisible forces accessed by rituals. This then sets the stage for an examination of these public displays. Henceforth, the Brazilian term xiré will be used to encapsulate these components.

The Padê – The Journeys Begin

The rituvals for Iansã, Oxalá, and Yemanja open the city streets to all manner of celebration. The order of the xiré is at once overwhelmed by improvisational dynamics as the unforeseeable and unpredictable spring to the forefront of the action. In the midst of the resulting ordered chaos, the sacred aspect, or the mission of the ritual, still dominates. Within the maelstrom, the ritual insiders guide the process toward fulfillment, but the spectator/participant moving in and out of the flow of events does not share in that teleological focus; motivation rather lies in fulfilling personal desires and sharing in the communal bonding that prevails during these festive celebrations. Ritual specialists, outwardly, are in control of the processual events, but to the extent that they invoke chthonic forces, the delicate balance is easily disturbed: not unlike the sudden appearance of an unexpected, maybe even unwanted, orisa, or the nonritual participants falling into trance states, or even the incursion of the state into the ritual. All these points of disorder, I consider, fall under the improvisational potentialities taken into account with the xiré. These rituvals become the fora in which to give homage to the orisas, to marvel at their

transcendence and transfigurative abilities when accessed through the human body, to seek comfort and obtain blessings for daily travails, and simply to briefly relinquish one's cares and inhibitions to the spirit of revelry. This "power play" is not limited to discursive versus counterdiscursive strategies. In its politicization of culture it evokes the very belief systems of the people and their constructions of transcendental and political authority (Manning 16).

The festa de Santa Barbara is the first in the cycle of festas populares around the city of Salvador. Conducted on December 4, the festa is an all-encompassing, public celebration and veneration of Iansã, under the guise of the Catholic saint Santa Barbara. Since each orisa within the Yoruba pantheon manifests a distinct personality, it delimits responsibility for particular aspects of life and its psychosocial implications. Communal referents are apparent in the color worn by the supplicants, the type of dress, the use of symbolic objects, and the facility of trance. The color a follower wears speaks of a particular attribute of an orisa and serves as an identifying marker of its presence in public and private space. Iansã is an energetic warrior spirit that traverses the land; she is the keeper of the dead and the protector of the living. Depicted as a beautiful woman with long, flowing locks, her devotees, under possession, dress in garments of red, magenta, burgundy and, at times, yellow; each of these colors are thought to address her specific functions. Wednesday is specifically consecrated to her, and all her devotees, along with those who wish to proclaim an affiliation with Candomblé, dress in her signature color of red, offset by white. Red and white are also the colors of Shango and, since she is his favorite wife, their use by Iansã's devotees is said to represent the closeness of that bond. I would also aver that the use of the color white gives the necessary etútù to temper the virulence of the red.

The devotees of an orisa are said to express its persona in their own daily interaction. Children of Iansã are known to be intractable and willful, which explains why they are characterized in the following manner:

> endowed with inexhaustible energy, women who are dynamic, nervous, restless. They are also women who have an intense sexual vigor, who are provocative, who conquer and dominate men. Eccentric, cheeky, they call attention to themselves by wearing brilliant colors, daring clothes, and eye-catching jewelry. The daughters of Iansã are extremely jealous and they do not tolerate being deceived. When offended or they discover that they have a rival, they don't hesitate in creating a huge scandal, caring little for what others will say. They are proud and obstinate women, rebellious and impertinent, impatient, choleric, cruel, always

willing to fight. They don't like children or domestic duties; when in love, they are extremely dedicated to their man. But, in general, they are ungrateful and egotistical. (Lépine 150)

It is after initiation that these aspects fully assert themselves. Most individuals identify with a particular orisa and consider the entity a guardian angel. Since the qualities of the orisa are common knowledge, when identifying oneself as a child of a particular orisa, for example, as a *filha* of Iansã, the assumption is automatically made that one has a choleric, passionate nature and is always ready to fight or to make love. Iansã's prowess as a warrior, her mutability, and her exuberance for life are the qualities most cherished about her. It is said that because Iansã is the guardian to the world of the dead, she teaches one to enjoy life. This joie de vivre is profoundly evident in those who are possessed by her spirit. Made visible in dance form, that energy and vibrancy is almost tangible as it is expressed through vigorous arm motions, swirling of the skirts, and flamboyant pirouettes that characterize her temperament.

Beginning with a Catholic Mass, the ceremony for Iansã/Santa Barbara can be seen as an example of the interlacing of African traditions and Catholicism. From early morning, congregants arrive in Pelourinho, the area where the ritual procession occurs. Meeting in front of the famous church, *Igreja do Rosario dos Pretos* [Church of the Rosary of the Blacks], those who arrive early in the morning enter to participate in the Mass conducted for Santa Barbara, and the later arrivals await the procession outside. Henry Drewal (1996) argues along with Pierre Verger (1997) that, although the qualities of the saints and the orisas parallel, there is a clear distinction in the minds of the devotees. Rather than using the term *syncretism*, which denotes a fusion or an intermixing of essences, they suggest the use of the term *juxtaposition* to describe the devotee consciousness in relation to the positionality of the orisas and the saints. In the thinking of the practitioners, an allegorical relationship exists between the entities as they dwell side by side in complementary accord. The Mass conducted at the Igreja attests to this juxtaposition of identities. Free and enslaved blacks built this particular church after being banned from worshipping in the Catholic churches. The parallel relationship between the orisas and the saints is seen in its beginnings because the founding members were also the leaders in the irmandades and Candomblé communities (Chapter 1). To this day, church members are leading Mães and Pais dos Santos and, curiously, the Catholic priests, some of whom were born into Candomblé communities, maintain the

affiliation. Hence, even though the ceremony may begin as a symbol of Catholicism with representational objects found in that tradition, the presence of the orisa dominates the ritual unfolding. The dress of the supplicants most potently accentuates this duality, for while Santa Barbara is the saint that is dressed in red, the devotees are dressed in the signature colors of Iansã, red and white. Undoubtedly extending a relational color symbolism to each entity, the devotees fill the base of Pelourinho to wait for the emergence of the figure of the saint and the women who honor her, and only after the orderliness of the procession does the tumult that invokes Iansã begin.

Complementing the rituals found in the terreiros, the procession is led by Mães dos Santos clothed in the traditional white, Baiana style of dress with swatches of red in either their headgear or as a scarf thrown over the shoulder. The Baiana dress is modeled after the dress of the Mães dos Santos in Candomblé ceremonies and composed of five crucial elements: the *camizu*, a lace trimmed blouse; the *saia*, a flowing ankle-length skirt; the *oja*, a white head tie; *contas* or *ilekes*, sacred beaded necklaces; and an optional *pano da costa*, a shawl worn over the left shoulder (Omari, "Candomblé" 151–53). The camizu and the saia are the necessary basics; the decorative details on the saia tell of the status of the Mãe and its color also indicates the orisa to which she is dedicated. The oja, or as it is commonly known across West Africa, the *gele*, is the first garment to be removed when possession occurs. Serving as an identificatory text, it is then tied around the body to indicate which orisa incarnates. For Ochossi and Oxalá, two ojas are used: Ochossi's crisscrosses the body and is tied at the waist, and Oxalá's is tied at the shoulders. For female orisas such as Iansã and Yemanja, the oja is tied across the breast into a bow in the back. The ilekes are also part of this hermeneutic text; the color, length, and types of beads denote one's status in the hierarchical arrangement of the terreiro. A clear indicator of status, only the principal Mães wear the pano da costa, or as it is referred to in Yoruba, the *iborun*; the most sought after panos are brought from Nigeria and made from *asoke*, the woven strip cloth. For this homage to Iansã, the celebratory white dress of the Baianas is used. Red swatches placed in individual ojas, as well as the use of red panos das costas, are clear indicators that this is a ritual to Iansã. Personalizing the dress, along with wearing the sacred beads for Iansã, the Mães add the ilekes of their own orisas and, at times, swatches of other colors in the oja to demonstrate that affiliation. Red and white, however, dominate the field of vision, as both the ritual specialist and the ordinary spectator/participant wear these colors as an emblematic link to the force of the orisa.

Parading through Pelourinho, the procession stops at key points to display the statue of the venerated saint. An image of Santa Barbara stamped on a red flag follows behind the Mães. In the unfolding, multifaceted but synchronic discourse, a palanquin is hoisted on the shoulders of the official members of the procession, containing images of other saints surrounded by a bed of red flowers. Pelourinho, the revitalized city center, is a locus for cultural life and entertainment: as such, it houses religious organizations as well as carnival and capoeira groups. Members of each organization, dressed in their signature colors, stand on the walkways waiting to give homage to the orisa. Joining in the flow of communitas after the passage of the sacred emblems, they follow the procession, adding multiple layers to the event.

During my first observation of the ritual,[8] one group in particular was quite conspicuous among the congregants: the young women and girls in *Banda Dida*, the only all-female percussion group head-quartered in Pelourinho. Invoking the image of Anastasia, the young women dress in the rough burlap cloth worn by the enslaved and cover their mouths with leather muzzles tied crisscross around their faces. Along with this muzzle, the central figure in the group wears a spiked iron collar around her neck. Surrounded by members of the band, she saunters slowly under a large umbrella that is reminiscent of the procession of kings and queens in West Africa. Anastasia was a young enslaved woman who was renowned for her beauty. Apparently, her owner became infatuated with her and repeatedly exercised his sexual rights. His wife's anger and jealousy led her to exact a grotesque pun-ishment, ordering Anastasia to be muzzled and beaten. The muzzle was to hide her beauty and the punishment was to disfigure. A hero-ine to Afro-Brazilians, Anastasia's tragic life and death attest to the suffering endured during the days of slavery. As a warrior spirit, her courage and comportment epitomize the dynamism and fortitude attributed to Iansã.

The procession, after passing through the streets of Pelourinho, continues to the lower city in the area of Barroquina. Stopping at the *Corpo dos Bombeiros*, the fire station, the ceremony reaches its crescendo. Inside the station, each group joining the procession dis-perses into its own sector. Drumming and dancing commence, along with songs giving homage to Iansã. Suddenly a shower of water descends on the crowd. The firefighters participating in the ritual unexpectedly flood the area. As Iansã is the lightning that accom-panies a rainstorm, this shower presages her appearance. Seemingly waiting for this signal, the juxtaposition of identities comes to an

abrupt end as the individuals carrying the palanquins laden with flowers and images of the Catholic saints rush at the crowd. The devotees, in effect, are saying it is now time to show who is really in control of these events. Each quarter to which they run becomes a staging point for the incarnation of the deity. In the chaos that ensues, some of the spectators run for cover and others remain in the newly created ritual hall. The improvisational dynamics spoken of by Margaret Drewal are in full reign. "Multiple and simultaneous discourses" erupt as one after another of Iansã's devotees become possessed and manifest her spirit through dance, accompanied by the singing and drumming of the ritual specialists (*Yoruba* 8). In the crush of the crowd and the ensuing melee, competing centers of action form around those embodying the orisa. It is not just the ritual participants who incarnate the deity; spectators also fall into trance states and temporarily become ritual actors. The drumming pervades the crowd as each ritual grouping unashamedly attempts to outperform each other for the most striking representation of the deity.

Banda Dida wins the competition in performances as their drumming rises above the bedlam created by the other groups. Giving the most arresting performance, the young woman dressed in the garb for Anastasia is clearly depicting a state of trance, but whether she is actually possessed by the deity is a matter of debate, for while the others incorporating the orisa are religious devotees, Banda Dida is purely a performance group. Ritual and dramatic enactment coexist in a field of oscillation because the nature of embodiment realized in the dance form allows for ready duplication by nonritual actors. Banda Dida signals how the African matrix functions outside the sacred sphere in its use as an identificatory text to which all can relate. When the Banda's initiate whirls in the energetic patterns that characterize Iansã, she generates a semantic field through the dance in which Iansã's iron will and unrestrained temperament are illustrated through the vehement thrusts of her arms and the whirling of her body (Pinto 73–75). Dance anthropologist Yvonne Daniel tells us that through dance the human body underscores its force and power. The community depends on healthy bodies for survival, and the dancing body is the ultimate signifier of health (267–68). Even if this representation of Iansã is limited to the performative, and not a manifestation of embodiment by a spiritual force, personification of such a powerful orisa conjoins the body politic with the community, and the community can see itself as strong, bold, fearless, and beautiful like the orisa.

In the crush of the crowd, it is impossible to focus on any solitary grouping over another, as the bearers still rush through the improvised ritual hall, creating pockets of chaos from which the deity incarnates. Like sparks falling after a jolt of electricity, possession passes from one group to the other and the shouts of *Opa ye!*, the salutation to Iansã, ring out in the crowd. The possession and dance allow for "historical catharsis, contemporary release, and meaningful social action" (Daniel 252). The ceremony becomes one of resilience and dedication. Though the fire station is transformed into an erratic and chaotic space, the semiotic fields created by the possessed tell a different story. It is one of strength, calm, and deliberation that comes from the control that the orisa exercises in its interaction with the human agent. These moments are indeed important, for they forge the connective link with an African ontological source, but more so, it is an expression of the living collective memory of the people as they align with cosmic will. The dancing bodies repeat timeless movements that are "erratic, jerking, undulating, unabashedly asymmetrical and rhythmically sophisticated," telling of Iansã's struggles and tenacity (Daniel 252). Experiencing these deliberately remembered patterns and interfacing with the divine, the community reflexively becomes one with the orisa to embody an alternate font of knowledge and empowerment.

Existing simultaneously, the secular aspect of the procession continues peaceably. For those who continue parading, the procession winds its way back to the Igreja in the midst of drinking and high spirits. The procession is relatively calm as groups amble by talking and greeting each other, but the sense of communitas prevails and appears most profoundly in the collective display of red and white garments worn by the marchers. Whereas in the sacred space, the revelry magnifies as the bombeiros continue to shower the participants with water. The celebration continues through the day in various guises: some continue in the ritual passages either watching or personally participating in the incarnation of the orisas; still others trickle to the surrounding area to drink beer and eat *caruru*, the stew made from okra that is consecrated to Iansã.

In my last observation of the festa, state participation was even more evident. As attested to by several sources, this rituval is growing exponentially, and the attempt to maintain order has reshaped its performative nature. No longer do the ritual actors enter the Corpo dos Bomberios; now only the bearers of the palanquin are allowed inside. Rather than an extended ceremony in which trance possession dominates, the palanquin is quickly shuttled out of the fire station,

accompanied by the official band of the firemen. Due to the increase in participants, it was impossible to move freely through the crowd to observe all aspects of the ceremony, but I was assured by several witnesses[9] that the trance possession portion of the ceremony continues near the fire station and the firemen place their trucks in the middle of the street and shoot water out at the participants. Both Habermas (1989) and Bakhtin (1981) speak of the heteroglossic nature of the public sphere and the competing field of traditions that are staged.[10] In such processes, different actors bring forward differing emphases and meanings to what may be the same concepts and modalities. Thus, the greater state participation can be interpreted on at least two levels: one, that the state is co-opting and controlling the rituval because, due to its increase in size, they fear the chaos that may be unleashed; or the state, in realizing that they cannot control the rituval, chooses instead to insert itself into the course of events and the corpus of Afro-Brazilian identity. Either way, it tells of the limits of unilateral power centers and affirms the multivalent insertion of the narrative of Africanness in the identity of the state, for the Baianas are a force to negotiate with whether through attempts at co-option or conviviality.

The Journey's End

The festa de Iemanjá takes place on February 2 each year. It is the last public rituval before carnival. Whereas the date for carnival may vary, the festa never does. On that day, the daughters and sons of Yemanja come to venerate her, ask for blessings, give offerings, and interact in carefree abandonment. Beginning at the *Casa de Iemanjá* on the oceanside, in the area of Salvador known as Rio Vermelho, the beach and the street become ritual ground for invoking the orisa through possession, singing and dancing, and gift giving. In Yorubaland, Yemanja, called *Yemoja* or *yeye mo eja*, signifies "mother of the children who are fish" and is considered the quintessential mother figure. Whereas among the Yoruba she is a water deity that lives in the Ogun river, in Brazil and other parts of the diaspora, she is represented by the ocean and is considered the life-giving force that lies in its depths. Twinning her capacity as the giver of life and her representation as the force of the ocean, Yemanja protects fishermen,[11] sailors, and all those who depend on the sea for existence. However, she is also a beautiful mistress who brooks no competition when you are one of her chosen. Jorge Amado, in his famous novel *Mar Morto* (1972), speaks of the tranquility, immensity, and profound power that is Yemanja. It is said

that she loves her children to such an extent that she calls them to her; hence, many who enter the ocean enter at their own risk, knowing that at any moment she may claim their lives. Yet as depicted in *Mar Morto*, to cross the threshold to the depths of the ocean, the metaphorical all-encompassing womb, and to see the face of Yemanja is to find such peace that life is no longer worth living.

Yemanja is known by a series of names, such as *Rainha das águas* [the queen of the waters], *Mãe da água* [the mother of the water], *Janaína* [the Indian spirit], *Mami Wata*,[12] and *Sereia da Mar* [mermaids] to name a few. When giving thanks to her or evoking her, her devotees chant the Yoruba phrase *Odo Ya*. In all her characteristics her femininity is emphasized, and her devotees are said to embody the generosity of character and unselfish nature that befits the mother of all. Hence, they are described as follows:

> usually are tall and robust, with a large frame, large buttocks, generous bosoms. She is calm, serious and full of dignity. Sensual, fascinating, she is very vain [in the way] she cares about her appearance. She is a faithful wife and mother, efficient, energetic, but jealous and possessive. The daughters of Yemanja, as a matter of fact, are much better mothers than wives, showing a lot of independence in relation to men, husbands, lovers, or fathers. However, they express maternal sentiments in the devotion and the love that they dedicate to the education of children, even if they are not theirs. They are closed, tranquil, sweet, patient, helpful, but at times they become furious in a way that is unforeseeable. Some, [who are] more combative, succeed well in business. (Lépine 147)

The celebration honoring Yemanja begins at dawn when supplicants assemble to bring offerings that compliment her femininity, such as white flowers and perfume, to her shrine at the oceanside. Some of the offerings are tossed into the ocean with a special prayer, but most are taken inside the Casa de Iemanjá. After waiting in an extensive line, entry is granted, and the supplicants place their offerings in front of the image of the orisa. Inside the shrine, which is simply a small, single room, one is directed as to where to place the offerings, after which the supplicant is allowed to pray and wash in holy water said to be consecrated by the spiritual force, the axé of the orisa. The local fisherfolk are the keepers of the Casa de Iemanjá, and the sacrosanct aspects of the ritual—to consecrate the water and the space—are done by them. A key portion of the ceremony for Yemanja occurs on the beach, located immediately below her shrine. Since this is an open day for the worshippers of the orisa,

individuals and groups arrive seemingly without regard to time constraints. However, the sacred aspects of the ritual occur in the early portion of the day, and as the day progresses the secular aspects of the celebration dominate. By nightfall, all facets of the ritual give way to carnivalesque revelry.

In the ritual reenactments, multiple performances or "multiple discourses," as suggested by M. Drewal, occur at the same time as groups from different terreiros congregate in specific sections of the beach to dance, drum, and sing praises to her. Paralleling the competition apparent during the performances at the festa de Santa Barbara, each house vies for the greater share of spectators as performances become more vigorous with greater intensity in the drumming, dancing, and calls for the orisas. It is not long before trance states occur. Dress is a clear indicator as to who is a ritual specialist and who is not, and this identification becomes even more apparent through the dances of possession. Ritual specialists move with grace and facility without faltering in the sand; those casual participants who are randomly possessed and fall into trance have little control and often lose their balance in the frenzy of the movement.

I spent the greater part of a day observing one house in particular, which appears to be a Candomblé-caboclo house.[13] Yet, rather than debunking the Nagô dominance in Candomblé forms, the evocation of the orisas that I witnessed validates the ubiquity of their representations in ceremonial modalities. A Pai de Santo led the events, as both the spectators and the members of the terreiro fall in and out of trance. Unlike the events in a Candomblé ceremony, no attempts are made to care for or control the participation of the individuals who randomly become possessed. Even though both men and women achieve trance states, women dominate the roda (the circle where dances of possession take place). These ritual participants take turns giving homage to the Pai de Santo, falling at his feet, waiting to be lifted, embraced, and acknowledged. Such gestures of submission parallel the *dòbálè*, the Yoruba greeting in which a younger man prostrates himself before an elder. The angle of the body, on its side or laying face down, and the motion of the arms are semantic indicators of which orisa is manifesting. By prostrating him- or herself in front of the Pai, the initiate is simultaneously recognizing his greater spiritual knowledge and asking for the blessings from that axé, the force of the transcendent, which he has cultivated. Power, then, is found within that spiritual source, in many ways paralleling the Foucauldian stance that conceives of power through a decentered set of relations negotiated between unequal subjects.

The polyphonic, improvisational dialogue implied by the xiré begins when ritual insiders and outsiders mesh as three women dressed in street clothing dance in the roda, obviously possessed by their orisa. One of the outsiders to this terreiro, if not the ritual process, dressed casually in black trousers and a white top, interrupts the ritual order to sing for her orisa during the course of possession. Following the pattern of the dances for Iansã, she repeatedly falls to her knees with her shoulders shaking convulsively to the rhythm, mimicking the orisa's kinetic energy. Rather than resisting and over-riding the desires of the orisa, the Pai joins in the chorus of the songs and urges the drummers to play the desired rhythms. Interrupting the drumming and dancing to sermonize, the Pai reasserts his role as the keeper of the xiré by giving injunctions and guidance to the congregants: to safeguard the home and to care especially for the children. Returning to the invocations to the orisa, he calls the spirit of Ochossi.

Dressed in a flowing white shirt and pants, trimmed with red embroidery, the devotee who incarnates Ochossi appears in the roda. From this elaborate dress it is apparent that he is a member of the terreiro, but it is the fluidity of his dance style that gives away his status. Within the semantic field he creates, he depicts Ochossi's role as a hunter. Dancing with high steps, with his knees bouncing almost to his torso, his fingers form the pattern of a bow and, arching his arms above his shoulders, he aims and shoots. Yet in the roda this status becomes irrelevant as the possessed spectators turned into participants continue dancing, paying no heed to the call to order. Quite unlike the ceremonies in the terreiros, once an orisa is called into the ritual ground, the one performing is expected to yield the space and retire. This lack of order would not be tolerated for long, as an ekede would guide her out of the dancing circle to an antechamber where she is called back into her body. In this free-flowing environ, one of the random participants, the woman dressed casually in black slacks and a white shirt, adds her voice to the proceedings by singing for Ochossi, but continues to dance. Rather than limiting her participation in the ceremony, she is allowed to sing and give praises to the orisa and only after is she escorted from the roda. The transition to Ochossi, how-ever, is further delayed as the filha from the terreiro who is incarnat-ing Iansã reenters the roda. Clothed in a long, flowing, peach-colored gown, and visibly in a trance state, she dances as an embodiment of Iansã accompanied by the devotee of Ochossi. Soon returning to her normal state of consciousness, she disappears for the last time from the roda. All these performative dynamics address the transcendental

authority manifested by the orisas, and the communication between the divine entities takes precedence over human contrivance. Since this is a public celebration for Yemanja, the orisas incarnate to give homage to her and to acknowledge the axé of the terreiro.

Multiple performances for this particular terreiro are occurring simultaneously; while the devotees are dancing in the roda, the initiate who incarnates Yemanja stands knee-deep in the ocean, receiving the supplicants who seek advice and wish to be blessed. The supplicants, feeling that they are in the presence of the orisa, speak of the problematic matters in their lives in hopes of receiving divine succor. Since this is a caboclo house, male participation in the sphere of possession is quite common. With a greater number of men undergoing initiation, possession is no longer seen as a sole prerogative of women.[14] This terreiro is quite conspicuous compared to the other groups on the beach, as both the leader and the devotee who first incarnates Yemanja are male. When Yemanja appears in the body of this man, it is startling. Standing well above six feet, quite portly and dressed in her signature colors, a flowing light blue shirt and pants trimmed with darker blue, this *filho*, while lacking her grace and beauty, depicts through possession her tremendous power. As he dances around the circle, his arms and shoulders rotate to mimic the undulating waves. These are not the waves that gently lap on the shores but the rougher seas that tell of the coming storm. His body displays none of the femininity of Yemanja as he moves purposely in the roda. When he falls in the sand with his torso shuddering rapidly, he embodies the movement of the tempestuous ocean. As he rises, he lifts his right hand in the air in a clenched fist and spins and circles, with only the whites of his eyes showing.

Yemanja is associated with the circle, which, according to Daniel "radiates energy both inward and outward, inward around and among those of her faith and nation, but also outward to uninitiated members" (268). The *Filho dé Santo* who incarnates her is a white *Baiano*. Given his stature and his appearance, which so obviously contrast with the popular depictions of the orisa, one almost expects a moment of apostasy from the gathering crowd. Yet, tellingly, his transformation is unequivocally acknowledged as a line forms with supplicants waiting for a blessing and a word of advice from the Mãe da água. In the midst of his circling, he stops and bends to give a loving hug to those waiting. In that moment, the motherly essence of the orisa manifests. As the mother of all, she is also the guardian of the community, and as her energy radiates to encompass all around her she extends the meaning of community to encompass the Yoruba

cosmos, the invisible and visible world, Orun and Ayé respectively. Running to the ocean, he sets up a court in the water for the suppli- cants to speak directly to the god force. No one questions, and each waits her turn to step into the water and be touched and spoken to by Yemanja herself. These acts metaphorically recode the orisa journey from Orun to momentarily dwell in this plane of existence, Ayé, and the ocean becomes the liminal threshold, where divine essence and the human agent can meet. Omari (Tunkara) suggests that during possession the orisas journey from Africa to the space of incarnation and "bring with them the sacred force (*axé*) necessary to revitalize and sustain the religion" ("Candomblé" 149). The orisas, as figures of translocation, bring Africa to the immediate consciousness of the supplicants. This has profound implications, for it shows that Africa is indeed the generative source for this alternate source of power. While these spiritual manifestations reinforce and revitalize the belief sys- tem, it also dissembles and reconfigures the notion of power within society. In this "power play," transcendental authority overtakes any and all aspects of political authority as the spectators become ritual participants who readily give homage to the supreme Mãe and, in turn, receive her blessings. This homage is not just religious reverence but a show of allegiance, of profound faith that ultimate control is in the hands of the divine Other.

In the midst of the roda, the Pai attempts to control his state of possession. Demonstrating some of the classic indicators that trance is forthcoming, his shoulders shake convulsively as he bends forward to facilitate being mounted by his deity. Managing for a while to rein in the power of the orisa, he soon obeys the call and, as Schechner suggests, brings forth the "transcendent Other" by incarnating the spirit of Ogun (*Performance Theory* 142). Possession by an orisa which is not one's own is a rare occurrence in the Yoruba-based ceremonies.[15] In these incarnations, the body becomes a living text transcribed with emblems of identity, and the dress and ceremonial objects signal the arrival of particular orisas. Ogun then came to give homage to Yemanja and to salute her on her day. The Pai is given the emblems of Ogun and placed in an iron man-of-war hel- met reminiscent of the ancient knights who dressed in armor, with a red cape thrown over his shoulders. Holding swords in both hands, he dances energetically, brandishing the swords in conjunction with the rhythm of the music. Since Ogun is the orisa that presides over both war and metallurgy, his symbolic objects—the helmet and the swords—mesh these concepts. Ogun is not the only orisa to arrive at that moment. Ochossi soon follows along with a host of Yemanjas,[16]

who are dressed in the variegated colors of the ocean, from sea-foam green to deep blue.

Bringing the proceedings to a minor halt, while in the midst of possession, the Pai de Santo chants praises to Yemanja. The drumming and dancing temporarily cease as he touches his left hand to the sand, the sacred life-giving earth, to give homage to the Mãe da água. The left hand is considered the hand of the spirit, and its use signifies that the orisa is present. He then turns his attention to those who wait to greet the orisa. Acknowledging and blessing the devotees present, he alternatively uses his left hand or crosses a sword over the heads of the waiting supplicants. The head, or *ori*, the Yoruba believe, houses one's spiritual energy and is the center for cosmic communication. "Any ritual act involving the head," states Omari (Tunkara), "is believed to create a spiritual link and bond between the officiant and the recipient" ("Candomblé" 142). Since the orisas mount the initiates through the head, it is a sacred site. During initiation the head is shaved, herbs are rubbed into the skin, and drawings are made on the scalp to bring the orisa to the devotee. When one is called to be initiated, it is said that one's head is being marked. It is not accidental that the term *orisa* derives from the conjunction of the noun *ori* and the verb *sa*, to choose, and it signifies "to choose one's head" and "to choose one's destiny." When the orisa greets the younger children, he not only passes the sword over their heads, he spins them several times, first to the right and then to the left and again repeated. Metaphorically, he projects them to the four corners of the globe, the points of light, for them to receive all the blessings in the universe. Children are the most favored by the orisas, as they are the guardians of the future, and parents literally push their offspring forward to receive this benediction.

Adding to the polyphonic nature of the performances, Ochossi dances as Ogun showers his devotees with blessings. In between performing in the roda, Ochossi runs back and forth to the ocean to sing praises to Yemanja. Then he, too, sets up court at the oceanfront, and the supplicants gather one after the other to receive his blessings and ordinances of protection. At the same time, in the roda, multiple representations of Yemanja manifest through women dressed in differing shades of green, blue, and white, each encoding an aspect of the deity. One devotee, in particular, incapable of restraining the possession, shakes uncontrollably. Unable to stand or walk, she is carried to the ocean as she chants, "carry me, carry me, carry me to the sea."[17] Possession occurs, voluntarily and involuntarily, but through it, the

god-force offers alleviation and guidance in the midst of personal and socially generated maelstroms.

Another transitional point occurs in the ritual invocations when the Pai changes his garments. This fully self-reflexive gesture immediately shifts the nature of the ritual unfolding. It is now time to give the offerings directly to the Mãe da água. Dressing in a blue headdress and mantle, covered by a silver crown with a single star and flashy, gold beads, he resembles a Sheik from a B movie. This is an interesting juxtaposition of identities, as the headdress and crown are newly constituted emblems that resonate with the traditional depiction of the orisa as a queen or Ayaba. The gold beads and the Sheik-like ensemble could very well be indicative of the self-reflexivity of the Pai and his conscious acknowledgement that this, too, is a performance, and his theatric pauses emphasize that this, too, is a social drama. In its totality, he appears like a Magi bearing gifts to his god. We may never know what position the Pai holds outside of the terreiro, but these depictions are to ensure that the onlookers register his majesty. He is not the denigrated object subject to social whitening or a demeaned role in society but a representative of divine agency.

Members of the terreiro take their places and follow along as he leads them in a procession through the streets. As he parades, he stops periodically and poses with a dignified facial expression, implicitly stating that this is our day to show the divinity in ourselves. Carrying gifts of flowers and an elaborately decorated cake, the group continues singing and slowly dancing toward the Casa de Iemanjá to give their offerings. Supplicants come to ask Yemanja for the sweet things of life and, thus, they give to her offerings that resonate with those desires: perfume, cake, flowers, and fruit. And since she is the essence of maternity and femininity, these gifts are thought to appeal to her fundamental nature. Through these offerings, physical, emotional, cognitive, and spiritual knowledge conjoin. Devotees and supplicants commingle in a temporal and spatial demarcation to bring history and spirituality alive and change actuality. Social forces are not limited to just officially sanctioned policies and actions, but include the coming together of the socially disenfranchised to participate in an epistemological sphere that requires all the senses. As Andrew Apter (1991) points out, sacrifice is a reciprocal act—one gives to the orisa in exchange for the blessings to come (214–15). This rituval is indeed a sacrifice; the songs, dances, possession trances, and offerings become the vehicles through which to temporarily harness the orisa's power to revitalize ritual insiders and outsiders and to generate a communal sense of belonging.

By mid-afternoon the ambiance radically changes as the sacred gives way to the secular, but each aspect of the day is balanced by the sense of communitas. The streets and the beach surrounding the Casa overflow with the dense throng. The crowd, however, clearly demarcates the space between the sacred and the secular activities. The beach remains the sacred ground for prayer and sacrifice, and the street is the space for open entertainment and revelry. One group after another enters the sacred space to place their offerings on the boats ready to set sail for that optimal point in the ocean where Yemanja will accept her presents. Some, on concluding their sacrifices, reenter the party zone on the street. Others remain on the beach and become the spectator/participants in the ritual calls and responses conducted by the terreiros. Having returned to the beach, our Pai attracts an even larger portion of the spectators as he continues to invoke the otherworldly forces, while the members of the terreiro sing and dance their way into trance states.

Marking this passage from sacred to secular time, the *afoxé*, *Filhos de* Gandhy, enter the sacrosanct space and carry their offering directly to the sea, drumming and singing as the offering is slowly lapped over and covered by the waves. Once the Mãe da água accepts the homage, the mood changes. Desacralizing the ritual space, the Filhos are the first to begin drinking beer on the beach as they disperse, slowly blending into the surrounding crowd. They may be the only group who can make this transition without condemnation, for they are one of the first groups to form a resistance block against the vilification of Candomblé (Guerreiro 2000; Félix 1987). It is not long before the spectators on the beach drift away from the sacred invocations to the open festivities. By early evening, all offerings are concluded and the street, stretching for a kilometer on either side of the Casa de Iemanjá, appears like a mini-carnival. Members of different carnival blocos arrive to perform, practicing their drumming and dancing style. Revelers on the streets transit from one group to another, drinking and socializing deep into the night.

In the Middle of It All

In between the rituvals commence a series of *Lavagens* [washings][18] for Oxalá, but none is as popular as the original, the Lavagem do Bonfim. Occurring either on the second or third Thursday in the month of January, this is the largest public celebration dedicated to the veneration of an orisa.[19] It takes place in January, as it is meant to juxtapose the identities of Bonfim with that of Oxalá. The rituval

attains epic proportions, as it involves an eight-kilometer procession from the *Igreja da Nossa Senhora da Conçeicão*[20] in the commercial center of the lower city to the *Igreja do Bonfim*. Baianas dressed in white carry vases filled with holy water, perfume, and flowers to the church steps to perform the ceremony. The Lavagem was first conducted inside the church, but the priests saw this physical act of veneration as part of the paganism of African religion. They therefore closed the church doors to the Baianas. It was not until the governor signed a decree on January 15, 1976, the date set for the Lavagem, that an accord was reached between the state, the church, and the religious adherents.

Even more evocative is the fact that the governor chose the site of Bonfim to grant freedom of religious expression to the Candomblé community (Silverstein 140).[21] The Lavagem can thus be seen as the ultimate engagement between Africanness/blackness, transcendental power, and the political, institutional power found in Salvador. Even before the decree, undaunted by the church's rejection, the women subverted the intent of the ban and proceeded to wash the steps of the church. This ritual, with its beginnings in a public act of dispossession, has become the ultimate symbol of resistance and a marker for these alternate constructions of power. Lending a note of irony to these proceedings, the crowd that participates in the Lavagem far exceeds those involved in the ceremonial Mass.

Undertaking the trek and accompanied by the drumming and dancing of their cohorts, supporters line the streets, waiting to cheer on the Baianas as they complete the ritual journey. Becoming a mini-carnival, as blocos and various cultural groups use the festival as the time to show their solidarity and unity, the Lavagem brings together all the different sectors of society under this African-based matrix. Adding to the level of entertainment, the blocos and afoxés consider this ritual the penultimate practice session before carnival and amplify their performances to mimic as closely as possible its conditions. Participants arrive from all around the state and other parts of Brazil. Due to this, the Lavagem becomes more than just a local phenomenon; it becomes an event that allows all Brazilians to claim the celebrations as an essential component in their identity.

Patterned along lines that invoke the xiré, a striking fluidity exists in the course of events. While the order is set for the time of day that each group begins the procession, the space in which they are performing, the open street, becomes a zone for the unexpected. Individuals, of course, have their favorite groups, with whom they process. Overwhelmingly, the *bloco afro, Ilê Aiyé*

receives the lion share of participants. From early in the morning, the throng congregates at the Igreja da Nossa Senhora da Conçeicão. The Baianas leaving the Mass pose in front of the church for the myriad of spectators and the overwhelming photo ops. Beginning in a seemingly impromptu manner, the procession forms and the journey begins. Wearing variegated shades of white, they recreate the pilgrimage begun by their ancestors. Performing an *ebó*, a ritual offering to the orisas, the Baianas walk the eight-kilometer journey in camaraderie, knowing that they are fulfilling their sacred duty. With the route lined with well-wishers and enthusiasts also dressed in white, they receive homage and encouragement for the deed to be done. For this ritual is more than just the washing of the steps of the church; symbolically, it is a cleansing of the soul of the city. It is an expurgation of evil intents and deeds. Oxalá is the force that exudes righteousness and virtue. In the reflection of his purity, symbolized by the fact that he and his adherents always wear white, adversity, negativity, or evil cannot exist. Giving homage to his wisdom, his patience, and his tranquility, this journey recreates the mythical journey that he made to the kingdom of Shango.

According to Yoruba myth, one day Oxalá set off to visit Shango in order to reconcile with his truculent wife, Nana.[22] Desiring an end to the marriage, Nana went to live in Shango's household. Before he embarks on this journey, however, Orunmila, the orisa of divination, warns Oxalá that he will face many dangers during the voyage. But Oxalá insists on traveling, as this is the only way he sees that he can reconcile with Nana. Orunmila then cautions him to accept his fate and any indignities suffered during the course of this voyage without becoming angry. On the way, Oxalá meets Eshu and, as is Eshu's nature, he tricks Oxalá and soils his garments. Known as the "King of the White Cloth,"[23] Oxalá's purity and charity are reflected by the clothing he wears. Returning home and beginning his journey again, Oxalá is once more ambushed and tricked by Eshu. By the end of a third exchange, Oxalá decides to continue on wearing the soiled garments. Unrecognizable in this corrupted state, Oxalá is mistaken for a horse thief and imprisoned in Shango's kingdom. Rather than becoming angry, he calmly protests his innocence and simply waits as instructed by Orunmila. The wait continues for seven years, and as Oxalá languishes in the dungeons, Shango's kingdom suffers through its worst tribulations. Only through divination does Shango learn that the troubles result from an unjust imprisonment. Finding Oxalá locked away, he can only beg for forgiveness.

The Lavagem, as it recreates this mythic journey, illustrates a compelling metaphor of renewal and restoration. The journey to the Igreja do Bonfim parallels Oxala's journey, and the ritual washing of the steps reenacts his restoration to an original state of transcendent purity. Shango, after discovering Oxalá in this defiled, degraded condition, arranges for him to be cleansed and to receive the highest honors. Through this redeification, Oxalá transits from his debased state to a place of grace. Renewed and reinvigorated, his transformation is represented through the washing of the church. However, now the crucial difference seen in this ceremony is that the Lavagem symbolizes the renewal of the city and its corpus of identity. Yoruba mythos conjoining with popular sentiment gives rise to this ritual homage. On that day, Oxala's purity of intent, willingness to forgive unconditionally, and transcendence of negativity envelopes the city-space, and for eight kilometers at least, the spirit of communitas holds sway as disparate groups come together to celebrate. We must also remember that the Lavagem stands as a symbolic victory over state-sanctioned discourse. Its date is an unequivocal reminder that Candomblé became an officially recognized practice in the purview of the city, allowing for the unfettered encounters found in all these festas.

A highlight of the Lavagem is the arrival of Filhos de Gandhy. Consecrated to Oxalá, the afoxé likens the aspects of Gandhi to the purity and peacefulness of Oxalá. As during the festa da Iemanjá, the casual attire of the group speaks to this blend of sacred and secular. Dressed simply in a white T-shirt, white pants, a white cotton turban with a blue pin, and blue and white plastic beads, members also add the sacred beads of their personal orisa. Embossed in bright blue letters on the shirts is the name of the group, and alongside is placed an image of their leader, who favors Gandhi. Horns trumpet to announce their arrival on the avenue. The group files through the lower city, separated by a human cordon. Younger members link arms around the procession, forming a chain that prevents celebrants from entering their staging ground. In the middle of the procession, like a king on a palanquin, a young man sitting on a stuffed camel is carried above the heads of the onlookers. The camel is a symbol of Africa, but a mediatized depiction, as the Filhos admit that they use it and the image of the elephant because they were prevalent tropes in films from the 1940s, the period of the group's inception. The musicians playing drums, *batuques*, and *shekeres* parade next to a small van loaded with a sound system and speakers. The Filhos are in the mood for fun, and in the midst of singing sacred songs to Oxalá, they stop to tease the women, take photographs, and drink beer.

Participants in the Lavagem arrive from all over: horsemen from the interior, indigenous groups in horse-drawn carts, and other partakers dressed in elaborate costumes. For the revelers on the streets, the casual attire of white shorts and tank tops prevails. By the time the procession of Baianas completes half the journey, the partying is in full swing and the spirit of carnival prevails. Yet it is not until Ilê Aiyé arrives that the magnitude of the celebration is seen. The music from the bloco can be heard down the length of the Avenue. Arriving on a small *trio elétrico*, a bus with an elevated platform, the singers stand above the crowd while the band follows behind with a full contingent of drums. Accompanied by its usual fans and the many others who are waiting for the opportunity to let go of all inhibition, the group plays its standards as the crowd becomes more frenzied. Jam-packed, as everyone is crammed together, the procession slowly makes its way along the eight-kilometer journey.

By this time, at the church, the washing commences; the perfumed water, evoking the sweetness of life, is thrown on the steps and the Baianas are giving homage to the orisa that guards the city and guides them in their daily struggles. In the past, the Baianas went in and out of spiritual possession, but during my last observation of the ritual, it was obviously a state-sanctioned political event. Andrew Apter speaks of the manner in which orisa ritual traditions are used to validate and sanction state power in Yorubaland (216–20). It appears that a similar movement is occurring in Bahia, for local politicians must acknowledge the Mães' importance in the matrix of the city. Much like the major orisa ceremonies in present-day Nigeria, the use of the lavagem for a political rally is obvious. It is especially important in these processes of affirmation because of the history of this ceremony, as it signals the movement from abrogation to acceptance of Candomblé. Less obvious is the fact that this ceremony attracts people locally, nationally, and from abroad; no matter what one's racial, ethnic, religious, or cultural affiliation, the lavagem has become part of the discourse of identity of the state.

In her study of the ways in which spirituality serves an ideological function in the narratology of black women, Judylyn Ryan suggests that the quest for the spiritual dynamic form is defined through the paradigm of growth and its decoding in a democracy of narrative participation. The paradigm of growth allows for "an internally defined point of departure" that establishes interdependent relationships and redefines privilege and power, where power is seen as both coercive and oppressive, creative and righteous agency (17–18). By foregrounding that internally defined vision through a fully participatory

narrative, it allows for a fullness of expressivity in the realm of representation, whereby marginalized black women are allowed to reveal their unlimited human agency. When we transfer this paradigm to the practice of Candomblé, the internally defined vision based on an African hermeneutic and epistemological base compels both the ritual insider and the outsider to redefine human agency. It extends the transformative potentiality of ritual through the power of the orisas to change the order of things within the social universe. The ritual insiders who carry the orisas increase their agency within the ritual realm; the onlookers, too, can increase their own actual and interpretative potentiality. The politicization of the rituval is not an overshadowing or a limiting of Afro-Brazilian agency or merely opportunistic on the part of the government; instead it becomes the signifier of Afro-Brazilians desire, the dream of inclusion in a national dialogue that affirms their heritage and culture and acknowledges its equal contribution to society. If we see it as such, then Candomblé devotees have indeed changed society, but only for specific days, for they still remain the negated Other outside the ritual sphere.

Throughout the day, the sense of communitas vibrates between the sacredness of the ceremony and the sense of play and enjoyment found among the revelers. Needless to say, most of the participants/spectators never reach the Igreja. They find a comfortable space, a place to eat *feijoada*, dance samba, drink beer, and talk with friends, and for them that is where the Lavagem ends. Yet in the cleansing of the steps, the Baianas revitalize and renew the life force in the city, its axé, and this energy is seen in the total abandon and sense of celebration of the people during the course of the day.

Òparí: The State of Things

In these moments of celebration, the African/black presence reigns and is made hypervisible in a city, which simultaneously affirms and negates that presence. Positionality in the social and political corpus shifts in tandem with the exaltation generated from the communal celebrations. These rituvals allow for these periods in which the epidermalized self, the body and being that speaks of and signifies the consanguineous and affiliative links to Africa, to openly display its position as the generative source of cultural identity. The black world is symbolically received in public space, in contrast to its usual position as a hidden, often-shunned, or co-opted corpus.

Baianas, who are the focus of the rituvals and the continuous, regenerative link to the spiritual sources that represent Africa, become

venerated beings. The Mães and Pais dos Santos, who inhabit the ritual processes, perform with intent to make evident that spiritual authority. They invoke and valorize African cultural forms and symbols and, by extension, themselves. They are the center of attention, action, and agency as seen by their carriage, posture, dress, and being. Transformations between the roles of the spectator/participant seen during the processual and possession rituvals then attest to the ascendancy of the spiritual forces and they themselves as communicants with divine authority. Symbols from color of dress to beads and ritual objects such as the sword of Ogun, the mirror of Yemanja, and the horsetail of Iansã are then incorporated into the corpus of life and into the corpus of the city as well as being used as emblems of the Africanness and the blackness of Brazil.

To think of these rituvals simply as acts that affirm Africanness and blackness, however, is to deny the complexity of the relations that exists between the peoples in mediation with the political entities. A universal acknowledgement of the power evoked through rituals takes place. The place and position of the Mães and Pais in society is symbolically "outed," magnifying their transcendental authority. Seen as intercessors between good and evil, their ability to evoke the supernatural is never questioned. What occurs during these public displays is an enlarged opening into the sacred space. The terreiro space is seen unequivocally as the space in which the power of blackness operates. Even with the multitude of whites participating in the religion, the hermeneutic elements of this sacred knowledge ultimately remain in the hands of older women who are of undeniable African descent. As the custodians of the shrines and keepers of the secrets within, the unknowledgeable who come to seek advice must give homage to these women and adhere to their counsel. These public rituals allow for an *outdooring*,[24] the public display of that power. Most often the Mães do not seek interaction with the political body, and accordingly, they do not overtly attempt to change the sphere of political authority. In fact, they often give counsel to key political personages, validating Rita Segato's (1998) argument that the process of conversion to Afro-based religious practices allows for the inversion of social and political roles that will ultimately change the dynamics found in the public sphere. Since possession rituals never directly challenge domination, they present symbolic oblique or opaque referentials that stand in direct opposition to hegemonic practices. The implication is that once an individual acknowledges and feels the power of the orisas, then s/he will acquiesce to the dictates of transcendental will for the correct pattern of life to unfold.

It is in the opening of these sacred spaces that new forms of cultural belonging incubate and that we see Afro-Brazilians create an alternate institutional order that dispels the daily traumas of life in Brazil. Hence the outing of the terreiro space should not just be read as part of or definitive of a resistance paradigm to the doctrines of embranquecimento and racial democracy, but rather as a way to supplant these doctrines. Candomblé initiates work for the community and the society, and the efficacy of this work manifests in the transformative impact beyond the ritual ground. The discourse of power shifts in the Foucauldian order to the multidirectional narrative that the orisas represent. Power thus becomes creative and righteous agency, as suggested by the first epigram, because it is an intangible force that affects all that it encompasses; it is no longer unidimensional, symptomatic of the powerful/powerless dyad, but flowing outward, touching and transforming all who are open to it, just like the axé of the orisas as possession passes from one person to the next.

Power, then, is in the hands of those with transcendental authority, not just those in the political realm. In light of this, the representational arch of the rituvals, which is made visible through the public processions, gifts presented to the orisas, prayers and public supplications, possession trances, singing, dancing, and elaborate costuming, evokes compelling responses. These specific forms, found in Candomblé, do indeed affirm that African heritage, but more so, as noted by Fine and Spear, they create cultural identities through the body of representations, and the rituals are a source of revisionary constructs for society. The Lavagem do Bonfim is the ultimate signifier, for it also celebrates the victory of this transcendental authority over the state-sanctioned authority. These celebrations profoundly affect the dispossessed individual in offering a glimpse at the future possibilities of society, the longed-for way of life in which one's Africanness/blackness is not subject to and manipulated by external social and political hierarchies. In this politicization of culture, those struggling for equal voice and choice for Afro-Brazilians enter the debate and use the agentative focus of such ritual encounters as a source from which to construct a society in which blackness is not only acknowledged on special days.

Chapter 3

From Candomblé to Carnaval: Secularizing Africa and Visualizing Blackness

*What explains the style of Brazilian Carnaval is the necessity of invent-
ing a celebration where things that need to be forgotten can be forgotten
if the celebration is to be experienced as a social utopia. Just as a wild
dream makes reality even more vehement, Carnaval can only be under-
stood when we take into account what it needs to hide in order to be a
celebration of pleasure, sexuality, and laughter.*

Da Matta, *Carnival, Rogues and Heroes*

*He wanted everybody to see him. When they saw him, they had to be blind
not to see.*

Aldrick in *The Dragon Can't Dance*

Like the rituals found in Candomblé, carnival is known for its
transformative effect on the body and the psyche. Individuals play,
create transgressive identities, and reposition themselves in hierarchi-
cal social arrangements. Dichotomies such as self and Other cease
to represent binary opposites, given that they often coexist during
rites of spirit possession, masking, or the simple act of dressing up
or down. In this complex play of identities, the following must be
asked: At what point do these dynamics cease being play and become
transformative political discourse? Thus I turn to the epigraphs above
to conceive and construct the diversity of experience and formulation
found in carnival. For Da Matta, who studies carnival in Rio, its luxu-
riousness hides the poverty and social misery that mars the Brazilian
sociopolitical body. For Aldrick, the synecdochical body that only
becomes animated through his role as the Dragon Masker during car-
nival in Trinidad, it is the time when the dispossessed can be seen and,

by extension, heard. While in Da Matta's formulation carnival hides sociopolitical realities, for Aldrick, carnival reveals them. Political engagement, we can infer, appears in the interplay between what is hidden and what is seen. This chapter examines *carnaval*[1] as a rhizomatic location in the Afro-Brazilian insertion of their Africannness and blackness. Primarily focusing on the bloco afro Ilê Aiyê as a locus and generative source of the Africa/black ideations, their aesthetic and political involutions are juxtaposed against the hybridic formulation of their rival bloco in the city of Salvador, Olodum.[2]

Theorizing Carnaval

Carnaval in Bahia is the culmination of the festas populares. Its end signals the time for rest, the rainy season, and planning for a new year. Carnival is traditionally viewed as the time of total freedom and debauchery before the hyperreligious activities of Lent, and this still remains the case. Yet in its present-day incarnation, Lent is the deemphasized telos to carnival's ethos. To say that the average Brazilian lives for carnival is not an exaggeration. Viewed as a national ritual by Bettelheim (1994) and Da Matta (1991), performances during this all-pervading event are seen as displays of "national solidarity and social cohesion" (Bettelheim, "Ethnicity" 180). Undoubtedly, Bettelheim's focus on carnival in Cuba and Da Matta's in Rio influence their interpretations. The Bahian carnaval, however, is a different type of celebration compared to the national spectacles found in Havana and Rio.[3] Lacking their famed scantily clad bodies, elaborate plumage, and stylized choreography, its regionalism stands as a counterpoint to the totalizing narratives of identity constructed from these national festivals. This is not to dismiss its dynamism as a cultural form but to foreground the differences between these national celebrations as pure spectacle and the regional celebrations as participatory, evocative events shaped by both local and national antinomies.

Carnaval, as explored in this chapter, becomes the dramatic arena in which Ilê Aiyê's and Olodum's conceptual and representational choices emphasize their political articulation. How did they begin? How do they differ? And what do they signify in the Afro-Brazilian sphere of reinvention and authorizing of individual and collective identity? These become the investigative questions. Multiple theoretical models engage with carnival as a political event (Green and Scher 2007; Patton 1995; Averill 1994; Stam 1988; Manning 1983). Robert Stam most immediately addresses the Brazilian carnaval and debunks the pleasure-scape model to suggest a multivalent approach

shaped by disparate, asymmetrical power relations and ideological constructions. Carnival diversity replicates the real world in its gendering, racial and sexual demarcations, and its modes of representation address underlying provocations and motivations (Stam, "Carnival" 257). Gage Averill's categories of *anraje* and *angaje* are most useful in addressing carnival's open and hidden agendas. Anraje is the charged, heightened emotional state reflective of the shared celebratory nature of these events; angaje speaks to its political engagement (Averill 218). Studying Haitian carnival, Averill suggests that its unbridled and chaotic actions generate communal fervor and defy authoritarian control, swelling with the potential for rebellion. Carnival is co-opted by the state and the elites to prevent open revolutionary acts, he upholds, and transformed into social and class conflict (219). Ilê Aiyê's and Olodum's ideations and representations are thus examined beyond their visibilities in order to address the underlying provocations and motivations, in relation to the limitations of hybridization and the self-determining processes involved in attempts at the closure of an identity. Such articulations allow for an understanding as to why Afro-Brazilians opt out of open frameworks of identity formation that are purportedly more freeing and fair and, instead, articulate narrower forms of belonging.

Abertura democracia = Abertura racial?

The *abertura democracia* marked a shift away from the superrepressive policies of the military dictatorship (1964–1985), whose propaganda bolstered the unidimensional conception of Brasilidade and prohibited the signs and discourse of racial discord. It was illegal to speak about racism or to suggest that any actions were racist, whether they were seen within institutional programs or in patterns of individual behavior, because it denoted a challenge to hegemonic ideology. Torture and censorship were used to contain ideological sedition or subordination, and the police became the center of castigatory repercussions in their mutation into paramilitary units used to control mainly the poor population (Verucci 551). Rising opposition formed around cultural dissent, and both internal and external forces conjoined in the consciousness of Afro-Brazilians to influence and generate alternate paradigms from which to construct their own significations. However, artists and activists remained relatively isolated from the masses because of the punishment regimen of the dictatorship (Dunn, "Tropicália" 76).

Even with the fear of reprisal, musicians and artists of the Tropicalist[4] movement indirectly challenged the political body by

intertwining the discourses of arts and politics. Disrupting the binaries of "high" and "low" culture, through their experimental and iconoclastic modes of artistic representations, the Tropicalists vivified Bakhtin's (1984) concept of the grotesque as an aesthetic, albeit temporary, equalizer by enacting countermodels that interfered with the national discourse of identity (Perrone 2000; Dunn 2000). As an aesthetic dislocation native to Brazil, performances became mediatized spectacles that explored new visual and gestural forms, from its main progenitor, Caetano Veloso, donning "mod" plastic outfits, to Gilberto Gil wearing African attire (Perrone, *Topos* 13). Song lyrics recontextualized the contributions of African and indigenous groups, initiating discourses that acknowledged the country's plurality (ibid. 8). Yet *tropicalismo*'s overlap as a cultural and political movement resulted in the exile of Veloso and Gil in 1968.

Gil is credited with introducing the discourse on blackness into the national aesthetic awareness, as his musical style reflects his profound engagement with Afro-Brazilian spiritual culture (Dunn 2000; Sparks 1992). His exploration of his négritude (Sparks 70)[5] did indeed spark a component of Afro-Brazilian conscientization,[6] but it was the United States–based Black Power movement of the 1970s that generated an image that corresponded with the desire to express an aesthetic and political difference. Négritude in Brazil differs from the Césairian and Senghorian archetypes, for it is simply an acceptance of being black. However, it becomes a radical intervention in the psychosocial sublimation of the discourses of embranquecimento and democracia racial; it shifts the agonistic internalized racism conferred by a society that objectifies and devalues the black being simply because of skin color to an interrogation of black subjectivity in white dominated spaces and a celebration of the cultural fabric of the lives of African-descended peoples. Afro-Brazilian interpretations of négritude become empowering acts that allow the black voice to reformulate its place and position in the discourses of power and to connect to the larger African and diasporic worlds. Hence it intertwines with Black Power ideology through the creation of the blocos afros, most specifically Ilê Aiyê in 1974 and the *Movimento Negro Unificado* in 1978 (MNU 9–12). What unfolds is a complex intertwining of the culture and politics of blackness coming through the soul and funk music in the black bailes of the 1970s, with its adages of black power, or *bleque pau*, that demanded an aesthetic that both confronted the national agenda and spoke to black self-reflexivity (see Chapter 6). When combined with Candomblé-derived matrix ideologies, it generates the next stages within Afro-Brazilian identity formation.

"Que Bloco é Esse?" [7]

Founded by a small group of men from the section of Liberdade in Salvador known as Curuzu, Ilê Aiyê inserted the black presence into the grand festival that is carnaval. Demonstrating the manner in which Afro-Brazilians assimilated global black culture and politics, Osmundo de Araújo Pinho argues, Ilê's influences came directly from the bleque pau movement and the independence movements in Portuguese-speaking Africa (200). Locally, Ilê's body of representations addressed the discriminatory policies found in the carnaval blocos; on the national stage, it expressed the political aspirations of the black vanguard fighting for equality in the nation. Beginning as a counterdiscursive movement, Ilê combined both a political and an aesthetic imperative in promulgating blackness to purposefully alter the sphere of African culture and the black being (Guerreiro 89). Appearing, at first, as only a topical refashioning, because they celebrated black skin, used African-styled clothing, and wore natural hairstyles signifying black power (Guerreiro 196), Ilê's aesthetic intervention becomes the revisioned ideal imago of blackness.

White-dominated carnaval groups either openly denied access to Afro-Brazilians or, through more subtle means, instituted prohibitory entrance fees. In the 1960s this led Afro-Brazilians to form and join *blocos de índios* [Indian groups] to participate in carnaval. Using the trope of the índio, Luiza Benicio (1998) attests, was a double-voiced strategy to press for political change (17–19). In the hybrid constructs of identity, being Indian mediated between the aporia of a black identity and its palatability to Brazilian sensibilities. A link could be made with caboclo incarnations in Candomblé, the Indian spiritual guides, who were commonly accepted as symbols of religious syncretism. "Just as Afro-Brazilians turn to the *Caboclo* for protection," Benicio states, "the use of the *Índio* image provided a shield for carnival participants" (17). It is difficult, however, to see the protectionism or a project of social reformation through the actions of these groups, since their imagery was based on films about the American West. Naming themselves Apaches, Sioux, and Comanches,[8] the blocos duplicated the violent, disruptive characterization found in these films, and because they were seen as unruly troublemakers, the police often beat their members. If indeed these groups had a political agenda, it was never expressed through concrete discursive strategies, and only speculatively through their potentiality for insurgency. Such antiblack violence and repression dialectically produced Ilê Aiyê as a site of resistance to insert a hypervisible black presence in carnaval.

In its oppositional thrust, Ilê at first denied entry to light-skinned blacks, and *Negro azvechie* [the blackest black] became the sought after aesthetic. Parading for the first time in the 1975 carnaval, with one hundred Negro azvechie participants (Félix, *Bahia* 224), dressed in African-styled garb in the colors of red, black, yellow, and white, the group directly engaged the discourse of embranquecimento, visually and lyrically. "*Que Bloco é Esse?*," the song that became their first popular hit, underscored their message of black empowerment. For Paul Gilroy (1993), music articulates the lived world; it is a site from which blacks assert and develop alternate constructs of self. Using music, and specifically song lyrics, as discursive tools, Ilê Aiyê involves itself in the purposeful remolding of hierarchical relations. Divesting the contra-black discourse of its authority, the song declares "É o mundo negro" [It's a black world], attacking the base of Brazilian identity. It de-objectifies embodied blackness by inverting insults from common phraseology, such as *crioulos doidos* [crazy niggers] and *cabelo duro* [nappy hair], and reconfiguring them as signifiers of black power and traits to be extolled. Further affronts are found with references to "banho de piche" [bath of tar], a deprecatory remark used to explain blackness of skin color, and "malandragem" [evildoer], the standard script describing the character of the black being. This song, in particular, charges Afro-Brazilians to transform internalized racism and sends a directive to Brazilian society that a change must come.

Onde fica a África???

Ilê Aiyê signifies "house of the world" in Yoruba. Antonio Carlos dos Santos (Vovô), its leader, has stated that they wished to use a term that evoked black power, but ironically, the police suggested that they name themselves less provocatively. In the era of the military dictatorship, any perceived rebellion was a cause for repression, and the group was under constant surveillance and scourged as communists. Within this hegemonic structure, Africanness/blackness as paradigms with which to articulate protest was out of the realm of comprehension, and the oppositional thrust of the group had to be constructed in terms that were readily identifiable as a threatening political ideology. The anthropologist Antonio Risério (1981) was the first Brazilian scholar to describe Ilê's carnaval presentations as a symbol of "re-africanization" (20). Deprecatorily, outside scholars such as Daniel Crowley (1984) characterize them as forms of naive, pathetic Pan-Africanism (24–30). Even though Ilê's message was indeed naive, because they first relied on picturesque images of Africa, only it and

later Olodum, dared to engage with Africa as a political positioning. Because of limited access to knowledge about the continent, Ilê's transformative discourse manifests in its exploration of the known Africa, found in Candomblé. Bakhtin (1981) causes us to consider the representational choices made in any discourse analysis, and in choosing to use the symbology found in Candomblé, Ilê reformulates a metaphorically coded relationship between Africa and Afro-Brazilians as sociopolitical fact.

Researching a particular country and its historical arrangements, Ilê relates vital information through its song texts and its visual markers, transforming them into recognizable emblems from the matrix of religion in order to make familiar an otherwise unknown sociocultural context. Tangential connections are restructured as psychic, spiritual bonds by using the corpus of representational objects in its own cultural repertoire. Instead of a tangible, actual identification with the African continent, the group promotes a revitalized ancestral knowledge to shape its resistant ideology. For example, in 2007 Ilê's theme was *Abidjan-Abuja-Harare-Dakar*, and its educational pamphlets provided statistical information on resources, centers of production, and infrastructural development, along with the governmental structure of the nation. Contrastingly, embossed in the *fantasias* were the iconographic markers of Candomblé, such as the cowrie shells used for divination, along with visuals of skylines from each city to evoke their development. By refocusing black subjectivity and relational sphere outside the space of Brazil, Ilê generates a landscape of unity and switches the discourse regarding Africa's so-called primitivity to address its spaces of globalized development. Implicitly criticizing the dominant ideologies that deemed Africa and black peoples unworthy of inclusion in all institutional spheres, the significance of such reorientation travels beyond the constituency of Salvador to challenge the pigmentocracy of the nation's structure.

In the succeeding years, Ilê and other blocos afros paraded in carnaval, giving homage to specific African countries. Considering the body of representations of Africa and African peoples used by Ilê as reflective of the real or an "authentic" Africa is to misconstrue the intent. Its representations rather orchestrate a discourse in relation to the theme of Africa, in a manner similar to that suggested by Mudimbe. But the crucial difference is that Ilê's performativity encodes and embodies new social dynamics that produced the discourse and its opposing narratives. Although the primary points of contact between Bahia and Africa continue to be mystical, the reimaginings of the African world launched more sustained intellectual

inquiry. Academics who joined Ilê's educational programs began to offset the allusive, hermeneutical knowledge derived from Candomblé with factual data about lived African experiences[9] and highlighted significant events in Afro-Brazilian history with themes such as *Terra do Quilombo* (2000) and *Pernambuco, Uma Nacão Africana* (2010).

Olodum in the Mix

One of the most polemic carnavals occurred, however, because of the theme of the competing bloco, Olodum, who in 1987 paraded using images from Egyptian mythology. Founded in 1979 by dissatisfied members of Ilê Aiyê in conjunction with MNU officiants, Olodum drew from a multiracial, transgressive population composed of prostitutes, drug dealers, and homosexuals living in the area of Maciel-Pelourinho (Pelourinho). Ari Lima suggests that while Ilê Aiyê and "Curuzu represent Afro-Bahian tradition, . . . Maciel-Pelourinho suggests a new, media-driven ethnic identity" (223). Pelourinho was considered the underbelly of the city, and the rise of Olodum coincided with the area's gentrification. Its becoming the entertainment center indisputably shifted focus to the group, boosting its popularity locally and internationally. Those looking for "authentic" Afro-Brazilian music no longer had to go into dangerous *bairros*[10] at night. They could stay in the midst of sanctioned revelry and still interact with blackness.

Faraó, the theme for the 1987 carnaval, astounded the populace: for the first time, Brazilians were exposed to the knowledge that Ancient Egypt had indeed been a black civilization. The premier song, "*Faraó Divinidade do Egito*," by Luciano Gomes dos Santos, became one of the most popular triumphs of the group. Predicated on Egyptian mythology and the research of Cheikh Anta Diop, it taught that Egypt, too, was an African country that attained the height of civilization in the ancient world (Perrone, "Axé" 47). Brazilians, like people in many societies, found it difficult to accept Egypt's black presence or even to consider it a nation in Africa. Yet, among Afro-Brazilians, the mythological figures of Osiris, Isis, Horus, and Seth resonated with the anthropomorphic depictions of the orisas. Recasting the myth of creation outside both the biblical context and Yoruba mythos gave credence to this redemptory history. Evocatively, by calling on the pharaohs Tutankhamen and Akhenaton, the song points to alternative paradigms of black masculinity to divest the dominant stereotypes of their value. The majestic figures, such as Tutankhamen, who symbolizes the wealth of ancient Egypt, and

Akhenaton, who represents the visionary capacity of the society, resonated in the psyche of the disenfranchised.

As Ilê Aiyê does, Olodum depicts itself as spearheading a project geared toward black psychological empowerment, and revitalizing and representing ancient ties to Africa is the means by which to generate a shared ethos. Understanding that Egypt is a source and font of black culture, therefore, begins the process of conscientization for those Brazilians who dismiss the contributions of African peoples to the world. Such cultural identification, however, had to be concretely linked to the Afro-Brazilian conceptualization of blackness. Egypt, through the song *Faraó*, allegorically shifts the signifier, "black," to a historical modality grounded in Africa and transforms it into a political intervention in Brazil's socio-scape. The song lyrics offer an alternate aesthetic model best expressed through its symbolic reversals, such as replacing "cabelos trançados" [braided hair] with the "turbantes de Tutancâmon" [turbans of Tut]. And by linking Pelourinho, one of the poorest areas in Salvador, with the glory of Egypt, it challenges the sense of despair and hopelessness often felt by the dispossessed. The song ends with a political call to the populace to "awake Egyptian culture in Brazil," to revisit this period of ascendance in history, and to envision its past greatness as a model for a willed future.

Olodum derives a different type of cultural legitimacy compared to that of Ilê Aiyê because of its divergent strategies. Even though Olodum is the shortened version of Olodumare, God in Yoruba lore, the group does not mimetically reproduce the precepts of Candomblé. Much as their songs typically affirm an African identity and a personal sense of negritude, recount histories of oppression, reveal social injustices, or denounce the racial dynamics found in the nation, Olodum presents a globalized, hybridized model for racial integration in Brazil. International links are constantly sought and affirmed through themes as diverse as ending apartheid in South Africa, praising the reggae legend Bob Marley, or giving a historical account of African countries such as the island-state of Madagascar (Perrone, "Axé" 46). More recently, Olodum's focus shifted to Brazil, bringing to life its own historical struggles. Its unique musical style, samba reggae, a syncretic musical idiom derived from reggae rhythms and samba, further expresses its hybridity. Dance forms mix African dance postures with hip-hop choreography. Visually, its signature iconography conflates the peace symbol with colors that symbolize African revolution: red, black, gold, and green. The popular song "Rally Around the Flag," by the reggae group Steel Pulse, codifies

this color symbolism through a mnemonic chant that tells us that red is for the blood, black is for the people, gold is for the wealth that was stolen, and green is for the land: Africa. Olodum's widespread popularity can unquestionably be attributed to its global melding of musical idioms, its fame in playing with artists like Paul Simon and Michael Jackson, its use of iconographic texts, and its revisionary thematic concepts. Yet in the local environ Olodum is perceived very differently.

The House of the World – Ilê in the Past

Carnaval for Ilê Aiyê actually begins during the month of October, with the official opening of the *ensaios* in Curuzu, a major event in the local scene. Leaders from other blocos, members of the MNU, the black intelligentsia, and thousands of others congregated to mark the official opening of the group. The headquarters of Ilê are located on a narrow street in the midst of Liberdade. In the past, during the opening event and in subsequent ensaios, the street was completely filled with admirers and spectators. On the opening night, in particular, there was a definite sense that something important was occurring and that this night was like no other. The feelings of expectation and excitement engendered a sense of anraje, foreshadowing the communal bonding that takes place during carnaval. For the ensaios, a stage was constructed to block the street, leaving only narrow pathways for the singers, dancers, and the chosen few to pass. The street was effectively limited to the inner circle and the rest of the crowd. The drummers helped shape that line of demarcation, as they stood in front of the stage, but behind a cordoned space, facing the public. The back of the stage led to the other end of the open street, but in the hours during the ensaios, it was the place in which the local intelligentsia milled with Ilê's members. The borders were fluid, and anyone and everyone could traverse between this semiprivate space and the public arena where the crowd was gathered. But few did.

The first ensaio of the season (2001) was remarkable due to the sheer number of people who came to see Ilê Aiyê begin its season. Since this had become a local tradition, only the most talented and experienced drummers performed that night, and the dancers gave special performances to the throng. The ensaios are practice sessions, and one occurred each Saturday night until the arrival of carnaval. It was a time to train new drummers, to teach the different rhythms of the songs for proper coordination, and to get them acclimatized to the long, intense playing sessions for carnaval. The number of

spectators varied each week. Free of charge, the ensaios took place on the streets and were always well attended by the locals, especially since they lacked funds and access to other forms of entertainment. Reconfigured as private space, a separate staging area only for Ilê Aiyê and its devotees, the street became an enclave in which to carouse. Vendors dotted the area selling alcohol, mixed drinks, and snacks. Every Saturday night until carnaval, one was guaranteed a free party in Curuzu.

Ilê still has two determining events that shape performative signi-fiers in carnaval: the *concurso* to choose the song for carnaval and *A Noite da Beleza Negra* to choose the Queen. Borrowing John H. Patton's categories, the performance dynamics can be seen as "socio-political event" and "communication event," enhancing Ilê's aesthetic corpus and providing charged moments for communal reflexivity (70). Through the ensuing competitions, Ilê's supporters consider themselves part of the selection process, for it is implied that the judges' choices are shaped by popular response. During the concurso, songwriters and poets compete for the title of *"campeão"* [champion]. Over a four- to five-week period in January and February, the selec-tion narrows as songs are eliminated. The winner is chosen based on the song's fidelity to the theme, lyricism, and, I would add, compat-ibility with the aesthetic vision of Ilê Aiyê. Its popularity, during and after carnaval, may guarantee its creator additional financial rewards, because the winning songs are often bought and recorded by popular artists such as Daniella Mercury.

A Noite da Beleza Negra summarizes Ilê Aiyê's aesthetic project, in that it is predicated on revising the negative valuation placed on African-based discourse and the black being who embodies it. This is the night when young women from all over Bahia compete for the honor of becoming Queen during carnaval and the ensuing year. To understand the impact of Beleza Negra on Afro-Brazilians is indeed difficult. It may best be considered a night of transfigurations. It allows for a celebratory inversion of the accepted standards of Afro-Brazilian femaleness, much like the contests created by TEN in the 1940s (Chapter 5). Ideally, one sociologist suggests, it is a time to reflect and to summarize the project of aesthetic reevaluation, seen in the changing perceptions about blackness, and to assess the next course of action.[11] However, it is one of the few society events for the black middle class, and it becomes a night to gauge and demonstrate one's social standing.[12] The women on stage vying for the title of *"Deusa do Ébano"* [Ebony Goddess] often become secondary in the quest to identify who is present and who is not.

During the course of the competition, the contestants are judged on their beauty or their representation of the black ideal that Ilê champions, their grace, dancing ability, and costumes.[13] Each of the contestants wears an elaborate costume meant to complement her African visage. Made most often with a blend of raffia and African-styled printed cloth, the dresses harmonize with ornate headdresses that partially cover the braided hairstyles. Counter to the concept of "*boa aparência*" found in Brazil, the contestants must be dark and have braids. Since "*tranças*" [braids] are unattractive in the dominant aesthetic, because they show that one has "cabelo duro," black women sporting these hairstyles are conceived as asserting their own sense of femininity and beauty. The bodies of these women become the idealized figurations of Africanness and blackness. Their beauty and sexuality are refigured tropes that express the longing for the idyllic nurturing of African culture in Brazil.

The Queen is the ultimate signifier of the generative Africa and its embodied blackness. Once chosen, she is serenaded with the song created for this moment, "*Deusa do Ébano*." Since this is a night of reversals, the black woman is symbolically enthroned and worshipped instead of debased and denigrated. Robert Young (1995) addresses the power of the white male gaze to authorize the black female. The master/slave dynamic allowed for an "ideological dissimulation," states Young, wherein white men enacted their sexual fantasies, but black women were taught to see themselves as ugly and unworthy through this continual victimization laced with derisive invectives (Young 152). Due to A Noite da Beleza Negra, the black woman is no longer the degraded object, the exotic creature constructed from white male fantasies, but the uplifted subject who embodies the ideals of beauty constructed from the desire of the black male to redeem her, to save her from historical and continual ignominy. Her beauty becomes a symbol of fecundity, of life and its creative, inspirational capacity. Ironically, however, she is still not determined from within but subject to the desires imposed by that male gaze. Apotheosized into Mother Africa during carnaval, this is an Africa where men rule and young women are aesthetic and sexual objects. While Beleza Negra is an attempt to give value to black femaleness, she is still an objectified symbol, for the black male is now the possessor of the gaze, and he swaggers in response to her beauty. The Queen reigns for a year and is then replaced by another. What happens to them afterward is never discussed, for only a few become dancers in Ilê Aiyê's repertoire. Yet there, too, her objectification becomes even more visible, because the dancers seem to be the playthings of the male directorate. Although

Beleza Negra is not a pageant with scantily clad women, never is the intelligence of the *mulher negra* evoked or celebrated.

As an aesthetic signifier, everything about the Queen's presentation is spectacular. For the first night of carnaval, it has become a tradition for her to be dressed in a private chamber of Ilê. Surrounded by female attendants, she is draped in the fantasia of the year, and her hair is wrapped in layers of elaborate cloth made into a striking *gele* [headwrap] to magnify her ascendance. Milling around are photographers, newscasters, and members of the Ilê Aiyê family. It is not uncommon for artists such as Veloso and Gil to pay homage to the group.[14] At the 2010 carnaval, Dilma Rouseff, now president of the country, and Jaques Wagner, the governor of Bahia, were present. All the same, the celebration officially begins only after Candomblé elders perform an ebó, an offering to the orisas, to ensure the smooth flow of the celebration. Mixing the sacred and the secular, the Mães dos Santos perform the ebó to open all the roads by pouring libation; sprinkling popcorn (the chosen offering to the orisa, Obaluaye), scented water, and white manioc flour; and reciting prayers. Such offerings are commonly used to invoke and activate the transcendental force of the orisas; for this opening night of carnaval, the offerings clear away all obstacles and impediments to the journey to be undertaken. Closing the ebó by releasing doves, symbols of peace associated with Oxalá, sets the stage for the forthcoming week; the procession then begins, since these ritual offerings acknowledge and bring the numinous authority of these otherworldly, affirmative energies into the tangible realm.

To describe the number of people who gather to accompany the group or to watch its leave taking is impossible. It is the time for the intensely celebratory experience that describes the state of anraje in carnaval. Everyone in the bairro and all the visitors to the Curuzu choose to accompany Ilê. A walk that takes five minutes on an empty street takes two hours to complete. The participants of carnaval, dressed in their fantasias, mix freely with the crowd as they slowly edge toward the main street. The drummers follow behind the two trio elétricos,[15] the vehicles that have come to define carnaval. Riding on the top of the foremost trio, the Queen has a separate podium from which she alternatively dances and waves to the surrounding crowd. Ilê Aiyê's singers are located on the second trio; with an amplified sound system built into the vehicle, the singing and drumming reverberates up and down the parade route. Still far away from the main staging area of carnaval, this procession and performance is for the community in Liberdade. It is ironic that Ilê Aiyê began as a group

intended to facilitate the entry of black folks into carnaval; nowadays, however, like the white blocos, it too has a prohibitory entrance fee; only a few members inside the community of Liberdade can afford to pay. The group justifies the cost as due to the expenses incurred by participating in carnaval. To join other blocos afros, such as Malê de Balê, however, costs significantly less; Olodum charges more than Ilê but gives away the fantasias to those who cannot afford them. When examining this free-flowing, fully participatory, prestaged carnaval within Liberdade, it certainly appears that it is a conciliatory gesture to the community from which Ilê builds its reputation.

Blackness Taught, Africa Sold

The *saída* [departure] from Curuzu tells everything about Ilê Aiyê today. Where the road to Curuzu ends or begins is where the revelry ends for most of the people who live in the area. Ilê Aiyê has become the choice bloco afro for members within Negro-identifying groups, but carnaval 2011 cost *reais* 500 for the fantasia, a sum too great even for many of the middle class to purchase.[16] When members of this economic minority cannot participate, it is a profound commentary on the privatization of the bloco. The poor are usually envisioned without power. Ilê, in its beginnings, represented the poor, disenfranchised Negro in an attempt to transform from inchoate resistance modalities to an articulated, performed form of blackness that came out of its lived trajectory. What this demonstrates is that the politics of the poor, combined with the politics of blackness, are more complicated than negotiations between dominant and subordinate positions. Ilê becomes a model for how undervalued citizenry functions horizontally in challenging domination and vertically by generating a locus of articulation for their betterment.

Philip Auslander argues in his text *Presence and Resistance* (1992) that cultural production is always subject to commodification, and as such, resistant art practices must take these economic factors into consideration, as they are a significant part of the operational environment. For Ilê, the discourse of blackness now has rewards through its mediatization as the premier bloco afro and the garnering of support through greater advertising revenue.[17] Whereas Olodum's commercialization is a constant topic of critique, Ilê's growing capitalistic mode is only whispered about. Ilê Aiye's "segregated visibility" (Hall, "*Black*" 468) heightened the visibility of Curuzu, as everyone wanted to see the bloco in its home space. Its earliest ensaios guaranteed, for the neighbors organized enough to take advantage of a new enterprise,

an ongoing flow of capital gain from the provision of food and drinks for the thousands of people who would gather every Saturday night to interact with its African matrix. Ilê's presence in various media engines and on international stages guaranteed a steady supply of fans from the outside that would leave behind their money as they partook in its celebration of blackness. As a result, present-day Curuzu looks nothing like it did in the past. It bears the marks of prosperity that come with changing circumstance, and the street that Ilê resides on is the most transformed. The housing infrastructure is no longer decaying; some of the homes are covered with tiles, a definitive marker of prosperity because it places the owner in a different tax bracket. The street that people once feared to enter now houses a fashionable clothing boutique, a hair salon, and various small grocery stores and bars. Ilê Aiyê's edifice has also long transformed. No longer do they operate out of a three-story tenement building but from an imposing new structure on the opposite side of the street, constructed from a combination of state and private funding. The new building has five large floors and houses the *sede* [headquarters] with a stage that allows for an audience of over one thousand people during a live show, a fully functional elementary school—*A Escola da Mãe Hilda*—and offices for the directorate.

Ilê's practice space has a door fee of ten reais—not a large sum, especially when compared with the 80 reais for Olodum's shows, but too much for the people who live in the neighborhood, who came to Ilê for free. The sede also has an area for those who do not want to mix with the masses, and for just R25 one can watch the show from the gallery above. What has also changed is that Ilê no longer performs every Saturday, and in fact, since they rarely performed in the interval between October and December (the former being the period of their most intense practice sessions), it is difficult to attend a show. Unless it is a major event, the cavernous space of the sede may only contain a hundred people. The show is so lacking in energy without a mass of participants that only the most enthusiastic can maintain interest.

The school is the realization of Mãe Hilda's dream of wanting to educate the children in the neighborhood. The curriculum, compared to that in the Brazilian school system, is infused with information about the African continent, its peoples, and black peoples in Brazil and the diaspora.[18] Unlike the school of Olodum, there seems to be a genuine commitment to educate and to inculcate a sense of Afro-Brazilian shared pride and identity within the student body. After months of observation of the Olodum school, I asked the ubiquitous

question to the students: What do you want to be when you grow up?[19] The answer was invariably a drummer or dancer. Not much at that time was different with Ilê's school, as both entities appeared to be using its educational modality to continue garnering support from the state and to feed its performance base with chosen students. Ilê's school having graduated from a back room enterprise has become an establishment that truly serves the community. This is the new Ilê, a bloco afro that has transformed into a business with a school attached.

Olodum's relation to the black intelligentsia has always been problematic, for their monetized drive is not hidden.[20] Since Olodum is no longer in the business of taking care of the poor and the disenfranchised, they view its co-option of the African matrix as a form of personal aggrandizement. Similar to Vovô, its leader João Jorge dos Santos runs Olodum as a personal fiefdom, with family members and a loyal staff under his command. Unlike Vovô, however, his presence is less visible in the day-to-day operations, and within the last ten years he has received a law degree and has run as a mayoral candidate. Olodum, having lost much of its local supporters, relies on the tourist trade for quick funds, and they are the ones who pay the 80 reais for its Tuesday night shows. Its workers are quick to point out that this price is still cheaper than the shows of popular artists such as Daniella Mercury. Olodum's stores sit prominently in Pelourinho, but to buy their T-shirts and paraphernalia one needs the budget of an outsider. Olodum has long priced itself out of the budgetary framework of its constituency, and to guarantee the energy necessary to parade on the streets, to guarantee its black face during carnaval, it gives away the fantasia to Afro-Brazilian participants. They willingly admit that when there is majority white participation, carnaval performances lack their well-renowned energy and vitality. And, as a bloco afro, how can they parade without black people?

Power, it must be accepted, is not derived solely from an ability to negotiate with the powerful. It comes from the acceptance by Afro-Brazilians that the blocos embody a force, a movement, a political stance they support. The impact of representational ideations like Ilê's is often dismissed, and the impact they have on the local black populace is never calculated into the critiques of African/black-centered discourses. Such discourses and representational modes are simply dismissed as naive or pathetic, as suggested by Crowley. But why they continue to proliferate, who supports them, and who is indeed empowered by them must be also be understood. Hence, the power that Ilê derives from its own surroundings and support from fellow

Afro-Brazilians must be calculated in the communication of what their concepts of Africanness and blackness signify. In tandem with recognizing its modalities of capital gain, for Ilê's enfranchisement of the discourse of blackness allows it space and credibility within the larger national construct. Although Ilê still does not allow whites to participate in carnaval, anyone with some color and features that speak of an African ancestry can now purchase the fantasia and parade with them. As a signifier of Afro-Brazilian politicization, to parade with them is a personal testament of achievement and a display of prestige in joining a group that others cannot afford (Ergood 146–49). Carnaval also becomes a time, even if for only a day, that one can show genuine camaraderie and communal spirit, and the anraje and angaje combine and heighten when participating with an organization that asserts one's selfhood and political orientation. This is the appeal of Ilê Aiyê to its constituent members.

Carnaval Changes, 2001 and 2011

For the week of carnaval, the city of Salvador is effectively transformed. Areas in which the carnaval celebration takes place undergo a series of remarkable structural transformations. The main areas of Campo Grande, Avenida Sete, the Avenida Carlos Gomes, where the blocos process, along with the sea route that winds through the area of Barra are all effectively closed to vehicular traffic: only the human flow and the trios pass through during the week. Barricades meant to forestall any possible destruction of property surround the participants in the staging area. All storefronts are covered with plywood; the impediments on the sidewalks such as telephones, bus shelters, trash receptacles, and traffic railings have been dismantled, trees have been uprooted and, in Campo Grande, a three-tier rostrum is temporarily constructed. Lest we imagine that removing these impediments allows for an intermixing of the spectators and participants in carnaval, we must understand that even the spaces for viewing the spectacle are socially segregated. Contrary to the free flowing carnaval envisioned by Bakhtin and Da Matta, parts of the rostrum are rented to those who can afford to pay the set prices. Some units are converted into individual rooms, containing couches and a refrigerator. Others are open units without the amenities, but access is limited to the press and invited guests. There are still rows of bleachers for the masses, but during the height of the spectacle the police guards will only allow those whom they deem acceptable to enter the stands.

In what Stuart Hall considers "canvases of representation" (*"Black"* 470), a cultural repertoire configured through embodiment practices and musical codings can indeed challenge social ideals and places the blocos in positions of heightened visibility, but with Olodum, its hybridity combined with its commercialism generates such a diffused fusion that its angaje seems lost. Its original political assertions and its commitment to the cause of Afro-Brazilian revitalization seem like overworn tropes used just to maintain its legitimacy as a bloco afro. This was readily apparent in the visual presentations of carnaval 2001.[21] Olodum's theme was *"Africa, Asia, Brasil,"* celebrating the African presence in Asia. Visually, the theme was not sustained in the fantasias or the carnaval presentations. Like the non-Afro blocos, participants dressed in shorts and a top embossed with Olodum's carnaval logo; dance presentations devolved into a series of choreographed steps without any cultural references. Olodum could have been any bloco on the street except that it had a dominant Afro-Brazilian presence and a percussive section, a defining feature of the blocos afros, which performs separately from the electronic instrumentality of the band. Pointing to the limits of Olodum's vision, the theme of the 2001 carnaval was duplicated in 2010 under the theme *"Índia, África do Sul—A Terceira Visão."* What shifted was the carnaval presentation, with female dancers dressed in Indian saris and some of the male drummers wearing crowns covered with cloth patterned on giraffe skin, while the tops of the fantasias appear to have been a combination of zebra-striped cloth and multicolored materials. Given that it has been in existence for over 32 years, one expects more than these stereotypical, topical characterizations by the bloco. For the 2011 carnaval, its dancers carried a small drum, papyrus-like scripts emblazoned with Olodum's peace sign, and a square drum with the "at" [@] sign from a keyboard to symbolize their theme of *"Tambores, Papiros e Twitter: A História de Escrita"* [Drums, Papyrus and Twitter: A History of Writing]. Olodum markets this as an evolution, acknowledging the contributions from Africa to the present in the art of communication. However, these depictions highlight its failures in representational and political continuity; its hybridity feeds its dilution of its original pro-black, pro-Africa ideations, for while it maintains a black presence among its drummers and dancers, the sense of processual blackness, an inculcation of values, cultures, and aesthetics that are freeing and transformational, has disappeared.

Ilê has long diversified its themes, from celebrating the continental Africa as seen in the 2001 carnaval theme, *"África Ventre Fértil do Mundo"* [Africa, Fertile Womb of the World], to celebrating Africa within society with its recent theme *"Minas Gerais"* (2011). The songs, fantasias, and performance styles function complementarily to present their aesthetic vision. In 2001, the song that won the concurso, *"Majestade África"* by Paulo Vaz and Cissa, led the procession. The lyrics give homage to Africa as the birthplace of knowledge and spirituality; hence, it is the "center for culture, science, architecture" and the "encyclopedia that the world researches." While it presents the idyllic Pan-African mythos by conflating all of the differences of the continent into a unitary whole, it also centers the dominant cultural contexts from which Afro-Brazilians derive authority, be it "Bantu, Gegê or Nagô." Revisioning Africa as the generative source, Ilê Aiyê becomes its representative body, "a copy of the original Africa" in Bahia.

The fantasias become self-reflexive texts to mark individual identity. Each participant receives a loose, long, flowing top, such as a *buba* for women and an *agbada* for the men, another length of cloth is used to wrap into a skirt, and sashes are used as head wraps in either yellow for women or red for men. For 2001 white was used as the background color for the fantasias, and Ilê's signature colors of red, yellow, and black highlighted the embossed textual referents in the cloth. "África" in bold, black letters was imprinted in the middle of the piece, bordered in less prominent lettering by the subtheme, *"Ventre Fértil do Mundo."* Images mix both Yoruba and Bantu metaphors; for instance, a double-edged ax, which is the often-used symbol for Shango, the orisa of thunder, tops the "I" of Africa. The Bantu term *Ntu,* signifying "man," is also set within. Replete with symbols of the orisas, such as the fan used by the female orisas, the bow and arrow of Ochossi, the dove of Oxalá, the swords of Ogun, and the *ibeji* [twins], the cloth connects the Africa that is known through Candomblé with its allegorical referents seen in smaller pictorials of the continent, side by side with the bust of a black woman. The key difference in the fantasia for 2011 is the use of the background colors yellow and red; yellow for the gold in the mines and red for resistance. Added to it is the figure of the black male—the forgotten miners and the farmers of the *Sertão.*

Each bloco parades three times during carnaval. The route that guarantees the most visibility passes along the coast, but only Olodum has sufficient resources to gain access to that route. Yet it is

only for one day or night. The most significant event in the carnaval experience, however, takes place on the night that the blocos perform in full regalia. This is the last night that the blocos are seen by all. One side of Campo Grande, the main square in the city, becomes the staging area, and only participants dressed in a fantasia or those with official identification can enter. Flanked by rostrums, spectators watch the performance of each group. Even though it is well after midnight, it appears to be the middle of the day because of the extensive, brilliant lighting all around the area. Television camera crews are located above the stage and independent journalists mill about on the street. This day is the culmination of the work of the blocos for the past year.

For Ilê, this particular procession highlights its anraje. It is the time when constructs of blackness engage with the public domain due to its hypervisibility in the social and political sphere. Forming a link crossing the staging area, the male directors begin the procession. Most stand well over six feet tall; dressed in their agbadas, they begin a slow, dignified procession down the street. The visual impact is arresting in its display of pride in being black. Immediately following is a group of Mães dos Santos, dressed in the traditional Baiana style. To indicate their status in the Candomblé community, they also wear *batas*, short, loose blouses that are reminiscent of the buba. Only senior initiates wear this garment, as it signifies that they have completed all their ritual obligations (Omari, "Candomblé" 154). Thus, these Mães are the most learned and the most revered in this microcosmic sphere. In the evolving discourse, they signify Africa as a source of creative and spiritual inspiration. These women guard the traditions brought by their forbearers, permitting the continuation of that psychic ancestral link. Connecting African aesthetics and spirituality, the Mães adorn themselves with elaborate ojas, and multiple strands of colorful ilekes are intertwined around their necks.

After this grand entrance, the performance texture shifts with the dancers' entrance to the staging area. Dressed in their signature style, they intermix raffia with the cloth for the year's fantasia. The use of raffia is quite evocative, as it is the archetypal dress of spiritual entities all across West Africa. More specifically, devotees who incarnate the spirits of Obaluaye and his mother, Nana, use it. The raffia is thought to conceal the smallpox ravaging the body of Obaluaye (Thompson, *Flash* 66–68). Just as the style of dress interlaces with religious discourse, the dance styles are part of this visual mimetic

repertoire. (Re)presenting the patterns found in the Candomblé ter-
reiros, the graceful sweeping arm motions, bent postures, and poly-
rhythmic steps of the dancers are all in keeping with the techniques
of African dance. The dancers usher in the Queen, who follows on
the trio elétrico. It is only after her arrival that the singers and drum-
mers appear. But it is the drummers who are the key to the car-
naval experience. This reliance on percussion is the crucial difference
between the blocos afros and other carnaval groups. Since carnaval
has now become a mediatized, electronic enterprise, the bands for
each group play on top of the trio elétricos, using electronic instru-
ments. Drums are the only instruments used by Ilê,[22] and thus the
stamina and expertise of the drummers drive the anraje and angaje
of carnaval. Ilê Aiyê is famous for its sound, *ijexá*,[23] the rhythms
associated with Candomblé,[24] and more specifically the rhythm of
Oshun. Its musical, axiomatic tie to Africa parallels the articulation
of black subjectivity found in the song lyrics. The dancers add the
visual layer to the sound and songs. Drawing on the dances found in
Candomblé, they borrow from the patterns of various orisas to cre-
ate a unique choreography. In this fashion, the graceful, undulating
arm motions of Yemanja are paired with the flamboyant pirouettes
of Iansā to generate a new semantic field that gives homage to the
aesthetic revisioning of blackness. Rex Nettleford (1993) suggests
that dance is "part of a society's ancestral and existential reality"
(97), and like the national dances of the Caribbean, their individual-
ity conjoins into a shared identity that evokes the ancestral within.
Ilê Aiyê prides itself on an unfettered carnaval performance, and the
participants never engage in a choreographed dance presentation.
Individuality in the midst of this collective ethos shines through.
First seen in the multiple variations created from the basic fantasia,
its improvisational dance styles intensify the verve of the canvas of
bodies on display.

The procession route is less than a mile, but it takes all night to
reach the end. Throughout the night, the drummers continue non-
stop. Once outside the staging area, the need to keep the processional
order diminishes. The focus then shifts outward, as the intent now
is to stop the spectators from entering into the bloco. Access is care-
fully monitored, and only those dressed in the fantasia of the blocos
are allowed to participate with the group. As the group is flanked
and hemmed in on all sides by the sheer number of spectators, the
rope and its attendants act as a protective barrier from the chaos out-
side. Carnaval, in practice, counters the theoretical depictions of the

free-for-all undertaking seen in the work of Da Matta, because this anraje is only for those who pay to enter the delimited area.

Conclusion: "Me diz que sou ridículo"[25]

In some ways the blocos afros represent subordinate social groups struggling against each other, over both the form and content of their expressivity of Afro-Brazilian struggles. Yet their carnaval presentations are part of the larger contention for legitimacy and social reconstruction in a modal existence that denies Afro-Brazilians entry (Green and Scher 11–12). While Ilê appears to be the most empowering in its stake on blackness, and it becomes natural to juxtapose Olodum's obvious hybridity against Ilê's "purity," what both groups demonstrate is that the discourses of Africanness and blackness contain a conjunct of class, capitalism, and power. The disjunction of performance strategies between Ilê and Olodum reflect carnaval's commercialization, politicization, professionalization, and intellectualization (ibid. 7). What helps Ilê maintain its currency, however, is its symbolic capital. Overwhelmingly, the participants in Ilê Aiyê are the black intelligentsia, the growing black middle class, who work with community projects, who belong to the terreiros, political organizations, and factions calling for changes in the political machine. Parading with Ilê is their moment of self-validation, during which they can freely express their convictions and desires for a changing face of Brazil.[26] However, since it is a bloco afro and not a political entity, it does not challenge the social order sufficiently to be perceived as threatening to the state, resulting in an implicit social sanction of its expression of blackness. In the arc of Afro-Brazilian politicization, this cannot be minimized, for Ilê has transformed from an entity that was excoriated and politically outcast to one that is naturalized. This is part of the journey from empowerment to power, for that symbolic capital provides the nurturing and affirmation necessary to continue the actual struggle against an asymmetrical social and political order.

Chapter 4

Aesthetically Black: The Articulation of Blackness in the Black Arts Movement and Quilombhoje

*O branco é o símbolo da divindade ou de Deus. O negro é o
símbolo do espírito do mal e do demônio.*
O branco é o símbolo da luz...
*O negro é o símbolo das trevas, e as trevas exprimen simboli-
camente do mal.*
O branco é o emblema da harmonia.
O negro, o emblema do caos.
O branco significa a beleza suprema.
O negro, a feiúra.
O branco significa a perfeição.
O negro significa o vício.
O branco é o símbolo da inocência.
O negro, da culpabilidade, do pecado ou da degradação moral.
O branco, cor sublime, indica a felicidade.
O negro, cor nefasta, indica a tristeza.
*O combate do bem contra o mal é o indicado simbolicmente pela oposição
do negro colocado perto do branco.*

Gisele A. dos Santos[1]

The Afro-Brazilian writers' collective Quilombhoje marks a radical departure in the positionality of black writers in the Brazilian mind-scape. As the collective formed to create works that both challenge the social marginalization of Afro-descended peoples and to give a venue and voice to artists who would never be recognized by the Brazilian literati, they open a space of freedom and fluidity of expression. Their expressivity, of course, first focuses on their blackness and

the aesthetic foundation from which to derive a spectra of artistic production, particular to their imbrication of the personal and the political in the creation of art. They deliberately discard the models of aesthetic engagement that privilege "art for art's sake" and reformulate it in the Du Boisian sense that "all Art is propaganda and ever must be" (par. 29). Du Bois advocates for a political art form, tying his concept of propaganda to the creation of beauty in truth and freedom. While Walter Benjamin (1969) critiques the attachment to the political in the reproductability of art (224), the Black Arts Movement (BAM) and Quilombhoje call for its intrinsic imbrication, likening artistic production to decolonizing strategies, in which a recuperated culture is seen as an essential factor in the substantial and psychological overthrow of dominant ideologies. Du Bois's entwinement of art and politics generates a relational dynamic that lives in the works of these movements and overarches their conception of literary production, for the heightened consciousness that art produces animates the passions for political involvement.

This chapter compares the BAM, as a literary precursor in the quest for a black aesthetic and political voice, to the Afro-Brazilian artistic collective Quilombhoje. Both movements investigate blackness as aesthetics and identity, engaging with history and social reality in both their politically and aesthetically charged dominions. Interrogating the fields of visual, verbal, and scribal representations of black peoples, they theorize beyond the boundaries of race and representation to formulate an entelechy of blackness that reverberates into mass consciousness. Both movements generate a body of work that spans all literary forms, but their commonality most profoundly manifests in their creation and use of poetry as symbolic of a politically reverberating art form. What differs may be their desired field of impact. The BAM's trajectory is to generate black consciousness in African-Americans, and in doing so they ask black artists and black peoples to revision their modus vivendi. Quilombhoje wishes to impact all of Brazilian society in order to revision the ideals of Brasilidade and to genuinely include Afro-Brazilians as equal contributors and participants rather than occasional celebrants or celebrities in the national imaginary.

Clyde Taylor (1988) argues that aesthetics is synonymous with Western aesthetics and was developed as an instrument of ideological control by the ruling classes in the eighteenth century. Elaborated in his seminal work, *The Mask of Art* (1998), Taylor deliberates on how the quest for a definition of aesthetics creates an oppressive ideological formulation that is destructive to the cultural orientation, and I

would add the identity and sets of identifications of black peoples. The twin birth of aesthetics and blackness, affirms Jean Devisse (1979), is found in the historicity of color theory. In his study of blacks in Western art, Devisse denotes, emphasizes, and traces the modality and thought processes under which the conceptualization of "black" as a color becomes an affective symbol that shifts the paradigms and perceptions about black peoples. Devisse's study dates back to the Pharonic age, but in examining the Western codex of visual representations, the denigratory aspects of blackness arise in the artistic renditions in the Middle Ages and its intellectual bridge, the Renaissance. This, too, is the argument from our epigraph noted by the Afro-Brazilian psychologist Gislene Aparecida dos Santos (2002) in her study of blackness in Brazil. Santos quotes the painter and theorist Jacques Nicolas Paillot de Montabert, who created this specific color signification in a manual for artists in 1837.[2] Attesting to this coda of representation in the visual arts, Santos argues that this negation of black subjectivity dates back to ancient Greece, but its specific influence on Brazilian writers, artists, and society generates from Enlightenment discourse.

Such conjoining of the discourse of aesthetics and blackness begins within the philosophical treatises of Edmund Burke and Immanuel Kant and specifies subject or object positions in a network of gendered, racialized, and ethnicized (national) bodies that become identificatory markers of sameness and difference. Both philosophers theorize the sublime as the ultimate representation of aesthetic signification and confer on blackness its most horrific and terrifying presence. Burke specifies a naturalized, organic connection between "darkness" and "blackness" and its signatory manifestation on the body of a black woman. His treatise bears revisiting in this long quote, describing the first sighting of blackness by a young, white boy:

> Among many remarkable particulars that attended his first perceptions and judgments on visual objects, it gave him great uneasiness; and that some time after, upon accidentally seeing a negro woman, he was struck with great horror at the sight. The horror, in this case, can scarcely be supposed to arise from any association. The boy appears by the account to have been particularly observing and sensible for one of his age; and therefore it is probable, if the great uneasiness he felt at the first sight of black had arisen from its connexion with any other disagreeable ideas, he would have observed and mentioned it.[3]

The innocence that this white boy purportedly exhibits is compounded by Burke's explanation of a previous blindness; the black

woman in his line of sight is not simply his first encounter with blackness but one of his first visual perceptions. This singular gaze provokes or generates a naturalized revulsion and rejection in the white psyche and generates a panoptic delusion about the black body, reconceived as an object of horror. Due to its unimaginable presence, a mere look at blackness is shocking, and the terror it evokes is a psychic, organic response because it evinces the uncontrolled aspects of being. The image of blackness overwhelms reason due to the inchoate, masochistic response, and the terror of alterity threatens the power and authority of the gaze. Hence the gaze of whiteness serves as an aesthetic judgment that constructs the actuality of blackness, with the effect of controlling the signification of blackness outside the representational spheres of black peoples, to render a model for Western aesthetic partiality that recodes the black (female) body as the abjectness of being.

Kant, in his *Critique of Judgment*, universalized for Europeans the criteria for aesthetic judgment, but it is in his *Observations on the Feeling of the Beautiful and Sublime* that he recasts Burke's metonymic links in stating, "dark coloring and black eyes are more closely related to the sublime, blue eyes and blonde coloring to the beautiful" (54). Kant's overarching premise, however, generated classifications of nationalities and, relationally, a typology of racial and gendered identities. Similarly, Baron de Montesquieu propagated a hierarchical taxonomy, but one based on climate and its effects on racial or ethnic identities. Kant created distinctions based on his invented criteria of aesthetic and moral judgment, so that the Spaniard was conferred with the "terrifying" nominative of the sublime; the Englishman was considered splendid; the German, noble; Indians and Chinese were grotesque; and the Negro was said to have "no feelings that rise above the trifling" (*Observations* 110). Kant's complete dismissal of blacks and his placement of them on the lowest rung in his hierarchalization, Meg Armstrong attests, was often repeated in "aesthetic comments comparing various nations, for instance at European and American fairs and expositions of the nineteenth century" (224). These fairs and expositions became the popular fora in which to exhibit the bodies of African men and women. Such specular subjugation allowed for the questioning of their humanity and, hence, their capacity for reason, rationality, and shared emotional capacity. The most famous of these visually codified beings is Sarah Baartman, the Hottentot Venus (Willis and Williams 2003). The manner of appropriation and subjugation of her body marks a singularly profound and abominable effect of the creation of this antiblack aesthetic rationale as a telos of

aestheticization. Embodied blackness thus came to signify the incarnation of grotesqueness, perversity, ugliness, and the irrationality of the sublime in its most terrorizing forms.

Enlightenment forefathers affirmed a lexical codification of "black" as dark, dusky, dirty, dingy, depressing, sinful, inhuman, and villainous,[4] and "white" as pure snow, lacking color, decent, harmless, auspicious, morally honorable, pure, without malice, and harmless.[5] Out of these forms of axiomatic judgments of blackness, we have inherited the persistent tropes and stereotypes about the black being. Its transformation from discourse to embodiment attests to Walter Benjamin's prescript that human sense perception is determined by both nature and historical circumstances (222). The inverted, distorted image of blackness as linked to the black body, I maintain, generates a socioepistemic metanarrative that conceptualized black peoples not just as different but as different in kind, and that still undergirds the field of aesthetic representations and its narrativizing ideals.

Connections between these master codes deriving from the nugatory gaze of Western subjectivity and its *otherizing* of darker peoples is not new and is the base for postcolonial theorizing that governs the axiological linkages in this work (Sala-Molinas 2006; Goldenberg 2003; Young 1995). Seminally, David Brookshaw (1986) confirms the premise that links the color black with the pernicious signification of the black subject in his study of Brazilian literature. Brookshaw quotes Gilberto Freyre to underscore the ubiquity of the negatively charged images on the Brazilian psyche: "I have never liked black as a color.... Its association with mourning, darkness and smoke, created in me a complex from an early age, which was also fed by fairy stories, in which there were wicked 'old niggers' of horrific appearance" (Brookshaw 5). Freyre's role in the creation of Brazil as a racial democracy need not be revisited here, but imagine what it signifies to the construction of Afro-Brazilian subjectivity if the foundational theorist of Brasilidade harbored such a deeply imagined fear of blackness.

It is, indeed, a grand failure in the schema of educational practices and a testament to the finitude of intellectualism that the concepts of art from the eighteenth century, developed by men who lived in worlds so different from our own and who had, at best, limited experiential knowledge, vast imaginations, and unchecked narcissistic personalities could still so dominate our sensibilities, judgments, and systems of codification. When examined in the history of artistic representations of black peoples by Europeans, whether in narrative

or visual form, whites create an imaginary spectra of blackness that can be likened to their self-reflexivity in the creation of what Achille Mbembe (2001) considers their "imaginary significations" about Africa (2). Africa's figuration as "the strange," "a vast dark cave," "a bottomless abyss," in which total confusion and chaos reign, encodes a mythic construct of otherness, culminating in a relational divide that assigns it a *nothingness* (Mbembe 2–5). It is a logical step to link the lacuna of real knowledge about Africa and its constructed identity to the selective visibility and constructed identity of the black subject. To use George Yancy's (2008) phrase, the "corporeal malediction" under which blacks have been constructed generates an "imago" of blackness that naturally leads to resistance on their part (*Black Bodies* 46). Mbembe as a postcolonial theorist and George Yancy as a critical race theorist have much in common, as they both demystify representational images and author-lived realities. They both offer similar understandings of the mythic foundation of Western discourse and its modus in creating an Other, albeit embodied either in the black person or the mythical Africa, to validate its normalizing assertions. Ergo whiteness cannot exist without blackness, and the West cannot exist without Africa. The relational equation appears as such—whiteness: blackness:: West: Africa. It justifies Marcus Garvey's belief that a strong, independent, unified African continent would change the image and positionality of black peoples around the world. Still, one cannot address the overdeterminacy of the black body without engaging Fanon's analysis of the epidermalization of the black being. Fanon speaks to its effects on the psyche of the objectivized black being, who then embodies this denigrated blackness and, as a result, suffers a dislocation from self and psyche. Through the imago of these distorted darker bodies lives an abstract, disembodied system of representation that generates what Ella Shohat and Robert Stam (1994) consider an "unthinking Eurocentrism," a codified system of knowledge and values so internalized that the subject of Western discourse does not realize it exists, let alone question its basic assumptions.

Aesthetics thus has a larger signification in this work, as it is indeed bound by ideology, as Clyde Taylor attests, and the fetishization of blackness within a Western coda demands a response from the black subject. It engenders a call for resistance to not only subvert these stereotypes but also to overthrow their signification and the systemic coda of representation that produced them. For George Yancy, resistance is tied to the affirmation of identity, outside the imagined black imago (*Black Bodies* 114). This is, then, a war against Western aesthetics or an "anti-thesis on aesthetics," as named by Taylor (1988). Artists

of the BAM and Quilombhoje set out to confront white racism and its representational spheres with the ontological fact of blackness, and in the process they generate a modus of aesthetic engagement specific to their political positionings. The BAM addresses art in its totality in the scribal, enunciatory, and visual spheres, whereas Quilombhoje is primarily a literary movement. This chapter focus on poetry derives from its centrality to each movement, conceptualizing it within a per-formative, liberatory ethos intended to release the word from the page and inject it into the mind of black peoples. Hence I argue that they transform from counterhegemonic to auto-hegemonic discourses, predicated on the construction of an artistic worldview that derives from the entelechy of blackness. Entelechy here is filtered through Clyde Taylor's lens, but I contour it to signify the control over rep-resentation and signification that generates cultural modes that are naturalized due to their ubiquity. Entelechy implies the centering of the black subject within her own self-constructed, self-verified codes that become the cultural capital for the journey from empowerment to power (*Mask* 58–61).

The Death of the White Thing[6]

At the 2005 African Literature Association Conference, Moyo Okediji gave a talk on shrine painting in Yoruba religious centers. One issue he challenged was the supposed universality of color theory. In color theorization, white is the saturation of all color and black is the absence of color, which is exactly opposite in the Yoruba theoretical model. Black is seen as the essence of all color, the beginnings of the color spectrum, and white is its absence. Yoruba shrine painters derive this theory from the nature of coal transmuting into fire. All colors are visible in the blaze of the fired coal, and white arises from its ashy remains. This interpretation has dual significance. First, it challenges what is considered a fundamental universal concept in the creation of art, and second, it has profound implications for the sociolexical constructs of the terms black and white. Just from its aesthetic sig-nificance, we can ask, How will color theorizing transform, if black becomes the normative standard from which all color is produced? Since the binaries of Western logic rewrote color signification on the body of the black being, what will happen if black peoples revision themselves as the center of aesthetic representation, discourse, and narrativizing ideals? How would this shift in color theory and its con-centric representational spheres affect the psyche of the black subject and the lived reality of blackness? This may seem like too immense a

leap to go from color theorization to psychic revisioning, but these links are, in fact, recoding a parallel positivistic road in the journey of blackness when compared to its trajectory from the Enlightenment discourse to the present.

Implicitly, the main objective of the BAM is to debunk whiteness in all its forms, from its aesthetic hold over art to its importance in the minds of black folks. Etheridge Knight, one of the foremost poets of the movement, most forcefully articulates its ideological thrust in the dissolution it envisioned of the normative standards set by a white, Western, aesthetic order that marginalized the black subject and harnessed his or her creative vista:

> Unless the Black artist establishes a "Black aesthetic" he will have no future at all. To accept the white aesthetic is to accept and validate a society that will not allow him to live. The artist must create new forms and new values, sing new songs (or purify old ones); and along with other Black authorities, he must create a new history, new symbols, myths and legends (or purify old ones by fire). (qtd. in Neal, *Visions* 63–64)

Although whiteness, defined in the BAM, is in direct opposition to blackness, the demand for a revisionary, subversive, and differentiating nature of black discourse by Knight predicated value from its own heuristic and ontological centers. The aesthetic envisioned was not a counterhegemonic discourse, constantly desiring white recognition or battling for a place in the hegemon; its auto-hegemony generates from within its own systems of spiritual and artistic knowledge, dialoguing within the spheres of representation they engender. The aesthetic would bring black life and black people to an understanding of themselves as subjects of their own discursive and representational fields in social, cultural, artistic, and political engagement. A poem such as Dudley Randall's "Ballad of Birmingham" quintessentially represents the subjectivized experientiality the aesthetic demanded.

The poem revisits the violence of the civil rights movement in order to retrieve radical meaning from an extant, unifying crisis. The innocent voice of a child, who wants "to make our country free" is juxtaposed to the protective mantle of a mother who sends the child to "church" instead (King 233). Recalling the collective suffering endured at the hands of white supremacists, it evokes the four little girls killed at the Sixteenth Street Baptist Church in Birmingham, Alabama, and allows for the "saturation" in black life that Stephen Henderson (1973) marks as an aspect of the aesthetic (63). Implicitly,

whiteness is given all of the terror Burke conferred on blackness through images of the "explosion" and the mother racing through the streets and clawing through "bits of glass and brick" (King 234). The poem ends with the mother lifting a shoe and saying, "here's the shoe my baby wore, / but, baby, where are you?" (ibid.), validating the ubiquity of bell hooks's charge that blacks in the United States endure whiteness as a "terrorizing imposition, a power that wounds, hurts, tortures," a position unimaginable to whites because they believe that blacks share the fantastical representation of themselves as innately good ("Representing Whiteness" 341).

A ballad form evokes feelings of sentimentality and melancholia, thematically focusing on a lost or erring love, and at times it becomes a moral tale or ode to lost youth or innocence. The bluesy evocation in this ballad shifts its tonality to register and sound like a death dirge. Building on a combined musical and literary tradition, its stresses on black life, even in its most despairing moments, forms the cutting-edge articulation of the BAM's aesthetic vision. A poem such as the *Ballad*, when addressed to black people, demands collective identification and repositioning as an agent ready for revolutionary change, since, whether or not one was involved in the movement, none were safe or exempt from its violence. When addressed to whites, it also demands transformation in subjective identification by developing an empathetic relationship with blacks through the "terror" they face. This tangential and tenuous identification becomes even more complex because it is predicated on acknowledging white complicity or active concourse within this oppressive paradigm, even if one has never committed a racist act or had a racist thought.

The BAM's Beginnings

The BAM was born in the political interstices of the civil rights movement and the African liberation struggles. Its first strivings were heard after the assassination of Patrice Lumumba, in 1961, and it received its final incubatory thrust with the assassination of Malcolm X in 1965. Malcolm was seen as the epitome of resistance, says Amiri Baraka, due to the way he influenced and was inflected into the movement: "We wanted a Malcolm art, a by-any-means-necessary poetry. A Ballot or Bullet verse. We wanted ultimately, to create a poetry, a literature, a dance, a theater, a painting, that would help bring revolution!" (Baraka, "BAM" 502). Malcolm's message of "Self Determination, Self Respect, and Self Defense" was a mantra for art-ists to engage with the people in a fundamentally different context

compared to aesthetic movements such as the Harlem Renaissance or the negritude movement (ibid. 496). The BAM's poets gave homage to these important precursors, creating a palimpsistic relationship by overwriting the intrinsic blackness of Leopold Sédar Senghor as well as Claude McKay's desire to be perceived as a poet, not a black poet, yet also making central Langston Hughes's engagement of art with the culture, language, and music of black folks.[7]

Malcolm, however, embodied the ideals of the revolutionary that the BAM envisioned. He was *power*, of the word, of the self, and of the people. He was *Blackness* manifested in his verbal virtuosity and his intellectualism. When Malcolm spoke, when he denounced white racism, he did not speak for himself or for the Nation of Islam; he spoke for the collective spirit of repression that black people faced in America. For this, he was the prophet of the BAM. He sparked the affective energy of art as a form of willed resistance, a dedication to the struggle for the liberation of black peoples from their nullifying and stultifying beliefs in white supremacy, to the omnipresence of white supremacy in their lives. Hence, Baraka's tripartite aesthetic charter formed a template for the BAM's imbrication of art and politics; his call for a true Afro-American art, the creation of a "Mass art," and "an art that was revolutionary" constructs an ideal of political engagement between the poet and the people (Baraka, "BAM" 502). Malcolm's death thus propelled the movement forward, and a month later Baraka moved to Harlem and created the Black Arts Repertory Theater/School (BART/S) (Sell 59; Smethurst 171).

To date the inception of the BAM is difficult, since it was a hydra-headed movement formed within diverse locations and through multiple organizations. Urban centers from Los Angeles, Detroit, Chicago, New York, New Orleans, and Philadelphia contained principle members who were attached to community-based political and cultural programs. However, it is commonly agreed that its institutional beginning was on April 30, 1965, with the founding of BART/S. Baraka, leaving the avant-garde, Beat scene in Greenwich Village,[8] established residence in Harlem and created the repertory company that reflected a new imbrication of aesthetic and political commitment to the black community. In its transnational formation, platforms of local groups such as the Black House in the San Francisco Bay Area, the Muntu reading group in North Philadelphia, and the Umbra Poets Workshop on the Lower East Side in New York provided the space for poets, musicians, critics, and activists to come together to debate the all-pervading questions regarding the

source and objectives of black artistic production (Sell 59–60). Out of BART/S came the seminal articulation of this new era of creativity, which enjoined its artists to return to the black community, to dialogue with it, and to produce art from within its context. In the eyes of the artists, the movement was not just a project of articulation, as Philip Brian Harper (1993) suggests (238–39), but one of reflection, reflexivity, and representation. And as Baraka attests, it involved folks from all different venues:

> There were cultural nationalists of all persuasions. Left Right & Centrist. Some as radicals some as progressives some as revolutionaries some as political Black some as mystical-spiritual Black. Some as Pick-Up-The-Gun Blacks, most as Hate Whitey Blacks. We had the most unity on that, that being Black meant despising as openly as possible ALL White People, Groucho or Karl. (Baraka, "BAM" 501)

Implicit in this collective is the sense that whiteness is power and blackness is powerlessness, for it is imbedded within and through every discursive and representational field in the global sphere. The desire and beguilement of Eurocentric paradigms become the points of confrontation and refusal. Because of the ubiquity and normalizing functions of Eurocentrism, whites can suppress or censor their knowledge of and relation to the histories and actualities of anyone they choose. They do not have to "see"[9] the black subject; they naturally defocalize from black cultures and social realities because of their socialization, and when they do allow blacks to be visible, that visuality maybe so disturbing that they deliberately block any associative capacity. The death of the power of whiteness to sanction and determine social relations and cultural constructs may have been the overarching commonalty of the writers of the BAM, but how that would be accomplished was a subject of debate, and it expanded into their poetic articulations. The pivotal ontological inquiries were, What is Blackness?, What is Black Art? And, what is a Black Aesthetic? (Baraka, "BAM" 499).

One answer came out of Baraka's poem "Black Art," which, at first, appears as a blatant antiwhite diatribe, but its denunciatory stance extends to all who impede black empowerment. When he states, "We want live / words of the hip world," the poet specifically positions himself in the psyche of the unvoiced, unnoticed black object who has never expressed his dislocation, dehumanization, and daily denigration in a white hierarchy (Jones, *Black Fire* 302). It could be the voice of the shoe-shine man, the garbage man, the janitor, or the lawyer

next door, who represses his personality and his subjectivity, knowing that an agentative, black speaking subject is considered a threat in the asymmetrical power divide of US race relations. The black object of the white gaze now refuses objectification and becomes the speaking subject of his own liberation, wanting "Assassin poems, Poems that shoot / guns" (ibid. 302). The poem is an explosion of rage. It is the venting of 500 years of color-coded frustrations. No one is exempt from that rage. Hence Jews, as the owners of property, the slumlords who benefit from the poor, become de-ethnicized signifiers of white exploitation; so, too, are the police who should represent justice but are often instruments of brutal repression. The mulatto who wishes to embody whiteness and the black politicians who kowtow to the political dominant are members of the petit bourgeois, who Baraka sees as "impediments to ideological clarity" (Baraka, "BAM" 500). Using onomatopoetic devises in the poem, such as the repetition of the "r" sound in "rrrrrrrrrrrrrrr" to reflect the airplane buzzing and the "tuh" as in "tuhtuhtuhtuhtuhtuhtuhth" for the shooting of a machine gun, allows for symbolical explosions on paper and in performance. The poem's crescendo impels the cathartic expression of black outrage. It licenses a vicarious pleasure in striking back at supremacist acts without actual physical engagement. Symbolically combating and punishing oppression, it prevents actual explosions in the public realm.

Then, subtly, Baraka assumes another mien to manipulate the identificatory processes of the reader/listener. Transfiguring from an offensive, denunciatory invective to a paradoxical call for universal love, the poem is a series of postures that ultimately reveals and reflects its rhetorical strategy. Blurring the distinction between performance and political action, it is a moment of profound psychological self-reflexivity, predicated on James Smethurst's characterization of the movement's "ventriloquism of the black speaking subject" (71). Utterance of revolution is conceived as an empowering act within itself, but it presupposes a subjective and objective alignment, illustrated by the closing mantra of a collective engagement between Black Power, Black People, and Black Art. The collective identification calls for a refiguration of the power dynamics, in both its internalized and externalized dimensions, demanding the resistance that Gramsci (2007) presupposes in his struggle over ideological hegemony. In an ironically Kantian manner, Neal declares that the BAM believes that "ethics and aesthetics are one" (*Visions* 65), with the imperative to confer black "self-determination and nationhood " (Neal, "BAM" 184).

The protean strivings for a transformative poetics in "Black Art" generated mediated responses to revivify and validate its rejection of hegemonic structures. "Two Poems," by Haki Madhubuti (aka Don Lee), antiphonally rejects, recodes, and amplifies Baraka's call for revolutionary change:

last week
my mother died/
& the most often asked question
at the funeral
was not of her death
or of her life before death
 but
why was i present
with/out
a
tie on.

i ain't seen no poems stop a .38,
i ain't seen no stanzas break a honkie's head,
i ain't seen no metaphors stop a tank,
i ain't seen no words kill
& if the word was mightier than the sword
puskin wouldn't be fertilizing Russian soil/
& until my similes can protect me from a night stick
i guess I'll keep my razor
& buy me some more bullets.

 (332)

The poem's two stanzas, at first, appear antithetical, but their commonality lies in their disruption of perceptions. The poem becomes a quintessential representation of the stylistic congeries of the aesthetic in transposing the performative to the written page. Its displacement of a capitalized "I" for its lowercase equivalent "i" tells of the desire of the speaking subject, the poet, to be part of the black collective, the common masses. Recoding the "tie" as an epiphenomenon, a visual signifier of whiteness and the respectability it connotes, the poem attacks the standardization or the unthinkingness of master-coded behavioral practices. Dispossession by the poet of this cardinal symbol radiates his freedom from the disease of whiteness interiorized by the self and the black community. Juxtaposed in the second stanza is the poet's quest for expression of this radical subjectivity. Here, Madhubuti stands in direct opposition to Baraka's call for an active poem, a poem that kills, and the pragmatics of his riposte

is undeniable because poetry, alone, cannot stem brutal, physical repression. Poetry can free the mind, he implicitly suggests in the first stanza, but the revolution must transform from the nominal to the active and corporeal to effect real change.

To Refuse and Resist: BAM's Aesthetics

The BAM's ontology revolves around what Stephen Henderson considers the *mascon*, the massive concentration of black experiential energy, activated through specific phrasing or terminology that has a definitive psychological and emotional impact (44)—the source of the entelechy of blackness. The aesthetic quest, however, extends beyond the cultural boundaries of African-American life to relationally and geographically encompass an African past rediscovered through explorations of West African orality and to connect to the Yoruba religion coming out of Cuba, Buddhist philosophies, and Islam, as propounded by Malcolm X in his incubatory stages with the Nation of Islam (Collins 16). Its revolutionary ethic, connecting with African liberation struggles and struggles around the Third World for liberation, find similitude in the discourses of Fanon, Nkrumah, Che, and Mao (Ako 97–99; Baraka, "BAM" 495–96). Its rhetorical focus may seemingly access differing aspects of liberation struggles, but the source of its stylistics, Henderson confirms, are consciously and unconsciously taken from black music, as seen in spirituals, shouts, jubilees, gospel songs, field cries, blues, pop songs, and jazz, and in black speech from oratorical patterns developed from the textures and timbres of the voice in sermons, toasts, the dozens, rapping, signifying, and the oral folktale (20–21).

Criticism of the movement ranges from its overt politicization (Gates 1987; Baker 1988); to its narrowly defined cultural nationalism (hooks 1995; Harper 1993); to its hyperbole and ethnic and gender chauvinism (Smith 1993; hooks 1995). None of these criticisms acknowledge that the BAM's plurality of voice causes it to be one of the most self-reflexive and theorized movements of its time. It develops through intersubjective voicings to wrest existential control of the significance of blackness that dates back centuries, and continues to engender a disempowering system of representations and actions from the dominant culture. Multiplicious constructs of the textures and contours of the aesthetic spawned a series of theoretical positions by the BAM's artists and activists, now concentrated in the text *The Black Aesthetic* (1971). These artists defined the aesthetic according to their particular directive, but the commonality of formulations

is in its "symbolism, mythology, critique, and iconography" (Neal, *Visions* 62).

More recent theorists, such as James Smethurst (2005), argue that the BAM's artistic conception creates a singularly, American avant-garde because of its futuristic vision. Artists transform the way art is perceived, received, and understood in the significance given to jazz musicians and the blending of motifs from popular cultural forms (68–75). This is the point at which the aesthetic character of Quilombhoje and the BAM combine, for they were both concerned with a radical aesthetic that enacts the future. Avant-garde art, by its nature, disrupts conventions, expectations, and established modes of representation and reception, and Lyotard best provides a theoretical base in which to situate these quests for aesthetic voice and poetic signification.

The avant-garde for Lyotard never loses its ability to disrupt the norm, and its ability to disturb is related to the feeling evoked in the sublime. Lyotard thus extends Burke's and Kant's concepts of the sublime, as the immeasurability of human response to great beauty or horror, to a concept of human limitations in regard to the synthesis of knowledge, reason, and representation. The sublime, in such a reading, is the feeling that indicates the limits of phenomenological thought. It is the unpresentable—that which cannot be presented or represented. The avant-garde attempts representation, which Lyotard names the *differend* and which Toni Morrison (1994) refers to in its most horrific signification as "unspeakable things, unspoken." Although Lyotard speaks to all artistic modes, poetry is a privileged site of representation in the way it destabilizes set meanings. It engages affectively to allow for different modes of reception, interpretation, and influence. Presenting the unpresentable, the emotive, the visceral is the task set by both movements, and each poet in each movement addresses it differently.

Representing blackness becomes both a vision and an impediment in the creative vista of each collective, for how does one define or give a set meaning to a psychic identification borne through a history of suffering? How does collective viscera become phatic will? It becomes an impossibility that lends itself to critiques of essentialism, bounded by the constrictions of language that cannot contain the fulsomeness of the beingness of one's epidermalization. It further spawns the next inquiry—Who is the Black Artist?—which is even more problematic in the Afro-Brazilian psyche and terrain. The poet, activist, and educator Jônatas Conceição[10] defines the artist as one who must "write with a significant conscience about his country,

about the people that live in the country, and about what the people did and are doing [this] is what the literature needs to recall." Jônatas represents the politically aware intellectual whose place and position in society is both problematic and ambiguous, since he cannot possibly write or embody the socially accepted narrative, like all of Quilombhoje's poets.

Quilombhoje's Quest for Voice

The similarities between the BAM and Quilombhoje occur on all levels of signification, from the collectivity in their inception, their quest for voice, their definitional and theoretical strategizing in the face of a Euro-defined literary canon, their imperative of political intervention, to the creation of an imaginative, iconoclastic poetics that signals a confrontation, a departure, and a revisioning of sanctioned social, political, cultural, and literary constructs. Both movements foster a group identity as "black" as an interruptive strategy to counter the ubiquity of whiteness, not simply as essentializing processes but also to engage with the entelechy of blackness as a source, a force, a matrix of cultural formulations, ideals, emotive longings, and political positionings from which to escape the dominant/subordinate. Still, their inventive fusions do offer moments of strategic positivist essentialism, within Spivak's (1996) caveat that such functionality enables political goals (*The Spivak Reader* 214).

The figuration of the black person in Brazil is in some ways more phantasmagoric than it is in the United States, wherein persistent tropes of the *negro velho* or *preto velho* [the old nigger], transformed into more bestial manifestations of the *bicho-homen* [man-animal], the *quibungo*, [the werewolf], and the *papafigo* [the bogeyman]. David Brookshaw argues that the conflagration of blackness and animalism developed from sudden sightings of runaway slaves who appeared wild (Brookshaw 5–6). The demonic Negro could be juxtaposed against other stereotypical depictions of the good slave, *Pai João*, [Father John], the faithful slave, the libidinous Negro, and the mammy. These few fundamental descriptors provide insight into the master narrative on blackness, and Brookshaw further argues that contemporary poetry stands between two discursive divides of branqueamento and *mestiçagem* predicated on the suppression of Afro-Brazilian rights and culture in the nation. Branqueamento, he admits, is a camouflaged discourse without political currency, but its aim to create a culturally and physically white Brazil still lives in the psyche and actuality of both white and black Brazilians. Laterally, the

discourse of mestiçagem, reflected by Carl Degler's "mulatto escape hatch," is a theory of assimilation that allows liberal-minded white Brazilians to select and incorporate chosen values and cultural articulations from the Amerindian and African-descendant population (Brookshaw 277–82; Telles 2004; Santos, "Mixed Race" 1998).

Quilombhoje derives its name from the Quilombo, the communities of runaway slaves who lived as free, and *hoje*, which translates to "today." The Quilombo as a space of resistance to enslavement and Portuguese hegemony stands as an evocative reminder of the courage, self-sufficiency, self-actualization, and organizing force of Afro-Brazilians. Added to its symbolic resonance is the urgency and immediacy connoted in the use of the term *hoje*, a trope to signal a "continuum" of resistance ideologies and the desire for empowerment (Brookshaw 290). The Quilombo, David Brookshaw clarifies, is still an ideal of Africa in its translocated context, a signal of the perseverance of African cultural values (290). It resonates with Abdias do Nascimento's conceptualization of a *quilombismo* movement, conjoining two interrelated sectors from its symbols of maroonage:

> a decentralized socialist form of political and economic organization, complemented by multiracial and pluricultural social organizations respecting the cultural values of all ethnic components and their specific identities…(and) the dynamic preservation, practice and development of the philosophical, spiritual, and communitarian values embodied in Afro-Brazilian religions. (*Africans in Brazil* 108)

Quilombos still exist and are populated by the descendants of these autonomous Africans. Lasting from 1597 to 1694, Palmares was the longest existent quilombo in the slave era and stands as a metaphorical reminder of the autonomy gained through acts of resistance. Although springing from a gathering of runaways, like-minded Portuguese subjects and indigenous peoples joined the community. It then endured as an emblem for the pluricultural community that can develop in Brazil when each sector of the population is recognized and respected, which becomes a rhizomatic leitmotiv for Quilombhoje.

Palmares was more than a community; it was a kingdom occupying a tremendous amount of territory across a chain of mountain ranges in the northeast state of Pernambuco. Divided into smaller communities, each sector had its own leader, and toward its end, Zumbi, the leader of one of the branches, led the final battles against the Portuguese invaders (Luz 321–41; Galdino 1996). As a warrior king, he has become a mythologized figure symbolic of African

resistance and autonomy. The *Dia de Consciencia Negra*, on November 21, is the day to celebrate the end of slavery, and linking to the resistance exemplified by Zumbi, it also becomes the day to celebrate his "immortality."[11] Zumbi has become such an emotive figure in the Afro-Brazilian psyche that to those in the spiritual community, he will gain the status of an orisa. We must understand that the orisas are generated from the concentration and intensity of psychic energy conferred to individuals. The logic then is that if the entire Afro-Brazilian community continues to look to Zumbi as an archetype of resistance, they call on his spiritual energy and thus imbue it with transcendental authority. If Zumbi gains such status, he would be the first orisa born outside the Yoruba pantheon, reinforcing the deliberate use of the Yoruba matrix in the Afro-Brazilian constructions of self because he and the Africans in Palmares came from the Bantu-speaking peoples, the first groups to arrive in Brazil. Already such representations have been forged in memorializing Zumbi,[12] for the monument constructed to him in Rio de Janiero uses the model of the Yoruba, Ori-Olokun.

The Making of Quilombhoje

Quilombhoje developed in 1980 out of a climate of political change for Afro-Brazilians when local and global forces converged to create the movement. Like the effect on the BAM, the political reverberations around the black world from the 1960s, seen specifically in the national liberation movements in Portuguese colonies in Africa and in the civil rights and Black Power movements in the United States, inserted a discourse of race-based solidarity into the Brazilian political terrain and sparked political and artistic responses (Andrews 164). In concert, the economic and political progress occurring during the abertura (1970s) eluded the black middle class in São Paulo, and their combined sense of disillusionment and disenfranchisement led the more politically minded to form the MNU to agitate for greater inclusion.

Paralleling the mutuality between the Black Power Movement and the BAM, Quilombhoje was the MNU's creative arm, the goal of which was to give poetic and literary contours to the burgeoning political voice. The Black Power agenda was to totally transform the political terrain, but in contrast, the MNU's goal is to gain equal economic and political access for Afro-Brazilians. The most comprehensive critique of the MNU arises out of the work of Michael Hanchard, *Orpheus and Power* (1994), in which he lambastes its emphasis on culturalism over political action. It is not often mentioned that Hanchard

(1999) revised his original critique of the MNU's cultural emphasis, seeing within its strategic choice to employ a politics of racial identity a resistant paradigm to engage with Brazil's hegemonic discourse and praxis in relation to its myth of racial democracy. Carlos Hasenbalg's (1992) critique of the MNU appears more relevant today, noting that its emphasis on racism and a black identity, rather than issues such as poverty, classism, and education, leads to its limited impact (159–61). Its attention to racial politics and quest for a collective racial identification appealed mainly to the Afro-Brazilian middle class, and most Brazilians dubbed it a racist group. Relatively isolated from other oppositional political factions, its efficacy, however, is apparent in the ways that organizations such as Quilombhoje, the blocos afros the Bando de Teatro Olodum, and a host of NGO's[13] adopted its critical voice to promote a consciousness that disarticulated the master codes of the dominant culture.

Before its beginning as a literary movement, founding members self-published a series called *Cadernos Negros* [Black Notebooks], which became the vehicle for Quilombhoje's artists in their expansion to major urban centers around the country. While the BAM's poets have been anthologized and are now part of the canon of African-American literature, Quilombhoje's readership is limited to the Afro-Brazilian literati and the academic community because of its deliberate recoding of blackness and its quest for aesthetic voice. A topical examination of Brazil's literary history shows that it was quite common for an Afro-Brazilian writer (whether mixed or black) to become absorbed into the white canon, especially if his or her work lacked a racial focus. Celeste Mann (1995) emphasizes that a writer is not considered Afro-Brazilian if the author does not emphasize his or her blackness (175). Quilombhoje's outsider status stems from its dismissal by the Brazilian literati, because any search for Afro-Brazilian writers today leads to the collective. Due to their profound influence on the growing numbers of Afro-Brazilian writers, various poets have self-published or created individual collections that are published outside Brazil.[14]

Quilombhoje's Continuum

Since the overt expression of a black identity is of little value within the dominant society, the minor critical attention to Quilombhoje disparaged its political content and racial orientation. Like critics of the BAM, who censured its nationalistic stance, Brazilian critics could not accept a politically motivated literature as literary. Emmauelle

Oliveira overwrites and missituates the political intent of the collective in characterizing the first series of *Cadernos Negros* as having a "careless use of grammar and language" and "overly simplified structure of texts" (*"Cadernos Negros"* 102, *Writing* 68). Yet the critiques of Zilá Bernd (1988, 1987) and Luiza Lobo (1993) construct the field of bias against Quilombhoje by impugning the collective's aesthetic charge. Suggesting that poor education and lack of exposure to literary studies account for the paucity of literary quality in the collective's works, they classify and lambaste the poetry as overtly didactic and moralistic in tone. They discount the collective's stylistic palette in its use of repetitions and the imperative form to convey its intentionally ideological stance, declaring that such devices causes the poetry to read more like a lament, a complaint, or a political treatise (Lobo 175–86; Bernd, *Négritude* 129–30). Yet this initial reception is part of a tradition of negativistic criticism of Afro-Brazilian poetry, undoubtedly stemming from the combined racialist profiles and "unthinking Eurocentrism" of white Brazilians, who valued Parnasssian and Symbolist aesthetics over the epic form of the collective. The effect, according to Márcio Barbosa, one of Quilombhoje's founders, was that the collective doubted and questioned whether a black person could even make art, but he also attests to the salutary freedom when they continued to do so ("Private Space").

A contrasting critical voice came from Antonio Risério, who revisits the Brazilian canon from the nineteenth century and argues that its reverence and emulation of Romanticism as a writing system discounts its awareness of a predated canon of African orality that traveled to Brazil with the enslaved (*Textos* 84). What Risério does that other scholars do not is examine Candomblé as a source of literary knowledge for Afro-Brazilians, paying particular attention to the tradition of the Yoruba *oríkì*, the praise poem, in his revisionary treatise (*Textos* 84–85; *Oriki Orixá* 1996). Discussing the appeal of poetry as both oral and performative to the disenfranchised, Jônatas Conceição suggests that most Afro-Brazilians have "knowledge about Brazilian oral literature, from an African perspective." Resultingly, their approach to textuality comes from a sonic engagement rather than a scribal one. If the orality found in Candomblé also influences Afro-Brazilian literary production, the tendency would be to develop an enunciatory, performative style that subtends the potency of the spoken word. This is most evident in a book launch by the collective; comparable to the opening night of a theatric event, it unfolds through staged recitations from the collection, drumming, singing, and orisa-based dances in elaborate costumery.[15] Such events mark the importance of Quilombhoje as both a literary and a political

movement, because everyone who is involved in Afro-Brazilian activist culture attends the opening.

Rather than limiting their creativity to the singularly subject/object identification, connoted by Barthes (1977), in the writerly/readerly text, Quilombhoje generates an interactive, performative, community-based, participatory experience that they hope reverberates in mindspace long after the performance. Márcio Barbosa's poem "Se o Oppressor Diz" is an example of the revisionary, enunciatory nature of Quilombhoje's discourse:

> Quando o oppressor
> Diz "negro!"
> Quer dizer feio
> E burro e pobre no meio
>
> Cada sílaba de aço
> É o mesmo velho cansaço
> As entrelinhas sabidas
> Antigas dores e dividas
>
> E se ele fala "Moreno!"
> É conversa que cansa
> Murmúrio de velho desprezo
> Ouvido já em criança
>
> Nós que somos parte
> Dizemos "negro!"
> Não só como quem dança
> Como quem tem arte
>
> Dizemos "negro!"
> Como quem perdeu o medo
> Como quem tem um segredo
>
> Falamos da força vital
> Que é a nossa teia
> Cantamos o axé ancestral
> Que está em nossas veias

<div align="right">(Cadernos Negros 27 112)</div>

[When the oppressor / Says "black!" / he means ugly / and in the midst stupid and poor / each steely syllable / is the same old tired between the lines knowledge / (of) old pains and debts // And if he says "Moreno!" / It is that tired conversation / (the) murmur of old contempt / now heard in children // We who are part / We say "black!" / Not only as dancers / [but] as someone who makes Art // We say "black!" / as someone who has lost the fear / As someone who has a secret // We speak of the vital force / That is our web / Sing the ancestral axé / That is in our veins.]

Barbosa, in addressing the binary of white/black domination, contextualizes the aesthetic signification of the term *Negro* and alludes to the myth of racial democracy by differentiating the term from *Moreno*. Unlike Walter Benjamin's assertion that across time perceptions change, Marcio attests to the next generation,"as crianças" [the children], educated to perpetuate the myth. The dichotomy between ignorance and knowledge in the poem allows for the assertion by the agentative Afro-Brazilian subject, "Nós que somos parte" [We who are part]. Affirming their right to be part of the nation, the combination of ancestral energy and spiritual force enables them to make art. Constructing a rootedness outside the Brazilian chain of signification, this link to ancestry generates a redemptive blackness that must be proclaimed, for how else does one begin the project of social and psychological reorientation necessary to effectuate the desired change regarding blackness in social perceptions and national discourse?

Nonetheless, the critical disclaim had impact and prompted a dialogue between Quilombhoje's poets and their canonized predecessors, such as Castro Alves, Lino Guedes, Solano Trindade, and others, to include poetic movements such as *Concretismo*. Concretismo relies on the abstraction of the word through graphic representations, use of typographical designs with variegated colors, shifts in fonts, word repetition, and positioning to shape meaning and intent. It generates, Oliveira states, a constructive and deconstructive binary in its visualization of verbal codes (179–80). An example is found with Jamu Minka's poem *"Crespitude"* [Nappyness]:

<div align="center">

Olho por olho
dente por dente
recuperamos o pente
ancestral
o impossível continha o bonito
caracol
carapinha
bumerangue infinito

Olho que revê o que olha
dedos que sabem trançar idéias
do original azeviche
princípio do mundo

Se o cabelo é duro
cabe ao pente ser suave serpente
o fundamental dá beleza
a quem não tem preconceito

</div>

e conhece segredos da
C R E S P I T U D E

<div align="right">(Melhores Poemas 74)</div>

[An eye for an eye / a tooth for a tooth / we retrieve the ancestral / comb / the impossible has within it the beautiful / coiled / kinky / infinite boomerang / the eye reviews what it sees / fingers that can braid ideas / from the original blackest black / origin of the world // If your hair is nappy / it combs like a smooth snake / the essence of beauty / for those who aren't prejudiced / and know the secrets of / NAPPYNESS].

Minka uses the texture of black hair to signify racial perceptions; placing the letter "c" in bold font, aligning it vertically, and capitalizing the term *crespitude* make hypervisible the stereotypes about the black being to debunk their aesthetic charge. The question the group faced was, were such stylistic innovations enough to convey the collective's mission to transform consciousness? Sônia Fátima da Conceição attests that "the urgency of our situation, on all levels, demands from us a particularly combative literature, a literature concerned with social change, because without it, [literature] for us doesn't have a reason to exist" (*Reflexões* 88). In a weekly fora of poetry readings and intellectual debates, they struggled together over the definitional parameters of their radical subjectivity.

Women and Quilombhoje

Part of the complexity of Quilombhoje is that it emerges at the complex intersection with the burgeoning feminist movement. Similar to the BAM, the gender integration of the collective came with multiple contentions (Oliveira 2008; Afolabi 2009). Women in both movements faced the same spectra of invisibility, for the dialogic and activist injunctions of feminism privileged white women, and the black movements reiterated the hegemonic stance of "patriarchy as a master narrative," as characterized by bell hooks, which Afro-Brazilian poet and activist Sonia Alvarez denotes as a presumption that "'race takes precedence over gender'" (hooks, "Postmodern" par. 5; qtd. in Oliveira, *Writing* 166). Lisa Gail Collins (2006) makes a brilliant argument for the intertwining of the Feminist Art Movement and the BAM in the United States, suggesting cultural corollaries in their shared utopian visions, their drawing on the same theoretical reserves, use of the same patron saints, and advocacy of the processes

of awareness and consciousness (281). A minor overlap in the claimant positions of some artists,[16] however, does not dissolve the dominant positions of white women in the arts or nullify the repudiation of the BAM's hypermasculinity and sexism. James Smethurst, nonetheless finds a redemptive feminism in the BAM and argues that the operational endeavors of its female participants, who dissent from inside the movement, shape its avant-garde character (84–89). What occurs with Quilombhoje is that in finding their voices the women have received more critical acclaim than their male counterparts (Afolabi 2001; Alves 1995; Durham 1995; Mann 1995), and politically, they have formed myriad collectives and social networks to focalize on their specific issues (Carneiro 1999).

Across the continental divide and its relational perspectives, the women of Quilombhoje, in voicing their oppositional and liberatory canvas within the collective, developed a self-generative narrative of female empowerment. Lacking canonized predecessors in the Afro-Brazilian literary terrain, the BAM's female artists become their natural foremothers, and none more so than Sonia Sanchez (Sterling 2008). Sanchez's signature style, modeling the abstraction of Concretismo but with a definitional focus on black female subjectivity, marks an inspirational, generative source for the combative literature that Sônia Conceição envisions. The graphic motif is not always successful on the written page, but the concept of extending the performativity of the work from an oral space to the scribal prompts such meldings as seen in her poem "Queens of the Universe." Its typography makes it difficult to read, but once the rhythmic cadence of the poem is internalized, the voice it triggers performs the poem in the subconscious just as if it were recited in a public space, generating a dialogic monologue filtered through reader receptivity and perception. Sanchez inverts the horror felt toward the black woman encoded in Burke's concept of the sublime with lines such as "this cracker wuz driving saw him look / sniff a certain smell and..." (Sanchez 186). The driver turns "his head in disgust" to complete his objectification of this black woman, but she inverts her positioning as a denigrated object of his gaze and, even more derisively of the olfactory senses, revels in her power to disrupt consciousness with her "strong/blk/smell..." (ibid.). The elision of the signifier black (blk), the fragmentation of lines, and the syllabic extensions doubly rupture the textual arrangement and the world in which it exists, for Sanchez dismantles the centuries of abnegation of "big/ass/blk/ women," (ibid. 187) whose coded bodies suture white normative standards yet are the objects of secret

desires and fantasies hidden behind the gazes of contempt (Young 1995; McClintock 1995; Gilman 1985). Sanchez's black woman challenges the gaze's affective currency on her psyche and the construction of her subjectivity. When she embodies her "smell of the nile," queen of the universe frame, her empowered self-reflexivity combines with her self-representation as the agent of her own discourse (Sanchez 187).

Such experimentalism registers in the earlier work of poet Esmeralda Ribeiro. Her use of typographic abstraction and graphic representation in the poem *"Mulher"* [Woman] reconstructs the term and the coding of womanhood through the prism of an inverted triangle, a figural pubis on the page:

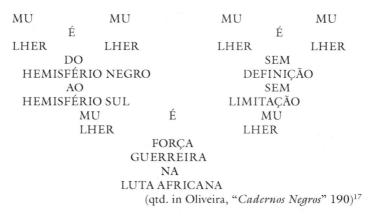

MU MU MU MU
 É É
LHER LHER LHER LHER
 DO SEM
HEMISFÉRIO NEGRO DEFINIÇÃO
 AO SEM
HEMISFÉRIO SUL LIMITAÇÃO
MU É MU
LHER LHER
 FORÇA
 GUERREIRA
 NA
 LUTA AFRICANA

(qtd. in Oliveira, *"Cadernos Negros"* 190)[17]

The fragmentation of the term *mulher* speaks to the fragmentary identity of the black woman in the process of constructing her own identity. Evolving from separate but interrelated spheres of influence, in the conjunction of past and present, "from the Black hemisphere / to the Southern hemisphere // Without Definition / Without Limitation," her bilateral generative source is the font of unlimited potentiality. Ribeiro figuratively transforms the embodied struggle onto the written page, and by the end of the short poem, her *mulher* transcends her incubatory fissures. Descriptors such as "Force / Warrior / In the / African Struggle" evoke the spirit of Dandara, the female general who was Zumbi's right hand in the building of Palmares.[18] Such motive power allows her to become the agent of her own discourse and identity and, in embodying the subject position, insists on a particular way of being in the world that extends outward to transform her field of representations.

The Imperfect Narrative

Members of Quilombhoje, however, found that these aesthetic exper-
imentations could not fully represent their politically charged intent.
Returning to their original maxim of content over form, they found
that their grammatical and syntactic imperfections carried the weight
of their political engagement; therefore, the texts are the doubled
signifier for their resistance, not just of the present-day oppressive
and offensive representations of the black subject, but also of their
history of negation. Clyde Taylor suggests that resistance is formed
around the "imperfect narrative," for it gravitates to the unconven-
tional, imprudent, and anarchic. Outside the purview of conventional
functioning, it doubles and decodes received knowledge. Its intention
is to reject set definitions and redefine its own categorizations (*Masks*
254–61). This imperfect form best describes the aesthetics of both
movements in the ways the artists re-vision and redefine language,
syntax, and structure to illustrate their politically charged intent and
content. Inflected into the early criticism of Quilombhoje's imperfect
narratives is the accepted belief that blacks are uneducated and illiter-
ate and, as such, cannot speak the Portuguese language correctly. Zilá
Bernd overcomes these preconceptions and attempts to construct an
aesthetic architecture for Afro-Brazilian poetry, admitting that "it's
difficult to speak of a Black poetic discourse for the simple reason
that each text is the bearer of specific (literary) strategies" (*Négritude*
132). Her characterization of the stylistic contours employed by
Quilombhoje, thus far, best describes its imperfect form.

Definitional constructs include its use of an *eu-enunicador*
[I-enuniciator] to nullify the distance between the self, as speaking
subject, and the recipient in order to create a unified "us"—a com-
munal voice that reveals what it is *to be in the black world* (*Négritude*
134). Articulatory thematics include the creation of a black epic or a
black cosmogony that establishes a historical relationship to Africa as
the source, with the aim of destroying the stigmatization regarding
themselves and their origin. In tandem, it generates new mythic para-
digms that exalt the *Quilombolas* and laud heroes from the struggles
against oppression. It creates a new symbolic order regarding the per-
ception of blacks and blackness by reversing the gaze and interrogating
white subjectivity and perception. The poets theorize within the text
through inclusions of a preface, epigraph, notes, and critical materials
about the authors and their works (*Négritude* 134–38; *Introdução*
86–92). The result, Bernd states, "being a poetry-explosion, based
on protest and denunciation of the injustices committed against black
people which still persists today" (*Négritude* 138).

In using the imperfect form, Quilombhoje simultaneously recovers the voice of the Afro-Brazilian underclass and gives it political resonance in order to debunk the authorial claim that white Brazilians hold on the literary canon, the Portuguese language, and, by extension, Brazilian society. Beyond the thematics and the focalization on self as us, as noted by Bernd, the aesthetics of the collective, like Madhubuti's (1971) characterization of the BAM's poetry, revolves around the use of short, explosive, polyrhythmic lines; it incorporates a dimension of musicality that demands that the poetry be performed; it is intense and often revisionary in its depth of signification; it employs irony and signifying but is rarely humorous; its intent is futuristic—it is meant to interrogate, to educate, and to construct a communal consciousness. The collective's questioning of form and content, in what I refer to as their *aesthetics of imperfectability*, must be understood as part of the processes of identity formation. By using Afro-Brazilian speech patterns, the collective incorporates this larger segment of society into its orbit and generates a distinctive language that confers a sense of belonging. This linguistic solidarity lends itself to more active forms of communal belonging that find expression in political form. Critics such as Bernd, Lobo, and Oliviera cannot see these differences because the use of the imperfect narrative is an engagement not just with form and content but also with the tensions brought by the dichotomies between imposed narratives and self-authorized representational paradigms. The effacement of the boundary between art and politics is in the ideological sedition of Quilombhoje's work. They begin to tell their own story and reclaim their sense of agency, and in the process demand recognition that in their blackness they, too, claim a central space in Brazilian canonicity and narrative ideal.

The Perfectability of the Form

Stuart Hall, in "New Ethnicities" (1988), speaks of two overlapping transformative movements, shifting from the "relations of representation" to the "politics of representation" (223–24). The "relations of representation" generate a monolithic counterhegemonic black identity to unify ethnically and culturally diverse communities for political action. Transforming to the "politics of representation" with the understanding that black is a constructed term, it opens debates on the diversity and differentiation among black peoples (Hall 225). Unlike the critics of the BAM and Quilombhoje, Hall's framework recognizes that different aspects of representation are historically laden and located within particular contexts, and he implicitly suggests that the

points of contestation develop organically. The previous poems are involved in the first phase of this discursive encounter, the "relations of representation," in the way that they recuperate and revitalize the demeaned black subject. In order to reach the second phase, characterized by a dialogic interplay between the forces of class, gender, sexuality, and ethnicity, Afro-Brazilians must draw from an equally strong center of identity. Before the black subject can enter into the debate centered on belonging in relations to gender, class, ethnic, and sexual politics, she must disarm herself of the inferiority conferred by her blackness. The relations of blackness have to be reconfigured for the subject to demand a place in the dialogue. A self-negating subject becomes an object of fetishization, stereotyping, and exploitation. A self-aware subject cannot be willingly objectified nor defined by outside political, economic, and personal agendas. A poem such as Oubi Inaê Kibuko's "*Poema Armado*" [Armed Poem] calls on the power of the word, the force of iteration, to transform the world:

> Que o poema venha cantando
> ao ritmo contagiante do batuque
> ao canto quente de força
> coragem, afeto, união
>
> Que o poema venha carregado
> de amarguras, dores
> mágoas, medos
> feridas, fomes
>
> Que o poema venha armado
> e metralhe o sangue-frio
> palavras flamejantes de revoltas
> palavras prenches de serras e punhais…(*Melhores Poemas* 114)

[That the poem will sing / the contagious rhythm of the Batuque / the hot forceful melody / Courage, affection, union // That the poem comes loaded / with bitterness, pain / sorrows, fears / Wounds, famines // That the poem comes armed // cold-blooded shrapnel / flaming riotous words / words filled with chainsaws and daggers…]

The author issues a similar challenge as that found in Baraka's "Black Art," for poetry to activate the struggle, but with a profound difference in its impact on the world and in its reassertion of the imperative of the group. Missing are the vituperative attacks of Baraka's poem; rather, this is a generative narrative, a call to action for the self-authorized and self-actualized individual. The word must

elicit a revolutionary sensibility; it must evoke the "batuque," a symbol of an African continuum. The word must tell of the "amarguras, dores / mágoas, medos / feridas, fomes" [bitterness, pain / sorrows, fears / wounds, famines] of a history of enslavement and discrimination. The word must take concrete form and become "palavras flamejantes de revoltas / palavras prenches de serras e punhais" [flaming riotous words / words filled with chainsaws and daggers...], through which the force of articulation effectuates change. This poem becomes an example of how artists evolve from counter-discursive positionings by directing articulation to the processual work of liberation. Quilombhoje's aesthetics of imperfectability is teleological, whether it is in its articulations of blackness, myth-making, and invocations of the Quilombo ideal, or its declarations of self and subjectivity. Its aesthetics aims to interrupt the ways in which dominant ideologies are imbibed and become self-defining within the psyche of Afro-Brazilians in order to propel the dialogic encounter toward the understanding that blackness is a transitional paradigm in the pathway to empowerment and power. Outside the transformational space, this self-definitional, auto-hegemonic poetic form challenges power and authority.

From Mythmaking to Self-Representation

Rather than seeing the purposeful engagement with African mythos as an attempt to redeem the signification of Africa in the politics of representation, it must be understood as the rightful placement of such narratives in the sphere of human archetypes. In Elio Ferreira's poem *"América Negra"* [Black America], the poet reconstructs the denigrated status of blackness in the Americas by showing that its source, Africa, is the source of all life. Africa, as a generative referent, transforms from soul source to the birthplace of humanity in its doubling and signifying on biblical mythos and Yoruba creation stories:

> Américas,
> Adão era negro
> Eva era negra
> Adão e Eva nasceram na África.
> Américas,
> Eu também sou negro.
> Adão e Eva no jardim do Éden.
> Sou filho do barro
> Filho da lama escura da Mãe África:
> A primeira mulher

O primeiro homem neste Dia da Criação.
Américas,
Eu sou negro:
A Matriz da raça humana.
Conta a lenda
Que Nanã tirou uma porção de lama
Do fundo das águas de uma lagoa, onde morava
E deu o barro a Oxalá
E do barro, Obatalá criou o homem e a mulher.
O sopro de Olorum fez os dios caminharem
E os Orixás ajudaram-nos a povoar a Terra.
Um dia, a mulher e o homem
Voltarão ao pó
Voltarão ao barro, à lama da Terra
À casa de Nana Burucu.

(Cadernos Negros 27, 50–58)

[Americas, / Adam was black / Eve was black / Adam and Eve were
born in Africa. / Americas, / I am also black. / Adam and Eve in
the Garden of Eden / I am son of the clay / Son of the dark mud
of Mother Africa: / The first woman / The first man in this Day
of Creation. / Americas, / I am black: / The matrix of the human
race. / Tell the legend / That Nana threw a bit of mud / to the
bottom of a pond of water, where she lived / And gave the clay to
Oxala / And in the mud, Obatala created man and woman. / The
breath of Olorun made the two walk / And the Orisas helped us
to populate the earth. / One day, the woman and the man / Turn
to dust / Turn to mud, the mud of the Earth / The house of Nana
Burucu.]

The second stanza generates a palimpsestic relationship with the first, to
recontexualize an African mythopoeic narrative as the explanation for
the universal source of creation and life. Invoking Yoruba myth in the
way that the orisas, Nana, Oxalá, and the supreme being, Olorun, cre-
ated life, he gives credence to this matrix as a source for a transcendent
blackness. Black in this ideation, as in the Yoruba color-coding system,
is the beginning of everything. Yet ultimately, the poem is a diasporic
narrative of exile, loss, and longing, not for Africa but for the subject's
sense of belonging in the Brazilian nation as an African-descendent:

Brasil
Meu Brasil Brasileiro.
Sempre fui seu amigo
Ouça bem o que lhe digo:

Mais cedo ou mais tarde
Você toma vergonha
Nessa cara mal lavada
E fica bonzinho pra mim
...
Sou filho de Ogum
Oh, Deus Guerreiro!
Oh! Senhor do ferro e ferreiro!
Brasil,
...
Brasil,
Ainda gusto de você
Todas as noites
Sonho com o Paraíso Perdido

(57–58)

[Brazil / my Brazil Brazilian / I was always your friend / Listen
well to what I say / Sooner or later / You are ashamed / of this
badly washed face / And it is handsome to me /.../ I am the son
of Ogun / Oh, Warrior God! / Oh! Lord of iron and the forge! /
Brazil, /...// Brazil, / I still love you / Every night / I dream of
Paradise Lost]

The poet revises his positionality in the Brazilian narrative and the
nation. His dream of the "Paraíso Perdido" [Paradise Lost] is the
dream of inclusion, a willed future for "Meu Brasil." He evokes his
orisa Ogun, the warrior, the builder, and the master of the forge, who
brings the tools of civilization to humanity (Barnes 57) in order to
shift the positionality of blackness, making it a source of power in the
Brazilian national narrative. His roots are indeed in Africa, but his
reality and future is in Brazil.

The Quilombo Continuum

The term *Quilombola* evokes maroonage, an escape and an exile that
leads to greater freedom. "The Quilombo is flux, dynamic, regenera-
tive," states Márcio Barbosa, "but also symbolizes the location of the
preservation of ancestrality" ("Private Space" 4). Poetic mythmaking
marks the Quilombo as a center and centric space, where all identities
and traditions converge, find concordance, and live in harmony. Its
synergy allows for a discursive newness that persists in a multirooted,
hybridic stance in which all traditions coalesce. The Quilombos incor-
porate and reconstitute indigenous and European contours under an
African homogenizing rubric. In this narrative, African thought and

life are the frameworks that determine hybridization in a horizontal-izing trajectory. In the poem "Memorias," Palmares is a relocated Africa, as Brookshaw suggests, in all its idyllic and bucolic fabrica-tions, but is used to generate a quasi-mythic, semi-futuristic gaze into what the world could be:

Memórias
Queria ver você Negro
Negro queria te ver
Se Palmares ainda vivesse
Em Palmares queria viver
O gosto da liberdade sentido
Gravado no peito, correr, sentir os campos
Campos ter a vida terra de negros
Livres ali toda a vida, toda a raiva
Toda a raça, toda a vontade, África
África tão subitamente roubando os sonhos,
Tão subitamente assinados
Liberdade tão subitamente trocada pela escravidão,
Negro correndo livre,
Correndo e plantando por lá,
Se Palmares ainda vivesse
Em Palmares queria estar. [19]

[Memories / I want to see the black man / black man I want to see you / If Palmares still lives / in Palmares is where I want to live / Loving the feel of liberty / Carved in the chest, running, feeling the open country / To live life in a black country / Free from all [the cares] of life, all anger / All races / All free, Africa / Africa too was suddenly robbed of its dreams / It too was suddenly branded / Freedom too was replaced by slavery / Blacks running free / Over there, running and creating / If Palmares still lives / In Palmares is where I want to be.]

Memories frame the narrative structure of the poem, the ancestral memory of freedom, and José Carlos Limeira evokes the natural-ness of blackness to divest any power given to color-coded racism. The statement, "Se Palmares ainda vivesse / Em Palmares queria viver" [If Palmares still lives / in Palmares I want to be] captures the nature of the chimerical, utopian longing. Palmares is a dream; it is the "imagined community" of diaspora longing, the space where one lives free, in concert with all like-minded peoples. Such a space has never existed, but the pluricultural model that this runaway commu-nity evokes is the ideal signification of what Brazil could be. In the

politics of representation, the self-actualized Afro-Brazilian refocuses the Quilombo space as one of ancestral belonging, where acts of communal liberation bring together the dreams and hopes of all the segments of Brazilian society.

In these narratives of social and cultural acceptance, Jônatas Conceição's poem "*No Nordeste Existem Palmares*" [In the Northeast Exists *Palmares*] imbricates the past and present struggles for Afro-Brazilian self-determination:

> Assim dizia um viajante antigo:
> "—Palmeiras, símbolos de paz e sossego"
> No Nordeste, palmeiras resistem.
> Brotam de concretos, casebres, barracos.
> A Natureza mostra força e poesia
> À noite, leves brisas amenizam passadas febres
>
> As palmeiras abundavam no antigo quilombo
> E não foram transplantadas para o Nordeste
> Aqui, junto ao mar de Amaralina
> Novos palmares também crescem
> Arejando cabeças trançadas
> Trazendo novas verdades
> Palmeiras são símbolos de paz e sossego...
>
> (Conceição, *Quilombo de Palavras* 25)

[So said an ancient traveler: / "—Palm trees, symbols of peace and tranquility" / In the Northeast, palm trees resist. / Well-springs of concrete cottages and wooden shacks. / Nature shows its power and poetry / At night, gentle breezes soften the feverish pace / palm trees were abundant in the ancient quilombo / And they weren't transplanted from *Nordeste* / Here, next to the sea in *Amaralina* / New palmares also grow / Aerating braided heads / Bringing new truths // Palm trees are symbols of peace and tranquility...]

Playing on the alliterative quality of the term *palmeiras* [palm trees] and *palmares* [the Quilombo], the palm tree prevails as a metaphor for resistance; its fecundity and pervasiveness stand counter to the modernizing force imposed on the terrain through the "Brotam de concretos, casebres, barracos" [Well-springs of concrete cottages and wooden shacks]. The natural environ conjured offers shade, lends protection, and provides calm in an otherwise bubbling cauldron of troubles. By sheltering the "cabeças trançadas" [braided heads], it is a safe place for the black subject to rethink and revision his or her place and position, but it also compellingly reminds us

that politics, too, is played out in the self-representational canvas of the body where even a hairstyle signals Quilombola ideals. Evoking Nordeste becomes a double-voiced strategy in the poem, playing on both the location of Palmares, in the northeast of the country, and Nordeste, one of the most infamous ghettos in Salvador. Located above the palm tree–lined sea wall of Amaralina, the poem suggests that Nordeste is not simply a peripheral space to be dismissed;[20] rather it is a site for a new consciousness arising, predicated on the unifying vision of Palmares. In linking the struggle of Palmares to the struggles in Nordeste, this often-told story of the Quilombo finds resonance in the social reality of the disenfranchised. The palm trees bring "paz e sossego" [peace and quiet], and provide shelter and shade, invoking the ideal representational corpus of Quilombo life and agency. More so, such symbology denotes a strategic entry into the politics of representation, and the demand for inclusion in all aspects of the Brazilian narrative of identity.

Self-hood and Self-Representation

In many ways the politics of representation demand what Mary Louise Pratt (2008) terms a "decolonizing optic," a gaze that dismantles the illusion of power and position in the act of reimagining subject relations outside subordinate dominant / structures (229). Miriam Alves's *Senhora dos Soís* [Lady of the Suns] is a journey into subjectivity that derives from a profound entwinement with nature over socialization, social categories, and social impositions:

> Sou
>> chama
>>> lama
>>> magma moldado
>>>> endurecido
> Sou
>> naturalidade
>> vento esfriamento dos tempos
> esquecer
>> meu rosto
>>> gusto
>>> não posso!
> Sangro
>> em vermelho
>> em preto
> o choro de todos os dias

Esquecer?
 não posso!
Sou
 o azul infinito
 onde o grito Arroboboi risca um arco-iris
 Sóis me guiam
Sou Luz
 aura da incandescéncia rubra, negra
Sou pedra
 bruta gema diamante engastada na rocha sólida
Ergui voz, cabeça espada

A palavra basta ressoou

 estourou as paredes divisórias

(Cadernos Negros 31 100–102)

[I am / flame / mud / molten hardened / magma // I am / birth-place / the freezing wind / I would like / To forget / my face / I can not! // I bleed / in red / in black / everyday cries / forget? / I can not! / I am / the infinite blue / where greeting *Arroboboi* brings the rainbow / Suns guide me / I am Light / aura of the incandescent ruby, black / I'm stone / hard gem diamond embedded in solid rock / I raised my voice, my head, my sword / The word responded / Bursting the partitions].

The lady of suns is part of the "lama / magma moldado / enurecido" [mud / the molten hardened magma], the elemental core of the planet. She is the "naturalidade" [birthplace], "o azul infinitio" [the infinite blue], the conjoining of sky and water. When she bleeds in red and black, her "o choro de todos os dias" [everyday cries] capture the quotidian aspects of suffering all over her planet. Yet her resilience also derives from the core of the planet because she is "pedra" [stone], the "diamante engastada na rocha sólida" [diamond embedded in solid rock]; her foundational self is built on the most-solidified substances. This poem is also a metaphorical evocation of the power of the orisas, for they are encoded in the natural substances of the earth: the mud for Nana, the motive, procreative feminine force; the greeting of "Arroboboi" that brings the orisa Ochumare, whose rainbow symbolizes a new day; the wind of Iansã that also brings change; and the infinite blue that speaks to the depths of the ocean, Yemanja, the protective goddess of all Brazil. In the politics of representation, the lady of suns is the conglomerate of nature and culture, the auto-hegemonic subject that creates her world. The ending of the poem brings forth this self-authorized, self-definitional woman who "Ergui voz, cabeça espada" [raises her voice, her head,

her sword], to manifest the procreative power that generates the word and the world she envisions.

Conclusion

This relational divide between identity and difference is intrinsically political, and the BAM as a political collective makes connections possible within the disparate relations of black peoples. Reflecting on what binds them—what makes this kinship possible—allows them to create connections that are at times imaginary but nevertheless persuasive, potent, and transformative. Its call for Black Power was just its beginning. Even though this explication of the movement focuses on its poetic texts, it was a movement centered on performance, and the majority of its texts came out of the theater. Its intent was performative and it decried LOUDLY and stridently, we want a black world, and what that world will consist of will be worked out later. Quilombhoje's interrogation begins within such moments of strategic essentialism. These movements do not encode a narrative of the "authentic" nature of black peoples; rather they examine the cultural practices of black peoples, seeing a commonality in the racism faced within the dominant political space that effects every level of representation of what it means to be black—*ser negro*, and finding similarity in the struggles for racial acceptance. They examine African cultural forms that live in history, myth, and religious practice to generate a unified field of aesthetic signifiers from which to construct an artistic imperative. More so, they demand a unification *to* the practice of art that would liberate black peoples. As the imagined objects of aesthetic judgment, as Black Artists, they are not simply reactionary agents but active subjects creating constructs of aesthetics that belie their encoding in the master narrative and its political field. The BAM imagines a Black World, and Quilombhoje desires inclusion into the existent structural framework of Brazil, but they commonly articulate a transformational arch in the self-representation and the self-authorization of black peoples.

Chapter 5

Performing Bodies Performing Blackness Performing Self: The Quest for a Transformative Poiesis

I subjected myself to an objective examination, I discovered my blackness, my ethnic characteristics; and I was battered down by tom-toms, cannibalism, intellectual deficiency, fetichism, racial defects, slave-ships, and above all: "Sho' good eatin'."

Franz Fanon, *Black Skins, White Masks*

Race is fate . . . it is destiny.

Nascimento, *Sortilégio*

The two epigrams above construct a modality for understanding the aesthetic signifiers in Afro-Brazilian theater. Like all discourses of the oppressed concerned with addressing social impediments, theatric arts become a venue in which to recognize race, debate racism, and reconfigure racial subjectivity and agency on the part of Afro-Brazilians. Transposing Franz Fanon's amazingly satirical quip immediately forges a connection between the burden of blackness and the acknowledgement of the pigmentocracy within the national discourse. Juxtaposed against an immutable declaration such as, "Race is fate . . . it is destiny," the signification of the negated Other is redressed within the received and perceived images of blackness and the metaphysical undergirding of Brazilian society by the Candomblé religious matrix. In Yoruba cosmology, choice is the most important component of destiny. One is given a choice of heads in Orun's realm of the unborn, and that choice is metaphorically linked to the effectuation of destiny. Personal agency begins in the spiritual, for that recreated or rebirthed essence becomes the *actional* human being in

Ayé. When metaphysical discourse enters into the realm of tangible space, it confronts ordinary, everyday social constructs and undergoes multiple levels of interpretation to engender understanding. Blackness, then, if we follow the logic within this ontological source, is a choice made in the spiritual realm, and for that matter, so is any affiliation to an ethnic, cultural, and social grouping. This is where we must begin, with Afro-Brazilian theatricality placing its trajectory in the lived choice of blackness, within the desire to transform its pejorative figurations, to destigmatize it as a signifier of a debased essence, and to create a performance template from the configuration of its African ancestry.

Historically divergent, the Teatro Experimental do Negro (TEN) and the Bando de Teatro Olodum exist in different epochs, in different locales, and under quite different leadership, but as the only two self-identified Afro-Brazilian theater groups in Brazil, their goals are remarkably similar.[1] Both are concerned with debunking perceived stereotypes of the black subject, within a quest for an alternate aesthetics that reshapes artistic form, structure, theme, performance style, and spectatorial gaze. The aesthetical challenge, to create a form that arises from the cultural nuances and polyvocality of Afro-Brazilians, engenders a symbiotic reshaping of Candomblé performativity into a model for dramaturgy, with attendant thematic foci on issues of race, racial representation, and class struggle due to the social and political minionship that rings Afro-Brazilian life and culture.

This chapter analyzes two seminal plays, *Sortilégio*[2] by TEN and *Cabaré da Raça*[3] by the Bando, to highlight the points of convergence and differentiation between both groups. It must be noted, however, that the Bando has not received much scholarly attention outside Brazil, and most of what was written in-country has been quite deprecating. This is not at all unusual or unexpected, simply because Afro-Brazilian artistic forms challenge the accepted Eurocentric norms and are often denigrated as developmentally untutored and lacking in aesthetic complexity (Chapter 4). Both groups recode a legacy and invent a tradition of dramaturgy, but the basic premise in this chapter is that the Bando extends TEN's aesthetic interlocution by creating an alternative, avant-garde idiom from an overlapping concourse of discourses on blackness, performativity of the African matrix, and political anticipation. Stylizing its own brand of mimesis in its (re) creation of the lived world of Afro-Brazilians, the Bando's involution of cultural and symbolic codes, in tandem with their political articulation, culminates in what will be called a *poiesis of incarnation*: a catalytic poiesis that transubstantiates the ability of the spiritual

to manifest and transmute circumstance to something that is much more material and substantive, signaling the reconfiguration of the individual self and society, due to the interruptive mediation brought on by the intertwining of the Bando's performative injunctions within the anima of the audience.

The Same Old Story . . .

The earliest roots of Brazilian theater featured a predominantly African/black and mixed-race cast. Only when the Portuguese royal family and, particularly, Dom João VI, the regent at the time, showed interest in the theater did its value as an artistic form gain recognition. Actors came primarily from the African-descendant population because theater was considered a dishonorable profession, only fit for them. With royal approval, the viewing public also changed its stance, and the theatric form became a genre worthy of white participation (Mendes, *Personagem* 3–4).[4] Blacks lost the preeminent place and space when roles previously cast without color boundaries took on racial signification. Reflecting and duplicating the imagery found in popular rhetoric, stereotypes about the immorality and brutishness of Afro-Brazilians, such as "preto imundo, boçal, degenerado, imoral, mentiroso" [filthy, stupid, degenerate, immoral, lying black], were part of the universally accepted language (Mendes, *Personagem* 23). The actor's repertoire was reduced to stock caricatures such as the tragic mulatto, the buffoon, the mammy, and the self-sacrificing slave, and eventually devolved into the freakish spectacle of whites in blackface (Mendes 1993, 1982; Edwards 1975, Turner, "Black Theater" 33–34).

TEN's birth in 1944 launched a new aesthetical-ethical vision for Afro-Brazilians to reconstruct the dominant codes of blackness, both personally and nationally (Edwards 32). Flora Mancuso Edwards asserts that the group, created by a visionary vanguard in Rio de Janeiro, comprising the poet, scholar, and future politician Abdias do Nascimento and five other Afro-Brazilian men, who were "determined to destroy the myth of racial democracy and, most important, determined to demand social justice for Brazilian blacks as blacks rather than as 'potential whites'" (32). Armed with this transfigurative political imperative, the group planned a variety of experimental programs to restore and integrate African values and heritage, and the theater proved to be an ideal vehicle through which to remold perception. TEN became a nurturing source from which to encourage and develop black productions and actors, to place them in roles that

neither demeaned nor obfuscated their African heritage. Drama, as a mirror of society, allows for a (re)educative process, and by transforming the pejorative images through fictive reenactments, TEN hoped to reshape perceptions in the actual.

TEN began its project in a turbulent era of factionalization in Brazilian politics, during the *Estado Novo* (1937–1945), the dictatorial years of the first Vargas regime.[5] Inconceivably, the government was both politically repressive and culturally freeing, banning oppositional alliances and parties yet not interfering in the cultural wars in which the intelligentsia, the politicos, and the ordinary citizens competed over the definitional essences of Brasilidade. TEN, in exposing the pervasive antiblack, anti-African nexus of the myth, offered a public critique that was too revolutionary and subversive for Brazilians but fit perfectly with the time. During the 1940s and 1950s, the black world was experiencing a period of profound change. Anticolonial protests found voice in Pan-African expressions, and aesthetic movements looked to African thought and sensibility for direction. Negritude as a philosophy and an aesthetic movement burgeoned. Black peoples around the globe, separated by both geography and language, began processes of self-analysis with reverberating effects beyond their confines. The budding Afro-Brazilian cultural and political movement was well aware of these international shifting modalities. Blacks, blackness, and Africanness became signifiers from which to evaluate self and society and to reformulate ideals.

Negritude, as an ideology, provided an alternate perspective in which to revision the tropes ascribed to blackness. Since black signified difference in the pigmentocracy of the nation, a crucial step in the recuperative cycle of the black subject was to transform the negative form of difference, imagined by whites, into the affirmative form of difference promoted by this aesthetic ideal. "Race and color differentiates us and we developed a specific sensibility," writes Nascimento, launching the first negritude manifesto in Brazil, but this difference, he inferred, derived from Candomblé culture (*Dramas* 10). For Nascimento, Candomblé offered a natural dramaturgical model, in that "[t]he great religious festivals—models of black vitality—with its liturgy actualized in dance, song and pantomime, are the original and authentic African theatrical forms" (ibid. 10). The intermix of a performative model from Candomblé bolstered the recuperative endeavor of the group and launched the most controversial play produced by TEN, and written by Nascimento, *Sortilégio*.[6]

The theater opened, however, with Eugene O'Neill's play *The Emperor Jones*.[7] Brutus Jones's tragic story, Nascimento thought, was

the ideal bridge with which to introduce the new theater to the public. The seminal change occurred with the production of *Sortilégio* in 1957, for only then did the group broach the dilemma of race in Brazil. It became the first public platform ever to address issues such as interracial marriage, social impediments to Afro-Brazilian mobility, and the role of African religion in the struggle against racial oppression. Unsurprisingly, government censors banned the play, stating that it contained unsuitable language that would only exacerbate the already fraught relations between blacks and whites (Fernandez, "Black Theatre" 11–12; Fernandez, "Censorship" 285–98). With the aid of organizations such as the São Paulo's Theatre Critics Association, it was finally placed in production. [8]

Sortilégio: Sorcery or Mystery?

The play begins with three Filhas dos Santos giving offerings to Eshu, the orisa of the crossroads, who unknots the course of human destiny. Analogically linking the three Fates, who weave human destiny in Greek mythology, with the three filhas, they perform a *rite of reversal* that challenges notions of racial identity and its psychical effect on Afro-Brazilians:

> III FILHA DE SANTO. Nobody chooses the color that they have. The color of the skin is not like a shirt that one changes whenever they want. Race is fate . . . it is destiny.

The ritual offering brings Dr. Emanuel, the protagonist, to face his destiny at a sacred grove, but the filhas are only agents of Eshu, for it is the orisa who has summoned him:

> II FILHA DE SANTO. Can it be that color is destiny?
> I FILHA DE SANTO. Destiny is in the color. Nobody flees from his destiny.
> II FILHA DE SANTO. A black man when he reneges on Eshu.
> I FILHA DE SANTO. . . . forgets the orisas . . .
> II FILHA DE SANTO. . . . dishonors Obatalá . . .
> III FILHA DE SANTO. He deserves to die. To disappear.
> I FILHA DE SANTO. Hard words. Our mission isn't one of anger.
> III FILHA DE SANTO. Eshu trembles from hate, spewing rage, when he ordered: "I want him here, on his hands and knees before the great hour."

I FILHA DE SANTO. Trembling. Not from hate. Eshu only has
 love in his heart. Eshu only does good.
III FILHA DE SANTO. And bad. He also does bad. Eshu's anger
 will fall on his head. Here, when . . .
II FILHA DE SANTO. . . . twelve strokes sound, Eshu walks in
 the streets.
III FILHA DE SANTO. It is the hour for Eshu. The great hour of
 midnight. The hour of frightening events.
I FILHA DE SANTO. I feel sorry for him.
III FILHA DE SANTO. [It makes] hair stand on end. Eshu will
 stop, he will confound time: past and present, what was and
 what will happen. (Nascimento, *Sortilégio* 164–65)

A lawyer by profession, Emanuel is destined to die at midnight for his
transgressions against the orisas: he has mocked Eshu and dishonored
Obatalá/Oxalá. Emanuel also stands at a judicial crossroads for hav-
ing strangled his white wife, but this is not the cause of his impending
demise. The tragedy is that he is contemptuous of his African ori-
gins and cannot envisage its spiritual codings as the path to cultural
integration proven so vital to the empowered subjectivities of black
peoples. Eshu as the guardian of the crossroads and the messenger to
the gods is "the ultimate master of potentiality" (Thompson, *Flash*
190); he thus influences interpretation and choice within the course
of human destiny. Metaphorically opening the door to Emanuel,
Eshu calls him to reckon with his betrayal.

Eshu also acts capriciously in rendering the affairs of humanity
and is often depicted as a trickster who confuses awareness and rec-
ognition, causing individuals to lose their reason and logic by giving
contrary signals. He is the master of disguise and deception, and he
will create conflict in human affairs if not properly acknowledged;
yet Eshu cannot create misfortune without the complicity of his vic-
tim or the intentional provocation by an enemy. As the "guardian of
the ritual process and of sacrifice," Eshu is duality and more, for he
creates chaos and keeps order (Pemberton 68). Like the Derridian
supplement, sacrifice is both an addition and a substitution. Sacrifice
is symbolically given to replace the supplicant; it removes evil or death
from his presence, and such absentia marks a cycle of individual or
societal renewal and regeneration. Eshu is always the first orisa to
be invoked and to receive sacrifice in any mediation between oth-
erworldly forces and humanity. He conveys the sacrifice to the ori-
sas, bringing blessings to the supplicant when it is accepted; if it is
not accepted, death may result. The crossroads, the *orita meerin*,
figuratively encodes aspects of choice and becomes the literal zone

of placement for offerings to Eshu in its conjunction of actual and metaphysical possibilities, for the road one chooses may be the road of destiny or the road of conflict. Emanuel is at the metaphorical crossroads, the point of choice, when he enters the abode of Eshu, but his awareness of fate calling is dulled by his prejudices and perceptions about blackness. Unbeknownst to him, he is subject to the orisa's judgment, and Eshu confounds time and space to untangle his destiny. Evolving through a series of flashbacks, interlaced with contemporary action, Emanuel's consciousness crosses linear time, past and present, until his fatal end.

Fleeing the police, Emanuel arrives in total disarray at Eshu's shrine. Trapped in a delusional state, in denial about murdering his wife, he steps into the web woven by the orisa. Seeing an offering for Eshu at the foot of a tree, he begins a series of desecrations by first contemptuously kicking it with his foot. Adding to the defilement, he characterizes the ebó as "such shit" (166), dually scorning the belief system and the orisa. Staging cues direct the reader to the orisa, surreptitiously watching this violation in the tree above. Evoking Candomblé beliefs, the orisas are visible and tangible to the spectators but remain masked and shadowed to the actors.

Unaware of the presence of the orisa, Emanuel has chosen to forget his ancestry. Raised in white society as a practicing Catholic, Emanuel embodies the strictures of embranquecimento and sees only degrees of aberration within Candomblé beliefs:

> EMANUEL. This is why black folks can't succeed. So many centuries in the middle of civilization and what's moved forward. Still believing in fetishes . . . practicing macumba . . . evoking savage gods. Gods?! By chance can the gods be the thing that [keeps] these ignorant blacks down? Gods this hysteria that eats . . . drinks . . . dances . . . Until they make love in candomblé. Gods! Such ignorance. (167)

Emanuel's disemia manifests in his attempts to mask his own blackness by denying his cultural heritage in order to bridge the differentials between class, status, and culture. Society, however, limits all his choices, argues Eliza Larkin Nascimento:

> Merciless, the ruling society does not allow Emmanuel to fully achieve . . . or to attain higher social status. It denies him full citizenship and the possibility of personal fulfillment, whether in love, profession, social life, or spiritual life. Neither the mask nor the sacrifice of self-denial are enough to free him from being hemmed in, repeatedly

humiliated by the police and absolutely frustrated in his relationship of love and affection. (285–86)

Foundational in Fanon's argument, in *Black Skins, White Masks*, is the black male's desire for affirmation through the white female body, and Emanuel's marriage to Margarida captures these assimilationist desires:

> Out of the blackest part of my soul, across the zebra striping of my mind, surges this desire to be suddenly *white*. I wish to be acknowledged not as *black* but as *white*. Now- . . . who but a white woman can do this for me? By loving me she proves that I am worthy of white love. I am loved like a white man. I am a white man. Her love takes me onto the noble road that leads to total realization. . . . I marry white culture, white beauty, white whiteness. When my restless hands caress those white breasts, they grasp white civilization and dignity and make them mine. (Fanon, *Black* 63)

Polarized entities caught in an exaggerated cycle of redemption brought on by mutual desire, the black male has often been persecuted and violently punished for harboring fantasies about the white female, and the white female has been guilty of overtly sexualizing the black male body. When a white woman, however, marries a black male, this mutual objectification unhinges as the black male symbolically receives validation and elevation. Whiteness in embracing blackness recodes the pathologies ascribed to black masculinity to become safe, desirable, and trustworthy, since the white woman is both the reproducer and purveyor of her peoples and their values.

For Emanuel, killing Margarida symbolically kills the defining power of whiteness to determine his internal and external vectors. Her murder becomes "more of an act of exorcism than it is revolution," suggests Edwards, triggering Emanuel's self-actualization and return to soul-source (*Theater* 206). Like the omnipresence of whiteness, Margarida is a noncharacter in the play world, but her acts and actions manipulate Emanuel's. Through his recollections, the audience learns that Margarida is not the repository of transcendent whiteness imagined of white women but a former prostitute who no white man will marry. An exaggerated dialectic of negation is played out when she aborts their child because she is afraid that it will be born black (192). Violence here is indeed cathartic,[9] and the return to blackness triggered by the murder leads Emanuel to the abode of Eshu, a space he thought safe but that is one of unresolved vacillations, as he recalls his former girlfriend, Efigênia.

Unlike Margarida, Efigênia is both tangible and corporeal, appearing first as the young ingenue that Emanuel loved. Yet this recollection is rimmed by entrenched racism and the inverse overt fetishism of the black female body by the white male. Efigênia suffers an amplified torment; at seventeen, a white man rapes her, thus diminishing and limiting her subjective world. Emanuel's attempt to defend her is met by police brutality and, contrarily, he is sent to jail, an act determined by "the eternal bitterness of color," comments Efigênia (179). The irony of this moment must be suspended from the text. Instead of discarding the falsity of embranquecimento, both Emanuel and Efigênia embrace its antithetical postures. First Emanuel rejects Efigênia and marries Margarida, and when faced with this disavowal, Efigênia becomes a prostitute because, for her, "a Black man is a curse" (180). In this contingent moment, both are overcome by the seeming indeterminacy of fate brought on by disempowering conditions of blackness. They long to transcend the tyranny of circumstance, but the irony of fate is that transcendence comes only through embracing who they are— which neither can do.

Efigênia's self-flagellation is offset by her apotheosis into Pomba Gira, the female embodiment of Eshu's sexual essence, for he is also a manifestation of unbridled sexual energy and power. Pomba Gira is the Madonna/whore complex, an innocent who becomes a prostitute, but reformulated as an archetype of female strength overcoming male victimization or domination (Capone 90). Embracing her spiritual avatar, Efigênia aligns herself with divine will by telling Emanuel, "The only important [thing] was my desire for men. Beautiful or ugly, short, tall, fat, broken teeth. Red or yellow. Everyone served! . . . I carried out a divine order. I performed a liturgical act" (181). Ambivalence girds this depiction, however, for the Yoruba believe that Eshu is the only orisa with purely male energy, and his most popular iconographic representations emphasize his phallic attributes, featuring a long, curved headdress in the shape of a penis. Pomba Gira is a diasporic incarnation, and her profligate libido constructs her apical female sexuality as a symbol of "living copula"(Pelton 108–9). Pomba Gira is also marginal and dangerous, linked to witchcraft and evil acts, and in some ways, she can be likened to the *Iyamis* in Yoruba mythos, the dark mothers who can harm or kill (Capone 90–91). Nascimento, however, evokes Pomba Gira as the principle of pleasure; her rampant sexuality becomes the totality of erotic energy, and her sensual excesses bring balance into a world in which sexuality is coercive and functions as a tool of domination.

However, in twinning the deity and Efigênia, Nascimento unintentionally reinforces the stereotypes of black women's unbridled sexuality. TEN's project is exactly the opposite, for it sought to reframe the aesthetic lens in regard to the black body and being. The group broached the assemblage of blackness, beauty, and femininity in two contestatory beauty contests: the *Rainha das Mulatas* [Queen of the Mulattos] in 1947 and the *Boneca de Pixe* [Black Doll] in 1948 (Turner, "Teatro" 78). Doris Turner argues that these contests are points for reflection on the construction of Afro-Brazilian identity because of the attempts to destigmatize blackness. Inherent contradictions of society appear nonetheless in the semantic fields of the contests; the *mulata* contestant receives elevation with the title of "Queen," while the black contestant is still diminished as the "doll" (Turner, "Teatro" 79). These contests may challenge aesthetic and stylistic power, but through an objectifying gaze of the female body (see Chapter 3). Efigênia's role may be polemically charged but retrogressive in its focusing on sexuality. Nascimento, in his quest for a dramaturgical model, however, desires only to juxtapose Emanuel's cultural apostasy against Efigênia's faithfulness. Resolution comes when Emanuel possesses the truth of his heritage.

Signaling his acceptance of his destiny, Emanuel invokes the ritual names of all the Eshus, and they come forward "like fantastic dreams from between the trees" (195):

> EMANUEL. I conjure the phalanges of King Eshu.
> CÔRO INTERNO. (grave, slow, in a liturgical tone) Saravá
> EMANUEL. Eshu the pagan!
> CÔRO INTERNO. Saravá . . .
> EMANUEL. Eshu of the darkness!
> CÔRO INTERNO. Saravá . . .
> EMANUEL. Eshu of the barred roads!
> CÔRO INTERNO. Saravá . . .
> EMANUEL. Eshu of the Forest!
> CÔRO INTERNO. Saravá . . .
> EMANUEL. Eshu of the Moon!
> CÔRO INTERNO. Saravá . . .
> EMANUEL. Pomba Gira!
> CÔRO INTERNO. Pomba Girô ô ô . . . (195)

Emanuel now becomes a ritual insider by calling on the myriad manifestations of Eshu to witness his submission. His call to Pomba Gira is a call to Efigênia in the symbolic reconciliation with his blackness, but this is the time of judgment, and Emanuel must stand alone

before the orisa. At a point of profound transformation, he sheds the external symbol of his whiteness, disrobes, and stands naked and defenseless before the shrine of Eshu. He finally admits to killing Margarida and, in taking responsibility for his action, he actuates his own liberation. Experiencing self-apotheosis through the euphoria of rediscovered divinity, he shouts to the world, "Whiteness will never again oppress me, are you all listening? Are you listening, God in the sky? I want everyone to hear. Come everybody, come!" (195). Freed of his psychic torment and social conditioning, Emanuel takes his rightful place within the cosmic sphere. Submitting to the lance of Eshu, his self-sacrifice brings balance and restores the divine order.

In generating a model for dramaturgy, Nascimento subtly weaves ritual into the play world. Staged in the background is an actual ceremony, to which Emanuel periodically refers. The play itself is structured like a Candomblé ceremony dedicated to Eshu, beginning with an invocation to Obatalá and ending, exactly at midnight, with the incarnation of Eshu and the ritual sacrifice. Midnight is the time when the forces of evil are let out into the world, and since Eshu mediates between good and evil, it is his time to wander freely on earth. Normally a Candomblé ceremony begins with Eshu and ends with Obatalá, but since this is a ceremony for him, the order is reversed to demonstrate that he is the orisa being revered on this night. Ritual songs function as textual demarcations to invoke each orisa and temporally guide the play. Making invisible action visible, the songs construct a shared semantic field for ritual insiders and outsiders to revision the auto-hegemonic potentiality of this African matrix.

More immediately apparent is Eshu's effect on Emanuel, through his manipulation of the cosmic forces. Blurring the lines between fictive reality and pure fantasy, the characters around Emanuel appear as shadowy, phantasmic figurations. Masked figures representing the orisas appear and disappear into the shadows, while the three Filhas dos Santos act as both choral accompaniment and narrators of events. Sitting in the midst of Eshu's shrine, Emanuel commits his final desecration, almost an act of theophagy, by imbibing the offerings to the orisa. Gradually, he "is possessed by the black gods, who enter him through the five senses: the taste of *cachaça*, the smell of incense, the sound of the drums, the sight of the Orisha, and the feel of the necklace around his neck" (qtd. in E. Larkin Nascimento 286).[10] The ending ebó, Emanuel's ritual sacrifice, closes the ceremony and the play as the three Filhas jointly avow, in the customary phrase that ends a successful ritual, "obrigacāo cumprida."

Due to his implicit entanglement in human awareness and choice, Femi Euba reconfigures Eshu as the "fateful/fatal satiric complex and concept in . . . black drama" (167–68). In Nascimento's interpretation of Eshu as a model for dramaturgy, his triadic essence as communication, fornication, and death can be read in the expatiation of the racial burden. Everyone within the Yoruba discursive universe has a fate, a meeting with destiny, and Eshu as the fateful/fatal construct is the communicative source for its fulfillment. In *Sortéligio*, race, fate, and color function as interchangeable metonyms to dramatize the social conflicts and psychical burden of blackness. Sexuality manifests as aberrant behavior in this racial divide as Emanuel denies and violates his cultural source and female bodies become the symbol of his excess. First he rejects his black lover, who, in turn, absorbs that abnegation to become a derivative of whiteness. Then he chooses a white wife who can only see him through the fetishistic prism of black sexuality. His fateful/fatal meeting with Eshu becomes a symbolic assertion of black identity, and the divine ecstasy he transmits forces a reordering of subjectivity. It must be asked, Why then must he die? Isn't his self-reflexivity and psychical transformation enough to suggest an alternate model of being? This, too, brings us into Yoruba belief systems, in which cosmic order is seen as a complex balance between the living, the dead, and the unborn. Thus Emanuel's negation of blackness must die for a new awareness to assert itself. Eshu's potentiality as a dramatic construct is its transformative functionality, allowing for confrontation with human excesses to expiate them and generate a new self-authorizing modality of awareness and empowerment.

A barrage of public critique engulfed the play, and its didactic message on the role of culture became secondary to the expressed outrage. Critics focused on the racial discord rather than its ritual context. Discarding the reformatory intent, Nascimento, ironically, was attacked as a racist who advocated the separation of the races (Turner, "Black Theater" 42–44). The tenure of TEN ended in 1968, and only with the creation of the Bando de Teatro Olodum, in Salvador da Bahia in 1990, did the black voice find a space and place devoted to its development.

The Bando's Beginnings . . .

Unlike Rio do Janeiro, Bahia did not have a strong theatric tradition. Thus when Marcio Meirelles created the Bando, he did it in conjunction with the bloco afro Olodum. Conceived of as an alternative

theater group, its planned trajectory was/is to represent the lived experiences of Afro-Brazilians, using the Bahian subject as its focus. Before the creation of the Bando, theater was limited to the university environment. Launching independently, the *Sociedade Teatro dos Novos* formed to counter the aesthetic dogma of the university stage and as a resistance block against the military dictatorship. To reinforce their independence, they constructed their own theater site, the *Teatro Vila Velha*, which became the home for the Bando.[11]

In the tradition of Nascimento, Meirelles, in observing ritual life in Bahia, saw a template for dramaturgy. Containing vivid dramatic content and scenic references, the task at hand was to demarcate the sacred, set it aside, and use the imagery and stylistics of the rituals to generate an aesthetic form. Formally trained performers, he thought, could not successfully reproduce these cultural essences. Instead, he looked for performers who were bred in the midst of these ritual forms. The "African colonization" of Brazil, as Meirelles (2001)[12] terms it, led to Bahia's dominant, African-descended population, and Olodum sent a general call for participants to mount the new theater movement. From 100 respondents, 30 were chosen, and they formed the nucleus of the Bando. Only a core remains from the original group, but the motivating impulses are still the same.

Desiring to foreground the "the daily reality in being Bahian: the streets, carnival, Candomblé, along with the poverty, marginality and social conflicts" (Dantas 44), the group faced the question, How do we as performers represent the real? According to Meirelles, the fundamental creative spark stemmed from the desire to speak "directly with the people" and to address issues relevant to their "here and now" (Meirelles 2001). The task before the group was to create a dramatic language that was nourished simultaneously by ritual forms and daily life. This form also had to complement the Bando's political imperative and nurture its ideals for social reformation. From the onset, this imperative is implicated in the naming of the group. *Banda* is used to describe a performance group or band. *Bando* is the masculine equivalent, but its connotation is very different, signifying a "gang" or a "group of bandits," a common referent for a group of blacks (Meirelles 2001). Recoding such a racial marker destabilizes received perceptions and lends itself to the creative impetus of the group.

Without any prompting during the course of our first interview, Meirelles thought it appropriate to speak of his own racial status and its impact on the development of the group.[13] Acknowledging that in

Brazil he is white, Meirelles also added that in other locations, he is considered "almost white" or "almost black."[14] More than aware that his whiteness confers on him social advantages, he speaks of it as both a hindrance and an aid in the creation of the Bando. At the inception of the group, his role as a leader and director was often challenged by the cast, and in the public sphere he has been accused of exploiting them and the black community to enhance his own status. At first the group constantly scrutinized his motives, but unlike white contemporaries in the United States, being a Bahian signifies participation in black cultural life, albeit, like Meirelles, as an outsider.[15] With the Bando he was forced to become the racial Other, acknowledge his privilege, and demonstrate his worthiness to lead the group. From this personal excavation, both sides established their complementary objective and the cohesive artistic process began.[16] Meirelles's position with the Bando still requires interrogation in its retrenchment of a paternalism that characterizes white/black relations in Bahia and was codified in Candomblé with the creation of the ogãns (see Chapter 1). He has, indeed, received benefits, having been promoted to secretary of culture for the state (2004–2010), while Bando members hold varying levels of employment. Further complicating the scenario, group members do not receive a salary; remuneration comes from equal shares of the box office proceeds or from other media outlets producing their work (Meirelles 2010; Washington 2010; Sá 2010). Notably, Bando members unconditionally support him and his elevation in society.

The Bando's Quest for an Aesthetic . . .

The Bando's quest for an aesthetic forces a rethinking of strategies to generate a dramaturgical form to maintain the integrity of their intent to recreate the world around them. Without formal training,[17] the group members used Salvador as a canvas for experimentation. Observing a particular person from daily life, watching his or her gestures and actions, the manner of speech and dress, and examining the issues under discussion has become the method for character development. The performers then bring this character to the rehearsal stage and develop a lived world around that persona. After which, dialogue and action unfolds around an agreed upon theme, and each actor, in any given performance, creates his or her own role and text. Out of this observer/performer methodology, a repertoire of characters evolved that transformed the private space of the theater into a resemblance of the public spaces in the city. The "twice-behaved behavior"

spoken of by Richard Schechner became multiple repetitions that honed the skills of the performers (*Between* 36).

Fundamental to the group is that spectators recognize themselves and associate staged performances to lived, personal actions. The evolving personalities, therefore, cross all sectors of society. Character types such as baianas, police officers, prostitutes, militants, washerwomen, priests, homosexuals, maids, and students found voice in the performative enclave. Yet critics lambasted its first production, *Essa é Nossa Praia* and misrecognized the Bando's avant-gardism, because the lived world the cast (re)envisioned and asserted appeared too real. Conflating the voice of the characters and the actors, the critics dismissed the group's artistic endeavors, stating that they merely brought their own personalities to the stage. A lone voice, only that of the journalist Marcelo Dantas, thought the play successful because of its very representation of the real:

> Characters from the city's daily life, present in the public imagination, and who represented fundamental symbols of Bahian culture took to the stage. Bringing with them, their particular language, their expressive gestures, their dance forms. . . . all these human types invaded the scenes with their own symbolic energy. (46)

Subsequent critical attention also dismissed the Bando's aesthetic vision as a retooling of Brechtian theater. Finally, this work addresses the Bando's avant-gardism in presenting and conveying the voice of the dispossessed within the distinguishing elements from the symbolic essence of Afro-Brazilian culture.

Reflecting the Real . . .

Cabaré da Raça is more than the Bando's triumphant achievement of representations of the real; it characterizes the journey of the Bando from mimesis to poeisis in its engendering of a transformed cultural identity through its representational forms (Fine and Spear 8). Its *poiesis of incarnation* derives from its interactive, participatory process, incorporation of multiple dramatic forms, substantiation of spiritual codings, and activation of political voice. Mimesis prompts a certain cultural distanciation—the mirror-like gaze triggers self-reflexivity—but the Bando's aim is to recharge this self-reflective process, to realign the consciousness of the spectators with the political, and to generate a field of interruptive engagement with the public sphere.

Understandings of mimesis have undergone radical shifts, from the Aristotelian view of authorial dominance and audience subservience to Auerbach's (1968) relativized vision of the real, suggestive of multiple realisms existing in concert but subject to the self-formulation and self-interpretation of the reader. Brechtian models enlarge the aesthetic possibilities of mimesis, outside the reliance on a fixed text and the shadowed interplay between the author/reader, to include its oral, performative dynamic. For Brecht, realism allows for a more precise form of theatrical signification. The quest for voice suggests a mutual implication between the audience and the actors/drama. Collapsing the distance between characters and actors, dramatic setting and world events, naturalizes the dramatic enactments. To approach the political, Brecht indicates, involves the manipulation of the referent in the unfolding drama. Realism, working in concert with ideological political motivations, depends on the stability of the referent and the shared meaning it evokes. Such stability codifies and reinforces the world as is (Brecht 186–91). It reinforces the real.

Mimesis also implies difference, suggests Michael Taussig, and the instability of the referent propels this alterity (129). The field of oscillation between Taussig's and Brecht's characterization of the referent derives from their fields, anthropology and theater arts. Brecht clarifies that the liminal space of the theater allows for the manipulation of the referent in order to generate a shared meaning from the collective experience, even though the represented act is not the event, the actor is not the character, and the spectator is not the citizen (195). Herein is where Brecht differs from the Bando, who nullifies any distanciation between the passive spectator and the active citizen. To engage with the political, both insist that the spectator transform the theatrical experience into practical, real action, but the Bando emphasizes the paired consciousness of the spectator as citizen, a simultaneous inter/intrasubjectivity, projected from an intense, transformative dramatic engagement.

Situating the Bando's aesthetics in the African cultural matrix was Meirelles's intent from the onset, but the myopia of the critical gaze precluded their understanding of the group's use of Candomblé performativity. However, the extension of critical investigation into the African and diasporic worlds leads to comparative referential models from which to explore the Bando's aesthetics. In such a journey, most intriguing is Kimberly W. Benston's conceptualization of African-American drama as a transformational process from *mimesis*, the representation of action, to *methexis*, the communal "helping-out" of the action. The binaries of actor and spectator, self and other, public

and private dissolve to generate a shared consciousness, common moorings (or referents) for the spectators. Transformation occurs in the consciousness of the spectator, who is no longer a "detached individual" but a "participatory member" of a political community, affirming a shared purpose and vision (Benston 63).

Harmonizing the political motivations of the Bando with its aesthetics depended on the personal formulae that each group member garnered from organic elements in Afro-Brazilian ritual forms. The engagement of ritual and drama, through the common cultural symbolisms, is measured in the music, dance, dress, gestural language, idiomatic expressions, food, hairstyles, songs, locations, hierarchical positions and roles created, mythos, and symbology incorporated into the emerging repertoire. The Bando's members coinvent a dramaturgy of "total art" in improvised negotiation with each other and the world they engage. Total art encapsulates the polyvocality of African theater traditions in its fusion of drama, music, embodied practices of singing and dancing, costumery, masking, staging, scenic manipulation, and audience participation, liberated from the written text (Anyidoho, "Poetry" 41–55). Communal and transformational, the Bando's total art evolves by combining African oral traditions with its embodied practices, detouring referents from everyday life and ritual events to formulate as a revisionary, subversive, multisensorial, polyvocal performance event.

Honing the Aesthetic

Key strategies in African oral literature, Ruth Finnegan (1970) points out, include using a formulaic structure in performance, creating improvisational sequences in the midst of the formula, and incorporating audience participation, either as choral accompaniment or to aid in the narration. Improvisation guides the aesthetic repertoire of the Bando, and the constant mutability of the play world enables an amazing variability in performance. Rather than creating a dissonant dramatic experience, these improvisations enrich the personae created and allow for a heightened mutual implication between the spectators and the performers. Meirelles (2001) likens this performative technique to jazz renditions, with individual riffs allowing for the virtuosity of each musician to shine but always returning to the rhythmic base. Each Bando member distinguishes his or her own voice through a range of character possibilities, ever creating and re-creating dialogue, but always returning to the structure of the play. Meirelles then acts as an editor, suggesting placement of the character,

restructuring dialogue, and coordinating action. Whether the Bando members, consciously or not, tap into African orality is debatable, but what is certain is that the performative matrix of Candomblé grounds them in the *longue durée* of obscured, devalued, and diminished knowledge that comes with blackness.

The first collection of plays existed solely as oral texts in the imagination of the actors.[18] If a performer left the Bando, before her final departure, she sat with her replacement and orally passed on the texts. Memorization of the lines, although crucial to the continuation of the drama, was not sufficient to meet the criteria of the group. They saw it only as an act of repetition. What they desired was repetition with a difference. The new performer had to generate an improvisational repertoire that complemented the production. The different nuances and cultural specificities she brought to the role innovated the imaginative voice and inspired further creation by the Bando members.

Moving to the Teatro Vila Velha in 1994 cemented the Bando's presence as a performance group. With the support of personalities such as Caetano Veloso, Maria Bethania, and Carlinhos Brown, critical acclaim soon followed. A turning point for the Bando occurred with the proposal by Caetano Veloso to produce the play *Ó Paí Ó* for television. Requiring a written text for production, the Bando had to codify their performance. Generating a written document, although difficult to coordinate, was not impossible. Since neither they nor the director knew the full text, all the actors recited their lines to an archivist in an open forum. After this first text, the group began their own publishing enterprise, resulting in a series of individual plays and a trilogy. The written text did not diminish the oral, improvisational style of the group, but simply provided reference materials for the public.

Repetition with a Difference

Cabaré da Raça is a performance of race. Bringing to light the stereotypical depictions of blacks in society, the play stands as a mimetic representation of these negative signifiers and their impact on the black being and body. The noted Brazilian playwright and director Augusto Boal (1985) states that all theater is political, with the actors and spectators cooperating and interacting with each other to change the course and nature of the production.[19] As a didactic, interactive play, *Cabaré* allows for this creative collaboration by presenting a series of polyphonic voices from the Afro-Brazilian world. Scenes are juxtaposed, one upon the other, without regard to linear time, much

like the interactions in public rituals in which orisas randomly incarnate and wrest the spotlight from each other because of their superior performance abilities (see Chapter 2). Each character has his or her moment at center stage from which to present a particular polemic, triggering spectator identification and imbrication in the unfolding narrative.

Seemingly recapturing the concurrent daily aspects of life occurring in a city like Salvador, each persona in the play world interacts in his or her own milieu, at times with the other characters and at other times with the spectators, who interactionally morph into members of the cast. The characters denote a voice in the multiple identities of the Afro-Brazilian world, and audience members become omnipresent witnesses and participants whose responsiveness catalyze actions on stage. The spectator may form an unwitting, and at times unwilling, performative body whose actions and reactions can and cannot be predicted. Interrogated and challenged by the characters in the play, each audience response propels the underlying critical intent.

The play establishes its interactive quality from the first line, in which Wensley, a militant within the MNU, speaks directly to the spectators and inaugurates the play's confrontational tenor:

WENSLEY. Good night resistance. Good night whites. This is a didactic, impassioned and interactive presentation. Thus . . .

My name is Wensley de Jesus. I am black, and I am not inside [society], I am outside!

I am creating problems by saying this. I don't recognize this system built by whites, for centuries we've been placed in circumstances that only benefit them. Because of this I am outside!

Because, for me, to be black is this, it is to be grubbing [at life], it is not to be inside. And the question that is put to you is: are you a black person?

But, before this, what does it mean to be black? This is the problem that we want to raise here in *Cabaré da Raça*! (3)[20]

Brecht suggests that giving voice to the political involves the manipulation of the referent (201). This referent is blackness and the frequently used stereotypes about the black being become the points of inquiry. Wensley delimits the lines of conflict: blackness versus whiteness, where blackness is deemed as Other. This Manichean split presages the dialogic points at which audience participation is elicited. Pivotal questions explored in the drama are, What is blackness? How is it determined? And what is its relationship to whiteness? The answers arrived at give a powerful critique of society and generate

the modality through which the alternate constructions of reality emerge.

As each character internally debates and externally voices his or her position in relation to this question of blackness, we develop a framework from which to identify the tensions at work in Afro-Brazilian society. For Wensley, the radical, the world is black and white, and all the racial shadings, hotly debated as they are, do not exist. His hostility is apparent in the rage voiced over the oppression of the black being, as across "the centuries we've been placed in circumstances that only benefit them" (3). His outsiderness and his blackness conflate in the demand for unequivocal revolutionary action, but this revolution is to take place in the psyche of the black subject.

Immediately following Wensley's testimonial, an oppositional dynamic is created through the characters of Jaque and Karine. Jaque, a *pagode*-loving enthusiast,[21] unsuspectingly counters all of Wensley's arguments. She confesses that after reading Gilberto Freyre's *Casa Grande e Senzala*, in the eighth grade, the class reached the following conclusion:

> JAQUE. . . . racism doesn't exit in Brazil. Why? Because neither blacks nor whites exist in Brazil. We are all mestiço.[22] This is beautiful. In my family, for example, my great-great-great-grandfather is of German descent, that is beautiful . . . and my aunt has an aunt who is Italian. Now, I get very offended when I am in the street and someone calls me a *Negona*. (4)[23]

Ironically, phenotypically, Jaque is obviously black without any evidence of mixed ancestry. In this depiction of the real, the appearance of each cast member is important to the unfolding polemics. Having imbibed the mythos of racial democracy, Jaque reflects the totality of the alienation of those in the Afro-Brazilian population from their blackness and their African roots. She is the consenting body that perpetuates the nation's famed concepts of hybridity, but unwittingly, as a result, she becomes an accomplice in her own negation. Lacking exposure to a normalizing rhetoric of blackness, she does not have agency to challenge her own dispossession.

In this racial divide, Karine represents another level of self-abnegation. Of mixed heritage, her views of blacks and blackness stand in complementary opposition to Jaque's. Karine adores blacks and blackness, but this passion is for the imago and not for the black person or the lived experience of negated or marginalized blackness. For Karine, "This question of ethnicity for me is not important: if

you are black, white, yellow . . . In my house everyone is white, I am morena. But I think that I have a black ancestor because I like blacks, I have *o suingue dos negros* [the style of black people]" (4). Karine is a famous singer and dancer, and in the allowable arena where blackness operates, her displays of black style enhance her sociality and status, and for her, blacks are "the happiest people in the world" (4). A consultation with a Mãe de Santo about her ancestry, she relates, confirms that she has a distant black ancestor. She, consequently, exults over the discovery because it explains "my passion for the drums and my voice that has been compared with Black American singers" (4). Karine manifests the hybridic narrative of the nation in its contra-black pathology that equally reduces blackness to signifiers of rhythm, joy, passion, and beauty. Her connection to an African past is imagined and carefully constructed to establish her artistic credibility, yet distant enough to not jeopardize her position in society. She is the embodiment of embranquecimento and democracia racial; her family, having whitened sufficiently, can give homage to a "distant" black antecessor without fear of expulsion from their privileged positionality. But Karine is different; she stands on the cusp of blackness, and when she introduces herself as a "morena," she is admitting that her blackness is corporeal, visible in her countenance, and resultingly, she is closing the privileged space of whiteness around her as a tenuous space of habitation.

In an interview with Auristela Sá (2001), the actress who created the role, she admits that Karine is a reflection of the majority of society, confessing that "she thinks and acts like a white person because it is much easier for her." Yet in a closed system of representation that produces self-negating characters like Jaque, Auristela considers Karine a positive character because she admits to her blackness. I disagree, for her coding of blackness is fetishistic at best, and her articulation and affirmation of ancestry read as psychosocial mechanisms to cope with her lack of whiteness. Subliminally, in naming her difference to whiteness, she moots her debatable status and allows the rationalizing framework within society to assert itself and confer on her the demographic sameness embedded in the democracia racial narrative. In preparation for the role, Auristela always wears a long, flowing hair weave, which Karine uses as a prop. At the end of each pronouncement, she adds, "Negro é lindo!" [Black is beautiful], and tosses her hair. Contradictorily, Karine's verbalization stands in opposition to her gestural language. While she praises blackness, each hair toss establishes a distanciation from the black masses, and the audience is well aware of this.

Abará stands as the contrast to the illusionist perspectives of Jaque and Karine, without the radicalism of Wensley. He enters telling all to stop, and he gives a detailed account of his experience the night before. Having survived a police assault at the bus stop, while he waited to return home, he relates, "I discovered that I wasn't black but I was a fucked up black man" (4). In the arc of representations, Abará is the figure of specular phobia, any and every black man on the street who is coded within the prism of criminality. The actor Melquesalem Santos (2001), in an interview, voiced his desire to call attention to such pervasive oppressive practices in the creation of the role because they are daily occurrences in the containment strategies of the state against its poor and black population. Many Brazilians believe that the poor cause their own problems and support state-sanctioned violence against them. Abará, while not the most emotive of characters, breaks the conspiracy of silence and complacency within society regarding the combination of police violence, racial profiling, and economic marginalization. When I asked Melquesalem if he had personally experienced racism, he simply responded, "And who hasn't?"

The play has 15 characters and, without a single protagonist to guide the action, the referents of blackness and its scope of (mis) representations propel its confrontational style. One of the seminal characters, who embodies the binaries addressed in the play, appears in the guise of Rose Marie. Dressed in an elegant evening gown, she enters the staging area to the sound of "Wonderful World" by Louis Armstrong. Rose Marie immediately establishes a distinction between her and other black women:

> I, Rose Marie, a black woman? I am well born, I am from a good family, I never had financial problems, I have my business and the manager of the bank where I have my account gives me VIP treatment. I don't understand what you are discussing here, racial issues, color issues? I, Rose Marie, have never been discriminated against. (5)

Suddenly, Rose Marie transforms, becoming the actress Rejane Maia. Changing her demeanor, style of address, and language, Rejane exposes the daily tribulations faced by Afro-Brazilian women. From the initial line, she dismantles Rose Marie's privileged existence as she speaks to the complexity of black life:

> REJANE MAIA. Now, I Rejane Maia, actress . . . I am discriminated against from the hour that I wake up and see the living conditions . . .

of the people in my community. I am discriminated against when I take a bus and they criticize my clothes, my hair. I am discriminated against when I go to the supermarket and the guard follows me as if I am stealing. I stop and say: "What is it my brother, did you lose something?" I am discriminated against because I am a woman and because I am black and many think that I ought to be behind the stove in someone's kitchen, or using my energy to clean the dirt from their homes or their city [streets], that the rich milk in my breast ought to be feeding the children of others, that my firm and round behind ought to be exciting erotic fantasies in the trenches of life, that my body ought to be in the beds of cheap motel rooms for tourists to dump their sperm and their fare. But I am a woman and I am black and I am proud of my large nose, my dark skin, my kinky hair, my ass and my history. I am a woman and I am black and my energy will be used to honor the memory of my ancestors: kings, warriors and priests that were uprooted from their land in order to bring to this new world their work, their tears and their joys. I am a woman and I am black and my milk will go to those children that are born from my womb or for those I decide to adopt. And my body will go to the man that I choose who knows how to love and respect me. And my ass is for swaying, celebrating joy, to the warlike beat of my race. My mother is not *Nossa Senhora*, it is *Nana Buruku*. (5)

Elin Diamond (1989) characterizes the real as "more than an interpretation of reality passing as reality; it produces 'reality' by positioning its spectator to recognize and verify its truths" (60). The play on similarity and difference in the self-articulation and self-definition of Rose Marie/Rejane, for the black subjects in the audience, cohere the defensive strategies of dispossessed women, and for the white subjects, they confront their alterity. Rose Marie/Rejane can also be interpreted as manifestations of a particular Afro-Brazilian double consciousness, with Rose Marie reflecting the exteriority of the black woman controverting her reality, who guards against objectification through a posture of alienation from it (Jaque); Regane is her interiority, her voice, demanding recognition, but hidden behind a posture of passivity that is Rose Marie.

That Rejane's persona dominates is not surprising, however, because the Bando's objective is always to give voice to the voiceless and to create political actors from its spectators. When Rejane speaks of her blackness in female form, she counters a history of controlling images of black femininity and white paternalism. If we must use the overworn trope of the subaltern, through this enunciation she rejects her caste-like position and the imposed abuse to her psyche, soul, and body. In an auto-hegemonic discursive act, she claims Nana Buruku,

the Yoruba orisa, as a guiding force, over the Catholic saint, Nossa Senhora. Calling forth the power of this warrior-mother, her sagacity and will transcodes a purposeful feminist engagement with the pathologies of dominance.

Interestingly, in Yoruba, *buruku* translates as "evil," and the orisa Nana Buruku is known for her awesome power. Her potency was widely acknowledged beyond the Yoruba domains, according to Robert Farris Thompson, and other West African empires such as the Asante and Dagomba (in present-day Ghana) deemed her so important and potent that they sent her offerings before going to war (*Flash* 68). Nossa Senhora is Mary, the mother of Jesus and the patron saint of Brazil; she is often linked to the female orisas, in part because of her depiction as a dark-skinned mother figure. Rejane's rejection of the Catholic saint is emblematic of the oppositional dynamics between her and Rose Marie, and of the precarious position of blackness in the Brazilian nation. The conundrum becomes, does she affirm a figure of Brazilian hybridity that may symbolically gesture to her through its appearance, but is a guardian of a society that systemically shuns her, or does she affirm the African matrix from which her blackness is normalized? Such interrogations make conceivable the reasons Afro-Brazilian activists promote identities as Negro or Afro-descendente, for the effort is to normalize who they are, to traverse beyond objectifying gazes in all their pathological contours as sources of celebration or negation.

Troping the Tropes

The actors solicit audience participation with questions that seem randomly ad-libbed, and debates ensue between them and the cast members, contributing to the unfolding drama. A section of the play hinges on the question of black male sexuality, and one character, Patrocinado, portrays the typical *caçador das gringas*,[24] the male beneficiaries of sexual tourism. Signifying on his chosen profession, Patrocinado's name translates to "sponsored," and he demonstrates a preposterous craving for the white, female body, attributing an unrivalled prestige to such sexual conquests. The ensuing dialogue between him and his friend Taíde reduces them to outlines of macho posturing in an irreverent coding of black male hypersexuality:

TAÍDE. My brother, I don't know anyone who leaves my bed protesting. It appears that I have something that attracts white women. When

I walk through the hotel well . . . the other day a woman put her room key in my hand with a note: "I am a white woman, blonde, with blue eyes and I am looking for a big black man to drive me crazy." After, I went with this guy to the bar in the hotel and my friend arrived, he said that I was reinforcing the myth that the black man is only good in bed . . .
PATROCINADO. If the black man is good in bed, I don't know. Now, I know that I am, I am! I am hung and hard, with my natty hair, . . . When I am in bed with a white woman who grabs my hair and groans: "aayy my Nat, my stud, aay you're my hot black man." (16)

In contrast to Emanuel in *Sortilégio*, Taíde and Patrocinado typify the marginal black male, undereducated and with limited potentiality for betterment. Possessing only their sexuality, social advancement is configured through the bodies of white women. Reinforcing their own phallicization, they gleefully boast about their sexual prowess, but then again, what else do they have except an anxious virility to reinforce their masculinity. Momentarily, however, Patrocinado subverts that characterization by asking the spectators, "Is the black man good in bed?" (16). The query triggers embarrassment and the spectators are dumbfounded, left wondering how to respond, but this becomes a moment of self-reflexivity, forcing an internal evaluation and revision with regard to the stereotypes attributed to blackness.

Stereotypes are never reprised without invoking their racist beginnings, and their performance reveals the dynamics from which they came, but it also suggests the potential for their disruption (Lee 96). The polemic culminates with the scene of the *Super Negão*, the Super Black Man as a cabaret montage satirizing images of black hypersexuality, along with Karine singing,

> É um cavalo? É um tição?[25]
> Não, é o super negão
>
> [Is it a horse? Is it a devil?
> No, it is the super black man].

Four naked men appear on the stage, dancing and lewdly gyrating in front of the audience, while singing the following refrain:

> He is the super black man, (rep)
> He is the super black man, look
> Look at the size of his penis
> When he appears, the crowd repeats

He is very sexy, sexy, sexy
He is very hot, hot, hot
He is very sexy, sexy, sexy
He is very potent, tent, tent. (17)

Such mimetic contrasts become a destabilizing mimicry, heightened by the obvious enjoyment of the actors, who blatantly thrust their penises at the audience. Interpolating Fanonian discourse, the enactment forces a psychosocial examination of the perceptions of blackness by using the elements found within the stereotypes. This deliberate objectification of the black body and the sexual fetishisms it generates compels an immediate reconfiguration of perception and thought. Albeit absurd and obviously farcical, this parody displaces images of the supersexual black male. From the self-reflective process, the audience, it is hoped, grasps its seditious message to disrupt sublimated codes of belief and generate a shared mediation that transforms public intent. The cabaret motif adds a level of playfulness to the deliberately confrontational action, and the dancing, cavorting black bodies become the common referents to engage in the process of social and political reconstruction. Blackness, here, impels self-reflexivity by all members of society to effectuate transformation in thoughts and actions.

Spectator/performer interaction also hinges on answers to the pivotal question, "Who suffers most from discrimination, blacks or whites?" From personal observation, although both blacks and whites are queried, only black spectators are asked to share their experiences.[26] The didactic nature of the work is the apparent cause for this exclusion, but the unspoken premise is that whites cannot be victims of racism. Invariably, however, the white spectators answer that both sides are subject to discrimination, while the black members respond categorically that they predominantly suffer. Considering that the play is example driven, such existential inquiries emphasize Kimberly W. Benston's *methexis*, providing a forum in which the spectators can speak and lived experiences can assert themselves. Rather than allowing for passive absorption, the play prompts an active immersion and a cross-identification that nullifies the performer/spectator distance. Within this liminal moment, when the spectators are isolated from the outside world and bound by the conventions that apply within, they acquiesce to the roles required of them.

The Bando innovates the cabaret form with its unique interpretation, and in the progression of the play, dramatic sequences are

often interspersed with rapping, singing, drumming, and dancing. Members of the Bando perform in all these artistic idioms, and their "total art" polyvocality registers with the oral/improvisational dynamic in *Cabaré da Raça*. Even though the play has a written text, the dialogue is intentionally transformed from one production to another. For this chapter, I have translated passages from the fixed text, which like most plays by the Bando developed in collaboration between the actors and Meirelles. In performance, the fixed text is used for the introductory and the closing lines, allowing the actors to cue each other. The inner structure of the dialogic sequences is subject to the impulse of the performer, and the intratext variability is based on each actor's improvisational techniques. Shifting on and off from the formulaic template, the actors rehearse assiduously and constantly reshape and revise their presentations, dialogues, and staging techniques.

The play ends in a grand conflagration by the cast members of the most insidious stereotypical, pithy sayings that rim the dominant narrative on blackness. In a call-and-response sequence, each actor evokes their referential power and the group collectively negates it:

JAQUE. A white person who is running is an athlete, a black person who is running is a thief.

TODOS. It's bullshit!

M.C. —A good black is a black with a white soul.

TODOS. It's bullshit!

ROSE MARIE. The difference between a black person and cancer is that cancer evolves.

TODOS. It's bullshit!

GEREBA. Brazil only likes two blacks: asphalt and Pele.

TODOS. It's bullshit! (21–22)

Such interpretation and reproduction is exaggerated or quoted mockingly to sever its impact and obviate the power of such a repository of derision and disdain. Signifying on an entrenched pigmentocracy, the actors destabilize the laissez-faire exclusionism that masks the power of whiteness to determine participation in the nation. Exorcising such stereotypes in the safety of a space of performance, in the fictionally generated world of mimesis, alleviates their traumatic impact but imprints them powerfully as experiential challenges to ordered beliefs. Culminating on a culturally affirmative note, the group sings *"Negrume a Noite"* [Blackness of the Night] by Ilê Aiyê. Beginning with a chant to the orisa Ochossi, the hunter who champions all just

causes, the group symbolically accesses his *asé*, his spiritual energy, in the fight for justice:

> Odé comorodé
> Odé arerê, odé
> Comorodé, odé
> Odé arerê (23)[27]

Poiesis

With groups like Teatro Experimental do Negro and the Bando de Teatro Olodum, theater becomes the liminal space for uninhibited speech and representation. It becomes the sphere for "undominated discourse," released from mythic constructs, falsified histories, circumlocutory communication, and suppressed rage (Scott 175). *Sortelígio* and *Cabare da Raça* cut through the subterfuge imbedded in Brazilian society, emphasizing a racial dimension that so many deny. Both TEN and the Bando challenge existing conventions of blackness and subvert such categorizations while establishing their own representational sphere. Such vision derives from an alterity to the dominant tropes of Africanness and blackness, restructured to generate a performative lexicon and codex. The Bando developed its own specific type of mimesis based on reflection and absorption to strategically represent the dialectics of class, race, gender, and sexuality, in an imbrication of aesthetics and ethics that generates a poiesis in its transformative intent. That poiesis is more than the art form, for the Bando's work is transformative, and it is for the spectator to actuate that change.

Melquesalem Santos of the Bando says that "[i]f we knock on a door and ask if there is someone there, and we do this more than one time, we will hit that timer in their heads that goes, Tim! Tim! Tim!" These groups represent a significant continuity in the reception and practices in the processual engagement of constructing and defining Africanness and blackness as new aesthetic paradigms and new social imperatives.

Chapter 6

Centering Blackness: Hip-Hop and the Outing of Marginality

500 anos o Brasil é uma vergonha

Racionais MC's, 500 Anos

Music permeates all life. It normalizes socialization processes. It reflects and refracts subjectivity and self-reflexivity, political processes, cultural injunctions and imperatives, social contradictions, and social change. Like most literary and performative artistic forms, it reorders existence and allows us to inhabit a different world through its imaginative cultural narratives. Complementarily, popular music, says George Lipsitz, is by nature dialogical. It embraces the past and allows for an ongoing interplay between history and the present, nurtured by the vision of the artist (Lipsitz, *Time Passages* 99). Since music crosses spatial and temporal boundaries, its dialogism is readily translocative in the ease and flexibility of its transposition from the global to the local context. In crossing global boundaries, music is reinvented in local spaces to reflect questions or definitions of cultural identity through its direct, experiential nature and its impact on the body, on levels of sociability, and on personal engagement. Turning the lens to black music styles, the global dissemination creates a polemic in understanding how music reshapes orthodoxies and constructs cultural narratives. While listened to and enjoyed, the social currency of black music is not necessarily inscribed on the black body. For as much as black musical traditions are found everywhere and have been co-opted into local contexts, acceptance of the black being (beyond the artists who create the music) is not a global phenomena. Still, local prejudices, contradictions, and failures to fulfill social contracts operate stringently with respect to the black being.

The song in our epigraph speaks of the 500 years of oppression and misrule within the Brazilian state. It is an exemplar of the way in which black music operates to negate hegemonic ideologies and the naturalization of their domination, and to formulate localized sites of cultural and artistic belonging—the imbrication of aesthetics and ethics, common within Afro-Brazilian protest modalities. Hip-hop, with its combined thrust of globalization and localization, or "glocalization" (Spady 2006; Sansone 2003; Canclini 1995), has become a new form of social discursive engagement activated by youth cultures (Basu and Lemelle 2006; Spady 2006; Alim, et al. 2009; Mitchell 2001). Hip-hop is the music that is the most responsive, the most descriptive, and the most emblematic of the disproportionate social decay and capitalist accumulation that marks life for the young, urban, black poor. In its symbolic deterritorialization from the African-American cultural sphere and its reterritorialization in Brazilian urban centers, it is a form of social resistance that creates sustaining narratives and builds transformational cultural and social networks.

This chapter maps how hip-hop music functions within social movements and state discourses as a transformative agent within the terminus they impose. It places Brazilian hip-hop in a musical "contact zone" through the confluence of black music from the Unites States and Afro-Brazilian musical traditions. Building on the seminal works of Pardue (2008), Barbosa and Ribeiro (2006), and Andrade (1999), it historicizes the movement within the influential sphere of the US Black Power movement, seen in the 1970s bailes black, its transpositions into Afro-Brazilian cultural life, and its innovation in a discourse of négritude or blackness. Hip-hoppers engage with a blackness ideation as aesthetics and ethics to express power and delimit their marginality. Focusing analysis on hip-hop videography, articulations of blackness are juxtaposed against the performative hybridity of the artists. Canclini's understanding of the functioning of hybridity through the deterritorialization of symbolic processes, the reordering of public and private space in the urban areas, and the influence of new communication technologies to access its "multitemporal heterogeneity" (*Hybrid* 3) offers set analytic criteria for mapping hip-hop's "performative injunction" with regard to Afro-Brazilian identity (Yudice, "Afro-Reggae" 53). Hip-hop performativity, articulated lyrically or through visual codes, inserts itself as an alternate social movement that makes visible hidden lives. Hip-hoppers, in rendering their own interpretative agency, provide their own understandings of the causality of their social dystopia. Their responses to social excoriation, economic minimalization, and the

real violence enacted on them is conceived here as a redeployment of the gaze to allow for their own imperatives to question established social order.

Hip-Hop Beginnings

Hip-hop began in dislocated urban wastelands, spaces consecrated by the poverty of its protagonists, the detritus in the environ, and the ramshackle nature of their homes, bounded by violence from internal actors and state-sanctioned officials. Forming within the confluence of African-American, Jamaican,[1] and Puerto Rican[2] cultural identities found in the South Bronx, in New York in the 1970s, it spread to urban complexes within the United States: the "postindustrial" state of Tricia Rose (1994), the "hood" of Imani Perry (2004), the "ghetto" of Robin D. G. Kelley (1997). Hip-hop was then conceived of as an outsider culture, "black noise," which celebrated criminality, violence, misogyny, and sexuality (Rose 1994). The term "hip-hopper" could easily be a metonym for stereotypes associated with blackness: criminality, violence, misogyny, destruction, primitivity, tribal, ad infinitum.

Divergent scholars agree, however, that hip-hop is a rhizomatic root of African aesthetic sensibility, from its percussive polyrhythms to the improvisational capacities of the disc jockeys (DJs), the verbal virtuosity of the emcees (MCs), and the antiphonal dimension of performance (Osumare 2007; Keyes 1996; Gottschild 1996). Other scholars/practitioners consider that its immediacy of African-American cultural content makes it a direct product of black American life (Cobb 2007; Chang 2005; Perry 2004). Even though hip-hop came directly from the United States, Afro-Brazilians have a traditional form of oral poetry, recited or sung to music, called *repente*; the *repentista*, improvising on the spot, creates stories about the events and people around him (Salles 1985). Rapping is not a new thing, either in Brazil or other Afro-diasporic spaces, but hip-hop is more than rap. Kyra Gaunt's (2006) description of it as an "oral-aural kinetic etude," a socially learned, embodied, musical response, aptly fits its cross-generational incubation, translocative fusings, and multiple performative template (2). George Lipsitz places hip-hop expressivity in the conjunct of "diasporic intimacy," and postcolonial cultural expression (*Dangerous Crossroads* 36). Its prosody, musicality, and embodied dissemination are its performative forms of Afro-diasporic crossovers and its political locus speaking "to the realities of displacement, disillusion, and despair" (ibid.).

Spatial Realities and Racial Textures

It is not by chance that São Paulo is the designated homeland of hip-hop, even though Rio de Janeiro and, to a lesser extent, Brasilia, are also influential centers. According to social anthropologist Jesus Félix, racism is more forceful in São Paulo, and forms of social seg-regation operate to impel Afro-Brazilians to create their own spaces for leisure and pleasure (35–36). In both São Paulo and Rio, the spatial demography has a decidedly racial component wherein "the lived experience of race has a spatial dimension, and the lived experi-ence of space has a racial dimension" (Lipsitz, "Racialization" 12). These racialized geographies are deemed the spaces of the *marginal*: the *periferia* [periphery], the *subúrbios* [the suburbs], and the *favelas* [shantytowns], with each space coded differently in each city. For São Paulo, Derek Pardue emphasizes the liminality and ephemeralness of the favelas as one part of the peripheral landscape that houses the poorest within society, or as noted, "city spaces rented to squatters" who live in *barracas* [shacks]. The periferia or the subúrbios, in con-trast, are environments built to contain the poor and working class, distancing them from the city. In Rio, even though Hermano Vianna refers to them as "pequenas Áfricas" [little Africas] because African cultural remnants proliferate there, the favelas can be likened to mic-ropolities that are more racially and economically diverse (Vianna 18; Arias 9). The irony, however, is that many of the favelas in Rio are next to some of the wealthiest areas, occupying locations that in any other real estate market in the world would command the high-est prices because of their locations on hillsides [*morros*] that over-look the city or the beaches (Arias 20; Telles, *Race* 201). This, too, generates a spatial demarcation, as the morros are for the outsider, poor, and black population; and the *asfalto* [asphalt], the developed city centers, are for the middle class and wealthy whites. What unites the *faveladas* and the dwellers in the periferia is their positionality as *marginal* in society, whether through their economic lack or their racial marking.

Hip-hop grew in the climate of such social segregation: both the richest and the poorest sectors of society in constant visual and vis-ceral communication, without an attendant discursive one. Hip-hop developed within a cross-generational, heteroglossic web of musicali-ties and was first called *funk pesado* [heavy funk] (Herschmann, *A Cena* 20–23), because of its incubation within the funk movement and the bailes black. While Tropicalismo was the localized form of cultural dissent during the abertura democracia, the funk movement

developed from a globalized sense of blackness emanating from the wellspring of US Black Power symbology. Soul/funk music was first played on the radio starting in 1967, regularly featured by a white DJ, Big Boy, on his show *O Baile da Pesada*, but was popularized in the traditional samba clubs and became the standard music in exclusive clubs for socially mobile blacks (Hanchard, *Orpheus* 112; Bolling 164). Venues such as *Clube Renascenca*, in Rio, when forced to destratify by the abertura, became sites for bailes like *Noites do Shaft*, whose intent was to promote a didactic, politicized sense of identity (Hanchard, *Orpheus* 112). In spreading to the masses, the dance movement was alternatively known as "Black Rio" or "Black Soul" because of its focus on the music of James Brown and Parliament Funkadelic. The technological innovation of turntablism became a new art centering on the DJ, who became both entertainer and activist. DJ Maurício, who first brought soul music from Rio to São Paulo, states that, at first, he only played James Brown—"I thought he was mad, this black *thang* was 'crazy'"—and named his baile "Black Mad" because of his love for the music:

> At the time, we didn't know the language, but it wasn't only the style, what we got from it was the rhythm since we invented the English on the spot . . . We didn't know the power of James Brown's messages, it had power from his style, which was contagious. (Barbosa, *Bailes* 153–54)

However, the significance of James Brown singing the phrase "I'm black and I'm proud" defined the "bleque pau" [black power] contexts of the bailes and the "Black is Beautiful" aesthetic intervention they promoted. "*Négritude*, ironically, comes with the 'imported' soul rhythm," states sociologist Márcio Macedo, and it transformed the vector of the discourse on blackness in all spheres of expressivity (20).[3]

When Black Soul traveled to São Paulo, the bailes became venues for political engagement by the MNU, who in appropriating a strategy used by the *Frente Negra* in the 1930s, saw the pedagogical potentiality of the dances and adopted them as propagandizing spaces in which to connect with the Afro-Brazilian population (Barbosa, "Apresentação" 11). In this period, African-American life and culture became a symbolic template for advancing racial discourse in Brazil; bailes such as Soul Grand Prix in São Paulo shifts this register, Michael Hanchard points out, with multimedia presentations in slides and films of African Americans in various forms of protest and

peace (113). Hanchard's critique of the MNU has been discussed in Chapter 4, but he accords to the Black Soul movement a newness in its incorporation of tropes of blackness that were decidedly outside both the white and black Brazilian purviews of allowance. The symbology of bodily codes such as the wearing of big Afros, platform shoes, and bell-bottoms, Hanchard argues, served as a catalyst for identity-based politics (112–13). George Yudice would undoubtedly agree with this observation, as he suggests that the *funkeiros*, in adopting a racialized music and aesthetic from outside Brazil's borders, opted out of not only the musical tradition that symbolized Brazilian nationalism but also the more local forms of cultural belonging and citizenship ("Funkification" 203).

São Paulo became a city of divided baile enthusiasts, because Black Soul quickly usurped an established samba-rock baile. Created and popularized by Jorge Ben Jor[4] and Tim Maia, samba-rock blended the two musical idioms with Caribbean rhythms like rumba and salsa (Macedo 18). Naturally conflictive, the samba-rock baile was decidedly apolitical, but the message of black pride that came with the soul/funk bailes shifted the template from one of pure pleasure to one of politics. Love may have forged the initial connection with the music, but the profitability of the bailes ensured their continuance. An entrepenurial elite developed when families and friends formed cooperatives to own the *equipes*, the sound systems, and control the spaces for the dances. For the first time, Afro-Brazilians controlled their own means of production (Jesus Félix 37), establishing what I consider *sound factories*, centralizing spaces in which blackness operated, simultaneously created and controlled by black entrepreneurs, who were, at times, DJs and marketing strategists, and also social activists. They played specifically black music, whether coined locally or brought from other locales, and allowed black bodies moments of psychological and kinetic respite in safe arenas to allow self-esteem to grow exponentially (ibid. 33). In the midst of this freedom, attendees could talk freely with their compatriots, critique a system that conspired against them, and fashion ways in which to mediate the white spaces that encircled them.

Over the next two decades, funk evolved to incorporate soul, R&B, techno, Miami bass, and hip-hop, with local additives like samba, axé, and forró,[5] and came to symbolize the playing of black music from anywhere in the globe. Outside the realm of social activism, blackness resonates alternately for the vast majority of the poor and working class, argues Livio Sansone, through the absorption of international music and consumerist trends ("Glocal" 137). "Black," in this view,

represents a cultural insertion that codes materialist desires and is seen as a source of style and individuality, from the type of music listened to and enjoyed, to the choice of clothing and the use of expensive sneakers and baseball caps (ibid.). Yet the bailes did indeed serve a functional purpose as the incubatory spaces for that hidden transcript of resistance to the concept of racial democracy and the formulation of new forms of racial and cultural belonging. Katrina Hazzard-Gordon (1990) articulates the importance of such independent spaces in the reconfiguration of marginalization. Transposing her analysis of how dance spaces like jooks, honky-tonks, and after-hours joints were integral to socialization in African-American life (76), the combination of embodied knowledge and alternate processes of socialization in the bailes allow for the same physical and psychological release from processes of systemic discrimination. Jesus Félix reports that a general response to the query regarding the reasons for attending the bailes is, "because I am with my equals and because I don't suffer from discrimination, here I am in a space where I feel equal to everyone" (33–34). As alternate spaces, "social sites" are sheathed from the surveillance of the state; freeing linguistic codes, gestural language, and local slangs operate outside the dominant codes (Scott 120–21). "The baile is also the time of construction of identity," states Márcio Barbosa, and its communal concourse allows for this reconfiguring of subjectivity:

> At the *baile*, the daily discrimination gives way to the positive images that its patrons construct for themselves. There, among his peers, the *afro-descendente* sees how s/he belongs to one culture and community, s/he can find similarities that generate sociability, share community joys and concerns, and relax to the sound of music and rhythms belonging distinctly to a history from which s/he is apart. ("Apresentação" 13)

The bailes thus become spaces that dually reflect social transformation, in offering escapism from the quotidian norms of societal exclusion (Sneed 70) and social reformation by forging a sense of collective, cultural belonging.

In São Paulo, sound factories such as Chic Show, Zimbabwe, Black Mad, and Circuit Power formed the connective link between the bailes and the burgeoning hip-hop movement. Promoting shows with soul and hip-hop artists from abroad, they also sponsored contests for local hip-hop performers, in which they created and honed their repertoires and performance skills. Zimbabwe, in particular, was the first to produce a hip-hop recording, and its series of compilation recordings

launched the hip-hop genre (Macedo 21–22; Pardue, *Ideologies* 99). The naming of Zimbabwe reflects the political ideation of its founder, in forging collective ties to spaces of black empowerment, for it simultaneously evokes the ancient kingdom in southern Africa and the revolutionary state, gaining independence from its apartheid precursor, Rhodesia. Zimbabwe's leader, Santiago, an MNU activist, saw within the hip-hop movement a new viable art form. That it came from the African-American cultural sphere resonated with the heroic signification Afro-Brazilians give to African-American constructs of blackness derived from their intersection with the Black Power movement:

> the black American is 12% of the country, which has 360 million inhabitants, and they make the noise that they make, because they know their culture, their history, and where they come from. We have no history, we don't have it because we don't claim it, that's very true. Since we are 60% of the population, why isn't our President black, why isn't our governor black? We don't have black politicians, we don't have that awareness, we don't have this culture, and since we don't have it, we also don't make art! (Barbosa, *Bailes* 195)

Santiago presents the much-touted argument by the MNU that demands a communal black identity through collective identification with Afro-Brazilian dynamic historical and cultural terrains. Yet he also addresses the fundamental imbrication of art and politics that comes with self-authorization and self-representation (see Chapter 4). Hence his investiture in the burgeoning hip-hop movement should be understood as an investment in an art form that shifts the template of blackness in society.

"Hip Hop Ya' Don't Stop"[6]

Derek Pardue (2008) argues that there are four moments or delineations of rap music with regard to the discourse on blackness. The first (1987–1992) promotes a *uñiao* ideology, with all the vectors of hip-hop expressivity coming together; the second (1992–1996) generates a unique resistant Afro-Brazilian ideology and actuates a négritude discourse in working-class blacks; the third (1996–1999) transforms into a "marginal aesthetic" with narratives about periferia life; and the fourth (1999 onward) marks tension between periferia narratives and négritude ideology (*Ideologies* 98–119). To this framework, I add the mediatization of hip-hop narratives, which begins in the earliest phases of the movement but grows exponentially starting in 2004,

when the internet becomes more readily available and less expensive to access for poor Afro-Brazilians (*Ideologies* 43–44; Rocha 93; Guimarães 43–44). These mediatized narratives become the object of further analysis in this work because they "live" beyond their temporal designations. Existing in cyberspace and in DVD or video form, they can be continually accessed and engaged with in meaningful ways by spectators. In allowing for a continual recycling of song and image, a video generates a purposeful involution, whether voluntarily accessing it multiple times or once by accident. The messages within these mediatized images are constantly renewed and refreshed based on the receptivity of the spectator. Hence I am more interested in the overarching narrative of hip-hop politicization. This is not to contest Pardue's categorizations but to build on and flesh out the lyrical importance and visual impact of different artists in their interpolation of critiques of societal disjunction into dominant ideologies.

The anthropophagic nature of Brazilian culture allows that US technological culture and consumerism is always a standard from which they gauge their successes (Herschmann, *A Cena* 111). Hip-hop music with its intersections and influences, particularly from the United States, can be viewed as another phase of this imitative, innovative process, but I would rather propose that these musical forms derive out of the intertext, the borrowings and exchanges that organically shape discursive and experiential knowledge. I take the concept of the intertext out of its poststructuralist beginnings as an engagement within written discourse, to an alternate space where the text is performative, found in the musical and lyrical codings, displayed on the body, and transmitted to the world. The dance scholar Brenda Dixon Gottschild's concept of intertextuality more closely models the engagement I am suggesting, in which the intertext derives from "[t]exts of past societies, cultural configurations, contemporaneous events, and mediatized images that affect and shape creativity" (2). Such texts decenter authored or originary narratives, as their multidimensionality allows for the formation of heteroglossic, interlocutory webs out of which to derive individuated creativity from its patterns and formulas. Borrowings and reformulations are natural, and taken out of a scribal privileged space, the intertext shapes experiential knowledge. Music is its natural medium in its blendings, exchanges, cross-fertilizations, and intersections of ideas, worlds, cultures, melodies, harmonies, rhythms, and styles. The intertext allows for hybridity to flourish and formulate the new, and from within these paradigms we can transit through hip-hop historiography and examine its viseralness in performance and sonic impact on society.

Intertextuality I: Reterritorialization

The intertexuality of Thaíde (Altair Gonçalves) and DJ Hum's (Humberto Martins) "*Senhor Tempo Bom*" [Mr. Good Times], one of the first hip-hop songs to be popularized, functions as a declarative recodification of Afro-Brazilian cultural forms. Giving homage to the funkeiro beginnings of hip-hop, it connects with a history of empowerment through music. Thaíde begins with a romanticized evocation of life in the favelas, remembering a time of "pura esperança" [pure hope] during his childhood (Lyrics.time). The song formulates a "cultural reversioning," as suggested by Cheryl Keyes, in foregrounding an African cultural context that consciously and unconsciously shapes hip-hop musicality (224). In describing his mother returning from a Candomblé ceremony carrying her ceremonial clothing, the song becomes an attestation of the centrality of the orisas in the lives of the faveladas. He invokes the sound of the *atabaque*, the mercurial sound of the drummers to ground this new musical form in the grand narrative of Afro-Brazilian cultural expressivity. The bailes, Thaíde attests, continue the tradition, but enfold the populace in new trajectories of black empowerment through the musicality of samba-rock, soul, and hip-hop.

The song historicizes hip-hop by speaking of the centrality of activists such as Nino Brown, who founded one of the first community organizations, *Zulu Nation Brasil*, and Nelson Triunfo, who began the break-dancing movement (Barbosa, *Bailes* 85–86, 163–64). When Taíde chants, "fui crescendo rodiado pela cultura Afro-Brasileira," [I was growing rhodium (platnium) from Afro-Brazilian culture], he places a burgeoning artist like himself in the receptive arc of collective wisdom from which the hip-hop movement unfolds. Hip-hop music is aggressive, confrontational, and offensive, Thaíde implies, and it activates the dissident voice of the youth and their "determinação" to bring about change. The song is one of the first public declarations of the hidden script of discontent by marginalized hip-hop artists, and it breaks an established pattern of public subordination (Scott 215). Due to the necessity of its openness to resistance, the song is politically charged; it affirms a type of hip-hop insurgency that follows in a protest tradition of "me malandreando / observando a evolução radical de meus irmãos" [my trickstering,[7] / observing the radical evolution of my brothers]. The trope of the trickster across African diasporic spaces is an affirmed carryover of African traditions. The trickster uses guile and deception to gain the upper hand, for he can never win a direct confrontation, due to his weakness or size in relation to his opponent. Illustrative of the veiled resistance strategies

of dominated groups, Scott suggests that such interplay generates the processes of the "socialization of the spirit of resistance" (164).

Signifyin(g) is a discursive strategy of indirection, predicated on reinterpretation and revision within an intertextual system of relations, with the intent to restructure the codes of power (Gates 51). Applying Henry Louis Gates's theory to the interpretation of the video images clarifies its semiotic codings. The rhetorical play bashes the viewer through both its musicality and its visual pastiche. The music sampled is from a popular hit in the 1970s by Jean Knight, *Mr. Big Stuff*, a song in which a woman rebukes and rebuffs a man's attention because of his overwhelming ego. The lyrics and video incongruously combine, but together they evoke funk symbology. Performing the song in a video from the 1970s, Jean Knight sports a huge Afro and the ubiquitous bright-colored pants suit (BlackSciFi), recoded in the quasi-farcical beginning of the video for "*Senhor Tempo Bom,*" with an animated cartoon figure of an Afroed female singer in a yellow catsuit (Flipeici). Forging a connective link with the sonic impact of funk, the funkeiros, and the hip-hop movement, Taíde appears through a visual tunnel that passes through the mouth of this cartoon character. Wearing a floral shirt, a bell-bottom suit, and an Afro in order to evoke the iconoclastic trends of the 1970s, he accomplishes that repetition with a difference that is fundamental to signifying and made even more apparent with the excessive glee shown by the dancers.

The visual montage unfolds as a sequence of signifiers that doubly invoke the joy that comes from moving one's body as freely as possible and the political insertion of one's will into public discourse. The hip-hop trajectories of break dancing, DJing, rapping, and creating graffiti art come together to visually code the iconoclastic rebel force of the music. The video shots veer between the group members, in their seventies regalia and large Afros, performing various dances like the syncopated moves popularized by soul groups, the robot, and the freestyling of the soul train line. Linking the past and present, a temporal juxtaposition is imposed with cuts between the seventies dancers, break dancers in a club, and the group in performance during a live show. Here the visual signification bolsters the lyrical import of the song, and Taíde's closing line calling hip-hop the "Black Power of today" registers its social injunction. Blurring the boundaries of aesthetics and politics, hip-hoppers intend to transform society from the outside, rather than from within its tropes of acceptability. "We use our music as our weapon," Thaíde states, (Alves 35), generating what Paul Gilroy considers an "alternate public sphere" in which life

and art combine with the performer and the spectators to challenge the normative (*No Black* 215). Thaíde and DJ Hum set the tone for the political and aesthetic engagement of the hip-hop movement to become a radical form of protest.

Intertextuality II: Hip-Hop, Funk, and the Cidades Partidas

The period from 1992 to 1993 was a period of intense upheaval in both Rio and São Paulo. The end of the military dictatorship was a long time coming, and with it came a sense of a reconfiguring of the national identity. However, the faveladas were even more outside the possibilities of social and economic access. Several *arrastões*, characterized as "looting rampages," on the beach in *Zona Sul* in Rio sparked retaliatory killings of favela residents by the police. In São Paulo, the massacre of 111 prisoners by the military police in the Carandiru House of Detention demanded new forms of confrontation and protest. The combination of an increasingly marginalized population, poverty, a globalized narcotrafficking industry, and brutality by the military police, who killed *meninos da rua* [street children], prisoners, and the poor with impunity, generated a youth population at odds with parental values and the reified social and economic strata of Brazilian identities, who then sought other paradigms with which to negotiate their outsiderness.

Rio's culture of violence, reflected in the spatial dynamics of the city, marked the geography of the *Zona Norte* and the *Zona Oeste* as favela or slum zones; the Zona Sul, the area for pleasure, entertainment, and relaxation, was demarcated for the white, middle classes. However, the beaches in the Zona Sul became sites of contestation because they were the only legitimate space that both faveladas and elites could occupy as shared territory. When the poor youth conducted the arrastões in the Zona Sul, an identification was immediately forged between faveladas, funkeiros, and criminality (Yudice, "Funkification" 201). The police conducted a series of "corrective measures," killing more street children and innocent favela dwellers (Yudice, "Afro Reggae," 53–54).[8] Micael Herschmann argues that media reportage intensified the stigmatization of the faveladas as criminals. Engaging in the project of constructing social reality, the media contributed to the perception in the public sphere that these youths were "'inimigos púbicos'" [public enemies] and "'delinqüencia juvenile'" [juvenile delinquents] (Herschmann, *A Cena* 88). Two vastly different reactions ensued. One was a de facto authorization of the terror by the middle class. The other reaction generated both an

interrogatory as to whether *cariocas* [residents in Rio] were living in a *cidade partida* [a divided city], comparable to an apartheid state—an analogy often invoked by members of the MNU—which led to the formation of citizens' action initiatives for social amelioration (Nobles 150; Herschmann, *A Cena* 14).[9]

Fueled by continued sensationalist media coverage, the stigmatization of the funkeiros remained in the mind-set of a bourgeois population that tacitly sanctioned the violence. Since hip-hop was associated with funkeiro culture and the derivative gangsta moniker from the United States, largely due to the global popularity of images of artists such as Snoop Dog, Ice-T, and NWA, it was deemed a complete outsider culture in the dominant sphere. However, the culture of violence generated a definitive shift in hip-hop articulation and began a localized hip-hop that told the stories of the agonistic dimension of living under state-sanctioned violence through the conjunction of blackness and poverty in systemic scripts of discrimination.

A shift in (dominant) public receptivity to hip-hop occurred with the recording by Gabriel O. Pensador, in 1992, of "*Tô Feliz Matei o Presidente*" [I'm Happy I've Killed the President], written in protest of President Fernando Collor de Mello and his corrupt administration. This was a form of radical protest from a member of the white middle class, but doubtless because of his social standing this song came to register as a protest against a limited transition to democracy and an excoriation of social ills. The song's popularity coincided with the excessive brutality against the funkeiros during the arrastões and added to the questioning of social inequity. Pensador's other hits included "*O Resto do Mundo*" [The Rest of the World], about the homeless, and "*Retrato de um Playboy*" [Portrait of a Playboy], an ironic chronicle of the life of the privileged. The song uses a well-known trope in the hip-hop lexicon, the "playboy," whose invented signification in terms such as "playboyzada," or even "boy," symbolize the white, wealthy strata; conversely, terms like *mano*, from the Spanish hermano, or the female equivalent *mina* or *mana*, refer to a sense of solidarity or collective identity from those involved in the hip-hop movement (Herschmann, *A Cena* 188; Pardue, *Ideologies* 137). Pensador's critique of violence, poverty, and racism in the pigmentocracy of Brazil succeeded in bringing the ills of the periferia into the focus of mainstream culture. It is not my intention here to name Pensador as the founder of Brazil's hip-hop movement, because he is not. I am simply pointing out that in the racialized consciousness of the middle class and the elite, a white rapper could be heard in a way that black rappers could not, and his voice inserted itself into

the rhetorical and discursive public sphere with an ease that those in the periferia did not have.[10]

Intertextuality III: Reordering Public Space

In São Paulo, hip-hoppers organize themselves into localized political and educational networks called posses. Commonly used by Jamaicans, the term *posse* denotes a particularly masculine sense of camaraderie and sociality, reforming its initial signification as a member of a local gang. In turn, Jamaicans borrowed it from American Westerns, popular in the 1970s and 1980s. The posses cultivate the multiple levels of hip-hop articulation in their combination of alternate social networks and community-based projects to strategically collaborate with NGOs and government-sponsored organizations in order to promote social change (Pardue, *Ideologies* 52; Andrade, "Movimento Juvenil" 89–91; J. Silva 33). Oppressed people rarely escape control and domination, but they can act in allowable arenas, suggests Lipsitz, to transform "the instruments of domination used to oppress them and try to put them to other uses" (*Dangerous Crossroads* 35), and the posses choose to work with both private and governmental institutions to combat the manifold inequities in society (Rocha 58).

Sociability in the posses allows for the development of a critical self-consciousness that Gramsci (2007) denotes as necessary for the creation of a cadre of intellectuals working for revolutionary change and the organic transformation of self. In the Freirian sense, the posses became an important vehicle for grassroots education; members simultaneously learn and teach about the struggles of global black peoples, to affirm ideations of négritude and valorize their own African matrix symbols, in tandem with educating about issues such as health, sexuality, and citizenship rights (Rocha 58; Andrade, "Hip Hop" 30). Tangential connections with the Afro-diasporic world become sources that ideologically inflect their initiatives. For instance, both Rappin' Hood (Antônio Luiz Júnior), the founder of *Posse Mente Zulu*, and Nino Brown, the founder of the posse Zulu Nation Brasil, denote the significance of the term "Zulu" as having a "'warrior attitude' on which black and other marginal resistance depends" (Pardue, *Ideologies* 108). Its use, however, is not simply to recode the Zulu Nation of South Africa but also to evoke Afrika Bambaataa's Zulu Nation as an ideological referent in the fusion of hip-hop and pedagogy (Silva 34; Pardue 76). Posse members collectively read texts such as *The Autobiography of Malcolm X*, *The Communist Manifesto*,

and *The Sociology of the Black Brazilian* (J. L. Santos)[11] in the quest to develop *auto-estima* [self-esteem] and *autoconsciência* [self-consciousness] (Andrade, "Hip Hop" 90; J. Silva 27). In creating this new sense of consciousness, hip-hoppers transform the lexical field of blackness and often eschew using the referent "Negro" (preferred by the MNU), seeing it as an influence from the African-American political sphere, and prefer to use the term "Preto" because of its singularity to Brazil. This is not to deny the African-American influence on hip-hop, for hip-hoppers connect to the Afro-diasporic world (over the African) in an unprecedented manner, to the extent that the Bronx and Harlem are sites of personal pilgrimages for authentication and rejuvenation of their cause. Renaming, thus, becomes a part of the self-reflexive processes within the transformative contours of Afro-Brazilian marginality and subjectivity.

One of the first groups to fully embody the overt politicization of hip-hop (Racionais MC's) fused the discourse of marginality and blackness to forge a unique Afro-Brazilian hip-hop style. Evolving from the baile Zimbabwe, their first CD, *Holocausto Urbano* [Urban Holocaust] (1992), changed the hip-hop landscape with songs such as "*Pânico no Zona Sul*"[Panic in the Southern Zone] and "*Racistas Otários*" [Racists Fuckers]. The title, *Pânico no Zona Sul*, refers to the spatial demarcation in São Paulo where the Zona Sul marks the boundary of the *periferia*, where the tension between the hidden transcript and the public sphere is most visible. According to Taíde, Racionais MC's "created a forceful poetry with an edge that only those who live in the *periferia* know. . . . they transformed a life of cruelty into poetry, it is something that very few know how to do" (Alves 123). Rap is public art, and rappers are some of the greatest, albeit unrecognized, poets. The poetry of Racionais MC's aggressively asserts itself into a listener's consciousness and channels a productive force of violence through symbolic, lyrical, and rhythmic forms of expressivity. Such violence is not to destroy but to transform the consciousness of subcitizens and their positionality in society.

A song such as "*Racistas Otários*" [Racists Fuckers], an analysis by Racionais MC's of the "o rotineiro Holocausto urbano" [the routine of the urban holocaust], demands that all members of society, those oppressed on the margins and those who benefit from social inequity, critique their system (Vagalume). In a sampling of human rights abuses for 2010, the Rio de Janeiro Institute for Public Security reported over 500 killings by the police of individuals described as "resisting arrest"; the São Paulo State Secretariat for Public Security reported that the police killed 392 people in the state from January

to September.[12] With the numerical dominance of Afro-Brazilians in the poor population, a natural supposition is that they are disproportionate targets of police brutality (Baeto 778). *"Racistas Otários"* systematically codes how Afro-Brazilians and the marginal poor are controlled and driven to a life of crime, becoming victims of social negation and categorized as total outsiders. They chant, "negro e branco pobre se parecem / Mas não são iguais" [poor black and white might look alike / But are not equal], due to a degrading and all-pervading discourse of assimilation. Foregrounding the issue of race within the differentials of wealth and status derogates the public discourse that attributes the social ills in Brazilian society to classism rather than racism. The choral chant signifies on the myth to emphasize its ubiquity as a subjectivized and territorialized discourse and laughs at the belief that "não há preconceito racial. Ha,Ha . . ." [there is no racial prejudice. Ha, Ha . . .]. Yet the ubiquity of racism sanctions social violence and operates within a dynamic of legitimacy that the state and the privileged endorse, in that prejudice "Te cumprimentam na frente / E te dão um tiro por trás" [Greets you in the front / And gives you a shot from behind]. The ordinariness of this violence continues, Racionais MC's opines, because of the lack of activism on the part of Afro-Brazilians. Validating Gramsci's concept of hegemony, that subordination cannot occur without consent, they demand that Afro-Brazilians regain the voice of protest found among their ancestors, who were willing to die for equality.

Passivity perpetuates oppression, and the lyrics perform an aesthetic and political intervention to activate political engagement. Since they record and produce their own music, suggests Jesus Félix, Racionais MC's did not have to temper their message to suit the dominant market (37).[13] Yet this, too, must be understood as a political intervention in the capitalist marketplace. Gramsci (2007) suggests that mass media perpetuates hegemony but also has the sagacity to see its potentiality in spreading counter-hegemonic ideals. In line with the destablilizing function of media, Milton Sales, a business partner of the group, considers owning the musical enterprise direct action for the community because the monies return immediately to the periferia, and the community-based projects of Racionais MC's are well known (Rocha 39). Their commercial success has spawned a new group of hip-hop entrepreneurs who also produce and sell their music.[14]

The group's combative stance and comportment in lines such as "Racistas otários nos deixem em paz" [Racist fuckers leave us alone] recall the heyday of Public Enemy and NWA, when such virulent

articulations of resistance were enough to cause people to listen and react. It is not about posturing or attitudinizing rage; it is more complex, for it demands a systemic evaluation of Afro-Brazilian positionality in the nation. When Racionais MC's states that they are stereotyped based on a "marginal padrão" [marginal standard], that the law that outlaws racism is "Inútil no dia a dia" [Useless in everyday life], they implicitly claim the rights of citizenship, to be treated with civility, and to occupy and traverse space with the freedom that whites enjoy. Ultimately, they seek recognition as to who they are as citizens, to be taken from the margins toward its center and integrated as equals rather than as subjects and objects.

Intertextuality IV: New Media

In its beginnings, hip-hop dissemination, for the most part, depended on local community radio stations. With the greater mediatization of hip-hop occurring through websites dedicated to the medium, the proliferation of MP3s and video shares, growing social networks like Facebook, the inception of MTV-Brasil and later YouTube, hip-hop networks expanded spatially and temporally. A video made years ago still lives in cyberspace and generates an affective ideology and response from viewers. Borrowing Aijaz Ahmed's terminology, the "regime of electronic pleasures" (286) proliferated with the growth of internet cafes and the lowering of the cost to use them. Periferia dwellers had greater accessibility to see and interact with other cultures, thereby changing the modalities of hip-hop from its imitative stages to a unique trajectory as "rap nacional" (Rocha 93; Sneed 60; Barbosa, *Bailes* 22). A prime example is the performance by Marcelo D2 of his phenomenal hit *"Qual É?"* in the Brazilian portion of Live Aid and in his Acústico show on MTV-Brasil. Hip-hop has even expanded to a city like Salvador, which, as seen in this work, is considered the nexus of African culture.

Video, more so than any other media, allows hip-hop performers to transcend their spatial racialization, enabling declarative moments of the hidden transcript. Some of the most popular videos include singles such as *"Diario de um Detento"*, from Racionais MC's, and live shows from groups such as *Detentos do Rap* and MV-Bill's *Falcão*, an intimate look into the life of a drug dealer. The formidable and unexpected success of the third CD from Racionais MC's, *Sobrevivendo no Inferno* [Surviving in Hell], recorded on their own record label Cosa Nostra, in 1997, confirmed that hip-hop had indeed changed the musical sphere. It was also an indication of the affective credibility of the hip-hop

narrative, as the CD's megasales (over one million copies) occurred
without the aid of popular media outlets (Pardue, *Ideologies* 111; Jesus
Félix 37). The song "*Diário de um Detento*" confirmed that they were,
indeed, the premier hip-hop group in the country.

"*Diário de um Detento*" is exactly that—a diary of the daily life of
a prisoner. The lead artist, Mano Brown (Pedro Paulo Soares Pereira),
raps in the song, "A vida bandida é sem futuro" [A criminal's life
doesn't have a future], and in chronicling a day in the life of this pris-
oner, truth is spoken and seen without any equivocation (Vagalume).
Contrasting the seeming innocence of childhood against the end
result of periferia living, the video begins with children playing domi-
noes on the street; it segues to a group of prisoners playing the game,
leading to the protagonist in his cell. The song begins with a signifi-
cant date and time, "São Paulo, dia 1 de Octobre de 1992, 8 horas
da manha," the day before the massacre at Carandiru. Reproducing
the appearances of hegemony that are vital to the exercise of domina-
tion, the opening sequences traverse between images of sociability
and hostility in the courtyard and around the cellblock, juxtaposed
against the implacability of the prison facade and the panoptic silhou-
ette of the guard tower. Some of the most disturbing vignettes are
those of dead bodies aligned in a morgue, visually reconfigured to
resemble bodies in a slave ship, laying head to toe, intersected by foot-
age of holocaust victims or other mass-death scenarios (Acg01).

Mirroring the scenic desolation in the lyrics, the song becomes a
commentary on the cycle of social decay that precedes criminality and
imprisonment. Stating that "Cada detento uma mãe, uma crença"
[Each prisoner is a mother, a believer] affirms a shared humanity often
denied to those imprisoned. The song unfolds through a sequence of
signifiers that foreground the human need for recognition and valu-
ation of life. When Mano Brown raps, "Minha vida não tem tanto
valor / quanto seu celular, seu computador" [My life isn't worth as
much / as your cell phone, your computer], he gives recognition to
the dominant sentiment that tacitly allows prisoners to be massacred.
This critique, however, does encompass the horrific choices made by
those who become incarcerated and, ultimately, trapped within a sys-
tem of dehumanization. Yet when he raps, "Ladrão, sangue bom tem
moral na quebrada. Mas pro Estado é só um número, mais nada"
[Thief, good blood has a moral code / But for the state he's only a
number, he's nothing], he is participating in an alternate social code
and modes of recognition developed by those who are outside the
dominant sphere of recognition, because in the public realm, their
lives are valueless: to the state they are only a number, and through

such essentializing processes it transforms the object of discrimination into a set of categorizations that are encoded as a typology or a pathology. Brown employs a form of discursive empowerment by inverting negative terminology and depriving it of functionality in the lives of the disenfranchised. A signifier like "Ladrão" becomes a marker of a particularly masculine sense of recognition and a sense of camaraderie, much like the appropriation of terms like "dog," "homie," or "nigga(h)" in the African-American context to mark filiation, friendship, or shared experiential contexts. Within this chain of signifiers, the ideal of "sangue bom" affixes a code of loyalty and fidelity that occurs in a confraternity, whether it is a hip-hop posse or a gang. It confers a bond that only death can break in this alternate social network. The expressed desire manifested in this song is for some integration and balance between the personal world and the wider world, such that the voice carries and one's action has positive repercussions within this alternate sphere and extends out into society. Ultimately, this song is a critique of the state and the place of the subcitizen in the national narrative of identity.

State violence becomes institutional and structural and effectively extinguishes a person as an individual subject. Equating life on the margins to a "modess usado ou bombril" [used Kotex or scrubbing pad] is a testament to its disposability in a country that uses "cachorros assassinos" [killer dogs] and "gás lacrimogêneo" [tear gas] against its people and gives medals to those who kill them. Just in the act of telling this story, of proclamation and declaration, Racionais MC's reclaim some sense of agency on the part of the marginalized to demand a space for themselves in the nation. Giving such stories visual and textual life outside oneself, in the sphere of representation, the overwhelming set of events or circumstances are brought into a more graspable framework. Representing traumatic events as story may seem reductive, for they become an act, a transitory moment, but it is a kind of redemption, because it subverts the power of events and circumstances to overwhelm and create affective traps due to the tyranny of circumstance. In many ways, hip-hoppers reinforce storytelling as a vital strategy for sustaining a sense of agency in the midst of disempowering circumstances and reclaim their subjectivity in creating authentic narratives of experientiality that transform their objectification by society (Jackson 15).

In the first DVD ever created of a live hip-hop show, the group *Detentos do Rap* [Prisoners of Rap] embodies the agentic element of storytelling. Story is about transformation, a way to transcend their marginal status to insert a voice of dissent and empowerment into the

Brazilian narrative of identity, and it allows for entry into the world of the spectator-participant on whom the hip-hop narrative generates a volitional aesthetic and political intervention. The show opens with the song "*Entrevista no Inferno*" [Interview in Hell], and the group arrives on stage with T-shirts tied across their faces. A common motif in hip-hop videos, the T-shirts become a visual code for the life of a drug dealer or a prisoner, since they appear as ski masks used to commit a crime. *Entrevista* begins like an interview, with a television reporter telling his viewers that he is visiting Carandiru, the worst prison in Latin America, to speak to the prisoners. He asks Mano Reco (Denilson Verteto), the leader of the group, "Can a prisoner return to society? And, what service can he give to society?" (Letras). Mano Reco's response hypostatizes public discourse by playing on its worst stereotypes of marginal subjectivity by equating the prisoners with "evil," "violence," and even the "devil." The level of significa-tion goes beyond the normally imagined field of horrifying images associated with blackness to suggest that terror is self-inflicted by an interiorized discourse, "Com a sua maneira de pensa" [because of the way you think]. Mano Reco reconfigures the omnipresent spectra of favela violence to magnify the threatening force of a voice and a discourse that shifts the terrain of culpability unto those who benefit from the vast disjunction of the system. Toward the end of the first stanza of *Entrevista*, Mano raps that he is "Protegido por Jesus a luz que me guia" [Protected by Jesus, the light guides me], presaging his evangelistic conversion and the righteousness of his cause, because his voice, freed like "um pesadelo" [a nightmare] in the world, will invert the infraposition of social dynamics. This song and video use story-telling to rework and remodel subject/object relations in ways that subtly alter the balance between actors and acted upon by allowing for transcendence of marginality, to actively participate and transform a world that discounts, demeans, and disempowers them.

The version of "*Diário de um Detento*" by Racionais MC's is a recreation of the text of Jocenir, a prisoner in Carandiru, who Mano Brown describes as the voice of the prison (Rocha 71). However, members of *Detentos no Rap* reformulate their reality, having met and formed the group in the prison. Mimicking the image of gang-sta' rappers, they wear the hip-hop regalia of oversized clothes, sweatshirts, and sports jerseys, with a significant difference—the beige pants given to prisoners in Carandiru. Yet emblems of gang-sta' hypermasculinity, from overt celebrations of sexual prowess to the capacity to commit atrocious act, are significantly missing from this DVD and their overall musical repertoire. This is indeed

a counternarrative of criminality. In the song *"Casa Cheia"* [Full House], the chorus repeats, "O Carandiru está de casa cheia / Muita maldade no ar muita droga na veia" [The Carandiru House is Full / Much evil in the air and drugs in the veins] (Letras). Gerard Béhague (2006) notes that listeners construct meanings for songs from within their own ideological beliefs and understandings (82), and when the audience starts singing along, the vehemence in their response indicates that this is not just a popular song, but one they connect to viscerally. An audience comprised mostly of young males of all shades from light brown to black, with an occasional Brazilian-defined white male face sprinkled in and a few women in all the color spectra, evidences hip-hop's intent to give "conscientização dos excluídos" [awareness of the excluded], to impart knowledge that generates agency and activates a sense of purpose for the "negros e pobres" [blacks and poor] (Barbosa, *Bailes* 203).

To a certain extent, hip-hop shows like this one mirror the opposition in Habermas's (1989) and Bakhtin's (1981) concepts of the public sphere. Habermas conceived of his public sphere as a neutral space for discourse, proposing that within these public interactions, ideological beliefs and competing interests could be set aside in order to reach consensus through interpersonal dialogue. Habermas wants no hidden agendas in dialogue, but his public sphere assumes a bourgeois space with free and equal access and willing consent of the participants; it acknowledges the better argument, without alternate manifestations of dissent in light of the rational debate and consensus building between the coalitions. Although not intended, it describes the sphere of the dominant, who use the guise of rationality and consensus to validate privilege, and is characteristic of Brazil's mythos as a racial paradise, because not only whites insist on its existence, the mixed-race and black populations do as well—a true consensus.

Contrastingly, Bakhtin ascribes within the public sphere an intermingling of diverse social groups, styles, and language, ranging from ironic to playful. It is a contested space in which social hierarchies are questioned and subverted through carnivelesque strategies, including parody and satire. This public sphere is marked by pluralistic heteroglossia. The outing of the hidden transcript of protest by these hip-hop artists responds to the embodied, situational, and dialogical elements of life that hip-hoppers bring to the stage. They use the power of language to signify on the social and the political, and in the Bakhtinian sense, language carries "a deliberate feeling for the historical and social concreteness of living discourse, as well as its relativity, a feeling for participation in historical becoming and in social struggle"

(Dialogic 331). The shows, in recoding the dynamics of spatialization in society, allow for the voices of black and brown youth to dominate this public sphere. "A cultura da rua" [street culture], through hip-hop articulation, generates a discursive and aesthetic interruption and a critique of an outmoded, outdated system that imprisons them in tautological complaisance and acceptance of their racial paradise and limits their potentiality for real change (Silva 28).

A compelling imbrication of both public spheres appears in a YouTube video of Nega Gizza (Gisele Gomes de Souza) performing her song "*Filme de Terror*" [Terror Film] to an all-white, female, middle-class, and middle-aged audience (Cufaaudiovisual). What Nega Gizza and all of these artists so forcefully articulate are the limits of the social contract with regard to the racial other. Conceptions of mulata sensuality, tropical beauty, and the happiness of the people, all metaphorical referents to democracia racial, are replaced by the image of a pedophilic nation that preys on its own people. It is a nation in which "Os brancos na orla, os pretos no morro / Os índios sufocados contra o muro" [The whites (are) on the seaside, the blacks on the hill / The Indians choked against (the) wall] (Lyrics time). Speaking her truth without equivocation to this group of women, Nega Gizza issues a challenge to dominant conceptions of who she is and who Afro-Brazilians are. The public sphere promotes the image of the happy black person, but the truth is that "Me deixem comer os restos dos ratos / Me deixem lustrar as graxas dos seus sapatos" [They left me to eat rat droppings / They tell me to shine your shoes]. Repositioning the discourse, she is forcing whites to confront the lies that bolster their privileged status, and blacks, who remain silent to their cumulative historical and systemic oppression, to face their own culpability in its perpetuation and to change it. Tellingly, there were only two comments on this YouTube site, the longest of which must be quoted here: "It's too crazy! nega gizza performing for this rich bunch in Brasilia. look at the lady in the audience. nega gizza is more fucked [hardcore] than mv bill, and look it's too fucking much" (Cufaaudiovisual). Because of such performances, Brazilians can no longer pretend ignorance about the conditions of Negros and *pobres*. The song ends with a profound attitudinal shift when Nega Gizza states, "Não vou morrer pelo Brasil!" [I'm not going to die for Brazil], for it smashes open the hidden transcript of discontent. Like Mano Reco's "nightmare," this alternate discourse is freed to challenge the social order and the place of blackness within it.

The commonalities of the social contract as envisioned by Hobbes and Locke involve the voluntary sublation of a primal, individualistic

will to live within the rules of a society and gain its benefits. For Locke, it signifies that political power is invested in society to pre-serve the "lives, liberties, and possessions" of its members through the enactment of legislation guaranteeing majority rights and punish-ing offenders (Second Treatise § 171). Explicit in the social contract is the benefit derived for all in society. Charles Mills, however, sees it differently and considers the social contract an agreement between those who are classified as white, who become its subjects, over non-whites, who are then its objects (12). The racial contract negates the point of differentiation that generates the social contract, the move-ment from a naturalized state to one of social conformity, since its parameters are between whites, who are self-classified as one subset of humanity and who categorize other "subsets of humans as 'non-white' and of a different and inferior moral status" (Mills 11). Mills posits that all whites benefit from the contract, with or without their acceptance of it, because it guarantees privileges over nonwhites through the exploitation of their land, resources, and bodies, with-out giving them similar socioeconomic opportunity or social equity. Systems of domination such as the police, the penal system, and the army are enforcers of the racial contract, working to guarantee the rights and property of white citizens and prevent crime against them (Mills 84). When Racionais MC's state in *"Capítulo 4, Versículo 3"* [Chapter 4, Verse 3] in *Sobrevivendo no Inferno*, that the majority of the prison population is black, they interpolate the terms of the racial contract:

> 60% of young people in the *periferia* without any criminal background have suffered police violence. Out of every 4 people killed by police, 3 are black. In the universities in Brazil, only 2% of the students are black. Every four hours a black youth dies violently in São Paulo.

Validating the castigatory repercussions in these racialized domains, student-anthropologist Sandra Soares da Costa gives a firsthand account of the effects of a *"dura"* [police raid] after leaving a hip-hop show. Costa characterizes the territory of the show as a "zona neutra" [neutral zone] because "the police don't come up. Nor do the drug dealers descend" (145). During the dura, the police separate women from men and, as she tells it, her obvious phenotypic difference as a white woman causes them to question her. Finding out that she is an anthropology student studying the hip-hop movement, they caution her by saying, "Girl, you shouldn't hang out with these people. It's a bad scene, they're all potheads. You should look for another dance

for fun. You're a nice girl, you have *boa aparência*, educated. You have to look for people on your level" (149). The use of coded terminology like "boa aparência" alerts the reader to her obvious difference (fair-skinned with long hair) from the Afro-Brazilians around her. The dura ends without incident, but Costa is surprised to read in the newspaper the following day that the same police officers brutalized, both verbally and physically, women and men in one of the hip-hop bands. Band members were severely beaten, women were kicked in their genitalia and men in their chests and hindquarters (149–50).

Exposition of such sinister aspects of the racial contract is a dominant theme in the work of rapper MV Bill (Alex Pereira Barbosa). From Rio, MV Bill may be the most popular and one of the most-respected hip-hop artists in the country. His consistence in using his social currency to address the "politics of containment" in favela life, the toleration of the marginals as long as they remain in their pre-scribed arenas (Collins, *Black Power* 30), manifests beyond the realm of his musicality. As a favelada, having grown up in the infamous *Cidade de Deus*,[15] MV Bill is both an insider and an outsider. His insiderness allows him to speak for the faveladas, and his activism, to speak to them and capture an extraordinary nihilism seen in his documentary, *Falcão: Meninos do Tráfico*. The documentary, in its exploration of the subterranean world of the drug trade, extends the sphere of representations of favela life and the subject/object gaze when the Falcão, the young men who sell drugs at night, become the subjects within this filmic gaze. In interviews conducted with the Falções during the course of the night trade, they appear as blurred images in front of the camera, holding guns in one hand and drugs in another. The youth give an account of a life that is beyond despair, that yields two ultimate ends: prison or death. In the opening of the documentary, one subject likens himself to "a bird that doesn't sleep at night." It is a world in which all the norms of society are inverted, where children "play" at being criminals in preparation for their eventual life in the drug trade. A limited arena of economic choices exists: to sell drugs, process drugs, or steal. Violence is the norm, for at any moment "*um sujeito homen* . . . a rival from another gang . . . 'comes' in my face, slaps my face, puts a gun in my face and says 'you're going to die.'" In this punishment regime, the police exist only to molest and kill or to be bribed with money, drugs, or guns. The racial contract makes natural a police state, in which drug dealers and the police entities become both enemies and allies. One subject of the documentary commented, "If crime ends, the police end. Because it is us who give the money to the police . . . If not for the drug trade today,

the 'police' would only get their salary." A result of the racial contract is that subordinated groups cannot develop an allegiance to society, as they consider it as working against them. When one of the drug packers maintains, "but that is what the government wants. You're trapped and they truly discriminate against us," his self-reflexivity is tied to a social critique of his placement in society's hierarchy.

The video to the song "*Falção*" begins with the voice of a homeless boy who steals to stay alive. In the documentary, MV Bill asks him, what happens if he dies? The boy's response characterizes the state of abjection that comes from the totality of alienation: "eu vou descansar" [I'll go to rest] (Renesenaj). This tragic voice and tale stands in contrast to the agitation, sense of purpose, and strength of delivery of MV Bill when he begins to rap, "Jovem, preto, novo, pequeno / Drogas, armas, sem futuro" [Young, black, fresh, small / Drugs, guns, no future] (Lyris time). The tonal emphasis on each word causes it to resonate and reverberate in the mind of the listener. The song highlights rap as an art form and as political praxis, a poetic force that channels the power of intense experiential cruxes. The danger and the horror the documentary captures is duplicated in a type of aesthetically represented violence employed in the song's delivery, with its swift, intense beat, its aggressively loud sound, and its confrontational lyrical content. Contrastingly, however, the music video *Falção* distills the intensity of the film, because its focus is on MV Bill's performance. The documentary hinges on unbalancing the viewer, by breaking the "conspiracy of silence and complacency about economic oppression, police violence, and social ills" to open a dialogue that continues in the public sphere (Shusterman 59). MV Bill states that his goal in making the documentary is "to help to think and rethink the laws in Brazil, to rethink the concepts of humanity that they talk so much about." And with the speaking voices from the margins, it forces the viewer to revisit the foundational question of the racial contract: Who is a human being? The disemia such a question generates in the tension it recalls between public representation and the intimacy of introspection collapses the space of intersubjectivity to refashion the experiences of the marginal and make them real and connected, so that their words are heard and their plight is understood.

Intertextuality V: Hip-Hop Négritude in the Multicontext

MV Bill's first CD is called *Traficando Informação* (1998), and in its eponymous song he raps, "Encontrei minha salvação na cultura hip

hop" [I found my salvation in hip hop culture] (Letras). Signifying on the idea of trafficking drugs, he is trafficking information. Modeling Gramsci's (2007) organic intellectual, the MV in his name stands for "mensageiro de verdade . . . falando pela communidade" [messenger of truth . . . speaking for the community]. One of MV Bill's latest performance iterations is rapping accompanied by a live rock band. Rock, a music associated with the white bourgeois, meets rap to generate a radical new form of hip-hop. In the MTV performance of the song "*Falcão*," featuring his sister, who raps under the name K'milla, the rock musicians replace the DJ (Renesenaj). The video becomes a deliberate, intertextual juxtaposition with a scenic background comprised of objects and statues relating to Candomblé, in contrast to the all-white musicians and audience members, and MV Bill and K'milla rapping in the foreground. MV Bill is considered the quintessential "quilombola urbano" (Rocha 121) due to the inclusivity in his music, his advocating for the rights of those on the margin, and his articulation of Afro-Brazilian forms of négritude.

Hip-hoppers employ négritude in the pedagogical context of "autoconhecimento" (J. Silva 29) and as a more holistic, empowering aesthetic signifier. When the artist Rappin' Hood tells the populace in "*Sou Negão*" [I'm Super Black], "Pra toda raça negra escutar e agitar // Não tenha medo de falar, fale com muito amor" [All of the black race, listen and stir // Don't be afraid to speak, speak with a lot of love] (Lyrics time), he creates a radical intervention in the construction of blackness in the individual psyche and the public domain. This is the second incarnation of the song "*Sou Negão*"; the first version, done with Posse Mente Zulu in 1992, offers a profound confrontational stance in this revisioning of blackness, with its choral chants of "Sou Negrão" [I'm very black] and "Cem porcento preto" [one hundred percent black]. Such deeply charged social statements repudiate the racial contract and the self-negation it promotes. Saying one is "one hundred percent *preto*," is mind-boggling to a population that wears T-shirts that list their degrees of white, black, and indigenous bloodlines. It's quite common to see someone who is phenotypically black with a shirt stamped with 25% *branco*, 25% *indigena*, 50% *preto*, or some other equivalent values. Charges such as "nós somos negros! . . . Você ri a minha pele [We're black . . . smile at my skin] and "Seja escuro, mas seja escuro e verdadeiro" [Be dark, be very dark and real], demand a rethinking of one's subjectivization and adherence to exercises of domination.

In both versions of the song, Rappin' Hood promotes a "diaspora literacy," which, according to Vévé Clark (1991), is an understanding

of the stories, tropes, and allusions across the different diasporic communities in its naming of local and global heroes of the black world. What shifts from the first to the second version is its framing and its musicality, with Rappin' Hood using samba as the rhythmic base in the second. A popular version of the song is performed with the great sambista Leci Brandão, and Rappin' Hood transforms the beginning of the song to pay tribute to this tradition (Toddynho7). Like MV Bill, Rappin' Hood is generating a négritude aesthetic engagement between hip-hop and Afro-Brazilian culture. While MV Bill generates a scenic engagement with its cultural markers in his videos,[16] Rappin' Hood transforms the musical context. Funkeiros had detached themselves from samba, considering it a co-opted offshoot of Brasilidade, but Rappin' Hood and other hip-hop artists redeem its significance as Afro-Brazilian music to reformulate and authorize the trajectory of individual and collective belonging in the nation.

The négritude aesthetic transforms the lyrical content of hip-hop songs, replacing the lengthy narratives about life in the periferia, lost in despair with shorter, equally descriptive verses that celebrate life and the black subject's ability to transcend marginality. A song such as "*Negro Drama*," by Racionais MC's, marks this difference. It is still a cutting-edge description of life in a favela, but with an ironic thrust about the impact of favela life and hip-hop culture on the bourgeois, to such an extent that "seu filho que ser Preto" [your son wants to be black]. It may just be a *whiggah* phenomenon, white kids who want to act black, but the song inverts favela life, black life, and revisions favela space as the place in which "os diamante, da lama" [diamonds come from mud] (Letras).

Nega Gizza conjoins feminism with négritude ideation. In the title of the song, "*Larga O Bicho*" [Release the Animal], Nega Gizza generates an ironic twist to tropes of blackness that she immediately debunks when she raps, "Sou nega de pele e na mente" [I'm black on the skin and in the mind] (Lyrics time). Hyperbolic and incendiary, she boasts that she is a "Mulher preta de espirto guerreiro // Acelerando o pensamento positivo [Black woman with a warrior spirit // Accelerating the positive thinking]. Black women in Brazilian pigmentocracy and parlance are affectionately referred to as *nega* [black] or *neguinha* [little black woman]. When Nega Gizza lauds black women, she refocalizes the color-coded optic on the skin to make it a marker of pride and resistance by rapping, "Trago na pele a força e minha juventude / Trago na massa encefalica a négritude" [I carry a force [an energy] and my youth in the skin / I carry blackness in the brain]. In a nation where *parda* and *preta* women are the most

marginalized of the poor (Sterling, "Women-Space" 75), to say that
my blackness brings reason and that my skin is a source of energy is
both militant and seditious in its reconfiguration of subjectivity and
communal identity. Her critique, however, extends beyond the binary
limitations of black women against white society, and Nega Gizza
places her subjectivity in the midst of this insurgent narrative form
to reproach the overt masculinity of hip-hop by stating that "O rap
não é privilégio do homen" [Rap is not the privilege of men]. Women
in hip-hop are usually vocalists, dancers, girlfriends, or wives to the
artists (M. Silva 96). Facing dual discrimination, Nega Gizza fights
for the centrality of the female voice within hip-hop and within the
multicontextual aesthetic and socioeconomic spheres of the nation.

Just as Nega Gizza's négritude is tied to her articulation of female
subjectivity and feminist discourse, a more recent group, Z'Africa
Brasil, creates an aesthetically collaborative engagement that allows
for their assimilation of diverse rhythms and musical forms. The "Z"
in Z'Africa stands for Zumbi, the leader of Palmares, and Z'Africa's
aesthetics reforges the connective ties historically, ancestrally, and
spiritually between Afro-Brazilians and their African pasts. Zumbi,
as already discussed, is a symbol of transformation. He and Palmares
evoke the idealized version of what blackness could signify in the
Brazilian world (Chapter 4). Songs such as "*A Raiz*" [The Root],
"*Antigamente Quilombo*," and "*Hoje Periferia*" [Formerly Quilombo,
Today Periphery], from the eponymous CD, revisit this trope of lib-
eration in the Quilombo, but with a difference. Z'Africa is about the
fusion of diasporic musical styles, creating a unique hip-hop expres-
sivity that includes samba, rock, reggae, funk, ragga, and rap. Sounds
from the black world, fortified by social critique, assert the desired
telos for hip-hop expressivity "to diminish the social exclusion and
suffering of those in the periphery" (Barbosa, *Bailes* 203). In per-
formance, groups such as Z'Africa generate an "audiotopia," defined
by Frederich Moehn as "sonic and social spaces where disparate
identity formations, cultures, and geographies historically kept and
mapped separately are allowed to interact with each other" (184–85).
For Z'Africa embodies the multiracial, hybridic ideal celebrated by
the Quilombos, but its hybridity is configured from African-based
sources, in contrast to the one eulogized in Brasilidade. In some ways
Z'Africa represents the evolution of hip-hop and the power of its
impact on the racialization and spatialization of urban spaces.

A legitimate argument can be made that hip-hop reflects global
homogenizing engines in its mediatization and marketability, seen
in television programs such as "Manos e Minas," featuring hip-hop

battles and popular artists. Such visibility results from decisions to work *within* rather than *outside* the system of Brazilian media and politics. The state, many believe, has an obligation to its marginal population, and hip-hop expressivity in mainstream outlets allows for visibility and integration into the local and global marketplace, an indicator to Afro-Brazilians of their increasing mobility. Z'Africa needs no defense for their musicality, and with an understanding of their lyrical content, recognition and praise must be given to their brilliance. One of their most popular songs is "*Tem Cor Age*"; the title generates an inspired word play, translating to "Have Courage" or "Dares" and "Have Color Act" (Vagalume). The group puns on that duality in the opening and ending refrain: "O que importa é a cor / E quem tem cor age" [how important is color / and who has courage or who dares]. This deliberate juxtaposition of "color" and "courage" speaks to the omnipresence of the revolutionary desire, to overthrow the combined social, economic, and psychological effects of living in a pigmentocracy. When Z'Africa sings "Tem cor age," a play on the term *coragem* evokes the courage to destroy color segmentation: "De mudar o rumo da história // Pra transformar cada dia em vitórias" [To change the course of history // To turn each day into victories]. The reactive positionality of the black subject shifts in such a song to an actional, transformed reality. The language of camaraderie, such as "ladrão," is replaced by the more emotionally evocative terminology of "Irmãos" [brothers]. Such a semantic flux reshapes the space of inter- and intrasubjectivity to understand that "O inimigo é outro / Não seja o espelho" [The enemy is another / He isn't in the mirror]. The song is an evocation of peace, a scarce commodity that is a centralizing force in any demand for social amelioration.

The brilliance of the song is multiplied by altering the significance of "Cor age" from "courage" to "color acts," for "Cor age pra ultrapassar as barreiras do impossível / Cor age é tudo" [Color acts to overcome the barriers of the impossible / Color acts is everything]. In their polyvalence, blackness is the root from which color derives and acts; it is agentic, auto-hegemonic, and all-inclusive. Opening the video with a blues riff, the words "Tem cor age" ring out as the choral accompaniment sung by children, adding to the idealized visualization of another type of life in the favela, one of joy and celebration (Mcpoppin's). The video unfolds as a kinetic pastiche with shots of older and younger capoeiristas, youths playing football and basketball, skateboarding, and b-boying. Creating a cross-generational unity through acts that make an impossible life livable, these joyful moments do not simplify the issues Afro-Brazilians face, nor are

they emblems of how black culture operates, but an evocation of the beauty within the ordinariness of life. Z'Africa's message is not univocal, nor is it pointing to an exclusive blackness or exclusively to blacks. What it signifies is that in their polyvalence, blackness as a conjunct of Quilombo ideology, diasporic subjectivity, and African matrix symbology confer meaning and identity, and in the multiplicity, the hybridity of signification, blackness is its center.

Conclusion

Storytelling is what rappers do, and hip-hop narratives serve an important epistemological function in authenticating knowledge and experience that is frequently misrepresented in, if not excluded from, official discourse. Hip-hoppers embody the situational and dialogical elements of everyday life. Hip-hop's emotional, volatile tone recreates a brand of masculinity and feminism that upends the inequity and social separation in society. Hip-hop, unlike other forms of protest in the black movement, is about confrontation—of the self, of society—in its deliberately employed blackness. Hip-hop's négritude does indeed connote a sense of rootedness in Afro-Brazilian cultural forms and a vision of black empowerment coming from an adapted discourse like the funk movement, but it further demands an end to the systemic marginalization of Afro-Brazilians. The space of despair that is endemic to periferia living is brought into the public sphere, but rather than being trapped in the systems of control and domination, hip-hoppers devise new modes of cultural collaboration to transform the public sphere:

> the lives of a generation of hip hoppers transcend the limits expressed in statistics. A generation of young blacks and peripherals have opportunities through this movement to build new life expectations and change their goals. Today, looking at the *manos* and *minas* who worked with me and mine in the past, I realize that this movement was able to transform our lives, there are great changes, mostly through individual achievements, but I believe that achieving our individual dreams strengthen us for collective action. (J. L. Santos)

Hip-hop becomes pedagogical and performative agency, to generate a disjunction between social and cultural construction of essence and the selection of cultural scripts to maximize cohesion and unity. Access to the world is mediated through the performative body, reiterating shared experiences, shared desire, and shared metaphors to

generate their own codes of belonging through the ideas they valo-
rize and the people they mythologize, to generate the mutuality of
an alternate social sphere. Art becomes an organizational emblem,
a movement to educate, and through the posses and social network
groupings it generates new agency and organizational structures for
the dispossessed.

Conclusion: Uma Luta que Nos Transcende

"Maio"
Quero ler na noite, cor, irmão
o rosto dos irmãos, braços, peitos,
todos lindos, nus, descendo todas
as colinas, transpondo as barreiras
se espalhando na semelhante
marca serpente do asfalto.
Quero ver colares, gritos, danças
e assumir como vestido agora
o manto brilhante do que vem,
o ato, o desacato, a conciência
e descobrir depois de tudo a luta pela
felicidade interior de ser negro

José Carlos Limeira[1]

At our historical juncture, we are faced with uncertainty in all our definitional constructs; these are the times in which grand narratives are debunked, totalizing designations are found wanting, and affiliations taken for granted are scrutinized based on their centrality to the definitions of position and power. In these times when negotiation, mutual imbrication, and ambivalence rule, why is it important to discuss Afro-Brazilian identity? In this era of globalization, just as separations elide due to the omnipresence of the internet, email, the media, and travel, they are reinforced by the major economic blocks, military might, and the lack of understanding of cultural difference. As we view the changing face of things and the increasing consumption of the materiality of the West, each day increases the distance between those included and those dispossessed. Religious and ethnic wars, battles over territory, and battles over oil are testaments

to the contestations between hegemonic structures and the Others they have created. Whether identity is constructed by national discourse, state ideologies, and dominant paradigms, or asserted by the speaking self, depends on the ability of social, cultural, and political subjects to cohere voice and assert who they are. Thus, if we consider it retrogressive to speak of identity, then we cannot fully understand the potency of dissimilitude and the desire to construct subjectivity and cultural autonomy.

Identities, today, are heteroglossic by nature. But the openness of signification that hybrid theorizing evokes and that serves as a discourse of empowerment for marginalized groups in other black Atlantic spaces, in Brazil, when employed by state organs, becomes a pernicious hegemonic discourse that prevents social change. For Afro-Brazilian activists, unitary forms of identity provide the modus for mass mobilization to insert the issues of socioeconomic marginality into the national consciousness. A racially unified identity becomes a strategic alternative aimed at promoting and engendering political engagement, as scholar and poet Ana Célia da Silva tells us:

> I think it is important in Brazil today to deconstruct the ideology of black inferiority and to show to the black person that he is part of the majority [of the population] and has rights. If you can succeed in this, you will have a democratic society in this country.

This work examines the acts and actions of self-representation by Afro-Brazilians in developing their own myths and rituals, heroes, aesthetic codes, and social cohesions and standards, mediated by a shared matrix ideology that shapes a way of looking at the world. Such intense mutuality in expressivity allows these self-presentations to be political acts that consecrate who they are and who they want to be in the national structure. Mãe de Santo, Maria das Graças de Santana Rodrigué, in the documentary *Scattered Africa*, offers a glimpse into the continued significance of identity to Afro-Brazilians; as she states, "where we are from, who we are, who I am. If I can be conscious of who I am after four generations, living in a country with a history of colonization and slavery, then I need to re-think my moment." In rethinking her moment, past relationality bears down on the present constitutive state and projects into mediations on the future. It allows for a willed intentionality, a future alterity that can be willed into existence (à la Raymond Williams).

I have argued that when Afro-Brazilians look to Africa as source narrative and around the black world for ideals to emulate, the dis-

courses of Africanness and blackness find legitimation in the construction of a lived Africa and an entelechy of blackness, as an activating force, a catalyst to an auto-hegemonic subject position arising from a complex history of religiosity, marronage, and transculturation. It implies the deliberate choice and creation of such root sources and racialized positionings, and the self-empowerment such choices imply. Patricia de Santana Pinho suggests in *Mama Africa* that Africa is conceived of as a source of purity by Afro-Brazilians "to recover from *mestiçagem* and disentangle . . . from the trappings of Brazil's narrative of racial democracy" (30). Yes, indeed, Afro-Brazilians resist the effects of hybridization in the quest for an African and black ideation. However, what Pinho and so many other scholars who eschew root discourses fail to understand is the intrinsic need to place oneself in a line of belonging that shapes who you are. Rather than bowing out of the narrative of democracia racial, Afro-Brazilians, I suggest, aim to create the dream of the *pluricultural* society that truly reflects the ideals envisioned through the lens of racial democracy, where their social and political currency are considered of equal value. For this reason, Afro-Brazilian identity is predicated on shifting the morphological equivalence of an African past and a Brazilian present as "Negra" or "Preta" as devalued and reduced significations of blackness.

Afro-Brazilian "corporeal malediction" manifests in official and unofficial governmental policies and societal praxes in what appear to be antithetical systems: first to extirpate blackness through the process of embranquecimento, and then to co-opt it in the discourse of democracia racial. The simultaneous correlative stance on the part of culturists and activists constructs a mode of engagement with a transformed imago of Africanness and blackness that is politically and aesthetically charged to touch the psyches of Afro-Brazilians to allow them to negate their negation. It is a case of subversion from within, a process of willing the future, as Florentina da S. Souza describes, to intervene in the processes of the actual transformation of the institutions of power (83). Models of agency from Candomblé and the Quilombo generate communal ties and shared experiential knowledge, and these African-based matrices must be seen as the sources of inspiration in the active engagement with the issue of identity. However, the Afro-Brazilian transformational telos is practical—to engender mutual identification in order to create proactive voting blocks that can shift the minefield of social and economic miasma that the y as a majority face. They engage with the discourses of embranquecimento and democracia racial, symptomatic of the ritualized narratives of identity employed by the Brazilian nation, because

their intrinsically codified systems of representation render subordinate the black body and its representational forms in an asymmetrical divide of power.

The Brazilian constitution forbids racial discrimination; however, bringing such a case to the courts for redress is difficult at best, and almost impossible for the average Afro-Brazilian. Acknowledging that the racial struggle in Brazil is not an open, jural contestation, but one bolstered by institutional order, the questions of race and its representation are most often addressed in the arena of culture. When culture becomes the site where the objectified Others become the purveyors of their own discourse, it too becomes a unifying rubric for political engagement. Just as their forbearers deliberately took on an identity as Nagô in slave-society Brazil, Afro-Brazilians continue to use the Nago-centric Candomblé to construct an African/black-based identity predicated on shared ancestry and shared cultural contexts. Candomblé, I proffer, rests on creating and preserving an alternate hierarchy derived from African epistemological and ontological systems that resist the "enlightenment" offered by Western hierarchization in its privileging of white over black and its conceptions of black peoples as not only different, but different in kind; it transforms the context of male privilege over female, and written texts over oral, and most cogently transcends the privileged belonging to a patriarchal, self-generating, triumvirate god force for a multivalent, cross-gendered set of spiritual forces. It is embodied praxis that codifies memory, allowing it to live beyond a temporal or spatial injunction as its rules, laws, institutional frameworks, and codes of comportment are carried in the body of the believer. In its reinstitutionalization in Brazil, verifiable African ancestry proved to be the salient feature guaranteeing access to the deepest font of knowledge and alternate site of power, as one generation of Africans passed on their knowledge to their descendants. Due to their strategic agency, an ideal Africa, singularly located in the Yoruba annex of influence, served as the site of origin and the source of ritual purity to advance the legitimacy of Candomblé-nagô and to strengthen the positionality of this nexus of elite, educated Pan-African priests. Unlike other spaces in the diasporic world, continuous religious interrelations exist between Afro-Brazilians and Africans, and their earliest transatlantic voyages become source codings for generations of Mães and Pais dos Santos, who are guardians and keepers of African culture.

Júlio Braga suggests that we view these Mães and Pais as "the anonymous heroes in the formation of Brazilian identity," for they reconstituted the memory of Africa and lived with it daily in the terreiro space. Africanness is thus the spiritual and emotive charge that

emboldens the demand implied in "ser Negro no Brasil" [being black in Brazil]. For Afro-Brazilians, this point of blackness, articulated as négritude, is the political ideation that addresses their positionality, political power, and personal subjectivity. Poet and academician José Carlos Limeira's suggestion as to the functionality of the discourse of blackness helps us to understand its transformative trajectory: "I think of *négritude* in terms of rescuing the contribution, and the possibility of contribution of black peoples. . . . who have the ability to transcend the pain and contribute to the creation of a country where they have been exploited, excluded and annihilated." Limeira effectively returns us to the crux of identity—it is as much *belonging* as it is *becoming*. In his poem "Maio," which serves as an epigraph to this chapter, he authors a dualistic vision of a line of descent from the past and of black peoples descending from the margins of society to its "asfalto," the city centers, to take their rightful place in the nation.

Belonging and *becoming* can only occur through the repositioning of an African identity to have a value in the public sphere equal to the one seen in the private space of the terreiro. The rituvals examined in this text recode the performative index of Candomblé and offer moments of social inversion by promoting levels of freedom from the norms of place and position; but more so, they suggest a model for power that is coterminus with the mutuality of human and divine agency. External vectors, such as Black Power formulations from the United States, combine with Candomblé representations and the Quilombo model to become evocative significations in this projected field of redemption. While the blocos afros formed to generate a performative interruption of the Brazilian narrative, the Movimento Negro Unificado organized the political sphere to push forward its own candidates and agendas for the black populace, resulting in the development of manifold political factions.[2] Groups such as Quilombhoje developed to reconstruct the literary landscape. Each as a rhizomatic strand, working in their particular spatialities, form a discursive sum that shapes present-day concepts of Africanness/blackness and, in turn, the future dynamics of society. These first endeavors were initiated by social activists, who succeed in generating what Kobena Mercer calls a "hyperblackness," greater visibility through media (154), to replace the denigrated signification and identity conferred on the black being, with a designative value based on the commonality of cultural belonging. Predicated on shifting the dynamical sphere of representations in the subjective and objective realms, they are projects that engage with emotional and psychical representations, consciously and unconsciously inflected in institutional divisions, selective exclusionary policies, fetishizing encounters, and overt romanticized imagery.

The poets of Quilombhoje stand on the relational divide between activists and artistic injunctions, and as the first to use *race* as a rubric for literary creativity, they mirror precursors such as the BAM. However, they extend that aesthetic dislocation in their *aesthetics of imperfectability* that generates a discursive and performative reconversion of Africanness and blackness. The Bando de Teatro Olodum similarly, in creating their own models for dramaturgy, recode the operational imperative of Teatro Experimental do Negro. However, in their creation of a *poiesis of incarnation*, they construct a multisensorial, multicontextual interactivity that presupposes processes of psychological, and hence, subjective redemption. The aim is to transform aesthetic judgments that continue as an affective disorder, which keeps disempowered the subjects and objects of racism and replace them with a narratology that places Afro-Brazilian paradigms within their rightful centrality in the nation. Hip-hop becomes the sum formation of all of these social and artistic movements, with its overlapping historical, ideological, and aesthetic conceptualizations. Rap music, to quote Tricia Rose, "conjures and razes in one stroke," and in allowing for multicontextual narratives to clash, interact, and coexist, it is both "deconstructive" and "recuperative" (*Black Noise* 13). Hip-hop narratives may or may not be tied to an African context, for they speak directly to the issue of what is black in Brazil. But they connect to the larger diasporic world, and the model of Quilombo engagement they enact becomes rhetorical and performative agency to transform the conscious and subconscious edicts and governances in relation to blackness and marginality.

Together, these movements create radical aesthetic interruptions that are transgressive and transformational, and they acknowledge the changing positionality and concerns on the part of Afro-Brazilians. They are involved in processes of decolonization, embodying and reflecting a liberatory politics that interrogates repressive and dominating structures. The imperative of such movements, much as Florentina da S. Souza describes, transcend the limits of the discourse of resistance. The phatic will their articulations generate radiates an auto-interruptive, auto-illuminative discourse for the transfiguration of Africanness and blackness in the psyche and the lived world. However, their transformational arc goes beyond a unified field of blackness to a unified sense of *belonging* and *becoming* in the nation.

The election of Luiz Inacío Lula da Silva in 2002 (Lula) as president changed the Brazilian political theater. As the head of the Workers' Party, and with a recognized commitment to class struggle, hope was given to the marginalized populations that their issues would

become central in the nation. And to a certain extent, they have. Lula's government generated initiatives to reduce poverty and racialization in an unprecedented manner. The Brazilian government has initiated quotas, which were unanimously ratified by the Supreme Court in April 2012, to allow for more Afro-Brazilians to enter universities. They have implemented social amelioration programs such as the *Bolsa da Familia*, which gives monthly stipends to female heads of household, and expanded the *Bolsa Escola*, which pays for school supplies for children and rewards families for children's continued attendance in school (Montero 136–37). They have also implemented a law requiring schools to teach Afro-Brazilian history. Yet critiques suggest that the Bolsas create a welfare state and that the quotas allow people who would never claim an Afro-Brazilian identity to do so for personal aggrandizement. Whether these initiatives generate meaningful social and economic transformation is debatable, but the election of Dilma Rouseff in 2010 was a vote for the continued trajectory of the government. How all these initiatives will affect racially based politics, and whether the quotas will correct the historic imbalance in the educational sphere, is yet to be determined.

Still, the most overlooked point in postrace discourses is that the need for constructions of African rootedness and black identity will no longer be necessary when everyone, including black people, accept the naturalness of blackness and cease to adhere to racialist thought and racially biased institutional practices. I want to end with the words of Ana Célia da Silva, who articulates the ideal vision for a Brazil that does indeed value its hybridity:

> We don't want the black person to have power and do the same things as the minority that is in power. We want a State that gives equal rights, human rights and citizenship to *all* its people, despite their sex, age, sexual orientation, class and color.

Even though Ana Célia is one voice, she is articulating the desire expressed by most politically motivated Afro-Brazilians. Candomblé and Quilombo models offer a paradigmatic synthesis that leads to the new world, à la Glissant's rhizomatic root, a space beyond binaries, a space where the history of slavery, dominant precepts, and coded whiteness are set aside for matrices that offer respite from divisions and an entry way into internal subjectivity that embraces all differences in its multivalent, cross-gendered, cross-class evocations.

Notes

Introduction

1. Qtd. in Walker, "Are You Hip to the Jive?" 7.
2. Nawal El-Saadawi entitled her address to the African Literature Association in 1996, "*Why Keep Asking Me About My Identity?*" Arguing against the trap of identity politics as either predetermined conditioning or created by the West, El-Saadawi vehemently claims that her identity is tied to her home, her land, her language, her pen, and an organizational structure to struggle for freedom and justice.
3. I find the significance of the term "subaltern" as coined by Gayatri Spivak (1995) to be too narrow, except in regard to the slave era, to describe the Afro-Brazilian situation because it implies an utter voicelessness. Although marginalized, the Afro-Brazilian populace still has considerable voice, only those with political power choose when and to whom they listen.
4. The Human Development Index uses the term "subhuman conditions" and specifically refers to the horrific housing conditions, poor infrastructure (sanitation, water, waste, and power facilities), as well as the degree of poverty and indigence.
5. *Feijoada* is made from beans and all different pork parts; it was first created and eaten by the enslaved, who, of course, received the worst rations but made from them the most amazing dishes.
6. *Mesticismo* is the term used to describe this interchange of cultures and ethnic groups in the attempt to forge a national, cultural, and spiritual identity. See Brookshaw 1989.
7. My use of the feminine is not a signifier of a solely female subject, but to insert a polemic in construction of the generic as male.
8. Delueze and Guattari (1987) originated the concept of rhizome, but theirs emerged in the aporia of epistemic and metaphysical knowledge; Glissant's rhizome comes from the trauma of rupture and memory rooted in the abyss of the slave experience.

1 Where Is Africa in the Nation?: History as Transformative Praxis

1. Qtd. in Yai, "In Praise of Metonymy" 114.

2. The term "Afro-descendente" has taken on more value since the implementation of quotas to allow persons of African heritage into the universities.

3. The physical parameters of a terreiro can be limited to a large house with many antechambers or a large territory of land constructed like a separate village. Space is divided into a main area for public ceremonies, separate houses or rooms that hold the shrine for each orisa, and the houses or rooms for the members of the terreiro and new initiates.

4. A completely hierarchical system, the Nagô Gêgê terreiros are often controlled by one Supreme Mãe de Santo or *Iyalorixá*, who is both the administrative and ritual head. Having specific functions with the terreiro, other Mães who are equally knowledgeable are given titles commensurate with their functions, such as the *Iyá-kékêre*, who is the deputy head next to the Iyalorixá; the *Iyá Bassé*, who prepares the sacred foods used in the rituals; *Iyalaxê*, who cultivates the axé of the terreiro by caring for the orisas; the *Iyá Têbêbê*, who learns and knows all the songs; along with a host of *iyawos* or *filha/filho de santo* who become receptacles for the orisas during trance. See Ziégler 119–21.

5. In Rio and São Paulo, the religious tradition continues mostly in Umbanda houses, a Bantu/Angola derived terminology, more derisively called Macumba. Other traditions also developed in the northeast, such as the Tambor da Mina, Batuque, and Xangô. See Wafer 5–6, 13; Merrell 129.

6. Slavery logs in Brazil list the port of origin of the enslaved without a record of their specific ethnic group. However, since many different peoples were transported from the same locale, they were given identities that differ from their actual points of origin. See Butler, *Freedoms* 32.

7. Pinho in *Mama Africa* (2010) simultaneously argues that Africa is an imagined construct but traces the permeations of the discourse and spheres of representations in the blocos afros.

8. Yoruba orthography is used for the term *orisa* throughout the text.

9. The story of Oduduwa shows the divergence between history and myth, but Abiodun adds further complications when speaking of the indeterminacy of Oduduwa's gender. See "Hidden Power" 19.

10. Lovejoy states that *Anagô* denotes a subgroup of the Yoruba who lived east of the Weme river. However, in the Americas the term came from the name the Fon and Allada used for the Yoruba. See "Yoruba Factor" 42. Conversely, João Jose Reis and Beatriz Mamigonian state that Nagô was specifically a Bahian creation used to define one's ethnicity, and argue that Yoruba speakers used the term *Nagô* to identify themselves in Bahia, even before the term Yoruba was adopted as an ethnic designation in West Africa (81–82).

11. *Gêgê* and *Jêge* are used interchangeably to denote the Ewe ethnic group, located in present-day Ghana, Togo, and Benin, and who are consanguineously linked to the Yoruba. *Bantu* and *Angola* are also

used to designate people from the Congo/Angola region. *Malê* refers generically to muslims.

12. In 1787 the Aláàfin of Oyo was asked to commit suicide by his subjects, who no longer supported his war campaigns against other local Yoruba peoples. In the same year, Agonglo, the King of Dahomey, was killed by his subjects when he appeared willing to convert to Christianity. See Akinjogbin 332–33.

13. With the exception of the Bantus, suggests J. J. Reis, all ethnic groups participated in the rebellion. Quite a few of the Yoruba-speaking peoples were Muslim, which added to the confusion about ethnic identification. What primarily characterizes this revolt as a Muslim revolt is the use of documents with Arabic script by its leaders to mobilize the population. See *Slave* 96–124.

14. The significance of these terms are interchangeable.

15. A person who identifies as *caboclo* has an obvious indigenous mix; *sarará* may be a lighter-skinned individual with blond or Afro textured hair; *café com leite* is a more obvious mulatto mix or *morena*; *cor de tônajura* may refer to someone who is quite dark but does not want to be identified as *pardo* or *preto*.

16. Harding (2000) points out that the cantos were male-dominated organizations that promoted an ethnic-based exclusive membership. Female organizations based membership on professions and proved more fluid in their ethnic composition. This leads Harding to conclude that the space for that pan-ethnic, Pan-African identity began as a result of female subjectivity and intentionality.

17. Mulvey offers a contravailing argument about the irmandades: on one hand, they allowed Africans to be Christianized and assimilated into Luso-Brazilian society, and on the other hand, they preserved aspects of African culture. What may be agreed is that the sodalities provided a modus for the famed "syncretism" of Catholicism and African religions, apparent in the juxtaposition between Catholic saints and orisas. For instance, Saint Lazaro is seen as a manifestation of *Obaluaye*, the orisa of smallpox. The annual tribute to the saint is replete with ritual acts found in Candomblé, such as the washing of congregants with popcorn, the food favored by deity. This cleansing is said to wash away all illnesses. See also Verger, *Flux et Reflux* 528, for more on the topic of syncretism in the irmandades.

18. The annual festival of Boa Morte is held during the last weekend in August, in the town of Cachoeira in Bahia.

19. The documentation of Boa Morte is taken from personal observations of the rite in August 2000, 2001, and 2002.

20. *Mãe de Santo* is a literal translation from the Yoruba, *Iyalorisa*, which signifies the mother of the orisa. This is the title given to an initiate who has completed all the levels of training in the religion. The male equivalents are *Pai de Santo* and *Babalorisa*.

21. Ruth Landes, with the help of Edison Carneiro, conducted her research with the main terreiro communities in Bahia in the late 1930s.

22. Ketu was an independent Yoruba-speaking kingdom that existed in the midst of the Oyo Empire.

23. The term *Ogãns* undoubtedly comes from the Yoruba term *Oga*, which is commonly used to mean boss or chief.

24. The pureza nagô model differs from other Candomblé in that it prides itself on incarnating only the orisas in its ceremonies, whereas others may incarnate indigenous and ancestral spirits.

25. Interesting deviations occur within this female sanctioning; for instance, Júlio Braga was initiated in Nigeria and returned to do his obligations with Pai Balbino, of Ilê Axê Opô Aganju, after which he opened his own terreiro, Ilê Axé Iansã Axeloyá. This points to the primacy that Africa still holds as the birthplace of the religion, since other Pais dos Santos have also established their own relationships with religious leaders in Nigeria and no longer subscribe to the epistemological prescripts of Brazilian terreiros.

26. Although Rachel Harding and Kim Butler refer to Iyá Nassô as a historic character, João José Reis considers her a mythical character because, previous to the work of Castillo and Parés (2010), there was no conclusive evidence of her existence. See Harding, *Refugee* 100–102; Butler, "Africa" 150–51; Reis, "Candomblé" 116–18.

27. A Babalowo is known as the "father of secrets" because of his years of study of the oral hermeneutic Ifá text, considered the source of ultimate truth in the Yoruba religion. Therefore divination from a Babalowo precludes contestations and challenges over the right course of action. See Bascom 11. Succession in the terreiros is still based on Ifá divination, and with this confirmation, the role of the Mãe as the ultimate power is not challenged.

28. The myth states that they returned to Ketu and that indeed could be so, but more likely, from recent research noted in Castillo (2011b), that a religious shrine was created by José Pedro Autran in Whydah, they returned or relocated to that popular port of call.

29. According to Castillo and Parés (2010), who confirmed and documented the history, no passport documents exist for Francisca's sons, but that could be explained by their deportation.

30. *Mina* is often used to refer to slaves from the coastline of Ivory Coast to Ghana and seems to refer to Elmina, Ghana's major slave port. However, it has became a referent for all slaves taken from West Africa. See Nishida, "Manumssion" 371; Bastide, *African* 144.

31. In the iwofa system, a debtor gave his or her labor to the creditor for periods of time until the debt was paid.

32. Dr. Lisa Earl Castillo speculates that Maria Julia da Conceição Nazaré was initiated by Iyá Nassô, based on Edson Carneiro's discussion of

the rivalry between the two Maria Julia's in *Candomblé da Bahia* and a newspaper article that speaks of her having a terreiro in the place called *Moinho* [Mill] in the1860s (*O Alabama*, Jan. 8, 1868, 4); Parés also cites *O Alabama*. See "Nagôization" 191.

33. Due to the strife over succession in Casa Branca, the Mães branched out and developed their own terreiros. Even with its founding by an African matriarch, Maria Julia da Conceição Nazaré, Gantois is considered the most hybridized of the great houses, in that many of its present-day members are whites.

34. *Africano livre* was a term applied to Africans found on slave ships intercepted by authorities during the illegal period of Brazil's involvement in the Atlantic trade. As a merchant, Eliseu probably traded in goods such as handwoven shawls, kola nuts, black soap, ink, and hot pepper. See Castillo, "Between Memory" 204–6.

35. See also Reis 2001, Harding 2000, and Landes 1994. Each of these sources refers to Seu Martiniano as a pivotal character in the formation of Candomblé-nagô. Landes, in particular, documents details such as his following in the religious tradition of his parents. She also reveals the great respect accorded him due to his religious knowledge.

36. More so than other terreiros in Salvador, Ilé Axé Opô Afonjá is set up like a small, independent African village. The Mãe de Santo, who is now Mãe Stella, lives in a separate dwelling. Initiates and older members who choose to do so may live at the terreiro and have separate homes within its space. Initiates give service to the terreiro by doing specialized tasks, from dispensing herbal remedies to keeping the calendar of Mãe Stella.

37. As an example of the continued transatlantic link, several of Felisberto Sowzer's descendants are well-known priests in the world of Candomblé. In Lagos today, another part of the clan is headed by Paul Bangbosé Martins, descended from Bamboxê via his youngest child, Theóphilo. In the 1960s, he visited his relatives in Bahia and the two branches of the family keep in regular contact. See Castillo, "Between Memory" 208–9.

38. In 1995 I conducted research with the descendants of Brazilian repatriates in Ghana. Arriving in 1837, the groups became an integral force in developing the city of Accra. Contracted as builders, they changed the face of the city to reflect the Mediterranean architectural style that characterizes Salvador. Their descendants formed a nucleus that exists today as a loose-knit filial federation.

39 Freed Africans were denied citizenship in Brazil and were often subject to deportation. Carrying a British passport gave them rights as British subjects and offered some measure of protection against deportation. See Castillo, "Between Memory" 203–38.

40. For confirmation of the role of the Alapini as the head of the Egungun cult, see Morton-Williams 1967; Johnson 1973.

41. See also the documentary *Atlanticô Negro*, in which Pai Euclides sends a message to his priestly counterpart in Benin by singing the opening ceremonial call in the *Fon* language.

42. This argument parallels V. Y. Mudimbe's in *The Invention of Africa* (1988), which demonstrates how the discourse on Africa was constructed in the Western purview.

43. Rodrigues (1938) proposed different penal codes for different races in Brazil and suggested that Blacks and Indians be considered of diminished capacity, like children.

44. Capone considers the institution of the Obás a "bricolage of Yoruba history" because the names given to them are either names or titles in the Oyo historical archive.

45. These concepts of syncretism have been challenged on manifold levels. See Carneiro, *Religiões* 95.

46. Such intellectuals included Aydano do Couto Ferraz; Álvoro Dória, the director of the Nina Rodrigues Institute; and Arthur Ramos as an honorary member. See Capone 188.

47. While Mattoso (1986) concentrates on the life of the enslaved in general, Isabel Reis (2001) examines the family structures that developed under the system of enslavement.

48. During the course of this research, I had many similar conversations with white Bahians. Suggestive of the omnipresence of race in the Brazilian psyche, even though I conducted my research with Afro-Brazilians, whites (nonblack identifying) unvaryingly, in purely social contexts, always imparted their bloodlines and degree of affiliation to each ethnic category.

49. See Beatrice Góis Dantas 1988, who documents the importance of an African ancestry to the process of initiation and to ascending the rungs of leadership in the terreiros; Harding, *Refugee* 93, affirms the value placed on associations with *"coisas do Africano"* [African things] in order to have an African-based identity; and Agier 134–57 speaks to the means by which a present-day Mãe de Santo connects with her African progenitors to legitimize her claim to lead a terreiro. Omari-Tunkara adds that black skin with African ancestry is most valued (22).

50. This other form of divination, the *owo merindinlogun* [sixteen cowrie divination], allows women to divine. Oshun was given this ability, and so female priestesses are following in her tradition. See Bascom 11–13; Ogungbile 2001.

51. Famous ogãns such as Jorge Amado and Pierre Verger greatly aided Candomblé houses as they legitimized the religion in the eyes of the dominant society and assisted in the revaluation of African culture.

52. Rachel Harding (2000), analyzing police documents from the 1800s, reveals the level of persecution faced by the practitioners. When questioned by the police, if the practitioner had a patron the name was often given, with the understanding that having the backing of such

a prominent figure helped to mitigate against the crime of practicing the religion.

53. Differentiating between a noninitiated and an initiated ogãn of a terreiro, Carneiro points out that the initiates are designated by the Mãe to perform ritual functions such as maintaining the altars to the orisas, performing ritual sacrifices, and leading the drumming during ceremonies. For each of these roles, a particular ogãn is chosen and given the appropriate title.

54. Both Page (1995) and Eakin (1997) speak of the permeable nature of African religious practices and their adaptation by white society.

55. The majority of participants on a visit to Júlio Braga's terreiro in November 2010 were black. There were a few white visitors and mixed-race participants in the ceremony. Visits to other terreiros, during the period of September 2010 to December 2010, affirmed that black participation was indeed still strong and vital in Candomblé.

56. My conclusion comes from personal observation and many conversations with participants in and around Candomblé during the last 10 years.

57. I take this from conversation with select Mães, who do not have the visibility of the Mães in the Great houses.

58. During the course of this research, I attended many of the public fora conducted by political activists in Salvador. Topics often centered on issues of culture as a form of resistance. Activists hope that the renewed, affirmatory valuation placed on African-based cultural expressions will force the Afro-Brazilians to transform their sense of self and agency.

59. I have personally attended deliberations on issues from beneficial health and environmental practices found in Candomblé to ways to combat gender and racial inequalities in the society.

60. The primary school located on premises of Ilê Axé Opô Afonjá uses Yoruba mythos and language as pedagogical tools. The goal of the school is to create a sense of value for the African aspects of culture in Brazil. Similarly, *Terreiro do Cobre*, the only all black terreiro, sponsors a youth program, using the Yoruba myths as a base for artistic representations. Public performances based on Candomblé mythos and rituals are too commonplace and numerous to allow for full enumeration in this note.

2 Ritual Encounters and Performative Moments

1. Myeroff (1984) characterizes rituals as elements found in cultural dramas that are used to mitigate against the forces of change, since they reflect continuity in a society across temporal and spatial divides.

2. MacAloon (1984) creates similar dichotomies, which include oral and written, doing and thinking, pop and high, and ludic and tragic.

3. *Baiana* is also a term used for the women who sell the popular *acaraje* [fried bean cakes] on the streets. Usually dressed in white, their clothing is based on the model from the nineteenth century still extant in Candomblé ceremonies. Known as religious practitioners, many of the women are powerful Mães dos Santos. In and around Salvador, their presence is a marker of the "authenticity" of African culture found in the city.

4. The Yoruba orthography used in Brazil dates back to the 1800s; hence, *ayé* is rendered as *aiyé*, as used by the bloco afro, Ilê Aiyé.

5. This was particularly evident during my observation of the ceremonies at Terreiro do Cobre during the month of April 2001, and at Gantois in November 2010.

6. The invitation does not extend to the sacred spaces that house the orisas, but to a reception area where the priestesses, priests, and laypeople mingle.

7. This is not to say that whites aren't lauded in the terreiro; often they are in seats of honor during the ceremonies, but rather than their presence overshadowing or negating the black presence, as is so apparent in the halls of political power, they sit quietly and wait to be acknowledged.

8. Personal Observation, December 4, 2000. I have also seen the ceremony from different vantage points in December 2001 and December 2010.

9. In these instances, I spoke to different people in the crowd and asked them about the changing content of the rituval (December 4, 2010).

10. See Chapter 6 for an analysis of the differences in Habermas's and Bakhtin's concepts.

11. In this role, Yemanja is likened to the saint *Nossa Senhora de Santana*.

12. Mami Wata is usually depicted as a mermaid with long, flowing hair, similar to the many depictions of Yemanja in the city of Salvador.

13. Given the magnitude of the performance by the members of this terreiro, the spectators, surprisingly, could not identify the group. Subsequently, I too could not obtain the name of the terreiro.

14. The exception noted is in Casa Branca. The house maintains a strictly female-dominated structure; the ogãns, therefore, are simply helpers in the process, and the sacred roda is reserved for women to incarnate the deities.

15. Obaluaye is the only orisa known to possess individuals who are not dedicated to him.

16. During this period, many of the filhas of the terreiro were possessed by Yemanja and danced in the circle with Ochossi.

17. Personal Observation, February 2, 2001.

18. An interesting connection may be found with the Yoruba term *wiwe* [washing]; it signifies any form of celebration in which large quantities of alcohol are consumed in conjunction with festive celebration.

19. My observation and analysis of this rituval comes from three separate observances in 2001, 2003, and 2008.

20. The Igreja da Nossa Senhora da Conçeicão is the church that is consecrated to Ochun and Yemanja and is the site of another festa honoring the protective mothers of the city, which takes place on December 12 each year.

21. Before 1976 a Candomblé ceremony was officially classified as a "diversion" and placed in the same categories as "a circus, a discotheque or a whore house." See Silverstein 140.

22. In the myths that traveled to Brazil, Oxalá is also married to Yemanja, and it is from this union that the majority of orisas are born. He has three children with Nana: Obaluaye, Osun, and Eshu. Obaluaye is covered in smallpox, Osun only has the use of half of his body, and Eshu is a trickster. Nana, therefore, sees in her offspring the misery of motherhood and blames Oxalá for not giving her children that are healthy and whole. Leaving him, she hopes, provides a fitting punishment.

23. Attesting to the diverse narratives constructed about the orisas, in this tale Oxalá is not married to Nana. See Courlander 83–86.

24. *Outdooring* refers to a ceremony done by the Gas and Akans in Ghana in which a newborn is shown to the world after passing its first seven days indoors. This is to ensure that the spirit of the child is protected from malevolent forces and desires to stay in this world.

3 From Candomblé to Carnaval: Secularizing Africa and Visualizing Blackness

1. The term carnival is used in the analysis of theoretical models that pertain to the general celebration; the Portuguese equivalent *carnaval* denotes the specific Bahian festival considered in this chapter.

2. During the course of this research, I studied four blocos afros—Ilê Aiyê, Olodum, Malê de Balê, and Muzenza—but I limit the analysis to these two.

3. Carnival in Rio and in Cuba is known as primarily a spectator event. Participants belong to carnival clubs or samba groups and undergo rigorous training to be part of the national show.

4. *Tropicalismo* is associated with *antropofagia*, cultural cannibalism, as it borrows aesthetic forms from around the globe to simultaneously deform the Brazilian narrative and generate its own artistic autonomy. See Perrone, "Topos" 2000.

5. Spark quotes an interview with Gil, who speaks of this artistic exploration of his "negritude" in relation to his attendance of FESTAC 1977.

6. Conscientization is used here in the manner suggested by Freire to refer to the development of modalities for resistance. See Freire 1972.

7. This song inaugurated Ilê Aiyê's carnaval.

8. Only in the later stages of these groups did they look to indigenous sources for motivation, after which blocos developed with names such as Tupis, Guranys, and Caciques of Garcia to pay homage to Brazilian Indians and Yoruba orisas. See Crowley 33–35.

9. Ilê's educational component can be credited to this group. Not only do they teach courses on African history and culture, they also generate pedagogical resources through the Cadernos de Educação. Each year a new booklet is created to amplify the carnaval theme and is subsequently used as a resource in Ilê's educational projects.

10. Liberdade has a majority black population and is considered dangerous to enter.

11. This academician prefers to remain anonymous.

12. Public space is considered the accepted place for blacks; events are often free since they are government sponsored. More affluent Afro-Brazilians tend to congregate in demarcated sectors within these public areas, such as the back of the stage at Ilê Aiyê. Private spaces such as bars, hotels, lounges, and certain restaurants, by implication, are for whites.

13. Interviews are normally part of the selection process. However, in the contest I observed, the sheer number of contestants precluded a question-and-answer component.

14. During carnaval 2001, Caetano Veloso attended the dressing.

15. The trio elétrico is an immense, two-storied vehicle rented for carnaval. The top level carries the band and all the equipment; it is equipped with a soundstage and lighting to allow for full performance while in motion. The bottom level is equipped with bathroom facilities, refrigerators and storage areas for refreshments that are sold to the participants in the bloco. Ordep Serra (2000) argues that the development of the trios transformed carnaval blocos into exclusive groups, since higher fees had to be charged for their rentals. See also Antonio Godi 1998 and Charles Perrone 1992 for further discussions on the impact of the trios on carnaval.

16. R500 is now equivalent to about $350, but since the minimum monthly wage is R540, attending carnaval with Ilê is simply impossible for most Afro-Brazilians.

17. Advertisers include Claro, Pepsi, Motorola, Petrobras, and Extra Hipermercados.

18. Personal Observation, August 2008 and November 2011.

19. Personal Observation, August 2001 to December 2001.

20. Supporters include Coca-Cola, the telecommunications company TIM, Bradesco, Petrobras, and A Tarde, one of the major newspapers in Salvador.

21. Both Ilê Aiyê and Olodum paraded on the same night; hence, this phase of documentation was divided between the two groups.

22. Although Olodum relies heavily on its drummers, it also has a group of musicians on the trio playing a full complement of instruments.

23. To seal their affiliation, Ijexá also refers to a Yoruba subethnic group.
24. I observed a woman becoming possessed when the drummers began playing the rhythms of Ogun.
25. This subtitle is taken from the song text of *"Ilê de Luz"* and translates as "You say that I am ridiculous."
26. It was of particular importance to the members of the group that Vanda Chase paraded with Ilê that year. As the only black, female newscaster in the country, the group considered her participation indicative of the national recognition of Ilê's aesthetic reinterpretation.

4 Aesthetically Black

1. Qtd. in G. Santos, A Invenção 58. The epigraph translates to the following: White is the symbol of the divine or God. Black is the / symbol of the spirit of evil and the devil. / White is the symbol of light / Black is the symbol of darkness, and the darkness symbolically expresses evil / White is the emblem of harmony. / Black, the emblem of chaos. / White is supreme beauty. / Black, ugliness. / White means perfection. / Black signifies the defect. / White is the symbol of innocence. / Black, of guilt, of sin or of moral degradation. / White, sublime color, shows happiness. / Black, harmful color, shows sadness. The battle between good and evil is symbolically expressed by the opposition of white and black.
2. Cohen (1980) also has the quoted text.
3. It is ironic that Burke deeply opposed slavery and argued vehemently for its opposition, yet this elemental naturalism in white alienation from blackness he encodes undoubtedly aided the ideological justification for slavery.
4. Dictionary.com explains how the terms *black* and *African American* came to signify identity. July 12, 2009. Web.
5. Note that the corresponding term *white* does not have a similar explanation; rather there is a list of notable personages with the surname White. See Dictionary.com. July 12, 2009. Web.
6. The title is taken from Neal's assertion that the black aesthetic must be the "destruction of the white thing, the destruction of white ways of ideas, and white ways of looking at the world." See *Visions* 64.
7. In the essay "The Negro Artist and the Racial Mountain" Langston Hughes argues that writers should tap into black cultural forms, particularly jazz, to create a specific black aesthetic.
8. Smethurst (2005) argues that Baraka was never a member of the Beats, but that he maintained a relationship with them that shaped the new American poetry.
9. Hooks defines "seeing" in this context as media representation on billboards, television, movies, and in magazines. See "Representing Whiteness" 340.
10. Jônatas, unfortunately, has passed away since I began this research. During the course of several talks, he spoke about finding cohesion

within the ideals of the *Movimento Negro* and was a self-described activist. He was also the Director of Education for Ilê Aiyê and a teacher of the Portuguese language.

11. Olivia Santana, the first black woman on the City Council in Salvador, used the term "immortality" to describe the feelings of Afro-Brazilians for Zumbi, in a public lecture on July 19, 2001. She stated that they do not celebrate his life but his immortality, since the ideals he represents live on in the struggle for justice.

12. The film *Quilombo* by Carlos Diegues may have aided in Zumbi's Yoruba image, as it relies heavily on Yoruba spirituality to depict the idyllic vision of Palmares.

13. To name a few, organizations include Geledés, UNEGRO (União de Negros pelo Igualdade), CEAFRO (Educaçao e Profissionalização para a Igualdade Racial e de Género), Niger Okan, the Instituto Cultural de Steven Biko, and Fundação Palmares.

14. The collections are too numerous to cite. These only represent a few. See Ribeiro, *Orukomi—Meu Nome* 2007; Alves, *Women Righting* 2005; Cuti, *Sanga* 2002; Minka, *Teclas do Ébano* 1986.

15. I have attended two launches of the collective, in March 2002 and December 2010.

16. For instance, consider how writers such as Nikki Giovanni, Audre Lorde, and Mari Evans can be claimed by both groups.

17. To preserve its graphic impact, I render the translation of the poem in the analysis.

18. In the film *Quilombo*, Dandara is Zumbi's general, confidante, and female alter ego.

19. José Carlos Limeira ended our interview with the reading of this poem.

20. In some ways paralleling the disparagement and dismissal of the northeast in the narrative of Brasilidade.

5 Performing Bodies Performing Blackness Performing Self: The Quest for a Transformative Poiesis

1. During the last ten years in Salvador, many Afro-Brazilian theater groups have formed, but have never stabilized enough to garner a reputation or create a legacy in the field.

2. Elisa Larkin Nascimento translates the title of the play as *Black Mystery*. I prefer the literal translation of the title, *Sorcery*, for it stands as an ironic reminder of the journey of the protagonist, Dr. Emanuel (283). All quotes from the text are taken from this edition of the play. See *Sortilégio* 159–97.

3. I translated all the text quoted from *Cabaré da Raça*.

4. Mendes quotes Roger Bastide, who documents the period from 1780 to the 1820s in travel journals of Europeans visiting Brazil. See *Personagem* 1–20.

5. Getúlio Vargas came to power for a second term in 1951 and committed suicide in 1954 after the military threatened to oust him.

6. The theater welcomed all authors who promoted constructive images of Afro-Brazilians. It also produced *Auto da Noiva*, by the Afro-Brazilian playwright Rosário Fusco, and works by white dramatists, *O Filho Prodigo* by Lúcio Cardoso and *Aruanda* by Joaquim Ribeiro.

7. Nascimento obtained permission from Eugene O'Neill in 1944 to use the play. The following endorsement by O'Neill was printed in the newspapers to promote TEN's objectives: "You have my permission to produce *The Emperor Jones* without any payment to me, and I want to wish you all the success you hope for with your Teatro Experimental do Negro. I know very well the conditions you describe in the Brazilian theater. We had exactly the same conditions in our theater before *The Emperor Jones* was produced in New York in 1920—parts of any consequence were always played by blacked-up white actors.... [Y]ou can always count on my support, because above all I want your theater to become successful and firmly established." See Turner, "Black Theater" 37, who quotes from Nascimento's "The Negro Theater in Brazil," and the program booklet of *Sortilégio*.

8. *Sortilégio* was TEN's first production written by an Afro-Brazilian. It was completed in 1951 but was not staged until 1957.

9. See Fanon's argument in *The Wretched of the Earth* (1963).

10. *Cachaça* is Brazilian rum. This quote is taken from Augusto Boal's notes when directing the play.

11. A detailed history of the theater is given in the *Relatório* [the Report], published by the Teatro Vila Velha, and in a personal interview on February 7, 2001, Meirelles confirmed this history.

12. Meirelles uses the term "colonization" ironically to refer to the dominance of African cultural forms found in Bahia.

13. During the course of this research, invariably in social situations, without any questioning on my part, white Bahians felt it necessary to explain their racial status. They usually acknowledged a black ancestor somewhere in the past, carefully explained about each different white ethnic group in their families, and spoke about their love for Bahian culture, but always stated that in Brazil, they are white.

14. It is important to understand that whiteness in this context is not simply based on phenotype or gene pool; it is also related to economic status. Because he belongs to the middle class, which is synonymous with wealth, and despite any visible African phenotypic traits, Meirelles is deemed white in that society.

15. This is one of the main contentions in Afro-Brazilian political struggles—that whites participate in black culture and then claim it as their own. This process of cultural whitening is seen as another form of discrimination in denying the African contributions to society.

16. In the course of discussions with the members of the Bando, I asked whether having a white director adversely affected the creative

process. Generally, I received a negative response, but also none of the members conceived of establishing a completely separate Afro-Brazilian theatric group.

17. Chica Carelli, the technical director, is the only member of the Bando who received formal theatric training.

18. The first plays include *Essa é Nossa Praia, Onovomundo, Ó Paí Ó, Woyzeck, Medeamaterial, Bai Bai Pelô,* and *Zumbi.*

19. In the interview, Meirelles disassociated the Bando's productions from Boal's frameworks and Brechtian dramatic models, stating that neither he nor members of the Bando read nor studied these theories.

20. Much of the language used in *Cabaré da Raça* is the local slang of Salvador. Due to this, many of the terms used have a double meaning; for example *panfletário* translates as "pamphleteering," but in the context in which it is used it signifies "passionate, almost violent." To preserve accuracy, I have tried to maintain the essence of the text, rather than to conduct a verbatim translation.

21. Pagode is the most popular form of music among the youth. Although rooted in samba styles, the rhythms are faster and the lyrics are more sexually explicit. Cultural and political workers suggest that it contributes to the apolitical bent in society.

22. Jaque uses the term mestiço instead of mulato. This is of significance because mestiço implies an interracial mixture between whites, Indians, and blacks, while mulato is the white/black mix. She is extending her identification to include all the racial groups in Brazil.

23. Negona translates as "mature black woman." Bandied around as an affectionate term, it may be a pejorative racial marker based on its context.

24. Caçador das gringas translates as "gringa hunters," a slang term for gigolos.

25. *Tição* can be translated as either a "firebrand," a "very dark man," or a "devil."

26. After extended observations of the performances, I could predict which spectators the actors would question. That selection, often based on appearance and seating arrangement, also determined the trajectory of the play.

27. This chant is used in ritual contexts to praise Ochossi and to invoke his power.

6 Centering Blackness: Hip-Hop and the Outing of Marginality

1. The DJ was the thing. Legend has it that DJ Kool Herc, Clive Campbell, brought a sound system that was common in the Jamaican ghettoes and wowed the crowds with this super blast of music.

2. Juan Flores (2000) points out that the Puerto Rican influences on hip-hop are well known in breakdancing and graffiti arts, but he also historicizes the Puerto Rican presence among the earliest DJs and MCs. Correspondingly, he acknowledges a larger pan-diasporic influence, which includes Dominicans and members of other Caribbean Spanish-speaking communities.

3. Even Vovô of Ilê Aiyê attests to its impact within the formation of the bloco.

4. Jorge Bem was also tangentially linked to the Tropicalist movement started by Gilberto Gil and Caetano Veloso, articulating its "Afro-Brazilian and Afro-diasporic dimensions." See Dunn, "Tropicália" 78.

5. Forró is the country music of Brazil; axé is a popular version of samba-rock.

6. This is a common line used in early hip-hop songs, of which "Rapper's Delight" was the first.

7. I am doing a literal translation to derive the essence of the word; it implies deception, but this usage signifies taking on new guises in a process of discovery.

8. Yudice states that eight street children were killed, with a known total of twenty people dead; countless people were shot.

9. Such initiatives include *Viva Rio*, which brought together peoples from all socioeconomic segments and zonal divisions of city to articulate a sense of united citizenship. See Herschmann, *A Cena* 14.

10. Notably, DJ Hum, one of the legendary founders of hip-hop, is also a white Brazilian, but he is considered a cultural insider, as a former member of a *batucada* [drumming band], promoter, and DJ in the bailes.

11. Email communication, June 24, 2011.

12. See the website, US State Department, 2010 Human Rights Report: Brazil, for more detailed listings of police violence.

13. Since 2004, Racionais's music has been distributed by one of the global music giants, Sony.

14. Such groups include *Conciência Humana, U Negro, Homens Crânios,* and *RZO*. See Rocha 40.

15. MV Bill music was featured in the eponymous film.

16. See the videos of MV Bill's songs such as "*3 Da Madrudaga*" and "*A Noite,*" which give quick vignettes of Candomblé ceremonies.

Conclusion

1. I want to read color into the night, brother, / the faces, bare arms and chests of brothers, / all beautiful, coming down the hillsides, / crossing the barriers, / spreading out/ like a serpent on the asphalt of winding streets. / I want to see amulets, shouts, dancing / and to put against my skin now / the brilliant cloth of that which is

coming, / action, contempt, consciousness, / and to discover after everything, the struggle for / the inner happiness of being black. The poem was translated by Jane Malinoff and Phyllis Reisman.

2. Gilberto Leal, 291–300, gives a comprehensive summary of the achievements of organizations within the black movement over the last 30 years.

Bibliography

Discography

Camafeu, Paulinho. *"Que Bloco é Esse?"* Ilê Aiyê 25 years. Ilê Aiyé, 1999. CD.
Lima, Carlos. *"Ilê de Luz."* Ilê Aiyê Canto Negro. Trama, 2006. CD.
Lima, Geraldo. *"Deusa de Ébano."* Ilê Aiyê Canto Negro. Trama, 2006. CD.
MV Bill. *"Traficando Informação."* BMG, 1998. CD.
Vaz, Paulo and Cissa. "Majestade África." Caderno de Educação do Ilê Aiyê.
 "África Ventre Fértil do Mundo. " 9 Salvador: Ilê Aiyê, 2001.

Periodicals

Journal Olodum. 5.11 (Novembro 1999): 4–5.

Pamphlets

Caderno de Educação do Ilê Aiyê. "África Ventre Fértil do Mundo."
 9 Salvador: Ilê Aiyê, 2001.
Caderno de Educação do Ilê Aiyê. "Abidjan, Abuja, Harare e Dakar."
 15 Salvador: Ilê Aiyê, 2007.

Interviews

Conceição, Jonatas, and Lindinalva Barbosa. Personal Interview. May 3, 2001.
Limeira, José Carlo. Personal Interview. April 21, 2001.
Meirelles, Marcio. Personal Interview. February 7, 2001.
Sá, Auristela. Personal Interview. June 15, 2001.
———. Personal Communication. November 16, 2010.
Santos, Meuquizalem Sacramento. Personal Interview. June 15, 2001.
Silva, Ana Célia da. Personal Interview. May 30, 2001.
Washington, Jorge. Personal Interview. June 6, 2001.
———. Personal Interview. July 28, 2008.
———. Personal Communication. November 20, 2010.
Braga, Júlio Santana. Personal Interview. May 25, 2001.

Websites

Acg01. *Youtube.com.* Racionais MC's. "Diário de um Detento." n.d. Web.
 July 20, 2010.

BlackSciFi. *Youtube.com*. "Mr. Big Stuff sung by Jean Knight." n.d. Web. July 16, 2010.

Cufaaudiovisual. *Youtube.com*. Nega Gizza. "Filme de Terror" (Brasilia). n.d. Web. July 22, 2010.

Flipeici. *Youtube.com*. "Thaide e Dj Hum – Sr. Tempo Bom." n.d. Web. July 16, 2010.

Letras.mus.br. Detentos do Rap. "Baseando em Fatos Reais." n.d. Web. July 20, 2010.

Letras.mus.br. Detentos do Rap. "Casa Cheia." n.d. Web. July 20, 2010.

Letras.mus.br. Detentos do Rap. "Entrevista no Inferno." n.d. Web. July 20, 2010.

Letras.mus.br. MV. Bill. Traficando Informação. "Traficando Informação." n.d. Web. July 21, 2010.

Letras.mus.br. Racionais Mc's. Chora Agora. "Negro Drama." n.d. Web. July 22, 2010.

Lyricstime.com. MV Bill. "Falção." n.d. Web. July 22, 2010.

Lyricstime.com. Nega Gizza. "Filme de Terror." n.d. Web. July 22, 2010.

Lyricstime.com. Nega Gizza. "Larga o Bicho." n.d. Web. July 22, 2010.

Lyricstime.com. Rappin' Hood. "Sou Negrão." n.d. Web. July 23, 2010.

Lyricstime.com. Thaíde & DJ Hum Lyrics. "Sr. Tempo Bom." Web. July 16, 2010.

Mcpoppin's. *Youtube.com*. Z'Africa Brasil. "Tem Cor Age." n.d. Web. July 26, 2010.

Radarcultura. *Youtube.com*. "Manos e Minas. Rappin Hood e Z'África Brasil." July 26, 2010.

Renesenaj. *Youtube.com*. MV Bill. "Falção." n.d. Web. July 22, 2010.

Toddynho7. *Youtube.com*. Happin Hood e Leci Brandão. "Sou Negão." n.d. Web. July 23, 2010.

Vagalume Letras de Músicas. *Vagalume.com.br*. Racionais MC's. "Racistas Otários." Web. n.d. Web. July 16, 2010.

Vagalume Letras de Músicas. *Vagalume.com.br*. Racionais MC's. "Diário de um Detento." n.d. Web. July 16, 2010.

Vagalume Letras de Músicas. *Vagalume.com.br*. Z'Africa Brasil. "Tem Cor Age." n.d. Web. July 26, 2010.

US Department of State. 2010 Human Rights Report: Brazil. Web. April 18, 2011.

Films

Atarashi, Romi, dir. *Acústico Marcelo D2*. MTV, 2004. DVD.

Barbiere, Renato, dir. *Atlanticô Negro: Na Rota dos Orixás*. Instituto Itaú Cultural Videografia. Filmmakers Library, Inc., 2001. VCR.

Diegues, Carlos, dir. *Quilombo*. New Yorker Films Video, 1986. VCR.

Meirelles, Fernando, dir. *Cidade de Deus*. Objetiva, 2003. DVD.

MV Bill and Celso Athayde, dir. *Falcão: Meninos do Tráfico*. CUFA, 2006. DVD.

Walker, Sheila, dir. *Scattered Africa: Faces and Voices of the African Diaspora.* Berkeley: U of California Extension, Center for Media and Independent Learning, 2002. VCR

E-mail Communication

Santos, Jacqueline Lima. June 24, 2011. E-mail.

Works Cited

Abiodun, Rowland. "Hidden Power: Òsun, the Seventeeth Odù." In Murphy and Sanford, 10–33.

Abrahams, Roger D. "The Language of Festivals: Celebrating the Economy." In Turner, *Celebration* 160–77.

Abreu, Martha. "Slave Mothers and Freed Children: Emancipation and Female Space in Debates on the 'Free Womb' Law, Rio de Janeiro, 1871." *Journal of Latin American Studies: Brazil: History and Society* 28.3 (Oct. 1996): 567–80.

Aflalo, Fred. *Candomblé: Uma Visão do Mundo.* São Paulo: Editora Mandarim, 1996.

Afolabi, Niyi, Márcio Barbosa, and Esmeralda Riberio, eds. *Cadernos Negros, Black Notebooks: Contemporary Afro-Brazilian Literary Movement.* Trenton, NJ: Africa World P, 2008.

———. "Beyond the Curtains: Unveiling Afro-Brazilian Women Writers." *Research in African Literatures* 32.4 (Winter 2001): 117–35.

———. *Afro-Brazilians: Cultural Production in a Racial Democracy.* Rochester: U of Rochester P, 2009.

Agier, Michel. "Racism, Culture and Black Identity in Brazil." *Bulletin of Latin American Research* 14.3 (Sept. 1995): 245–64.

Ahmad, Aijaz. "The Politics of Literary Postcoloniality." In *Contemporary Postcolonial Theory.* Ed. Padmini Mongia, 276–93. New York: Arnold, 1996.

Ajayi, J. F. Ade, and Robert Smith. *Yoruba Warfare in the Nineteenth Century.* Cambridge: Cambridge UP, 1964.

Akinjogbin, I. A. "The Expansion of Oyo and the Rise of Dahomey, 1600–1800." In *History of West Africa.* Vol. 1. Ed. J. Ajayi and M. Crowder, 304–43. New York: Columbia UP, 1972.

Ako, Edward O. "The African Inspiration of the Black Arts Movement." *Diogenes* 135 (Fall 1986): 93–104.

Alcoff, Linda Martin, et al., ed. *Identity Politics Reconsidered.* New York: Palgrave Macmillan, 2006.

Alexander, M. Jacqui. *Pedagogies of Crossing: Mediations on Feminism, Sexual Politics, Memory and the Sacred.* Durham, NC: Duke UP, 2005.

Alim, H., Awad Ibrahim, and Alastair Pennycook, eds. *Global Linguistic Flows: Hip Hop Cultures, Youth Identities, and the Politics of Language.* New York: Routledge 2009.

Alves, César. *Pegunte a Quem Conhece: Thaíde*. São Paulo: Labortexto Editorial Ltd, 2004.

Alves, Miriam, ed. *Enfim . . . Nós, Finally . . . Us*. Trans. Carolyn R. Durham. Colorado Springs: Three Continents P. 1995.

———. *Women Righting/Mulheres Escre-vendo*. Trans. Maria Helen Lima. London: Mango P, 2005.

Amado, Jorge. *Mar Morto: Romance*. São Paulo: Marlins, 1972.

Andrade, Elaine Nunes de, ed. *Rap e Educação, Rap é Educação*. São Paulo: Summus, 1999.

———. "Hip Hop: Movimento Negro Juvenil." In Andrade, 83–92.

Andrews, George Reid. "Black Political Protest in São Paulo, 1888–1988." *Journal of Latin American Studies* 24 (Feb. 1992): 147–71.

———. *Blackness in the White Nation: A History of Afro-Uruguay*. North Carolina: U of North Carolina P, 2010.

Anyidoho, Kofi. "Poetry as Dramatic Performance: The Ghana Experience." *Research in African Literatures* 22.1 (Spring 1991): 41–55.

———. *The Pan-African Ideal in Literatures of the Black World*. Accra: Ghana UP, 1989.

Apter, Andrew. "The Embodiment of Paradox: Yoruba Kingship and Female Power." *Cultural Anthropology* 6.2 (March 1991): 212–29.

———. "The Historiography of Yoruba Myth and Ritual." *History in Africa* 14 (1987): 1–25.

Arias, Enrique Desmond. "Faith in Our Neighbors: Networks and Social Order in Three Brazilian Favelas." *Latin American Politics & Society* 46.1 (Spring 2004): 1–38.

Armstrong, Meg. "'The Effects of Blackness': Gender, Race, and the Sublime in Aesthetic Theories of Burke and Kant." *Journal of Aesthetics and Art Criticism* 54.3 (Summer 1996): 213–36.

Auerbach, Erich. *Mimesis, the Representation of Reality in Western Literature*. Princeton, NJ: Princeton UP, 1968.

Auslander, Philip. *Presence and Resistance: Postmodernism and Cultural Politics in Contemporary American Performance*. Ann Arbor: U of MP, 1992.

Averill, Gage. "Anraje to Angaje: Carnival Politics and Music in Haiti." *Ethnomusicology* (Spring/Summer 1994): 217–47.

Baeto, Lucila Bandeira. "Inequality and Human Rights of African Descendants in Brazil." *Journal of Black Studies* 34.6 (July 2004): 766–86.

Bailey, Stanley R. *Legacies of Race: Identities, Attitudes, and Politics in Brazil*. California: Stanford UP, 2009.

Baker, Houston A., Jr. "Our Lady: Sonia Sanchez and the Writing of a Black Renaissance." In *Black Feminist Criticism and Critical Theory*. Ed. Joe Weixlmann and Houston A. Baker, Jr., 169–202. Greenwood, Fl: Penkevill Publishing, 1988.

Bakhtin, Mikhail M. *Rabelais and His World*. Trans. Helene Iswolsky. Bloomington: Indiana University Press, 1984.

―――. *The Dialogic Imagination: Four Essays*. Trans. Caryl Emerson and Michael Holquist. Ed. Michael Holquist. Austin: U of Texas P, 1981.

Baraka, Amiri. "The Black Arts Movement." In *The Leroi Jones / Amiri Baraka Reader*. Ed. Amiri Baraka and William J. Harris, 495–506. New York: Thunder Mouth P, 2000.

Barbosa, Márcio, and Esmeralda Ribeiro, ed. *Bailes: Soul, Samba-Rock, Hip Hop e Identidade em São Paulo*. São Paulo: Quilombhoje Literatura e Fundação Cultural Palmares Ministério da Cultura, 2006.

―――― and Esmeralda Ribeiro. "Apresentação." In Barbosa and Ribero, 11–13.

―――. "From the Private Space to the *Quilombo*: *Quilombhoje* in Brazilian Cultural Movement." U of Massachusetts-Amherst. March 31, 2005. Address.

Barnes, Sandra, and Paula Ben-Amos. "Ogun, the Empire Builder." In *Africa's Ogun*. Ed. Sandra Barnes, 39–64. Bloomington: Indiana UP, 1997.

Barthes, Roland. *Image/Music/Text*. Trans. Stephen Heath. New York: Noonday, 1977.

Bascom, William. *Ifa Divination: Communication between Gods and Men in West Africa*. Bloomington: Indiana UP, 1991.

Bastide, Roger. *As Religões Africanas no Brasil*. São Paulo: Livraria Pioneira, 1971.

―――. *The African Religions of Brazil*. Trans. Helen Sebba. Baltimore: John Hopkins UP, 1978.

Basu, Dipannita, and Sidney J. Lemelle. *The Vinyl Ain't Final: Hip Hop and the Globalization of Black Popular Cutlure*. Michigan: Pluto P, 2006.

Béhague, Gerard. "Rap, Reggae, Rock, or Samba: The Local and the Global in Brazilian Popular Music (1985–95)." *Latin American Music Review* 27.1 (Spring/Summer 2006): 79–90.

Ben, Vinson, III, and Matthew Restall, eds. *Black Mexico: Race and Society from Colonial to Modern Times*. Albuquerque: U of New Mexico P, 2009.

Benicio, Luiza. "Afro-Bahian Carnival: The Dialectic of Tradition and Change." M.A. Thesis. U of Iowa, 1998.

Benjamin, Walter. "The Work of Art in the Age of Mechanical Reproduction." In *Illuminations*. Ed. Hannah Arendt. Trans. Harry Zohn, 217–51. New York: Schocken Books, 1969.

Benston, Kimberly W. "The Aesthetic of Modern Black Drama: From *Mimesis* to *Methexis*." In *The Theatre of Black Americans*. Ed. Errol Hill, 61–78. New York: Applause Theatre Book Publishers, 1987.

Bernabé, Jean, Patrick Chamoiseau, and Raphaël Confiant. *Eloge de la Créolité: In Praise of Creoleness*. Trans. M. B. Taleb-Khyar. Paris: Gallimard, 1993.

Bernd, Zilá. *Introdução á Literatura Negra*. São Paulo: Editora Brasiliense, 1988.

———. *Négritude e Literatura na América Latina*. Porto Alegre: Mercado Aberto, 1987.

Bethell, Leslie. "The Decline and Fall of Slavery in Nineteenth Century Brazil." *Transactions of the Royal Historical Society* 6.1 (1991): 71–88.

Bettelheim, Judith. "Carnival in Santiago de Cuba." In *Cuban Festivals: An Illustrated Anthology*. Ed. Judith Bettelheim, 137–69. London: Garland Publishing, Inc., 1993.

———. "Ethnicity, Gender and Power: Carnaval in Santiago de Cuba." In *Negotiating Performance: Gender, Sexuality, and Theatricality in Latin/o America*. Ed. Diana Taylor and Juan Villegas, 176–203. Durham, NC: Duke UP, 1994.

Bhabha Homi. *The Location of Culture*. London: Routledge, 1994. .

Boal, Augusto. *Theatre of the Oppressed*. Trans. Charles A. and Maria-Odilia Leal McBride. New York: Theatre Communications Group, 1985.

Bolling, Ben. "White Rapper/Black Beats: Discovering a Race Problem in the Music of Gabriel O. Pensador." *Latin American Music Review* 23.2 (Fall/Winter 2002): 159–78.

Braga, Júlio Santana. *Na Gamela do Feitiço: Repressão e Resistência nos Candomblés da Bahia*. 1995. Salvador, Brazil: Editora UFBA, 1999.

Brecht, Bertolt. Brecht on Theatre: The Development of an Aesthetic. Ed. and trans. John Willet. New York: Hill and Wang, 1982.

Brookshaw, David. *Race and Color in Brazilian Literature*. Metuchen, NJ: Scarecrow P, 1986.

Burdick, John. "The Myth of Racial Democracy." *NACLA* 25.4 (Feb. 1992): 40–48.

Burke, Edmund. *On the Sublime and Beautiful*. Harvard Classics. 24.2 New York: P. F. Collier & Son, 1909–14. Web. July 11, 2009.

Burke, Peter J., and Jan E. Stets. *Identity Theory*. Oxford: Oxford UP, 2009.

Busia, Abena. "Migrations." In *Testimonies of Exile*, 8–9. Trenton, NJ: Africa World P, 1990.

Butler, Kim D. "Africa in the Reinvention of Nineteenth-Century Afro-Bahian Identity." In Mann and Bay, 135–54.

———. *Freedoms Given, Freedoms Won: Afro-Brazilians in Post-Abolition São Paulo and Salvador*. New Brunswick: Rutgers UP, 1998.

Campbell, Horace. *Rasta and Resistance: From Marcus Garvey to Walter Rodney*. Trenton, NJ: Africa World P, 1987.

Canclini, Nestor Garcia. *Hybrid Cultures: Strategies for Entering and Leaving Modernity*. 1995. Minneapolis: U of Minnesota P, 2005.

———. *Consumers and Citizens: Globalization and Multicultural Conflicts*. Minneapolis: U. of Minnesota P, 2001.

Capone, Stefania. *Searching for Africa in Brazil: Power and Tradition in Candomblé*. Trans. Lucy Lyall Grant. Durham, NC: Duke UP, 2010.

Carneiro, Edison. *Candomblés da Bahia*. Rio de Janeiro: Conquista, 1961.

————. *Religiões Negras: Notas de Ethnografia Religiosa*. Rio de Janeiro: Editora Civilização Brasileira, 1981.

Carneiro, Sueli. "Black Women's Identity in Brazil." In *Race in Contemporary Brazil: From Indifference to Inequality*. Ed. Rebecca Reichmann, 217–28. University Park: Pennsylvania State UP, 1999.

Castillo, Lisa Earl. "Between Memory, Myth and History: Transatlantic Voyagers of the Casa Branca Temple, Bahia, Brazil, 1800s." In *Paths of the Atlantic Slave Trade: Interactions, Identities, and Images*. Ed. Ana Lúcia Araújo, 203–38. New York: Cambria Press, 2011a.

————. "O Terreiro do Alaketu e seus Fundadores: História e Genealogia Familiar, 1807–1867." *Afro-Ásia* 43 (2011b): 213–259.

————. "The Exodus of 1835: Àguda Life Stories and Social Networks." International Colloquium on Slavery, the Slave Trade and their Consequences. Iloko Ijesá, Nigeria. Aug. 24, 2010a. Conference Presentation.

————. and Luis Nicolau Parés. "Marcelina da Silva: A Nineteenth-Century Candomblé Priestess in Bahia." *Slavery and Abolition* 31.1 (March 2010): 1–27.

Castro, Yeda Pessoa de. "Língua e Nação de Candomblé." *África* 4 (1981): 57–77.

Chang, Jeff. *Can't Stop, Won't Stop: A History of the Hip-Hop Generation*. New York: St. Martin's P, 2005.

Clapperton, Hugh. *Journal of a Second Expedition in the Interior of Africa, from the Bight of Benin to Soccatoo*. London: John Murray, 1829.

Clark, Mary Ann. *Where Men are Wives and Mothers Rule: Santeria Ritual Practices and Their Gender Implications*. Gainsville: U of Florida P, 2005.

Clark, Vèvè. "Developing Diaspora Literacy and Marasa Consciousness." In *Comparative American Identities*. Ed. Hortense Spillers, 40–60. New York: Routledge, 1991.

Clarke, Kamari Maxine, and Deborah A. Thomas. *Globalization and Race: Transformations in the Cultural Production of Blackness*. Durham, NC: Duke UP, 2006.

Clifford, James. *Routes: Travel and Translation in the Late Twentieth Century*. Cambridge, MA: Harvard UP, 1997.

Cobb, William Jelani. *To the Break of Dawn: A Freestyle on the Hip Hop Aesthetic*. New York: New York UP, 2007.

Cohen, Peter F. "Orisha Journeys: The Role of Travel in the Birth of Yorùbá-Atlantic Religions." *Archives de Sciences Sociales Des Religions, Les Religions Afro-Américaines: Genèse et Développement dans la Modernité* 47e. 117 (Jan.–Mar. 2002): 17–36. Web. May 18, 2011.

Cohen, William B. *The French Encounter with Africans: White Response to Blacks, 1530–1880*. Bloomington: Indiana UP, 1980.

Collins, Kimberly M. "Black Consciousness Is the Cornerstone of Liberation: The Black Arts Movement in African American Literature and Visual Culture, 1966–1976." Diss. Saint Louis U, 2007.

Collins, Lisa Gail. "The Art of Transformation: Parallels in the Black Arts and Feminist Arts Movements." In *New Thoughts on the Black Arts Movement*. Ed. Lisa Gail Collins and Margo Natalie Crawford. 273–96. New Brunswick Rutgers UP, 2006.

Collins, Patricia Hill. *From Black Power to Hip Hop: Racism, Nationalism, and Feminism*. Philadelphia: Temple UP, 2006.

Conceição, Jonatas, and Lindinalva Barbosa, eds. *Quilombo de Palavras: A Literatura dos Afro-Descendentes*. 2nd ed. Salvador: CEAO/UFBA, 2000.

Connerton, Phillip. *How Societies Remember*. New York: Cambridge UP, 1981.

———. *A Familia-de-Santo nos Candomblés Jeje-nagôs da Bahia*. 1977. 2nd ed. Salvador: Corrupio. 2003.

Costa Lima, Vivaldo da. "Os Obás de Xangô." *Afro-Ásia* 2–3 (1966): 5–36.

Costa, Sandra Regina Soares da. "Uma Experiêcia com Authoridades: Pequena Etnografia de Contato com o Hip Hop e a Polícia num Morro Carioca." *Pesquisas Urbanans: Desafios do Trabalho Antropológico*. Ed. Velho and Kuschnir, 139–55. Rio de Janeiro: Jorge Zahar, 2003.

Courlander, Harold. *Tales of Yoruba Gods & Heroes*. New York: Crown Publishers, 1973.

Cowley, John. *Carnival, Canboulay and Calypso: Traditions in the Making*. Cambridge: Cambridge UP, 1996.

Crowder, Michael. *A Short History of Nigeria*. New York: Frederick A. Praeger, 1966.

Crowley, Daniel J. *African Myth and Black Reality in Bahian Carnaval*. Los Angeles: Museum of Cultural History, UCLA, 1984.

Cunha, Manuela Carneiro da. *Negros Estrangeiros: Os Escravos Libertos e sua Volta à África*. São Paulo: Brasiliense, 1985.

Cuti. *Sanga*. Belo Horizonte: Mazza Edições, 2002.

Da Matta, Roberto. *Carnival, Rogues and Heroes: An Interpretation of the Brazilian Dilemma*. Trans. John Drury. Notre Dame: U of Notre Dame P, 1991.

Daniel, Yvonne. *Embodied Knowledge in Haitian Vodou, Cuban Yoruba, and Bahian Candomblé*. Chicago: U of Illinois P, 2005.

Dantas, Beatrice Góis. *Vovó Nagô e Papai Branco: Usos e Abusos da África no Brasil*. Rio de Janiero: Edições Graal Ltd., 1988.

Dantas, Marcelo. "A História Bahian Teatro da Vida." In *Trilogia do Pelô*. Ed. Marcio Meirelles e Bando do Teatro Olodum. Salvador: Ediçoes Olodum, 1995.

Degler, Carl. *Neither Black nor White: Slavery and Race Relations in Brazil and the United States*. Madison: U of Wisconsin P, 1986.

Deleuze, Gilles, and Félix Guattari. *A Thousand Plateaus: Capitalism and Schizophrenia*. Minneapolis: U of Minnesota P, 1987.

Deren, Maya. *Divine Horsemen: Voodoo Gods of Haiti*. New York: Dell Publishers, 1970.

Devisse, Jean, and Michel Mollat. *The Image of the Black in Western Art II: From the Early Christian Era to the "Age of Discovery."* Cambridge, MA: Harvard UP, 1979.

Diamond, Elin. "Mimesis, Mimicry, and the "True-Real." *Modern Drama* 32.1 (March 1989): 58–72.

Diamond, Elin. *Performance and Cultural Politics.* New York: Routledge, 1996.

Dobbin, Jay D. *The Jombee Dance of Montserrat: A Study of Trance Ritual in the West Indies.* Columbus: Ohio State UP, 1986.

Dorson, Richard. "Material Components in Celebration." In Turner, *Celebration* 33–57.

Drewal, Henry John. "Signifyin' Saints: Sign, Substance and Subversion in Afro-Brazilian Art." In *Santería Aesthetics in Contemporary Latin American Art,* 263–89. Washington, DC: Smithsonian Institution P, 1996.

———. John Pemberton, and Rowland Abiodun. "The Yoruba World." In *Yoruba: Nine Centuries of African Art and Thought.* Ed. Allen Wardell, 13–42. New York: Center for African Art with H. N. Abrams, 1989.

Drewal, Margaret T. *Yoruba Ritual: Performers, Play, Agency.* Bloomington: Indiana UP, 1992.

Du Bois, W. E. B. "Criteria of Negro Art." *The Crisis* 32 (October 1926): 290–97. Web. August 4, 2010.

Dunn, Christopher. "In the Adverse Hour: The Denouement of Tropicália." *Studies in Latin American Popular Culture* 19 (2000): 21– 34.

———. "Tropicália, Counterculture, and the Diasporic Imagination in Brazil." In *Brazilian Popular Music & Globalization.* Ed. Perrone and Dunn, 72–95. New York: Routledge, 2002.

Durham, Carolyn Richardson. "The Beat of a Different Drum: Resistance in Contemporary Poetry by African-Brazilian Women." *Afro-Hispanic Review* (Fall 1995): 21–26.

Eakin, Marshall C. *Brazil: The Once and Future Country.* New York: St. Martin's P, 1997.

Edwards, Flora Mancuso. "The Theater of the Black Diaspora: A Comparative Study of Black Drama in Brazil, Cuba and the United States." Diss. New York U, 1975.

Edwards, Gary, and John Mason. *Black Gods: Orisa Studies in the New World.* Brooklyn: Yoruba Theological Archministry, 1985.

Elam, Harry Justin, Jr., and Kennell Jackson. *Black Cultural Traffic: Crossroads in Global Performance and Popular Culture.* Ann Arbor: U of Michigan P, 2005.

Ellis, A. B. *The Yòrúba-Speaking Peoples of the Slave Coast of West Africa.* 1964. Chicago: Benin P, 1984.

El-Saadawi, Nawal. "Why Keep Asking Me About My Identity?" In *Migrating Words and Worlds: Pan-Africanism Updated.* Ed. E. Anthony Hurley et al. 7–24. Trenton, NJ: Africa World P, 1999.

Ergood, Bruce. "Os Blocos de Santa Rita do Sapucai: Carnival Clubs in a Small Brazilian City: More Than Culture Producers." *Studies in Latin American Popular Culture* 10 (1991): 141–55.

Euba, Femi. "Legba and the Politics of Metaphysics: The Trickster in Black Drama." In Harrison et al., 167–180.

Falola, Toyin, and Matt D. Childs, eds. *The Yoruba Diaspora in the Atlantic World*. Bloomington: Indiana UP, 2004.

Fanon, Franz. *Black Skins, White Masks*. Trans. Charles Lam Markmann. New York: Grove P, 1967.

Fanon, Franz. *The Wretched of the Earth*. New York: Grove Weidenfeld, 1963.

Félix, Anísio. *Filhos de Gandhi: A História de um Afoxé*. Salvador: Gráfica Central, Ltd., 1987.

Félix, Anísio, and Moacir Nery. *Bahia, Carnaval*. N.p: n.p., 1993.

Fernandez, Oscar. "Black Theatre in Brazil." *Educational Theater Journal* 29.1 (March 1977): 5–17.

———. "Censorship and the Brazilian Theatre." *Educational Theater Journal* 25.3 (Oct. 1973): 285–98.

Fine, Elizabeth, and Jean Haskell Spear, "Introduction." In *Performance, Culture and Identity*, 1–22. Connecticut: Praeger, 1992.

Finnegan, Ruth. *Oral Literature in Africa*. London: Clarendon Press, 1970.

Fleetwood, Nicole R. *Troubling Vision: Performance, Visuality, and Blackness*. Chicago: U of Chicago P, 2011.

Flores, Juan. *From Bomba to Hip-Hop: Puerto Rican Culture and Latino Identity*. New York: Columbia UP, 2000.

———. "Puerto Rican and Proud, Boyee!: Rap Roots and Amnesia." Ross and Rose, 89–98.

Fontaine, Pierre-Michel, ed. *Race, Class and Power in Brazil*. Los Angeles: U of California, 1985.

Foucault, Michael. *Power/Knowledge: Selected Interviews and Other Writings, 1972–77*. Trans. Colin Gordon. New York: Pantheon, 1980.

França, Maria José do Espírito Santo. "Candomblé and Community." In *Black Brazil: Culture, Identity and Social Mobilization*. Ed. Larry Crook and Randal Johnson, 53–58. Los Angeles: UCLA Latin American Center Publications, 1999.

Freire, Paulo. *Pedagogy of the Oppressed*. Harmondsworth: Penguin, 1972.

Freyre, Gilberto. *Casa-grande e Senzala: Formação da Família Brasileira sob o Regime e Desenvolvimento do Urbano*. Rio de Janiero: José Olympio, 1964.

Friedman, Susan. *Mappings: Feminism and the Cultural Geographies of Encounter*. Princeton, NJ: Princeton UP, 1998.

Galdino, Luiz. *Palmares*. São Paulo: Editoria Ática, 1996.

Gates, Henry Louis, Jr. *Figures in Black: Words, Signs and the "Racial" Self*. New York: Oxford UP, 1987.

———. *The Signifying Monkey: A Theory of Afro-American Literary Criticism*. Oxford: Oxford UP, 1988.

Gates, Henry Louis, Jr., and Nellie McKay, eds. *Norton Anthology of African American Literature*. 2nd ed. New York: W. W. Norton & Co., 2004.

Gaunt, Kyra. *The Games Black Girls Play: Learning The Ropes from Double-Dutch to Hip-Hop*. New York: New York UP, 2006.

Gayle, Addison, Jr., ed. *The Black Aesthetic*. Garden City, NY: Doubleday 1971.

Gilman, Sander L. *Difference and Pathology: Stereotypes of Sexuality, Race, and Madness*. Ithaca: Cornell UP, 1985.

Gilroy, Paul. *"There Ain't No Black in the Union Jack": The Cultural Politics of Race and Nation*. London: Hutchinson, 1987.

———. *Against Race: Imagining Political Culture Beyond the Color Line*. Cambridge, MA: Harvard UP, 2000.

———. *The Black Atlantic: Modernity and Double Consciousness*. Cambridge, MA: Harvard UP, 1993.

Glissant, Edouard. *Poetics of Relation*. Trans. Betsy Wing. Ann Arbor: U of Michigan P, 1997.

Godi, Antonio Jorge Victor dos Santos. "Música Afro-Carnavalesca: Das Multidões para o Sucesso das Massas Eléctricas." In *Ritmos em Trânsito: Sócio-Anropologia da Música Baiana*. Ed. Livio Sansone e Jocélio Teles dos Santos. 73–96. São Paulo: Editora Dynamis, Ltd. 1998.

Goldenberg, David. *The Curse of Ham: Race and Slavery in Early Judaism, Christianity, and Islam*. Princeton: Princeton UP, 2003.

Gottschild, Brenda Dixon. *Digging the Africanist Presence in American Performance: Dance and Other Contexts*. Westport, CT: Greenwood P, 1996.

Graden, Dale. "'So Much Superstition Among These People!': Candomblé and the Dilemmas of Afro-Bahian Intellectuals, 1864–1871." In Kraay, 57–72.

Gramsci, Antonio. *The Modern Prince and Other Writings*. 1957. Trans. Louis Marks. New York: International Publishers, 2007.

Green, Garth L., and Philip W. Scher. "Introduction: Trinidad Carnival in Global Context." In *Trinidad Carnival: The Cultural Politics of a Transnational Festival*. Ed. Garth and Scher, 1–24. Bloomington: Indiana UP, 2007.

Grimes, Ronald L. "The Lifeblood of Public Ritual: Fiestas and Public Exploration Projects." In Turner, *Celebration* 271–83.

Grossberg, Lawrence. "Identity and Cultural Studies—Is That All There Is?" In Hall and du Gay, 87–107.

Gudmundson, Lowell, and Justin Wolfe. *Blacks and Blackness in Central America: Between Race and Place*. Durham: Duke UP, 2010.

Guerreiro, Goli. *A Trama dos Tambores: A Música Afro-Pop de Salvador*. São Paulo: Editora 34, 2000.

Guimarães, Antonio, and Lynn Huntley. *Tirando a Máscara: Ensaios Sobre o Racismo no Brasil*. São Paulo: Editora Paz e Terra, 2000.

Guimarães, Maria Eduarda Araujo. "Rap: Transpondo as Fronteiras de Periferia." Andrade, 39–54.

Habermas, Jürgen. *Structural Transformation of the Public Sphere: An Inquiry into a Category of Bourgeois Society*. Trans. Thomas Burger and Frederick Lawrence. Cambridge, MA: MIT P, 1989.

Hall, Stuart. "Ethnicity: Identity and Difference." *Radical America* 23.4 (1989): 9–22.

———. "New Ethnicities." *Black Film, British Cinema*. Ed. Kobena Mercer. ICA Documents 7 (1988): 27–31.

———. "Introduction: Who Needs 'Identity'?" In Hall and du Gay, 1–17.

———. "What Is This 'Black' in Black Popular Culture." In *Black Popular Culture*. Ed. Gina Dent, 465–75. Seattle: Bay P, 1992.

Hall, Stuart, and Paul du Gay, ed. *Questions of Cultural Identity*. London: Sage Publications, 1996.

Hanchard, Michael. "'Black Cinderella?' Race and the Public Sphere in Brazil." In *Racial Politics in Contemporary Brazil*, 59–81. Durham, NC: Duke UP, 1999.

———. *Orpheus and Power: The Movimento Negro of Rio de Janiero and São Paulo, Brazil, 1945–1988*. Princeton: Princeton UP, 1994.

Harding, Rachel. *A Refugee in Thunder: Candomblé and Alternative Spaces of Blackness*. Bloomington: Indiana UP, 2000.

———. "'What Part of the River You're In': African American Women in Devotion to Òsun." In Murphy and Sanford, 165–88.

Harper, Philip Brian. "Nationalism and Social Division in the Black Arts Poetry of the 1960s." *Critical Inquiry* 19.2 (Winter 1993): 234–55.

Harrison, Paul Carter, Victor Leo Walker III, and Gus Edwards. Black Theatre: Ritual, Performance in the African Diaspora. Philadelphia: Temple UP, 2002.

Hasenbalg, Carlos A. "Negros e Mestiços: Vida, Cotidiano e Movimento." In *Relações Racais no Brasil Contemporâneo*. Ed. Nelson do Valle Silva and Carlos A. Hasenbalg, 139–64. Rio de Janeiro: Rio Fundo, 1992.

Hazzard-Gordon, Katrina. *Jookin': The Rise of Social Dance Formations in African-American Culture*. Philadelphia: Temple UP, 1990.

Henderson, Stephen. *Understanding the New Black Poetry*. New York: Morrow & Co., Inc., 1973.

Herschmann, Micael. *O Funk e o Hip-Hop Invadem a Cena*. Rio de Janeiro: Editora UFRJ, 2000.

Herskovits, Melville J. *The Negro in Bahia, Brazil: A Problem in Method*. N.P.: American Sociological Review, 1943.

hooks, bell. "An Aesthetic of Blackness: Strange and Oppositional." *Lenox Avenue: A Journal of Interarts Inquiry* 1 (1995): 65–72. Web. June 22, 2009.

———. "Postmodern Blackness." *Postmodern Culture* 1:1 (Sept. 1991). Web. June 22, 2009.

———. "Representing Whiteness in the Black Imagination." *Cultural Studies*. Ed. Lawrence Grossberg et al. 338–46. New York: Routledge, 1991.

Htun, Mala. "From 'Racial Democracy' to Affirmative Action: Changing State Policy on Race in Brazil." *Latin American Research Review* 39.1 (2004): 60–89.

Hughes, Langston. "The Negro Artist and the Racial Mountain." In Gates and McKay, 1311–14.

Jackson, Michael. *The Politics of Storytelling: Violence, Transgression, and Intersubjectivity.* Denmark: Museum Tusculanum P, 2002.

Jesus Félix, João Batista de. "Questões de Identidade." In Barbosa and Ribeiro, 33–40.

Johnson, Samuel. *The History of the Yorubas.* 1969. London: Routledge, 1973.

Jones, Leroi. "Black Art." In *Black Fire: An Anthology of Afro-American Writing.* Ed. Leroi Jones and Larry Neal, 302–3. New York: William Morrow & Company, Inc., 1968.

Kant, Immanuel. *Observations on the Feeling of the Beautiful and Sublime.* Trans. John T. Goldthwiat. Berkeley: U of California P, 1960.

Kelley, Robin D. G. *Yo' Mama's Disfunktional!: Fighting the Culture Wars in Urban America.* Boston: Beacon P, 1997.

Keyes, Cheryl L. "At the Crossroads: Rap Music and Its African Nexus." *Ethnomusicology* 40.2 (Spring/Summer 1996): 223–48.

King, Woodie. *BlackSpirits: A Festival of New Black Poets in America.* New York: Random House, 1972.

Kraay, Hendrik. "Introduction: Afro-Bahia, 1790s–1990s." In Kraay, 3–29.

———, ed. *Afro-Brazilian Culture and Politics, Bahia 1790s to 1990s.* New York: M. E. Sharpe, 1998.

Landes, Ruth. *The City of Women.* Albuquerque: U of New Mexico P, 1994.

Law, Robin. "The Heritage of Oduduwa: Traditional History and Political Propaganda among the Yoruba." *The Journal of African History* 14.2 (1973): 207–22.

———. *The Oyo Empire 1600–1836: A West African Imperialism in the Era of the Slave Trade.* Oxford: Clarendon, 1977.

Lawal, Babatunde. "The African Heritage of African American Art and Performance." In Harrison et al., 39–63.

Leal, Gilberto R. N. "Fárígá/Ìfaradà: Black Resistance and Achievement in Brazil. In Walker, 291–300.

Lee, Don L. (aka Haki Madhubuti). "Toward a Definition: Black Poetry of the Sixties (After Leroi Jones)." In Gayle, 222–33.

Lee, Josephine. "The Seduction of the Stereotype." In *Performing Asian America,* 89–135. Philadelphia: Temple UP, 1997.

Lépine, Claude. "Os Estereótipos da Personalidade no Candomblé Nagô." *Candomblé: Religião do Corpo e da Alma, Tipos Psicológicos nas Religiões Afro-Brasilieras.* Ed. Carlos Eugênio Marcondes de Moura, 139–63. Rio de Janiero: Pallas, 2000.

Lima, Ari. "Black and *Brau:* Music and Black Subjectivity in a Global Context." In Perrone and Dunn, 220–32.

Lima, Fabio Batista. *Os Candomblés da Bahia: Tradições e Novas Tradições.* Salvador: Universidade do Estado da Bahia, Arcadia, 2005.

Limeira, José Carlo. "Maio." Trans. Jane Malinoff and Phyllis Reisman. *Callaloo* 8.10 (Feb.–Oct, 1980): 64–65.

Lindsay, Lisa A. "To Return to the Bosom of their Fatherland: Brazilian Immigrants in Nineteenth-Century Lagos." *Slavery and Abolition* 15.1 (1994): 22–50.

Lipsitz, George. *Dangerous Crossroads: Popular Music, Postmodernism, and the Poetics of Place*. New York: Verso, 1994.

———. *Time Passages: Collective Memory and American Popular Culture*. Minneapolis: U of Minnesota P, 1990.

———. "The Racialization of Space and the Spatialization of Race: Theorizing the Hidden Architecture of Landscape." *Landscape Journal* 26:1 (2007): 10–23.

Lloyd, P. C. "Sacred Kingship and Government among the Yoruba." *Africa: Journal of the International African Institute* 30.3 (July 1960): 221–37.

Lobo, Luiza. *Crítica sem Juízo: Ensaios*. Rio de Janeiro: Francisco Alves, 1993.

Locke, John. "Of Paternal, Political and Despotical Power, Considered Together." In *Two Treatises on Government (1680–1690)*. 2.15 Web. July 7, 2010.

Lopes, Nei. "African Religions in Brazil, Negotiation, and Resistance: A Look from Within." *Journal of Black Studies* 34.6 (July 2004): 838–60.

Lovejoy, Paul E. "The Yoruba Factor in the Trans-Atlantic Slave Trade." In Falola and Childs, 40–55.

Lovelace, Earl. *The Dragon Can't Dance*. Essex: Longman, 1998.

Lovell, Peggy A. "Race, Gender and Development in Brazil." *Latin American Research Review* 29.3 (1994): 7–35.

Luz, Marco Aurélio. *Agadá: Dinâmica da Civilização Africano-Brasileira*. Salvador: Editora da U Federal da Bahia, 2000.

Lyotard, Jean-François. "The Sublime and the Avant-Garde." In *The Lyotard Reader*. Ed. Andrew Benjamin, 196–211. Oxford: Blackwell, 1989.

Mabardi, Sabine. "Encounters of a Heteregenous Kind: Hybridity in Cultural Theory." In *Unforeseeable Americas: Questioning Cultural Hybridity in the Americas*. Ed. Rita De Grandis and Zilà Bernd, 1–20. Amsterdam: Rodopi, 1999.

MacAloon, John J, ed. *Rite, Drama Festival, Spectacle: Rehearsals Towards a Theory of Cultural Performance*, Philadelphia: Institute for the Study of Human Issues, 1984.

Macedo, Márcio. "Anotações para uma História dos Bailes Negros em São Paulo." In Barbosa and Ribeiro, 15–25.

Madhubuti, Haki. "Two Poems." In *Liberation Narratives: New and Collected Poems*, 43. Chicago: Third World P, 2009.

Mann, Celeste Dolores. "The Search for Identity in Afro-Brazilian Women's Writing: A Literary History." In Moving Beyond Boundaries: Black Women's Diasporas. 173–78. Vol. 2. Ed. Carole Boyce Davies. New York: New York UP, 1995.

Mann, Kristin, and Edna G. Bay, ed. *Rethinking the African Diaspora: The Making of a Black Atlantic World in the Bight of Benin and Brazil*. Oregon: Frank Cass, 2001.

————. *Slavery and the Birth of an African City: Lagos 1760–1900.* Bloomington: Indiana UP, 2007.

Manning, Frank E. "Cosmos and Chaos: Celebration in the Modern World." In *Celebration of Society: Perspectives on Contemporary Cultural Politics,* 3–30. Bowling Green, Ohio: Bowling Green U Popular P, 1983.

Marable, Manning, and Vanessa Agard-Jones, ed. *Transnational Blackness: Navigating the Global Color Line.* New York: Palgrave Macmillan, 2008.

Martin, Percy Alvin. "Slavery and Abolition in Brazil." *The Hispanic American Historical Review* 13.2 (May 1933): 151–96.

Martins, Suzana. *A Dança de Yemanjá Ogunté: Sob a Perspectiva Estética do Corpo.* São Paulo: Perspectivas, 1997.

Matory, J. Lorand. *Black Atlantic Religion: Tradition, Transnationalism, and Matriarchy in the Afro-Brazilian Candomblé.* Princeton: Princeton UP, 2005.

————. "Gendered Agendas: The Secrets Scholars Keep about Yorùbá-Atlantic Religion." *Gender & History* 15.3 (Nov. 2003): 409–39.

————. *Sex and the Empire That Is No More: Gender and the Politics of Metaphor in Oyo Yoruba Religion.* Minneapolis: U of Minnesota P, 1994.

————. "The 'Cult of Nations' and the Ritualization of their Purity." *South Atlantic Quarterly* 100.1 (Winter 2001): 172–214.

Mattoso, Katia M. de Queirós. *To Be a Slave in Brazil: 1550–1888.* Trans. Arthur Goldhammer. New Brunswick: Rutgers UP, 1986.

Mbembe, Achille. *On the Postcolony.* Berkeley: U of California P, 2001.

McClintock, Anne. *Imperial Leather: Race, Gender, and Sexuality in the Colonial Conquest.* New York: Routledge, 1995.

Meirelles, Marcio, and Bando do Teatro Olodum. *Cabaré da Raça.* Salvador: Teatro Vila Velha, n.d.

————. *Trilogia do Pelô.* Salvador: Ediçoes Olodum, 1995.

————. *Zumbi.* Salvador: Teatro Vila Velha, n.d.

Mendes, Miriam Garcia. *A Personagem Negra no Teatro Brasiliero (Entre 1838 e 1888).* São Paulo: Editora Ática, 1982.

————. *O Negro e o Teatro Brasileiro.* São Paulo: Editora Hucitec, 1993.

Mercer, Kobena. "Diaspora Aesthetics and Visual Culture." In *Black Cultural Traffic.* Ed. Harry E. Elam and Kennell Jackson, 141–61. Ann Arbor: U of Michigan P, 2005.

Merrell, Floyd. *Capoeira and Candomblé: Conformity and Resistance through Afro-Brazilian Experience.* Princeton: Marcus Weiner Publishers, 2004.

Mills, Charles W. *The Racial Contract.* Ithaca: Cornell UP, 1997.

Minka, Jamu. *Teclas do Ébano.* São Paulo: Ed. do Autor, 1986.

Mitchell, Angelyn, ed. *Within the Circle: An Anthology of African American Literary Criticism from the Harlem Renaissance to the Present.* Durham, NC: Duke UP, 1994.

Mitchell, Tony, ed. *Global Noise: Rap and Hip-Hop Outside the USA.* Middleton, CT: Wesleyan UP, 2001.

Moehn, Frederick. "Music, Citizenship, and Violence in Postdictatorship Brazil." *Latin American Music Review* 28.2 (Dec. 2007): 181–219.

Montero, Alfred P. *Brazilian Politics: Reforming a Democratic State in a Changing World.* Cambridge: Polity P, 2005.

Moore, Robin Dale. *Nationalizing Blackness: Afrocubanismo and Artistic Revolution in Havana, 1920–1940.* Pittsburg: U of Pittsburg, 1997.

Morrison, Toni. "Unspeakable Things Unspoken: The Afro-American Presence in American Literature." In Angelyn Mitchell, 368–98.

Morton-Williams, Peter. "An Outline of the Cosmology and Cult Organization of the Yoruba." *Africa: Journal of the International African Institute* 34.3 (July 1964): 243–61.

Movimento Negro Unificado. *Movimento Negro Unificado, 1978–1988: 10 Anos de Luta Contra o Racismo.* São Paulo: Confraria do Livro, 1988.

Mudimbe, V. Y. *The Idea of Africa.* Bloomington: Indiana UP, 1994.

———. *The Invention of Africa: Gnosis, Philosophy, and the Order of Knowledge.* Bloomington: Indiana UP, 1988.

Mulvey, Patricia A. "Black Brothers and Sisters: Membership in the Black Lay Brotherhoods of Colonial Brazil." *Luso-Brazilian Review* 17.2 (Winter 1980): 253–79.

———. "Slave Confraternities in Brazil: Their Role in Colonial Society." *The Americas* 39.1 (July 1982): 39–68.

Murphy, Joseph M., and Mei-Mei Sanford, ed. *Òsun across the Waters: A Yoruba Goddess in Africa and the Americas.* Bloomington: Indiana UP, 2001.

Myeroff, Barbara. "A Death in Due Time: Construction of Self and Culture in Ritual Drama." In MacAloon, 149–77.

Na'Allah, Abdul-Rasheed. "The Origin of the Egungun: A Critical Literary Appraisal." *African Study Monograph* 17.2 (Oct. 1996): 59–68.

Nascimento, Abdias do. *Africans in Brazil: A Pan African Perspective.* Trenton, NJ: Africa World P, 1992.

———. *Dramas para Negros e Prólogo para Brancos.* Rio de Janiero: TEN, 1961.

———. *Sortilégio, Mistério Negro.* In Nascimento, *Dramas.* 160–219.

Nascimento, Elisa Larkin. "Sortilege: Building an Afro-Brazilian Identity on Stage." In *Marvels of the African World: African Cultural Patrimony, New World Connections, and Identities.* Ed. Niyi Afolabi, 277–300. Trenton, NJ: Africa World P, 2003.

Neal, Larry, ed. "And Shine Swam On." In *Black Fire: An Anthology of Afro-American Writing.* Ed. Leroi Jones and Larry Neal, 638–56. New York: Morrow, 1968.

———. "The Black Arts Movement." In Mitchell, 184–98.

———. *Visions of a Liberated Future: Black Arts Movement Writings.* Ed. Michael Schwartz. New York: Thunder Mouth P, 1989.

Nettleford, Rex. *Inward Stretch, Outward Reach: A Voice from the Caribbean.* London: Macmillan Caribbean, 1993.

Nishida, Mieko. "From Ethnicity to Race and Gender: Transformations of Black Lay Sodalities in Salvador, Brazil." *Journal of Social History* 32.2 (Winter 2008): 329–48.

———. "Manumission and Ethnicity in Urban Slavery: Salvador, Brazil, 1808–1888." *The Hispanic American Historical Review* 73.3 (Aug. 1993): 361–91.

Nobles, Melissa. *Shades of Citizenship: Race and the Census in Modern Politics.* Stanford, CA: Stanford UP, 2000.:

O'Hear, Ann. "The Enslavement of Yoruba." In Falola and Childs, 56–73.

Ogungbile, David O. "The Seeing Eyes of Sacred Shells and Stones." In Murphy and Sanford, 189–212.

Okediji, Moyosore B. *The Shattered Gourd: Yoruba Forms in Twentienth-Century American Art.* Seattle: U of Washington P, 2003.

Oliveira, Emanuelle Karen Felinto. "Cadernos Negros and *Quilombhoje*: Literature, Cultural Politics and Social Resistance." Diss. UCLA, 2001.

———. *Writing Identity: The Politics of Contemporary Afro-Brazilian Literature.* West Lafayette, IN: Purdue UP, 2008.

Oliveira, Maria Inês Cortes de. "Ethnicity in Bahia: The Case of the Nagô." In *Transatlantic Dimension of Ethnicity in the African Diaspora.* Ed. Paul E. Lovejoy and David V. Trotman, 158–80. New York: Continuum, 2003.

———. *Os libertos: Seu Mundo e Os Outros.* Salvador: Corrupio, 1988.

Omari, Mikelle Smith. "Candomblé: A Socio-Political Examination of African Religion and Art in Brazil." In *Religion in Africa: Experience & Expression.* Ed. Thomas D. Blakely et al. 135–59. London: James Currey, 1994.

Omari-Tunkara, Mikelle Smith. *Manipulating the Sacred: Yorùbá Art, Ritual, and Resistance in Brazilian Candomblé.* Detroit: Wayne State UP, 2005.

Osumare, Halifu. *The Africanist Aesthetic in Global Hip-Hop: Power Moves.* New York: Palgrave Macmillan, 2007.

Oyewùmí, Oyèrónke. *The Invention of Women: Making an African Sense of Western Gender Discourses.* Minneapolis: U of Minnesota P, 1997.

Page, Joseph A. *The Brazilians.* Reading, MA: Addison-Wesley Publishing Co., 1995.

Paravisini-Gebert, Lizabeth, and Margarite Fernandez Olmos. *Creole Religions of the Caribbean: An Introduction from Vodou and Santeria to Obeah and Espiritismo.* New York: New York UP, 2003.

Pardue, Derek. *Ideologies of Marginality in Brazilian Hip Hop.* New York: Palgrave Macmillan 2008.

Parés, Luis Nicolau. "The 'Nagôization' Process in Bahian Candomblé." In Falola and Childs, 185–208.

———. "The Birth of the Yoruba Hegemony in Post-Abolition Candomblé." *Journal de la Société des Américanistes* 91.1 (2005): 139–59. Web. December 8, 2010.

Patton, John H. "Communication in Ritual Performance: Carnival in Antigua 1989 and 1990." *Studies in Latin American Popular Culture* 14 (1995): 69–86.

Pelton, Robert D. *The Trickster in West Africa: A Study of Mythic Irony and Sacred Delight*. Berkeley: U of Califórnia P, 1980.

Pemberton, John, and Funso S. Afolayan. *Yoruba Sacred Kingship, "A Power Like That of the Gods."* Washington, DC: Smithsonian Institution P, 1996.

Pemberton, John. "Eshu-Elegba: The Yoruba Trickster God." *African Arts* 9.1 (October 1975): 20–27, 66–70, 90–92.

Perrone, Charles A. "Axé, Ijexá, Olodum: The Rise of Afro- and African Currents in Brazilian Popular Music." *Afro-Hispanic Review* XI.1–3 (1992): 42–50.

———. "Topos and Tropicalities: The Tropes of Tropicália and Tropicalismo." *Studies in Latin American Popular Culture* 19 (2000): 1–20.

Perrone, Charles A., and Dunn, Christopher. *Brazilian Popular Music & Globalization*. New York: Routledge, 2002.

Perry, Imani. *Prophets of the Hood: Politics and Poetics in Hip Hop*. Durham, NC: Duke UP, 2004.

Pinho, Osmundo de Araújo. "'Fogo na Babilônia': Reggae, Black Counterculture, and Globalization in Brazil." In Perrone and Dunn, 192–205.

Pinho, Patricia de Santana. *Mama Africa: Reinventing Blackness in Bahia*. Durham, NC: Duke UP, 2010.

Pinto, Tiago de Oliveira. "Making Ritual Drama: Dance, Music and Representation in Brazilian Candomblé and Umbanda." *The World of Music* 33.1 (1991): 70–88.

Piza, Edith, and Fulvia Rosemberg. "Color in the Brazilian Census." In Reichmann, 37–52.

Pratt, Mary Louise. *Imperial Eyes: Travel Writing and Transculturation*. 1992. New York: Routledge, 2008.

Projeto Novo Vila, Relatório 94/96. Salvador: Teatro Vila Velha, 1996.

Quieroz, Maria Isaura Pereira de. *Carnaval Brasiliero: O Vivido e o Mito*. São Paulo: Brasiliense, 1992.

Quilombhoje. *Cadernos Negros 27*. São Paulo: Quilombhoje, 2004.

———. *Cadernos Negros 31*. São Paulo: Quilombhoje, 2008.

———. *Cadernos Negros: Os Melhores Poemas*. São Paulo: Quilombhoje, 1998.

———. *Reflexoes Sobre a Literatura Afro-Brasileira*. São Paulo: Conselho de Participação e Desenvolvimento da Cumunidade Negra, 1985.

Ralston, Richard D. "The Return of Brazilian Freedmen to West Africa in the 18th and 19th Centuries." *Canadian Journal of African Studies* 3.3 (Fall 1970): 577–92.

Ramos, Arthur. *The Negro in Brazil*. Trans. Richard Patee. Washington, DC: Associated Publishers, Inc., 1951.

Randall, Dudley. "Ballad of Birmingham." In King, 233-34.

Reichmann, Rebecca, ed. *Race in Contemporary Brazil: From Indifference to Inequality*. University Park: Pennsylvania State UP, 1999.

Reis, Isabel. *Histórias de Vida Familiar e Afetive de Escravos na Bahia do Século XIX*. Salvador: Universidade Federal da Bahia, 2001.

Reis, João Jose, and Beatriz Galloti Mamigonian. "Nagô and Minas: The Yoruba Diaspora in Brazil." In Falola and Childs, 77–110.

Reis, João Jose. "Candomblé in Nineteenth-Century Bahia." In Mann and Bay, 116–34.

———. *Domingos Sodré, Um Sacrdote Africano: Escravidão, Liberdade e Candomblé na Bahia do Século XIX.* São Paulo: Companhia das Letras, 2008.

———. *Slave Rebellion in Brazil: The Muslim Uprising of 1835 in Bahia.* Baltimore: John Hopkins UP. 1993.

Ribeiro, Esmeralda. *Orukomi—Meu Nome.* São Paulo: Quilombhoje, 2007.

Risério, Antonio. *Carnaval Ijexá.* Salvador: Corrupio, 1981.

———. *Oriki Orixá.* São Paulo: Editora Perspectiva, 1996.

———. *Textos e Tribos: Poéticos Extraocidentais Nos Trópicos Brasileiros.* Rio de Janeiro: Imago Editora, Ltd., 1993.

Rocha, Janaina, et al., ed. *Hip Hop: A Periferia Grita.* São Paulo: Editora Fundação Perseu Abramo, 2001.

Rodrigues, Raymundo Nina. *Os Africanos no Brasil.* São Paulo: Editora Nacional, 1932.

Romo, Anadelia A. *Brazil's Living Museum: Race, Reform and Tradition in Bahia.* Chapel Hill: U of North Carolina P, 2010.

Rose, Tricia. *Black Noise: Rap Music and Black Culture in Contemporary America.* Hanover, NH: Wesleyan UP, 1994.

Ross, Andrew, and Tricia Rose. *Microphone Fiends: Youth Music and Youth Culture.* New York: Routledge, 1994.

Ryan, Judylyn S. *Spirituality as Ideology in Black Women's Film and Literature.* Charlottesville: U of Virginia P, 2005.

Safran, William. "Diasporas in Modern Societies: Myths of Homeland and Return." *Diaspora: A Journal of Transnational Studies* I (Spring 91): 83–99.

Said, Edward. *Culture and Imperialism.* New York: Knopf, 1993.

———. *Orientalism.* New York: Vintage Books, 1979.

———. "Traveling Theory." In *The World, the Text and the Critic.* 226–47. Cambridge, MA: Harvard UP, 1983.

Sala-Molinas, Louis. *Dark Side of the Light: Slavery and the French Enlightenment.* Trans. John Conteh-Morgan. Minneapolis: U of Minnesota P, 2006.

Salles, Vicente. *Repente & Cordel: Literaturea Populare em Versos na Amazônia.* Rio de Janiero: FUNARTE, 1985.

Sanchez, Sonia. "Queens of the Universe." In King, 186–87.

Sangode, Iyalosa Ayobunmi Sosi. *The Cult of Sango: The Study of Fire.* New York: Athelia Henrietta P, 1996.

Sansone, Livio. *Blackness without Ethnicity: Constructing Race in Brazil.* New York: Palgrave Macmillan, 2003.

Santos, Deoscóredes M. dos. *Historia de um Terreiro Nagô.* 1962. São Paulo: Max Limonad, 1988.

Santos, Gislene Aparecida dos. *A Invenção do "Ser Negro": Um Percurso das Idéias que Naturalizaram a Inferioridade dos Negros*. Rio de Janiero: Pallas Editora, 2002.

Santos, Jocélio Teles dos. "A Mixed Race Nation: Afro-Brazilians and Cultural Policy in Bahia, 1970–1990." In Kraay, 117–33.

Santos, Juana Elbien dos. *Os Nagós e a Morte*. Petropolis: Vozes, 1976.

Santos, Sales Augusto dos, and Laurence Hallewell. "Historical Roots of the 'Whitening' of Brazil." *Latin American Perspectives: Brazil: The Hegemonic Process in Political and Cultural Formation* 29.1 (Jan. 2002): 61–82.

Schechner, Richard, and Willa Appel, eds. *By Means of Performance: Intercultural Studies of Theatre and Ritual*. Cambridge: Cambridge UP, 1990.

Schechner, Richard. *Performance Theory* New York: Routledge, 1988.

———. *Between Theater and Anthropology*. Philadelphia: U of Pennsylvania P, 1985.

Scott, James C. *Domination and the Arts of Resistance: Hidden Transcripts*. New Haven: Yale UP, 1990.

Segato, Rita. "The Color-Blind Subject of Myth; or Where to Find Africa in the Nation." *Annual Review of Anthropology* 27 (1998): 129–51.

Sell, Mike. "The Black Arts Movement: Performance, Neo-Orality and the Destruction of the 'White Thing.'" In *African American Performance and Theater History: A Critical Reader*. Ed. Elam, Harry, J. and David Krasner. 56–80. Oxford: Oxford UP, 2001.

Serra, Ordep. *Rumores de Festa: O Sagrado e O Profano na Bahia*. Salvador: Edufba, 1999.

Seyferth, Giralda. "Antropologia e o Teoriado Branqueamento de Raqano Brasil: A Tese de João Batistade Lacerda." *Revistado Museu Paulista* 30 (1985): 81–98.

Sheriff, Robin E. *Dreaming Equality: Color, Race, and Racism in Urban Brazil*. New Brunswick: Rutgers UP, 2001.

Shohat, Ella. "Notes on the 'Postcolonial'." *Social Text* 31/32 (Spring 1992): 99–113.

Shohat, Ella, and Robert Stam. *Unthinking Eurocentrism: Multiculturalism and the Media*. New York: Routledge, 1994.

Shusterman, Richard. "Rap Aesthetics: Violence and the Art of Keeping It Real." In *Hip Hop and Philosophy: Rhyme 2 Reason*. Ed. Darby and Shelby, 54–64. Chicago: Open Court, 2005.

Silva, José Carlos Gomes da. "Arte e Educação: A Experência do Movimento Hip Hop Paulistano." In Andrade, 23–38.

Silva, Maria Aparecida (Cidinha) da. "Projecto Rappers: Uma Iniciative Pioneira e Vitoriosa de Interlocução entre uma Organização de Mulheres Negras e a Juventude no Brasil." In Andrade, 93–101.

Silverstein, Leni M. "The Celebration of Our Lord of the Good End: Changing State, Church, and Afro-Brazilian Relations in Bahia." In *The Brazilian Puzzle: Culture in the Borderlands of the Western World*. Ed. Hess and DaMatta. 134–54. New York: Columbia UP, 1995.

Skidmore, Thomas E. *Black into White.* Oxford: Oxford UP, 1974.

Smethurst, James Edward. *The Black Arts Movement.* Chapel Hill: U of North Carolina P, 2005.

Smith, David Lionel. "The Black Arts Movement and Its Critics." *American Literary History* 3.1 (Spring 1993): 93–110.

Smith, Robert. *The Yoruba and Their Homeland.* London: Methuen & Co., Ltd., 1969.

Sneed, Paul. "Favela Utopias: The Bailes Funk in Rio's Crisis of Social Exclusion and Violence." *Latin American Research Review* 43.2 (2008): 57–79.

Soares da Costa, Sandra Regina. "Uma Experiência com Authoridades." In *Pesquisas Urbanas: Desafios do Trabalho Antropológico.* Ed. Gilberto Velho and Karina Kuschnir, 139–55. Rio de Janiero: Jorge Zahar Editor, 2003.

Souza, Florentina da S. "Identidades Afro-Brasileiras? Contas e Rosários." *Caderno CRH* 33 (July/Dec. 2000): 75–102.

Soyinka, Wole. "The African World and the Ethnocultural Debate." In *African Culture: Rhythms of Unity.* Ed. Molefi. K. Asante and Karimu W. Asante, 13–38. Trenton, NJ: Africa World P, 1990.

Spady, James G., et al. *Tha' Global Cipha: Hip Hop Culture and Consciousness.* Philadelphia: Black History Museum P, 2006.

Sparks, David Hatfield. "Gilberto Gil: Praise Singer of the Gods." *Afro-Hispanic Review* XI.1–3 (1992): 70–75.

Spivak, Gayatri. "Can the Subaltern Speak?" In *The Post-Colonial Studies Reader.* Ed. Bill Ashcroft et al. 24–28. London: Routledge, 1995.

Spivak, Gayatri Chakravorty, et al. *The Spivak Reader: Selected Works of Gayatri Chakravorty Spivak.* New York: Routledge, 1996.

Stam, Robert. "Carnival, Politics and Brazilian Culture." *Studies in Latin American Popular Culture* 7 (1988): 255–63.

Sterling, Cheryl. "Black Arts Movement and Quilombhoje." In Afolabi, Barbosa, and Ribeiro. 5–33.

———. "Women-space, Power, and the Sacred in Afro-Brazilian Culture." *The Global South, Special Issue: Latin America in the Global Age* 4.1 (Spring 2010): 71–93.

Taussig, Michael. *Mimesis and Alterity: A Particular History of the Senses.* New York: Routledge, 1993.

Tavares, Ildásio. *Nossos Colonizadores Africanos: Presença e Tradição Negra na Bahia.* 2nd ed. Salvador: Edufba 2009.

Taylor, Clyde R. *The Mask of Art: Breaking the Aesthetic Contract—Film and Literature.* Bloomington: Indiana UP, 1998.

———. "We Don't Need Another Hero: Anti-Theses on Aesthetics." In *Blackframes: Critical Perspectives on Black Independent Cinema.* Ed. Claire Andrade-Watkins and Mbye B Cham, 80–85. Cambridge, MA: MIT Press, 1988.

Telles, Edward E. *Race in Another America: The Significance of Skin Color in Brazil.* Princeton: Princeton UP, 2004.

Thompson, Robert Farris. *Flash of the Spirit: African & Afro-American Art & Philosophy*. New York: Vintage Books, 1984.

Torres, Arlene, and Norman E. Whitten Jr. *Blackness in Latin America and the Caribbean: Social Dynamics and Cultural Transformations*. Vol. II. Bloomington: Indiana UP, 1998.

Turner, Doris J. "Black Theater in a 'Racial Democracy': The Case of the Brazilian Black Experimental Theater." *CLA Journal* 30.1 (Sept. 1986): 33–34.

———. "The Teatro Experimental do Negro and Its Black Beauty Contests." *Afro-Hispanic Review* 11.1–3 (1992): 76–81.

Turner, Victor, "Are There Universals of Performance in Myth, Ritual and Drama?" In *By Means of Performance: Intercultural Studies of Theatre and Ritual*. Ed. Schechner and Appel, 8–18. Cambridge: Cambridge UP, 1990.

———. ed. *Celebration: Studies in Festivity and Ritual*. Washington, DC: Smithsonian Institute, 1982.

———. "Liminality and the Performative Genres." In MacAloon, 19–41.

———. *The Ritual Process: Structure and Anti-Structure*. Chicago: Aldine Publishing Co., 1969.

———. "Social Dramas and Ritual Metaphors." In *Dramas, Fields, and Metaphors: Symbolic Action in Human Society*, 23–59. Ithaca: Cornell UP, 1974.

Twine, France Winddance. *Racism in a Racial Democracy: The Maintenance of White Supremacy in Brazil*. New Brunswick: Rutgers UP, 1998.

Vargas, João H. Costa. "When a Favela Dares to Become a Gated Condominium: The Politics of Race and Urban Space in Rio de Janeiro." *Latin American Perspectives* 33.5 (July 2006): 49–81.

Verger, Pierre Fatumbi. *Flux et Reflux de la Traite Nègres entre le Golfe de Bénin et Bahia de Todos os Santos*. Paris: Mouton, 1968.

———. *Orixás: Deuses Iorubás na África e Novo Mundo*. Trad. Maria Aparecida da Nóbrega. Salvador: Corrupio, 1997.

———. *Os Libertos: Sete Caminhos na Liberdade de Escravos da Bahia*. Salvador: Corrupio, 1992.

Verucci, Florisa. "Women and the New Brazilian Constitution." *Feminist Studies* 17.3 (Fall 1991): 551 Web. March 28, 2005.

Vianna, Hermano. "O Movimento Funk." In *Abalando os Anos 90: Funk e Hip-Hop*. Ed. Micael Herschmann, 18–19. Rio de Janiero: Rocco, 1997.

Wafer, Jim. *The Taste of Blood: Spirit Possession in Brazilian Candomblé*. Philadelphia: U of Pennsylvania P, 1991.

Walker, Sheila S. "Are You Hip to the Jive? (Re)Writing/Righting the Pan-American Discourse." In *African Roots/American Cultures: Africa in the Creation of the Americas*. Ed. Sheila Walker. 1–44. Lanham, MD: Rowman & Littlefield Publishers, Inc., 2001.

Werbner, Pnina. "Introduction: Dialectics of Cultural Hybridity." In *Debating Cultural Hybridity Multi-Cultural Identities and the Politics*

of Anti-Racism. Ed. Pnina Werbner and Tariq Modood, 1–28. London: Zed Books, 1997.

Williams, Raymond. "The Analysis of Culture." In *Cultural Theory and Popular Culture: A Reader.* 4th ed. Ed. John Storey, 32–40. Harlow, UK: Pearson Education, 2009.

———. *Problems in Materialism and Culture.* London: Verso, 1980.

Willis, Deborah, and Carla Williams. *The Black Female Body: A Photographic History.* Philadelphia: Temple UP, 2003.

Winant, Howard. "Rethinking Race in Brazil." *Journal of Latin American Studies* 24 (Feb. 1992): 173–92.

Yai, Olabiyi Bablola. "In Praise of Metonymy: The Concepts of 'Tradition' and 'Creativity' in the Transmission of Yoruba Artistry over Time and Space." *The Yoruba Artist.* Ed. Roland Abiodun et al., 107–15. Washington, DC: Smithsonian Institution P, 1994.

Yancy, George. *Black Bodies, White Gazes: The Continuing Significance of Race.* Lanham, MD: Rowman & Littlefield Publishing, Inc., 2008.

Young, Robert. *Colonial Desire: Hybridity in Theory, Culture and Race.* London: Routledge, 1995.

Yudice, George. "Afro-Reggae: Parlaying Culture into Social Justice." *Social Text* 69, 19.4 (Winter 2001): 53–65.

———. "The Funkification of Rio." In Ross and Rose, 193–217.

Ziégler, Jean. *O Poder Africano.* São Paulo: Difusão Européia do Livro, 1972.

Index